FRANK
BRANGWYN

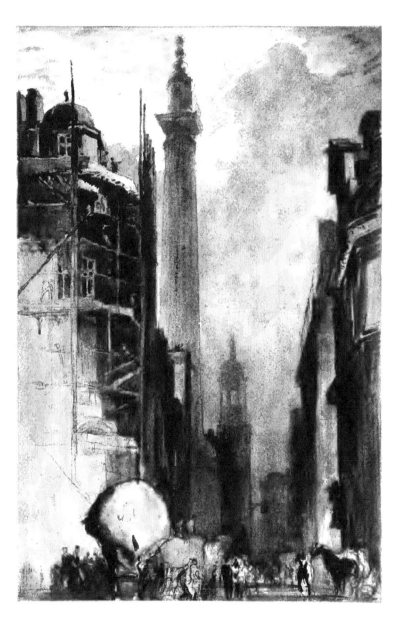

'THE MONUMENT, LONDON.' STUDY FOR THE
ETCHING IN THE COLLECTION OF MRS. LYON

PRINTS & DRAWINGS BY FRANK BRANGWYN WITH SOME OTHER PHASES OF HIS ART: BY WALTER SHAW SPARROW

LONDON: JOHN LANE, THE BODLEY HEAD
NEW YORK: JOHN LANE COMPANY. MCMXIX

PRINTED BY WM BRENDON AND SON, LTD, PLYMOUTH, ENGLAND

CONTENTS

LIST OF PLATES

PRINTS DRAWINGS

PRINTS AND DRAWINGS

INTRODUCTORY: CRITICISM, CONTROVERSY AND WRITING ON ART

 good story may be told usefully about an American visitor in London, a dollar democrat and dictator, who liked very much the modern movements in art and literature He had no wish to put his money into furniture that belonged, more or less, to half a dozen centuries and countries, never did he yearn to set up his quarters in a museum house as variously old as Warwick Castle, nor in a new "classic" mansion shining with marble and Portland stone ; and, more noteworthy still, he was discreet enough to believe that the Old Masters of painting would live on all right without help from his millions.

Dealers were troubled, perplexed, annoyed, astounded ; and the millionaire's secretary—not a girl in those days, but a plain man accented in Philadelphia and sharpened in New York—was bored all day long by the silken guile of certain high financiers of the Trade who baited their traps with mercantile warnings and costly masterpieces. As collectors like to tell themselves with pride that they are expert investors, the American heard that modernized art was unsafe, a mere quicksand that swallowed up changing fashions. Young executors got near to grey hair when they had to turn yesterday's fame into gold at auctions. Great dealers alone were safe trustees for posterity when much money had to be lent at a proper interest to the fine arts Had they not for sale many old pictures so far-famed, and so coveted by public museums, those glorious paupers in the markets, that a millionaire could buy them at their present Alpine prices and yet be aware that he had gilt-framed securities, whose money value would continue to leap upwards?

"Very tropical, these old big boys," the American said "Could I not keep hot in winter, blizzard or no blizzard, if I looked at their prices? But I'm out to see the young big boys, who're in flesh and blood still,

thank my lucky stars. So I take my choice—and go slow. There's Lutyens. You know Lutyens? He's good enough for me in architecture. No Jack and the Beanstalk in Lutyens; he didn't grow out of nothing except magic. He's all there—*himself*, but with some ages and sages in him. And I'm captured by two or three British painters. Not more at present. Don't ask me to be a hotel where volunteers lodge and do what they please. Some years ago I set my eye ranging over Brangwyn, who's as easy to see as New York if he comes your way. Here's my man in etching and my man with the big brush. Large . . . ! He's mighty large is Brangwyn. Have I seen already some acres of Brangwyn? Maybe more. Yes. And I've seen a bit of him in the States, where Nature and the towns are all large: and Brangwyn's in scale. Aren't you tickled with joy when a big painter in the States keeps his backbone and his own size and space, refusing to be fixed up as a pigmy for a cabinet? You see what I mean? Stars, but you ought to see! Let me fudge a bit with words, then. Great nations and times. . . . They don't need painters who're only villages in genius. What they need are big fellows who're provinces in genius. You agree? Surely. Gulliver's

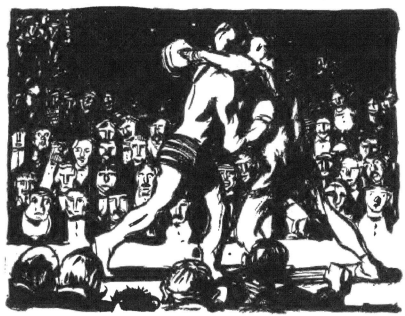

grand among the Lilliputians; but tell me what he is in Brobding-
nag? Is he more than a bit of human snuff for a splendid giantess
to take in with her breath through the corridors of her nostrils?
No! And I maintain, too, that our age is too much of a Brobding-
nag for most painters, etchers, sculptors, and writers. Let me have
Brangwyn, then, and a few others. Not more 'Few but Fit' is
my motto."

One evening the millionaire talked in this way to a knot of guests—
several painters and several writers on art. He had seen the Brang-
wyns in the Skinners' Hall, and they made him feel quite small
enough to be happy. But all at once he noticed that his guests were
mum and glum. They fingered their bread restlessly, and their
nostrils looked bellicose. The millionaire wondered why. Was
Brangwyn not their man? Did they dislike the Brangwyn paint
and colour, opulent, sumptuous, alive? or his lusty manliness, a
generous great swagger free from bombast, and as natural and way-
ward as winds, harvests, and the sea?

These questions were to a friendly evening what sparks are to a train
of gunpowder. One by one the guests made F B. into their target,
and soon they shot their criticisms so rapidly that volley-firing began.
The American raised his eyebrows and listened with amused, ironic
patience "Well, gentlemen," he said at last, "you've talked, and
I'll admit that a painter you dislike might write much in praise of
deafness But I know a thing or two In my time I've cursed the
Rockies, for the Rockies don't suit me when I'm tired, stale, cheap,
and glad to be coddled by my daughter Is Brangwyn too robust
for you, gentlemen? Is he *your* Rockies? It must be so if you
mean what you have said. But it can't be helped. Mishaps in
sympathy and taste come of their own accord; but if Brangwyn had
been born in my own country, and if I disliked him as much as you
do, I should still be no end proud that he belonged to the States, as
I want the States to be large and great all round. Besides which,
surely, it's good to live and let live in the art of our own day To
be cocksure when one is nasty towards a big man is to forget that
the big man will be alive and big many generations after I've got
back somehow, anyhow, into dust. My business after death is to
nourish tulips and snowdrops. Let me alone, then I enjoy the
ages to come, *now*—enjoy 'em all I can in the greatness of a few big
men, who are my neighbours in the flesh. Faults, failings? Of
course he has faults, large, ample, and daring faults! How could a

big man grow bigger if he had no big faults to correct? Right or wrong, then, gentlemen, give me Brangwyn! Will you drink to his health?"

Is this good story true? In criticism it is, no doubt, being a story with "undergarments," as mild and good old William Hunt used to say when work had depth and substance; but it may have been in part invented. Perhaps a satirist wanted to break ridicule on certain painters and writers who in recent years—as if obeying one of Nature's rules, that small organic things must be offensive, like bantams and bacteria—have tried to police all the æsthetic judgment in vast London, our nation-city. How confident they have been of their associated worth, their newness and their originality! Upon my word, they have forgotten that only minor minds yearn to be quite new and entirely original, because an art wholly new and original would be as wonderful as a new species of mankind.

To be original, to have a style in the blood, as Brangwyn has had since boyhood,* is a very uncommon birthgift, most people always being other people also: and when it is present, present as true genius, it borrows from work old and new, choosing for its alembic any materials which are useful and necessary. Turner, the most original and various of modern painters, played the covetous bee with passion, and even in work seldom noticed to-day, as in naval pictures by De Loutherbourg.† And Shakespeare also knew what was his by right of conquest in the arts of other men. As there would be no vast rivers if tributaries went their way alone to the sea, so there would be no unusual greatness if big men did not collect enough from their forerunners and from their contemporaries, while keeping their

* Professor Selwyn Image, to whom in this book I owe many debts of most pleasant gratitude, was greatly struck by this fact when Brangwyn was only sixteen. In those days, from time to time, they made a small etching together or in company, after the boy had shown his friend how to attack a plate.
† He stole from Loutherbourg his idea for "The Battle of the Nile," exhibited 1799, as he got hints from the Poussins for the "Fifth Plague of Egypt," 1800, and the "Tenth Plague of Egypt," 1802.

4

own magic atmosphere. Brang- wyn's observation has ranged freely through the arts; he has collected much, but never as a conscious copyist; and digestion being trans- mutation, we find in his best work few quotations, and no stolen plumes dishonour his output.

True genius has two aspects: it appears to be human nature in essence, a single creative agent with a double sex, its qualities being in part masculine and in part femin- ine; and it belongs to no time exclusively. Heir of the ages past,

and selector from all influences current in its own day, true genius blends what is undying in itself with other imperishable things chosen, conquered, assimilated, and is fit to prove that classics are the only futurists. In Brangwyn's genius the male attributes hold empire over the female, while in much modern genius the male attributes are too chivalrous, so apt are they to yield pre- cedence to the female qualities. Take Burne-Jones as an example, and note the contrast between him and Augustus John. In the Johannine genius the male qualities dominate, with plebeian energy and a candour not always apt; in Burne-Jones, I ask leave to say, the feminine attributes often govern as spinsters always remote from common life, yet never quite at ease in their isle of dreams. A Burne-Jones knight of the Middle Ages appears to wear armour as a protection against thorns during sweet adventures among rose bushes; and the Burne-Jones women, once so much adored, are they not maladive and self-pitiful, as if their only joy was a mild pride in their ability to feel unreal grief? To me it seems patriotic always to look out for those painters and writers who are brave, bold, and strong, each with his own limits and blemishes. For the genius of earlier England was masterful, our Elizabethan playwrights having the same mettle as the sea-rovers, and Milton a close kinship with Cromwell's Ironsides. So I am glad that Brangwyn at his best has in him enough East and enough West to represent our later England and her empire.

If truisms were understood by artists, writers, and the people, quarrels over opinions would be rare and our world would be somewhat of a paradise. Enterprise would be judged, not as a thing to split us up into bickering factions, but as a thing to be watched and discussed quietly, because it lives from within itself or dies from within itself. Ill-tempered criticism implies absurd beliefs that violent censure can destroy life in enduring enterprise, or that excessive praise can keep life in perishable novelties

No student of the fine arts ought to speak in public about his likes and dislikes until he understands these and other truisms He should call up before his judgment the mingled benefits and banes in criticism and controversy, questioning and cross-questioning his candour until he knows *why* he wants to speak publicly about his likes and dislikes, and also how he must try to speak in order to be of any use at all to good work and the nation. Let him get rid of the stock belief that truth-seeking alone is the ideal to be made real * Truth-seeking, we may assume, made its beginning with the first men, and will end with the final generation; and what has it produced? Infinite good and infinite evil. Who can weigh and measure the harm done by the worst products of truth-seeking: fierce zealotries, envenomed persecutions, anarchy in politics, and the untruth that enthusiasts rarely fail to speak? Truth-seeking and truth-speaking are infrequent friends; and few critics remember that past efforts of truth-seeking have collected a great many sovereign truisms, which should be to our moral judgment what clocks, watches, railway guides, maps, are to our material needs.

It is a sovereign truism that a day without a good fight in it is a day lost. Contention is a thing invaluable when just limits are set to it by sound reason There is no better stimulus, and it is feared by the toadies who gather about great men and often deprave the development of greatness Even wrongheaded combat is infinitely better than apathy, and better also than overmuch tolerance. Nature has hours of peace in years of struggle, and we as Nature's children take part in her wondrous duet between life and strife; but, somehow, few

* Robert Browning says —
> "Truth is within ourselves, it takes no rise
> From outward things, whate'er you may believe.
> There is an inmost centre in us all,
> Where truth abides in fulness "

persons ever take pains to be sure that they are fighting in the best way for the right men or the best causes. With the over-confidence of youth they become dogmatists in their teens, and travel on through their more virile years until they learn from bitter experience that most fanaticisms have the vogue of fashions. No wonder the middle-aged are often younger than the young; they have outgrown those disenchantments that youth seeks and finds, generation after generation

More than once I have talked with Brangwyn about these matters. The young who revered our pre-Raphaelites as masters who would govern the future, were displaced by youngsters who gave their worship to *plein air* and square brushes. None could say briefly, or even at all clearly in many words, what this *plein air* doctrine was; but modest Bastien Lepage came to be accepted as *plein air;* and around this humble man devotees thronged, until the real Impressionists invited and received more insulting criticism and slander. Since then we have had many other innovators, and each group has collected rapt idolatry and virulent abuse

Even the best of these sects wronged themselves often by being far too self-conscious, wasting their energy in talk as kettles waste the motive-power of steam. Their ablest men live on mainly at second hand, as fertilisers, just as last year's rain and sun and toil live on in this year's harvests and the bread we eat. Brangwyn borrowed from Impressionists all that he required, as J. S. Sargent took what *he* needed, like Charles Cottet, Lucien Simon, and many others.

Unless we remember the defects of modernized peoples—their self-absorption and profuse cant, and their self-advertisement—we cannot be fair to the pathfinders in modernized art. Painters, sculptors, authors, craftsmen of every sort, with only an exception here and there, have found in their noisy journalized age a persistent foe, whose prying fuss and flurry have irritated all weak spots in their characters, causing youngsters to set greater store by the cockiness of wayward inexperience. Brangwyn has fared much better than have a great many other painters of his generation, natural shyness and a keen sense of the ridiculous having kept him apart from the self-conscious and their fluid talk; but it appears to me always that, had he been born in the times of spacious Tintoret, or in the atmosphere that made Rubens and the Netherlands equals and boon companions, his lot as a creative worker would have been a great deal happier and richer.

7

Even the huge size of modernized towns keeps great men from knowing enough at first-hand about one another; either it divides them into rival sects and parties, or it produces by reaction a hermit craze, as in poor Mathieu Maris. Turner appears to have been the last of those big men who passed through their evolution as naturally as corn grows through a changeful season; though even he felt that his times were his foes A premeditated egoism was all around him; and while one faction declared that progress and steam-machines travelled together at increasing speed, another faction was alarmed by the gathering evils of industrialism and injustice Dickens himself, brooding over the miseries of his age, grew from Pickwick into a social reformer, wistful and impatient. Men of science found progress among the pains of creeping evolution, while democrats wanted to snatch Utopia from fierce political controversy, aided by fierce controversies over art and fiercer controversies over the Renanized gospels "Lord, what fools these mortals be!" as Puck cries truly from Shakespeare's wisdom. As a preparation for 1914, when we were caught napping after fifty years of warning, Victorianism was no doubt invaluable.

Controversies over the dead are often necessary, of course, but what are they worth to living men and movements? It is a difficult question. Can they gain anything lasting from ill-temper, excessive statement, and injustice? Year after year Brangwyn would have cancelled his work if he had tried to obey the profusely varied opinions, often hostile, which have come to him as zealous volunteers When he was sixteen or seventeen, and at work one day in South Kensington Museum, a famous painter told him—the hint was broad and plain—to look out for another career Most faultfinding is a boon only in matters of fact; and it needs always welltested evidence, careful revision, and sedulous impartiality. Really great men get this fact from their intuitions, and they like to be prodigal in the charity of encouragement, like Sir Walter Scott A big man of fine mettle will defend all honest work, though it may clash at all points with his own; and he will not waste time by using either bastinado or knout when impenitent dullards and recidivists worry the literary and artistic world. Dullards and impostors need banter and ridicule; bastinado and knout should be kept for those statesmen who impose tragedies on their native land, and also for newspaper cant, clap-trap, and other phases of pestilential humbug

8

It is the small men who try to kill their forerunners, or who snarl and bite when innovations offend against convention and custom And yet, how can society be harmed by even the most inferior painters and draughtsmen? All the feeble painters of a century do less harm to domestic life than is done in a year by a few bad plumbers and by shoddy furniture. How tame they are when we compare their work with the mischief noised abroad by industrial quarrels or by shrieking falsehood in newspaper headlines! Is it then worth while to make much ado about inferior prints, drawings, and paintings? To strike at them in fierce criticisms is to strike also at many poor homes and families; and what right have we to assail breadwinning? As a rule it is persons without self-control who are most eager to control other persons* As the east winds of humanity, they feel nothing when they ravage a victim's inmost sensitiveness.

To meditate over these matters is to be convinced that quiet and honest interpretation, not sectarian criticism or bitter controversy, is the true office for a writer on art to fulfil Let him choose what he loves best, and then let him show all its qualities in order to explain why he loves it best in its finer and finest work. To be a bond of union between this chosen work and the reading public is a useful and necessary office in national service, because art—good workmanship and great—is only a hermit when it is studied and liked by small circles only. In Ancient Greece, let us remember, art, religion, and the people seem to have been almost as united as the air's constituents; and even the unlettered of the Renaissance were at home in the varied inspiration that genius called into pictorial presence from the same Bible stories To-day, on the other hand, so estranged is art from the people, so cloistered in experts, that many phases of fine work are not regarded as art, and many a picture show is visited by few except artists and writers on painting, etching, and sculpture The only picture shows that "pay" are kinema theatres. Even our Royal Academy has fallen into leanish years from the overthronged enthusiasm of the eighteen-eighties. Surely, then, there's need enough for less sectarian criticism and controversy, and need enough also for a great many interpreters †

* It is a fact of common observation that men who have given their lives to the study of Greek and Latin, and who know but little of present-day affairs, are likely to lose their heads with pedantry and venom when they review current work. They forget that even the humour of Shakespeare finds pedants wearisome
† See Chapter I for a detailed analysis of what interpretation in art means.

In 1910 I tried in a book to review the early art and life of Brangwyn,* in order to show that adventures in his life and sequent phases of development in his work are akin and allied. It became my business to hit out from the shoulder—not, of course, against candid opinions, but—against abusive criticism, my necessary business, too, because I had followed the evil from year to year through many thousands of newspaper attacks on Brangwyn But critics hate to be criticized, just as surgeons hate to be cases for an exploring hand and knife to work upon. Thus my counter-attack was resented here and there, some critics feeling as aggrieved as troops would be at Bisley if a target began all at once to fire back at their marksmanship. Their vanity was too sensitive. To resent unfair attacks on a big man is one of those privileges which small men should add to their belief in fair play.

Consider also another point. What is the imagined plot of a novel when we compare it with many of the hard, adventurous lives through which artists have struggled into fame? Romance at second-hand is in novels, while romance at first-hand is in biography and the wonders of politics, which Napoleon described as Destiny But this greater romance, as a rule, is much more difficult to make real in books than that which novelists weave around their imagined plots and persons. Sensier made only a twilight story from Millet's romance; he feared to keep at close quarters with his living plot and its great story, lest Millet should be hurt in his deeper pride

Here's the rub always Not more than a sketch can be written of the romance in a living man's career; but I am happy to say that my incomplete sketch of Brangwyn's early life and work has not yet been overwhelmed by the transitory novels that come and go with the literary year's brief seasons. If, then, you set up your home in the work of a man of genius and try to speak about it as truly as you can, good luck may come to you from your subject, as Sensier found a lifebelt in Millet and Fromentin mainly in that fine, rich book, *Les Maîtres d'Autrefois*.

It appears to me that Fromentin is among the few safe guides that young writers on art can read and read again. He employs with rare tact the atmosphere of social history that should remain around genuine classics; he is humbled into discretion by the fact that a

* *Frank Brangwyn and His Work* 1910 Second edition, 1915. Kegan Paul, Trench, Trubner and Co , Ltd , Broadway House, Carter Lane, London, E.C.

10

student's abilities must always be lean and mean when they are compared with the aggregate of genius in the permanent masters; and he forgets only here and there how swift is the reaction in most readers when praise and blame are overdone.

Who can explain why the spiritual action and reaction of these excesses are neglected studies? Even when they are studied with care, the ideal mean separating too much from too little in praise and blame is an El Dorado, as elusive as it is attractive. Who can guess at what point praise becomes irritating to most minds, or at what point fault-finding begins in most minds to provoke contradiction?

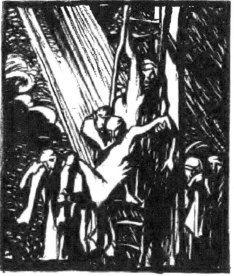

Some help can be got from a few more sovereign truisms. The first one is that fault-finding is much less difficult to write than to praise, flowing with ease—often as a spate—into copy that is easy to understand. If we wish to praise truthfully we are obliged to think patiently, because the higher qualities of art evade words and phrases. Homer feared to describe Helen lest his words should rob her beauty of its eternal persuasion; so he left Helen as a dream of loveliness in mankind's imagination. And the best art, is it not a thousandfold Helen? Yet we cannot in books leave her graces undescribed. In some way or other we have to put into sentences—often death sentences, too—what we see and feel and know about the qualities of great art. Thought and revision have to creep nearer and nearer to those epithets and phrases which are, or for a moment seem to be, akin to what we need, though even the best are but improved false steps among perils of the second-rate. Never are they better than photographs of sunsets; and as a radiance in monochrome is not a sunset, so the finest interpretation of art is not the whole art interpreted: it is only a thing allied, affiliated, and a literary adventure.

No wonder, then, that praise creeps, while fault-finding flows, into criticisms on art.*

And another trouble is that praise needs from its readers a very alert sympathy for subtle shades of meaning, not in words and phrases only, but also in parallels, analogies, and other aids to reflective judgment. Have we a right in this newspaper age to expect from many persons the search and research that complete reading requires? I believe not, most minds being debauched by our newspaper Press The collaboration between readers and good writers on art, as between spectators and painters, sculptors and architects, has to be coaxed from its apprenticeship into a popular custom and enjoyment. No wonder, then, that those who are skimmers only, not readers, become impatient when a writer on art makes many calls on their unwillingness to think seeingly.

How many persons in a thousand ever try to remember that speech, written or spoken, is not real thought until it is seen under the form of visual conception until it is present before the mind in pictures more or less clear and detailed? The highest thought, as in Shakespeare, is wondrously graphic, so closely is the vestment of words fitted to the visible drama in ideas and characters beheld by the mind's many eyes. Shakespeare grows from one thought picture to another, often between commas, and we must grow with him if we wish to see his meaning. In each of his best plays Shakespeare is a National Gallery in Armada Square.

These being the virtues of writing and the perils of reading, let us turn to another cardinal truism Fault-finding is not only easier to write than praise and easier to read, it gives a longer pleasure to most persons, particularly when it is accompanied by cant about safeguarding art's honour and the public taste Even your most intimate friends, when you are praised in print, are apt to wonder "how the dickens you got at the reviewers"; and they feel a half-secret joy when a reviewer gets at you with rapier or bludgeon.† And I fear that our countrymen, with their habitual cant about peace, enjoy primitive football in criticism, the rough-and-tumble of knouted

* I employ the word art, of course, as meaning all good workmanship fit for its purpose Art should be the soul of industries as well as the founder of National Galleries and Museums

† A famous author said to me : "Whenever I am roasted by a reviewer a good many of my friends find it worth while to let me know. They try to hide their joy, of course, but they can't and don't "

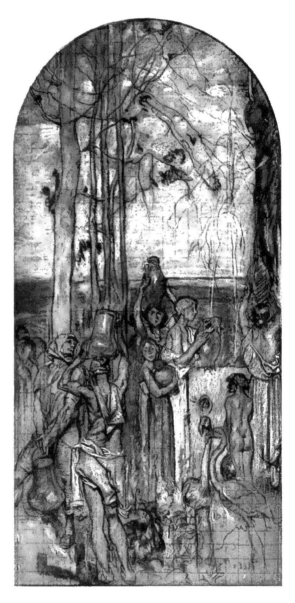

SKETCH FOR A PANEL IN MULLGARDT'S COURT
OF THE AGES, PANAMA-PACIFIC EXHIBITION
(*The Blocks lent by " The Studio " Magazine.*)

censure, a good deal more than do most other peoples. Thus the French, when typically French, dislike such premeditated assault as Macaulay poured over Robert Montgomery. Do we need earthquakes to kill mice? But lineage tells. In our language the verbs that describe the giving of pain, discomfort, or correction, are profuse and subtle: strike, knock, hit, bash, slap, rap, tap, thump, beat, punch, whip, bang, whack, thwack, batter, pelt, buffet, pound, belabour, bruise, chastise, castigate, trounce, whop, flog, hustle, hurtle, birch, drub, roast, and many others. Our forefathers seem to have explored for neighbourliness in the maxim: "Bruise the flesh and better mankind."

Out of all these considerations a few guiding rules emerge. Though readers, most readers, like praise to be rationed, sternly Rhonddaised, and censure to be as free as a Christmas dinner, it is a mark of an inferior mind to be niggardly in praise. Another rule is that censure, being easy to read and enjoy, is easy to remember, while praise, being hard to read with understanding, is hard to remember, so a little censure will cancel in most minds the effect of much praise. As a rule, then, let censure be as a question asked; and let eulogy come as an offering to all from the honest joy we feel. Of course, an interpreter is bound by honour to his readers never to hide what

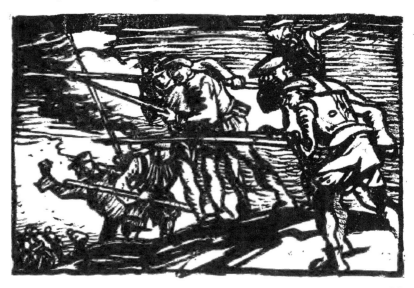

he does not like and never to be false. But his tone must be modest and temperate.*

Yet there are writers on art who play as recklessly with fault-finding as do shrewish women. In their hands the word "but" is a deadly bullet often, a sniping shot at point-blank range. Example· "Mr. So-and-so is a pupil of the Belgian school, and his vigour and variety are unaffected and welcome; but his colour is bad, as the painter has mixed his pigments with Ypres mud." Unhappy painter! Who cares for his vigour and variety?

In 1910 I was accused of praising Brangwyn far too little and far too much· and both accusations were right to the persons who made them One can but try to be neighbourly with that elusive somewhat which prevents excess in the management of likes and dislikes Some reviewers were offended by my use of the qualifying phrase, "at his best," though it is necessary when a big man's life-work is shown through its transitions.

III

As the most reasonable and useful office of a writer on art is interpretation, let me try now to speak about what I regard as Brangwyn's present relation towards current movements. Since 1910, two agents of modernism have become well-known. One is post-Impressionism, so called, and the other is the composite art which has come with authority from Méstrović. What a turmoil swirled around these influences! A great many persons welcomed the post-Impressionists as they would welcome puppies fringed with tails; and who can forget the sentimental devotees who almost wept with joy? Méstrović's followers appeared to forget the War, though they imagined that his finer sculpture, rotundly ample and alive with good health, came from centuries of persecution in the Balkans.

Brangwyn was amused by the wrong pedigrees given with zeal to Méstrović's virility Having studied German sculpture, and the

* Bacon says "Too much magnifying of man or matter doth irritate contradiction, and produce envy and scorn" Hence Dr. Johnson tells us never to blast a reputation with exaggerated praise, nor let censure defeat itself by being overdone

14

Secessionists in Austria, he knew that our foes in this War had been tutors in pre-war times to Méstrovic, who had united a good deal from their full-blooded research to his own gifts, and also to his study both of early Gothic sculpture and of Southern Slav traditions Greek and Roman sculpture also entered into the gleanings that Méstrović alembicated, not always with success. A female nude gains nothing from an unwelcome pose, and is it wise in these days to hark back to early Gothic in order to portray Christ on the Cross as withered and mummified, a mere skeleton wrapped in shrivelled skin? Is Méstrovic a new Voltaire in his thoughts on Christianity? Is it his aim to suggest that the ages have been as insincere to the inward spirit of Christianity as they have been honest towards the fecundity of women ? Not even the women summoned up into art by Rubens are more plenteous, more promiseful of lusty health in the next few generations, than the mourning widows in Méstrovié sculpture.

Public monuments alone will give to this big sculptor, this natural force, such opportunities as an abundant style needs in a swift rise to maturity To keep the studio atmosphere out of art, and to set limits to the hindrances that local aims and ideals wield, are needs which all artists ought to keep prominently before their minds Brangwyn forgets them now and then , and Méstrovic also, though he, too, loves the inspiriting discipline of monumental work The stronger an artist is, perhaps the more likely is he to copy from himself when he gives his genius to studio pieces

Here and there Brangwyn copies from himself, like Augustus John, and among those modernists who snarl at the academic, there are many who forget that he who copies from himself is auto-academic, and as uninspired as the pseudo-classicism of Leighton French Impressionists dawdled too often in autograph moods and methods, sometimes halting within themselves like plants which have ceased to grow, and sometimes revolving around their past work like a top around its point. Later pathfinders also have trifled frequently with self-repetition, and some have drawn very near to automania, like the Cubists, who remind me often of enchanted gramophones able to make for themselves a few puzzled registers. Automatic repetition is common also in post-Impressionism, as in Gauguin, whose inferior work is but a variation on two or three ideas. Gauguin is an original colourist with a pleasant note in decoration , but he made a cage for his zeal, and too often his zeal sings in it like a bird

15

But we must go to Van Gogh if we wish to see the primitive candour and passion that give to post-Impressionism a peculiar immaturity. Van Gogh enslaved his pigment and hustled it as a menial; his surfaces are browbeaten, but his conception of Life and Nature is touchingly sincere. Though his vision is weak in focussing power, Van Gogh had fortunate hours. His portrait of himself reveals the whole man through and through: as a wayward spirit in art of a primeval vigour; as a rough-hewn man scarred and seared by suffering; and also as a coloured bulk in space with air and light suffused around it, a transfiguring bath of atmosphere

What Van Gogh reached at times by hard-slogging effort, haltingly and with much grief, Brangwyn has achieved again and again, almost without premeditation, so unmindful has he been of self during his productive moods. Some artists behold as visions what they must needs do, while others, like Michelangelo and Beethoven, take much thought and time in the gestation of their germ-ideas ; but yet the great have one thing in common—they are unconscious of their greatness while they are doing their best work, so wrapped up are they in the joy that accompanies inspired production. As Milton wrote, "When God commands to take the trumpet and blow a dolorous or jarring blast, it lies not in man's will what he shall say or what he shall conceal."

Poor Van Gogh, I fear, knew not this mood, this swift vagrant from the point of home to the point of heaven, though he came near to it in a picture of the Dead Christ. I think here of Jeremiah when reproach and derision harry him all day long, and the truth suppressed in his heart is as a burning fire shut up in his bones. What is poor Van Gogh in art but a rugged and homespun Jeremiah, labouring always through pain dimly to express the true? And how different is the spontaneous emotion in Brangwyn's etching of The Nativity, or in his austere oil-painting of The Crucifixion amid the clouded radiance of a malign sunset scowling towards darkness and earthquake ! In the babel of talk about Modernity, please note, it is often forgotten that genuine art is a big man's emotion* and its vision aided or impeded by four cardinal influences: his temperamental endowment, the auto-customs of his brain, the training which he has received from all the sources open to his meditation and observation, and last, but not least, current history in all its phases and in all its actions and

* *Emotion* See Chapter I for an attempted analysis of emotion in the arts and in Brangwyn's career.

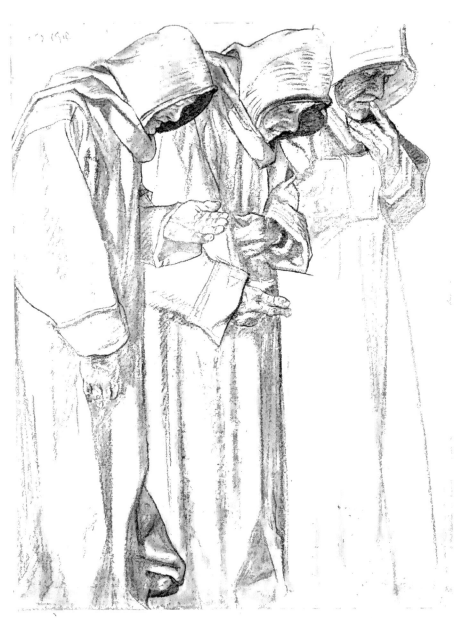

A STUDY OF MONKS IN BRANGWYN'S CARTOON
FOR A PANEL IN ST. AIDAN'S CHURCH, LEEDS

reactions. So a big man's art at its best, like it or like it not, is as inevitably what it is as any other among Nature's phenomena; and if at first you do not like it, be modest, just live with it as if you *do* like it, and friendship will come.

Letters are addressed to me from time to time in which Brangwyn is slighted, as Turner was slighted; and always I am expected to believe that art exists as an authoritative conception in every mind that puts into words some notions about art, though art depends for her existence on the varying gifts, temperaments and ideas with which talent and genius carry on from age to age an unbroken evolution, sometimes dispersive, at other times ordered into long-lasting traditions and developing schools. Never can there be an absolute standard by which every big man's art must be judged, as every genius produces a standard in part new.

Suppose a Parliament of the greatest Dead could assemble near the Thames, and suppose it debated the modern movements in art and literature. Two or three Cavemen are there, for they discovered the birth of art among varied colours and patternings on and in a great many natural things, such as the plumage of birds; and it was they who made the first public galleries of art in firelit caverns. Side by side with these prehistoric primitives are the greatest of the simple best ones gone, often separated by words, but united by the universal appeal of colour, form and drama. What would this Parliament say

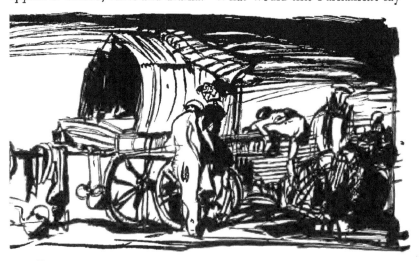

of F.B. at his best? Would the most enterprising of the elect—Titian, Tintoret, Michelangelo, Rubens, Velasquez, Shakespeare, for example —find in him a lineal descendant as fitly good in his wayward time of industrialism as they were in their own epochs? I believe so, because kinsmen in art know one another. They hang together like the fresh, sweet grapes on those orient bunches which were carried from the Promised Land, every berry a luscious round world of potential wine.*

Yes, and the germs of all things present are to be found somewhere in the past. Take Caliban, for example, and note how akin he is to the pictures now drawn by scientists of the apelike progenitors in man's ancestry. For Shakespeare's art is closer than modernity— closer by enchanted miles—to the whole æsthetic truth

<div align="center">IV</div>

What is the whole æsthetic truth? Brangwyn is amused by the narrow answers that writers give to this question. Consider Ruskin's dogma: "I say that the art is greatest which conveys to the mind of the spectator by any means whatsoever the greatest number of the greatest ideas; and I call an idea great in proportion as it is received by a higher faculty of the mind and as it more fully occupies, exercises, and exalts the faculty by which it is received. He is the greatest artist who has embodied the greatest number of the greatest ideas."

Which art is *the* art and who is *the* spectator? Has he a mind as wonderful as the aggregate of greatness to be studied—and studied in phases almost innumerable—as true art? If not, he is human, a spectator like Ruskin himself, with prejudices, and some imperfect sympathies, and a judgment not always to be trusted. No such superman as *the* spectator of *the* art has ever existed or ever will exist; and how is a great idea to be defined? Is Goneril or Regan a great idea? Does she add to our material comfort, or does she lift us above our ordinary

* Do you remember Brangwyn's picture of the spies returning from the Promised Land? It was exhibited at the Royal Academy in 1908. A noble work full of sun, it hangs to-day in a sunny part of our Empire, the Art Gallery at Johannesburg

selves? Disgust mingled with fear is the tribute of just emotion that we all pay to Regan and Goneril. Yet these beautiful she-devils are masterpieces of art, as Nym and Pistol are among the dregs of debased manhood Not all great ideas exercise and exalt the higher faculties of our minds. Many bring comfort to us and exaltation, while others may bring discomfort and worse feelings also. In fact, Nature and Mankind are either variously attractive or variously unattractive, or a diversified mingling of attraction and repulsion. Goneril and Regan are like those plants in which beauty and poison are united, or like those malign snakes which are exquisitely patterned. Remember, too, that we *see them on the stage*, and not merely in our minds when we read. Ruskin's thought, then, dallies with only a few sets of great ideas; invaluable sets, but as certain as the unpleasing sets to produce reaction if they are thrust into a routine and made tyrannous. To my mind, then, the greatest artists are they, who, not bestial and lewd, have embodied in the greatest number, with subtle wit, humour, and judgment, and good workmanship, the most varied and contrastful emotions, ideas, and subjects.

It is true, no doubt, that to-day's prints, drawings, and pictures, like to-day's books, have too little poetical persuasion, and too much of those qualities, terrene, penetrating, sincere, which are to the dark aspects of social and moral truth what medical research is to our physical ailments Between right and wrong in the use of a little more and a little less, our common lot in all things moves to and fro, a pendulum swinging between action and reaction; and swinging often so fast that we cannot say with truth what is actionary or what reactionary. Brangwyn fears that a rebound from extreme modernism, already begun, may renew in art the false classic and the epicene, with other manifestations of cant and claptrap; and from the *Saturday Review* (29 December, 1917) I choose a warning —

"Roughly stated, the position is this· the older idea was that art was necessarily intended to distil exclusively the noble and beautiful from life; the new idea is that art is mainly concerned with the true, no matter how repugnant or bestial it is The only concession made by the moderns, in literature if not always in painting, is that craftsmanship should be beautiful. Thus we have with the old schools" [but not among the Dutch and Flemish masters as a rule] "a conspiracy of silence and hush-up over the gross ugly facts of life, and with the new a frankness in expounding, and a deliberate insistence on, the crude or the obscene Their charter, they consider, is

their creed that what is good enough for God is good enough for them, and art, and that the great thing is to see life whole. But, with a curiously incomplete vision, they not infrequently confound the part with the whole If life is not entirely white, it is surely not all black. Exclusive musing on the purely beautiful and noble soon starves art; but dwelling on the gross or cruel perpetually is no more nourishing If it is humbug to give out that all is harmonious, exalted or refined, it is equally misleading to restrict one's statement to the opposite qualities."

I know not who wrote these frank opinions. They invite and deserve meditation; but varying atmosphere in and around art and life rules over our attitude towards ugly facts. We accept from the Elizabethan genius a great deal of stark realism that would offend us in to-day's work. It is easy to pick holes in modernity, its many very different atmospheres having no prestige sanctioned by long custom and centuries of transmitted vogue; but let us not scratch at it with words like claws, misled by the false belief that excesses of ugly facts and ideas in to-day's handicrafts are worse in kind and more repugnant than similar excesses among those venerable classics who remain forever youthful As Macaulay said: "The worst English writings of the seventeenth century are decent, compared with much that has been bequeathed to us by Greece and Rome Plato, we have little doubt, was a much better man than Sir George Etherege But Plato has written things at which Sir George Etherege would have shuddered. Buckhurst and Sedley, even in those wild orgies at the Cock, in Bow Street, for which they were pelted by the rabble and fined by the Court of King's Bench, would never have dared to hold such discourse as passed between Socrates and Phædrus, on that fine summer day under the plane-tree, while the fountain warbled at their feet, and the cicadas chirped overhead "
Let us be fair, then Our current art and literature have in them much to provoke regret, yet they illustrate the swift-changing moods of our wayward epoch, and what need will there be for any historian to make on their behalf an apology as sophistical as the one which good Charles Lamb offered for the impure comic dramatists of the Restoration?
Still reactions are capricious, erratic, incalculable; and we know also how buyers are managed by "criticism" from our noisepaper Press, which advertises for payment any sort of shoddy made by factories, yet helps many a phase of honest effort in good work to lose its vogue, as if artists were dresses and hats When æsthetic fashions
20

go, men of genius often disappear for a considerable time, and a re-
bound from modernism, already begun, is unlikely to befriend that
candour towards the true which many artists and writers of to-day
reveal It is this candour alone that can disentangle our country
from petted and very perilous defects habitual cant, with chattering
self-righteousness, and very culpable negligence towards unwelcome
facts, with other sorts of debilitating self-deception. Brangwyn is
as frank as Beaconsfield in his contempt for claptrap. No cant de-
praves his art: an art bred and braced at sea, trained abroad by free
air adventure, matured at home by diverse and intrepid work,
and not yet at its meridian

CHAPTER I EMOTION, ART, & FRANK BRANGWYN

motion in art is thought and life in unnumbered phases, and chief among these phases are the qualities with which genius and talent are endowed from age to age. Never can we hope to interpret any artist unless we transfuse into the words we employ an increasing amount of his qualities. We must let his work act on us until our feelings repeat the modulated emotions that rule over his career. In other words, we must try to see as he sees and to feel as he feels, then his best work will direct us always, just as good musicians are directed by the composers whom *they* interpret—whom they translate into ordered sound from the gifted silence of print.

It is easy to see when a writer on art is at home within the emotion that his chosen master circulates, for the way in which he writes becomes akin to the master's appeal. If he writes in the same manner when he goes from one artist to another, he is only a diarist who relates what he likes and dislikes as an egoist outside his chosen studies. Such diarists can be reckoned up by dozens, and the reading public should learn to scorn them by comparing their unresponsive words with the varied emotion by which artists are set apart from one another. What would happen in a concert hall if musicians played Wagner as they played Beethoven? They would be ridiculed as fools. Yet few persons care when blunders equally absurd come in a routine from writers on painting and on other handicrafts. Egoist after egoist delivers judgments unashamed on all arts all day long, yet his hearers and readers do not join the striking classes.

But it cannot be helped To listen thoughtfully is hard work, and the general reader skims over so much print that he has no wish to delay his eye-exercise by thinking He knows not how to judge the verdicts which writers on art put before him with fluent authority. And consider the trade which writing for the Press on art has kept in fashion. Exhibitions of many sorts have to be viewed and reviewed, often in a scamper, and newspapers cannot live unless they live to please. Vulgar ways of looking at things and vulgar ways of speaking about them belong to the peremptory needs of journalism, so a man who writes on art for the newspaper Press must be a journalist; and since he is called upon to have his say freely on many hundreds

of artists, old and new, his trade requires from him a mixture of warm self-confidence and encyclopædic half-knowledge Now and then, no doubt, sagacious fatuity may get him into trouble, though its vogue is rarely challenged.

False interpretation is displayed in a great many random opinions There are modernists who seem to believe that emotion and current movements came into art at the same moment. They tell the world that modernism is emotion from artists and authors, as though earlier arts had come somehow from paralysis, which cuts off emotion—either partly or entirely—from its dynamo, the human brain. What would a Shakespeare be if a spot of blood from a ruptured vessel blotted his brain? His emotion would lose its potential comedies and tragedies, just as Joseph Chamberlain lost his enthusiasm, with his worth to the State, in a stroke of incomplete paralysis

Every action of every brain has its birth in an emotion, and the emotion may be very simple or very complex If you say, "I'll move my little finger," the emotion is very simple; but if you say, "I'll play an exercise on the piano with both hands and as rapidly as I can," the governing emotion begins to be manifold; but yet it is quite simple when compared with the multiple emotion that sways a great violinist, who discovers to us the genius of a composer whom he interprets, while revealing his own mellow gifts.

Great emotion wins from a violin tones and notes which are uncanny. No Stradivarius had them in his mind when he made the violin, and thus the instrument seems to be remade and perfected by a great player, who seems also to remake the composers he loves best, though he rarely loses them in the pride of his genius. We see, then, that emotion from a fine violin is a very complex art· a great composer *plus* the responsive genius of a great interpreter and *plus* the apt skill with which the instrument was fashioned by a great craftsman Here is an orchestration of emotions, and it claims from us a fitting sympathy in gifts of the spirit How can we respond to its appeal unless we are other musical instruments within its enchantment? *

* It is worth noting that Van Gogh used in a vague way a parallel between pictorial art and the violin During 1889–90, when he was ill at Saint-Remy, he played the sedulous ape with reasonable thought to a good many men, including Rembrandt, Delacroix, Daumier, and Millet. He would take a print in black-and-white by Millet, for instance, and then translate freely into colour the impression made upon him by the monochrome. And he said, "*Mon pinceau va entre mes doigts comme ferait un archet sur le violon*" Van Gogh played his violin even from Gustave Doré, for his picture of the "Prison Yard" was adapted from one of Doré's drawings—"London A Pilgrimage," 1872 Is it not pleasant to note this exploring modesty in Van Gogh's self-assertion?

Even persons who rarely go from words into real thought feel what happens when they are captured and moved by noble music. Rapt in the other-worldly sounds, they are carried afar off from their common selves. But prints, drawings, paintings, though musical with an orchestration of their own, make only a dull appeal to most persons, and for three reasons mainly. Not only are these arts materialized by their tools and pigments, and not only do they give a new presence to objects and effects more or less known to all mankind, and therefore likely to be criticized by all mankind; but also they are apt to set in motion the hurried reading habit acquired from newspapers and novels. Most persons believe that pictorial art is a thing, not to stir them into emotion like music, but to be read, perused, like printed pages and photographs. They want artists to blend in their work the story-

teller's gifts and the camera's factfulness; and it takes them a long time to learn that geniuses, the fine flower of all animate life, are above inanimate Nature. A man of genius has no right to let himself be held in thrall by what he sees around him, his work on our globe is to endow what he sees with what he feels and thinks, adding a wondrous somewhat that is for ever his own new gift to mankind.

Yet most persons wish painters of genius to vie with the many millions of landscapes and story-telling scenes which are framed everywhere by window casements!

The useful and necessary thing, then, is to persuade writers on art that their difficult duty is to teach ordinary persons how to study prints, drawings, paintings, and other phases of the good workmanship named Art; how to dwell inside the enchantment of true art, how to share the emotions with which genius and talent produce a life beyond life. This duet of wise feeling between a student and his chosen artists will never be perfect, but why is it neglected? Although a very wide gap keeps our artists far off from the people, and also from their rightful part in national service, not many real efforts are made to set up a bridge of sympathy.* Indeed, even artist after

* I do not forget the work begun in 1915 by the Design and Industries Association, nor the patriotic enterprise of *The Studio Magazine*.

artist—and now and then Brangwyn is among the number—sometimes fights against himself by putting in his work a staring discord, which he would leave out if he remembered that greatness ought to attract duffers while claiming from the wise the whole of their wisdom

Shakespeare's groundling audience knows and loves the Master, just as it knows and loves sunlight; and, as we have seen, no great arts exist outside themselves until their spirit is transfused by kindred emotion into an increasing number of interpreters * Why, then, should any artist obstruct his present and his future by hurting any just sensitiveness that is common in human nature? To place art in the domain of tastes acquired, and acquired with slow effort, is a blunder made by many modernists, as if art found with so much ease a receptive public that it could not be estranged from mankind by overcrowding it with problems and provocations In technique, above all, many modernists have been too rash, forgetting the lesson of modesty which Shakespeare in "Hamlet" gives to the players. The passing of emotion from artists to their students is impeded by an excessive display of seasonal whims and methods Good schools are invaluable because their technique has growth—they and their disciples grow up together—while sects in art are often troublesome, so apt are they to generate rival sects by reaction, hindering a national study of ordered change in the means by which good design, good workmanship, true art, in short, is kept alive and generative

And these facts lead on to others of equal value If you are at home within Brangwyn's best work, you complete Brangwyn's best appeal by collaborating with its changing emotion, if you are *not* a guest within his best art, yet pick holes in it from outside, you wrong it and him; and what if *at times* you are hurt by something not essential to the work as art? Then Brangwyn wrongs himself and you by allowing a discord to remain between his appeal and your eager wish to be his near kinsman in feeling

Briefly, then, we can no more separate a painter from the public than we can separate a musician from his audience, or a playwright from the pit and gallery. But there is no need for him to make weak and foolish concessions Many concessions he must make

* Imagine all the masterpieces of pictorial and graphic art lost on an island uninhabited, and now imagine their discovery first by rude sailors, then by half-ignorant passengers, and then by persons of true genius They do not exist as known masterpieces until genius perceives their value

E

both in and to his art, but they are governed by that sound judgment which rules over all safety and progress in human affairs.

<div align="center">II</div>

But yet, of course, there's the eternal hitch between knowing how to do and knowing what ought to be done.* Consider the need of knowing precisely what we mean when we speak of emotion in Brangwyn's handiwork, or in any other work that merits daily investments from the uncertain time in our transitory lives. We give our all when we give our months and years to the interpretation of an artist's genius; and yet, so far off are words from the effects stored up by emotion in pictorial and graphic art, that a true analysis of Brangwyn's gifts of the spirit cannot be written without much groping and many tentative suggestions.

First of all, then, let us try to put a ground-plan around this eluding analysis To me it seems evident that Brangwyn's emotion, and emotion in every other genius, ought to be divided into four periods·

1 The primitive period of childhood and early youth, when emotion is often so unsought, so unpremeditated, so inborn and instantaneous, that we may describe it as instinctive, like the constructive routine shown by bees in their honeycomb, and by Australian bower-birds in their gabled and adorned little halls of courtship, which Darwin studied with glad surprise

2 The early period of conscious observation, research, and effort, when emotion becomes manifold, collecting inspiration from a great many sources old and new, but without losing its birthright of intuition or instinct.

3 The period of manhood, when complex emotion is exercised and matured, usually in the development of those qualities that come freely from a dominant passion or bent.

* Portia says "If to do were as easy as to know what were good to do, chapels had been churches, and poor men's cottages princes' palaces . I can easier teach twenty what were good to be done, than be one of the twenty to follow mine own teaching"

4. The period of middle-age, when emotion is likely to be chastened by a gradual change in the mind's outlook, concentration becoming easier as ideas become less frequent and less tyrannous.*

Brangwyn has passed through three of these periods, and has made two or three steps into the fourth

Further, it is my belief that the emotion in a true artist's happy toil ought to be summed up in two phases: his moods and what I venture to call his technical inspiration. Let us now try to learn how these two phases are to be viewed by minds that see clearly.

Brangwyn talks about his moods, like every other artist. What does he mean? Now and then he may mean no more than that he is fit for work and eager to be busy, as all artists, somehow, from time to time, pay a tax of days to idleness, rather than learn that a desire to work will come in working, like warmth on a cold day from exercise. Poor Dalziel, the engraver, needed about fifteen years in which to collect the drawings which he had commissioned for his book of Bible pictures. But there are other moods, and they mean definite things in productive work, and notably the points of view from which an artist will see and feel his chosen motif.

During these sagacious moods he will choose the key in which he will harmonise his effects, and will get what we may call his outward emotion, or envelope of emotion, with which to surround the inward and spiritual appeal that a fine motif makes to everyone

This union between the envelope emotion, or mood, and the inward emotion either suggested by or resident in a well-chosen motif, marks the threshold from which students of art can enter as friends into the homes that genius makes for itself in work achieved

Already I have spoken about Brangwyn's painting of The Crucifixion (p. 16). Let us take it again as an example, for the same tremendous epic is repeated, with variations, by an etching (No 195) and several large drawings.

The subject here has an enthralling inward emotion felt by all true Christians, felt in a way so very similar that we may speak of it as the same way. Great reverence and wondrous awe, with terror and humbled pity, dwell in the emotion that reigns within the Calvary of our Faith. But moods of many varied sorts can and do envelop

* A few artists have lived to enjoy a fifth period—the one of virile old age, when to the concentration of middle life a happy and strong mind adds many youthful memories *Ce retour au berceau*, as the French call it, inspired all the most personal work done by Poussin (1594-1665)

this emotion, just as mists of differing tints hang from day to day around the same wild sinister gorge in the darkling hills at sunset. My own mood is a fear that Man, cursed by his ill-used brain, is for ever as great a foe to himself as he was to the Highest that put divine trust in him During this mood the Calvary of our Faith is the place where Christianity sets and dawns with the day's light, always to find among men the same lust of cruel self-will in the same blind confidence. From day to day Golgotha is mankind self-crucified amid the eternity of forgiveness that is Christ.

But an emotion made up of awe, reverence, humbled pity and terror, with a just and terrible fear of our common human nature, will evoke from every artist a different mood, or veil of sentiment. In Brangwyn's austere vision, with its strangely rustic fervour, its abrupt nobleness, the mood emotion comes from that ineffable contrast between the invaded gentleness of Christ and the coarse strife of humanity personified by one of the two malefactors. Here the poetry is a dramatizing realism, rough-hewn, stormful, vehement, but as reverent as Rembrandt's divine homespun, and almost as contemporary with the awful drama as a soldier is with the deafening bombardment around him, that produces in a few hours a 'thousand-fold hell

If Brangwyn had painted an idealist dream of The Crucifixion, he would not have transferred the two thieves from the Gospels to his picture, his etching and his drawings; but his mood is true and noble. The only idealism in the Gospel stories of The Crucifixion is the reserve shown by St John when Jesus bows His head and gives up the ghost. Matthew, Mark, and Luke have no reserve; they cause Nature, or the Divinity active in Nature, to rebel against the second great fall of human reason, which ought always to recover from Christ the Paradise lost in Eden. Brangwyn's tragedian vision could have been still more realistic without equalling the care with which three of the Gospels speak of the sudden earthquake and reveal among the onlookers a cold curiosity mingled with depraved mocking and satire. As for Brangwyn's etching of The Crucifixion, it is more insistent than his oil painting, and more so than his coloured drawings are, as black and white give a somewhat dogmatic force or blow to impassioned realism, and I confess to being worried a little by the workman on the ladder and by the faces of two onlookers, though I understand that this etching, like Rembrandt's broad and rapid "Three Crosses," otherwise known as "Christ Crucified between

28

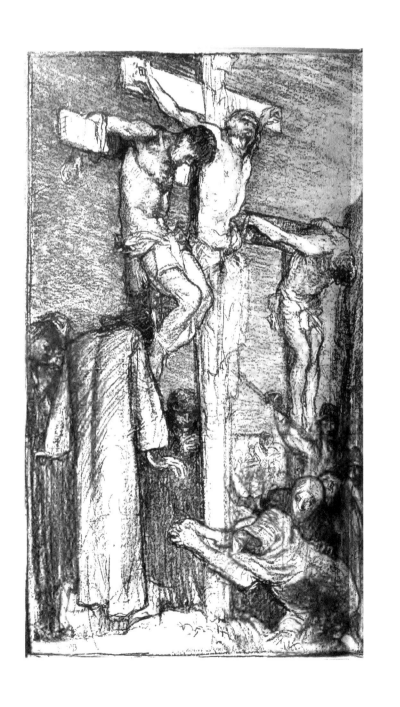

THE CRUCIFIXION

Two Thieves," must be viewed synthetically, as a whole, and not bit by bit. The great aquaduct in the background is well placed and finely symbolic, since an aquaduct is a bridge that conveys water to the thirsty, and since the ancient Roman power lingers on still in timeworn aquaducts and bridges

For the rest, this etching, like the oil-painting or the chalk drawings, is as original as honour and reverence in art can be. It is not a translation from the Italian Old Masters, nor a dream-tragedy from a dateless period, nor is it surrounded by the time fashions of our Saviour's brief stay on earth. The whole tragedy is contemporaneous with ourselves, like Christianity; and thus we cannot help thinking of Rembrandt, who reveals the story of Jesus among the good Dutch, and thinks always of Jesus as the Son of Man among humble and common lives

This attitude of faith is not understood by a great many persons Even Hamerton, in his well-known essay on Rembrandt's etchings, stands outside it here and there as a note-taker, instead of penetrating into the hidden essence and the life of the most humane artist that our world has been privileged to see "When the voice is silenced," Hamerton says, "a pathetic little group bears the body, tortured no longer, to its resting-place. This scene is represented in a little etching, 'Christ's Body carried to the Tomb,' in which the simple-hearted, affectionate followers are unconscious that theirs is the grandest funeral procession of all time " This last idea shows how far off Hamerton is now and then from Rembrandt's scriptural art "The grandest funeral procession of all time!" Could any idea be less likely to find a home in Rembrandt's imagination? His great heart seems to carry in it all the sorrow known to mankind, and his small etching of The Entombment had a very simple and beautiful origin. Once a year the humble were called upon to imagine the burial of Christ and to feel, by an effort of imaginative faith and love, its awe and mystery; and Rembrandt, deeply moved by this act of commemorative devotion, tried to show, in a rapid sketch on copper, how the poor of his own day were present once a year in the garden where Jesus was laid in a new sepulchre hewn out of a rock.

Rembrandt's heaven-worthiness, wondrously rustic and homeful, with its original attitude towards the Gospel story, has been a stimulus to a good many modern artists, ranging from Millet's "Flight into Egypt" to Legros' "Prodigal Son" and Fritz von Uhde's pictures, and many will remember a most winsome and poetical painting by

Maurice Denis, "Notre Dame de l'École." But it is Brangwyn who has given the most ample body and purpose to the Rembrandt mood and idea. His etching of The Nativity ought to make friends everywhere, but I have no doubt that his conception of The Crucifixion will continue to make foes as well as friends; custom and convention rule over most lives, and Brangwyn has gone home to his purpose with a hush of his own and a candour far off from conventional religion.

Have we another artist who could transfuse from the four gospels a synoptic vision of the Crucifixion as searchingly deep in mood or as rich in technical inspiration as Brangwyn's oil-painting, with its studies and the etching?

By "technical inspiration" I wish to denote three things: (a) all emotion within and around a motif; (b) the manner and the mood in which a motif is viewed and felt and conceived; and (c) the skill with which an artist's handiwork adapts itself to its high office—the realization of things felt and seen *with passion* by an æsthetic mind. Let me repeat, we must never part the magician called technique from the other magicians named emotion, imagination, mood, and

ETTORE COZZANI PERCHE AMIAMO L'INGHILTERRA

conception As well try to divorce words from the ideas and the poetry that words make real in prose and verse

In English art, above all, we must watch the technique, for the English hand in art has blundered more often than the English heart and head: except in Sir Joshua Reynolds among several others of younger time who had a truer and a richer feeling for the susceptibilities of paint than for gifts of the spirit in "historical painting," to use an old phrase. Manipulation, not imagination, is Reynolds's main quality But as often as not, and perhaps more often than not, our English failing has been this· that clever eyes and able minds have had fumbling allies in hands imperfectly trained

In Victorian days, for this reason mainly, England got rid of many native schools and styles by sending her boys and girls abroad, there to learn how to draw and paint with continental ease, and in methods as inconstant as our English climate. So tentative have some of these imported methods become that our super-modernists, finding themselves alone and lonely with their mutual admiration, have to seek consolation from a fugitive disrespect for good workmanship. Examples. "We have become much less interested in skill, and not at all interested in knowledge." "We are intensely conscious of the æsthetic unity of the work of art, but singularly naïve and simple as regards other considerations." Is it possible for any mind to be self-conscious towards a fashion in art, and yet naïve and simple towards many elements which geniuses for thousands of years have deemed essential to good design, but which extreme modernists delete from their artistic equipment? Devotees of the newest innovation are proud because they "are entering a sphere more and more remote from the sphere of ordinary men"; they wish to be alone and lonely, believing that the number of people to whom art appeals should become less in proportion as art becomes "pure" Let us remember always that every microscopic sect likes to regard itself as the world's judge and jury

Brangwyn smiles at the cockiness that yearns to make art so "pure" that only small groups of sectaries can imagine themselves "pure" enough to live near their workmanship Is it not the mark of humble good sense to doubt the little men of a day who in a few months have discovered "a pure art" by which æsthetic minds are cut off from "evil old influences"? Brangwyn's ambition is to play his part in the lineage of artists, just as he plays his part in the lineage of his family or in his country's birthright traditions Is he not

31

right? What good can be done by trying to separate any phase of good workmanship from our national life? I cannot accept many of the *obiter scripta* that the super-modernists noise abroad with confidence, as in the following quotation:—

"In proportion as art becomes pure the number of people to whom it appeals grows less. It cuts out all the romantic overtones of life which are the usual bait by which the work of art induces the ordinary man to accept it.* It appeals only to the æsthetic sensibility. . . . In the modern movement in art, then, as in so many cases in past history, the revolution in art seems to be out of all proportion to any corresponding change in life as a whole."

This ferment of futile words comes naturally from excessive zeal, but yet it does harm, causing a great many persons to sneer at embryonic research. What sectaries need is humour: never do they laugh at themselves and at one another: and they are always apt to see in every crust a permanent loaf of bread. They forget to think, and often they are bewildered by very simple historic truth, such as the usual want of much detailed likeness between art and life, even in epochs when precise representation was an accepted principle in some sense or other with every school of æsthetics.

To use other words, the modesty of true genius held up its mirror to Nature, but emotion and imagination added many precious elements to this modesty; and while the general character of life was roughed together by millions of people always more or less at odds as rivals or competitors, the general character of art was an amalgam com-

* Note the silly misuse of the words "bait," "cuts out," "induces," etc., as if Art were a woman who ensnared the poor ordinary man by offering baits. Art is good and great workmanship, except to writers on art who are barristers also and mainly.

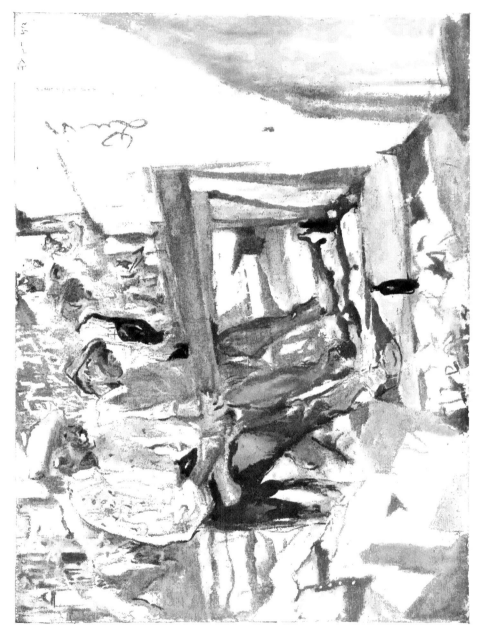

posed by only a few rare men, each with moods of his own and a technical inspiration of his own. Hence art and life could not reflect each other closely enough to be very like each other. Allied and akin they were always, and essential to each other, but different always and inevitably, as they are now. Indeed, true art is for ever nobler than life; even the follies and grave sins that men put into her, from age to age, are better than the sins and follies which all types of society keep from age to age.

In Brangwyn's technical inspiration, as a rule, there is instantaneous union between the governing emotion, whatever it may be, and its embodiment by swift and copious technique. Our country has had no painter more genuinely a painter, for F B paints in all materials—pastel, etching, lithography, charcoal, chalk. Seldom does he draw a line which has not the quality of a painted stroke informed with his inborn dislike for linear assertion. There is some danger here, of course, a passion for linear probity being a fine discipline. In his best work he knows when to stop; and often he stops at a point which a great many onlookers find "unfinished," or "too sketchy." Many a painter would have tried to put some mellowing revision into a swift revelation of Christ's martyrdom; but inspiration is a wayward guest, and Brangwyn knows that mellowing revision is too often a vile thing when it is done by after-thought from the criticism of cold blood.

My dear old master, Professor Legros, a few years before his death, painted, one enchanted day, a sketch of The Flight into Egypt, over-flowing with twilight mystery and hinted loveliness, but afterwards in cold blood he tried to improve his vision and its ethos, and the critic in his mind ruined what his genius had revealed. Murder in good work begins when an artist knows not where to break off, when to let well alone. Brangwyn's work recalls to my mind frequently the rapid William Muller, who in a sitting, out of doors, painted a large picture, then wrote behind his canvas: "Left for some fool to finish." But this wisdom can be overdone; it has limits forgotten sometimes by Brangwyn and very often by some other modernists. Henri Matisse, for example, unless I do him injustice, has overstrained the good sense which never pours an icy "finish" over the glow and passion of inspired hours and days. We have to accept from him, with a charity that matures, much that is embryonic. Is there no resemblance between some of his work and the awkward pathetic softness of unfledged birds in a nest?

F

33

After all, art is the silver dish into which genius puts golden fruit, and when useful innovators put silver and copper fruit into art's silver dish, let us remember that the golden can be added by after-comers What I like most in Brangwyn is that although his abounding style at its best is usually vehement and always his own, and therefore likely to offend like all things outside and above custom, its improvisations are whole in their moods and coherent in their technical inspiration. Mistakes do appear in them, of course, and we shall try to look at them truly, as offshoots of a prolific growth; but the main point here is that Brangwyn's versatility, not less often than not, has the rarest mark of true greatness; an emotion without breaks or gaps, that flows through opulent handiwork from end to end of much busy space To try to do overmuch is either to spoil much that was worth doing, or to do nothing with much ado; and to leave off too soon is to make too many calls on the kindness of those onlookers whose imaginations are able to grow great art from embryo efforts. It is only from time to time that Brangwyn has ruined his technical inspiration by doing overmuch, or by stopping too soon, like a runner before he has reached the tape And I speak, of course, not of the oddment industry that is common in the lives of all very swift artists, but of the work into which he has put his whole nature Brangwyn is Brangwyn when he is at his best.

III

Let us move on now into some thoughts on the periods of emotion through which an uncommonly vigorous and versatile style has come down to its middle-age Brangwyn is fifty-one, and his hand has been busy with pencils and brushes and colours from early childhood. Long before he had reached his teens and velveteens, when, as a very small boy, he lived with his parents in sleepy Bruges, his birthplace, he knew what he wished his life to be and how he would shape it if he got a fair chance. Yet he was not precocious, for he took to art as ducklings take to the water, or as young birds fly from their nests

34

1 *The Period of Primitive Emotion.*

In one sense Brangwyn has never outgrown this period because he has never outgrown his instinctive zest and zeal and aptness There are hours when he talks so well that master after master from other days seems to be whispering into his mind, just as the ages past seem to whisper to bees when a honeycomb is being waxed into its architectural routine, and so much at odds with conscious labour is the instinctive guidance under which he works at his best that his large canvases ought always to be laid in by pupils from his cartoons and sketches, and all research in history and archæology should be done for him in "briefs" by "devils" No kinsman of Rubens has a right to dull his instinct by wasting his nerve power on preliminary toil and fatigue. As well employ delicate race-horses to scramble field-guns into action over cratered battlefields. How can an artist meditate, how can he put enough mind into his work if he wastes physical energy ? *

The young period of primitive emotion in Brangwyn's work is the period of his apprenticeship, it ranges from his earliest efforts at Bruges to his rather haphazard, though very useful, studies under Mackmurdo and William Morris, and thence to the first sea change that his mind suffered in bluff experiences near our eastern and southern coasts. He worked for Morris from about 1882 to 1884, and in 1885, after a trip in a coasting vessel, he sent to the R A "A Bit on the Esk, near Whitby "

Roughly stated, then, the period of primitive emotion ranges from the age of five to seventeen or eighteen

I wish it had been Brangwyn's happy lot in this period, as it was the happy lot of Degas in a period as important, to meet an artist of the type of Ingres, a great and sympathetic draughtsman who united to classic feeling an alert homeliness, always eager to be at ease in the characters of men and women and children Ingres died in 1867, leaving no French successor, but Portaels in Brussels was a great host towards his pupils, as I know from personal observation Portaels would have been an excellent master to curb with gruff gentleness the enthusiasm of young Brangwyn, enticing him towards those qualities which were dormant in his genius, just as a good singing master tries with a coaxing patience to develop in a pupil's

* Let us remember how the genius of Baudry was enfeebled by the huge decorations done without help for the Paris Opera House One day Baudry said to Jules Breton " You cannot guess how I use up my physical strength "

voice any note that is weak. Some think that Legros would have been a good teacher for the lad Brangwyn On this point I am doubtful Master and pupil would have been too much alike in temperament, the better and richer comradeship comes from sympathy of contrast between those who teach and those who are eager to learn Affinities blend so easily that an explosive may be formed Portaels described good teaching as divination seasoned with unpleasant truth, and all his pupils had styles unlike his own and unlike one another's He would have kept Brangwyn on the rough highway cut out for the boy by the boy's own adventurous gifts, while convincing him that he would gain, not lose, if he drew for a couple of years or so from the nude without worrying about the qualities which he desired to get with his facile and stormful brush But it was Brangwyn's lot to quarry out of hard times an education fit to be his guide; he managed wonderfully, thanks to his great instinct and thanks to his unassuming courage But yet—and the truth must be told—he needed such friendship as Couture gave to Manet and as Ingres gave to the grateful Degas. His early work in all its many phases would have been deeper and richer in purpose and in body if fortune had been his friend by bringing to him such a master as gruff, generous old Portaels.*

Instinct, marvellously useful as it is, has many troubles when it begins to find its way unaided from its own sphere into more or less conscious and painful effort. What is instinct? I regard it as apt intelligence transmuted by heredity into a birthright custom almost as automatic as the heart's action. We know not why ordinary men are instinctive only in stupid irrational ways, genius and talent alone having constructive instincts that unite mankind to the building routine of birds, bees, ants, and beavers. It was instinct that caused Brangwyn to enlist for his affection the great plebeian artists, such as Morland, Rowlandson, Millet, and Degroux. The Welsh blood in his veins is the ancient Iberian blood, and Wales, with her bleak and windful beauty, did not leave poverty for wealth until the modern era of coal-mining began. Thrift was born in her people; and in Brangwyn, the man, thrift is always present, just as the poor are always present in his charity as an artist

* The Portaels Studio was a fine school in the eighteen-eighties, and a finer one still in 1865, when its figure painters included Cormon, Emile Wauters, Agneessens, Hennebicq, the brothers Oyens; its landscapists, Van der Hecht and Verheyden , and its sculptors, Van der Stappen

36

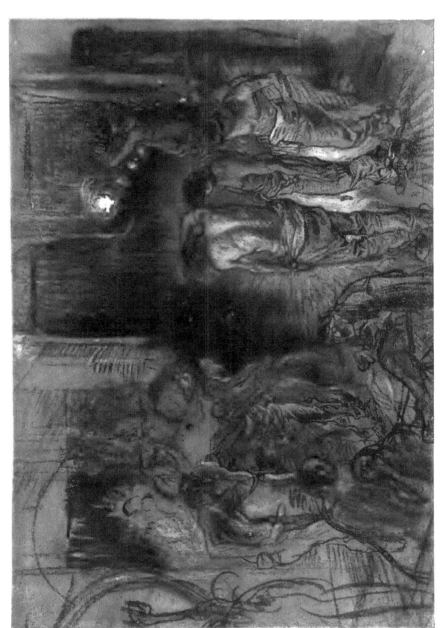

INDUSTRIAL. LIGHT AND HEAT: IRON WORKERS.
IN THE COLLECTION OF THE JAPANESE GOVERNMENT

If my readers, turning to the volume of 1910, will consider my account of Brangwyn's earliest work, they will understand me when I say, in an after reflection, that his free style became adolescent very soon and grew a beard when very young Here is the most remark-able fact in the emotion that governed his first period and its technical equipment The boy felt as able men feel so his manner of work had a truly adult glow and force when it was yet as tentative as were the efforts of other lads. And this means that the female elements of his genius were put aside by the hardships of a tough struggle, which would have caused an unmanly boy to trifle with self-pity Since then, too, the female elements in Brangwyn's genius* have never been at all alert; but, during the period of middle age, they may awake, as they do in Legros' etchings, which pass gradually from rude manliness towards gracious tenderness

2 *The Second and Third Periods.*

Periods mingle together, and I know not at which date a struggle began between instinct and questioning doubts between subconscious gifts and that consciousness which opened upon life when his mind quickened into growth and self-criticism But the sea, with its multifarious magic and its merciless power, made the boy very conscious of two disconcerting old truisms —

1 That the tools and materials used by painters and draughtsmen are feeble things, and act as foes not only between conception and execution, but also between students and Nature, forcing so many limits on a free use of naturalism that paintings and drawings, when compared with Nature's Reality, are Appearance only, sometimes inspired with fertile emotions and great ideas

2 Hence good workmanship by painters and draughtsmen is as a varied dream of things seen, seen imaginatively, within the bounds of those changing customs and conventions, by means of which the big men have marked, and will continue to mark, their varying atti-tude towards Nature and the limits imposed on their handiwork by material agents, their tools and materials Painted sunlight will never be sunlight, for example, but we are thankful that Monet became a sun-worshipper, like Camille Pissarro. Painted tides can never ebb and flow. their cyclonic fury is a mute idler, and their

* Note the look of womanhood, for instance, that shines out from the manful candour and good nature in the face of Rubens, and note also the glimpse of womanhood in Napoleon's modelled cheeks, as in his deft, pliant hands, with their chubby inquisitiveness

unrippled gaiety and charm on sweet serene days are a beautiful make-believe; but yet a few Englishmen, and Brangwyn is among the number, have salted art as true sailors, with moments and visions of the sea that cause the old Viking element in our national character to awake, and we feel that our dear island is too small to be a safe home for the wayward and roving high spirits that won her vast Empire. From the first Brangwyn's aim was to reveal, in a broad, free manner, as near as possible to the movement of water, all that he could suggest of the sea's weight, volume, colour, and stupendous power, passing over many a detail in the drama of gathering waves: many a detail that Turner watched silently for hours, and then noted swiftly with a few lines and a wash of water-colour.* Ships delighted him, and he loved the bantam-like tugs which with strutting effort brought big vessels into harbour, their fog-horns crowing into a mist, and a long trail of black smoke blotting the foul weather. His gray marines culminated in "The Funeral at Sea," exhibited during the winter of 1890. In this picture his mood is that of a simple sailor, who, sailor-like, is rather shy towards the sentiment which the subject asks from him; and his technical inspiration is seamanly in other respects. It is bluff and virile, and somewhat hard and taut. For the rest, let me refer you to the analysis given in 1910.

Passing from "The Funeral at Sea" to "The Convict Ship" (1892) we find a changed mood and a different spirit in the paint. Pity and irony direct the mood, and the colour, gray and desolate as the human wreckage, has in it so much passion that we know this picture comes from the heart. But already the young painter's work has become very composite, thanks to foreign travel. He has visited the Dardanelles, the Bosphorus, Constantinople, the Ægean, the Sea of Marmora, has made trips to Spain, and another to South Africa, and out of these and other vagrant studies come "The Slave Traders" of 1892 and "The Buccaneers" of 1893 †

* Turner described how he came to paint "The Snow-storm"—a grand impression of a winter storm at sea "I did not paint it to be understood," he said to the Rev. W. Kingsley, whose mother had passed through a similar tempest and was enthralled by Turner's picture "I wished to show what such a scene was like I got the sailors to lash me to the mast to observe it I was lashed for four hours, and I did not expect to escape, but I felt bound to record it if I did But no one has any business to like the picture Is your mother a painter?" "No,' said the clergyman "Then she ought to have been thinking of something else," answered Turner
† Both of these marine moods, the gray and the sumptuously coloured, appeared in commissioned work done for *Scribner's Magazine*, and students of Brangwyn should collect these good Scribner prints

A revolution parts "The Funeral at Sea" from "The Buccaneers" Eye and hand, mind and mood, and the motive-power behind and in the technique all alike are astonishingly altered In the earlier picture we feel that England is anchored to the sinister North Sea; in the later, that she, the greatest of all sea-rovers, past and present, is moored to the East as well, let us hope securely And yet, so irrational is the British character, that we must go to several French artists, as to Guillaumet, Delacroix, Dehodencq, Dinet, Regnault, Decamps, Ziem, Fromentin, Charles Cottet, when we wish to discover the nearest affinities to the Easternism in Brangwyn's earlier work

Eight years ago I said much about the very unusual effect produced in Paris by "The Buccaneers," and the picture remains an event. Its amazing virility, its wild, fierce dramatization, the tropical frenzy of its colour, and the staring heat which seems to leave the world without air, these are enchanted wild oats, and I wish young men of our race would sow them often Brangwyn got somehow from himself a temper akin to that which put the devil into many an old sea-dog who cared not for incessant scurvy when he sailed after foes, fame, loot, and El Dorado Cant speaks to-day—cant, a vice detestable— as if our forbears were doves and saints, but doves and saints, like cant and claptrap, are more likely by far to lose empires than to win them among hardships and flocking dangers Yes, and however gentle the manners of mankind may become, the nation that will endure longest will be nearest secretly, in her inward self, to Nature's unending strife; and so we must not cry out when young artists and writers hark back to the primal emotion which enabled Brangwyn to paint "The Buccaneers." How Kit Marlowe would have rejoiced over such a picture! And the world-brain that put so much barbarian terror into the poetry of "King Lear" would not have thought "The Buccaneers" too opulently hot and fierce. In a recent etching, "The Swineherd," Brangwyn represents another primal emotion, almost Calibanesque, as we shall see

I am trying to suggest that Brangwyn, after roughing it among sailors of the North Sea, added many qualities to his moods and to his technical inspirations by roughing it abroad under skies that glared and a heat that clasped as with sweating hands. Never will you draw near to his earlier adventures in art, nor yet to his etched works, unless you feel and see that they are autobiography as well as wayward genius Note, for instance, that although there appears to

39

be no restraint at all in "The Buccaneers," yet one great effect of penetrating sunlight is left out deliberately because it would have turned a narrative picture into a mere fight of pigments against the sun, whose heat when very intense appears to look into many things as the X-rays do into flesh, making them glow into transparence or translucency Some modernists have taken for their motif this effect of ardent sunlight Brangwyn has never vied in this way against the tragic-beneficent heat which keeps life alive on our globe Such daring does not set his genius. In all his work—prints, drawings, oil-paintings, water-colours—you will find that he loves weight as ardently as Michelangelo loved it, but differently, of course, since Michelangelo drew and painted as a masterful sculptor In *his* weight there is animate marble; in Brangwyn's, sincere homage paid by a manly painter to the many thousands of substances that vast winds cannot sweep away and destroy It shows how light and heavy things rest on solid earth always heavier than they *

And this quality of weight in his technique leads on to a few summarizing remarks on Brangwyn's attitude towards representation in other words, towards his intercourse with Human Life and Inanimate Nature and the degrees of likeness that the arts gather from Inanimate Nature and Human Life. Quite early in his career his temperament parted company with two very different principles: the principle of detail, to which Ruskin offered so much devotion, and the principle of unlimited fresh air, to which Monet paid reverence before an altar of new technique Brangwyn has always loved in many old masters the use of apt, wise detail, such as Van Eyck contrived to store up in thousandfold breadth and modesty; and unusual longsight for years compelled his eyes to pick out details with a camera-like tyranny But his temperament asked for big canvases—sometimes even too big—and large brushes, as it has asked for big plates, sometimes too big, for his etched work; and details were collected with a sweeping touch into plots and large masses Monet's technical appeal moved too much by jerks, and was also too scattered, to be of use to a style that struck blows with a bold, full rhythm. The difference between Monet's style and Brangwyn's, and therefore between two temperaments, is similar to the difference between a jerky, intermittent pulse and a great heart's rhythmical systole and

* Few British painters or draughtsmen have much feeling for the weight of things Girtin is among the few, so is Rowlandson, so is Raeburn, to take three examples. Babies and battleships have about the same weight in the work of too many artists

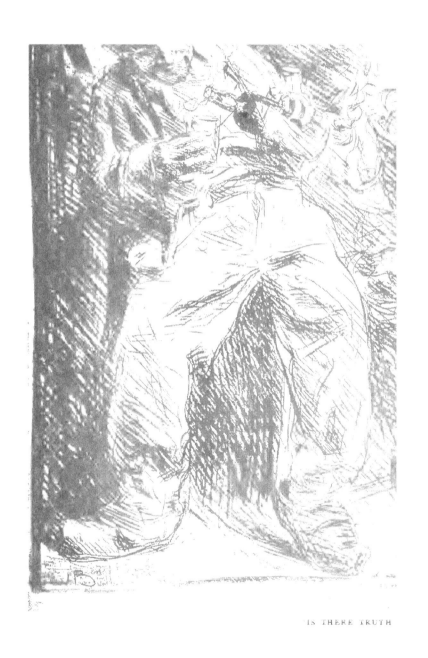

IS THERE TRUTH

diastole, by which the circulation is kept up with ordered vigour. And you will see at once that the pulse of emotion in prints, drawings, pictures of all sorts, depends on the systole and disastole of an artist's own style. In the presence of a fine Brangwyn such as " Breaking up ' The Duncan,' " to choose one of many etchings, I say to myself· " The style has heart enough to run ten miles, and more, without getting a stitch in its side." But a style of this sort, mark well, is sure to be somewhat of a tyrant, it makes rules of its own and enforces them, and sometimes gets itself into scrapes It never coaxes, but goes its own way in its own great stride, causing many onlookers not only to lose their breath, but also to feel cross, and sometimes justly so *

Though Brangwyn takes from Human Life and Inanimate Nature no more than he can use with fluent ease and insistent breadth, he never talks about the whys and wherefores, and only in occasional mishaps has he violated natural forms, though never in a manner far-sought and dear-bought Not once has he been like certain recent modernists, who declare that they rediscover in fumbled anatomy, puffy and embryonic, the principle of structural design and harmony, displacing " the criterion of conformity to appearance" and re-establishing " pure æsthetic criteria " Are there any limits to the irony of self-praise?

There is pathos in any ugliness that the hazards of heredity and life's hardships give to women and men; but even this inevitable overthrow of the human body's noble shape can be exhibited too often within the charities of art What need is there, then, for any modernist to go back with pride to such deformities as come from ignorance of hand into the craftsmanship of savages? Such *misconformity* to appearance has often noble hints of greatness, yet it can never be in educated art anything more than a make-believe barbarity Still, the only things to be feared and hated as foes to art are lethargic temperaments, those rearward spirits that pursue no aim intrepidly, but view with blinking eyes all daring, and slink with creeping feet into the boudoir of timid compromise

But for all that, no doubt, history suggests to all modernists that a noble sense of personal worth is an æsthetic emotion and a necessary

* Mr A. Clutton Brock says "Beauty to most people consists, not in design, but in what they call ' style', and style changes as quickly as fashion in dress " Let me say, then, that I use the word " style ' to denote all the invariable tokens of Brangwyn's presence in his handiwork

element of greatness. Could a Matisse lose anything worth keeping if he claimed from the Greek sculptors his right to inherit enough modest respect for nobleness of matured form? Surely all embryonic art, however promising, comes within Bacon's verdict: "As the births of living creatures at first are ill-shapen, so are all innovations, which are the births of time."

And it is right here to dwell on these matters. They unite us to our own times, and Brangwyn's career has had errors of judgment: days in which our artist has forgotten, or has seemed to forget, that the world is a hostess who closes her doors on those who ask overmuch from her amenity. These errors are akin to the lees and dregs of good wine that matures; but if I failed to point them out, not once but several times in my chapters, I should have to brace myself to encounter the charge of being a censor, and so unwilling to pass for press any known fact harmful to a big man in office. How could art exist if there were no moods and ambitions to make mistakes as well as masterpieces?

In the etchings, to which we move on now, we shall find frequent changes of mood and of technical inspiration. Eight years ago I gave a discursive chapter to some of the earlier proofs; since then a large series has been printed, and now it is a duty to reconsider the whole output as completely as I can. To me it seems probable that Brangwyn will pass away soon from his etched work, because he has got from this phase of his art, with the help of very thoughtful printing, sometimes tinted, all the fine results that he can hope to achieve, without making use of mezzotint, which would suit his vivid style as a great chiaroscurist.

CHAPTER II SOME CURRENT FALLACIES VERSUS THE BRANGWYN ETCHINGS

opular fallacies are never easy to kill, they collect and retain so much crude human nature that many find their home from age to age in the least vulnerable of our mortal foes—The Average Mind Now and then, by rare good fortune, one of them may be driven into exile, like a naughty prince banished by democrats; but a coaxing gray mare among fondled fallacies, such as the belief that feeble men can summon peace perpetual into a world always at strife, is likely to be as attractive to the Average Mind as artificial lights are to moths

Fallacies have gathered about the art of etching as about everything else, and writers and talkers pay homage to those that they like best I dare not guess that these are delicate fallacies, mere consumptives that live in the open air without renewing their strength, so I cannot imagine that any words of mine will make some of them less bewitching to their supporters. But yet, as W. E. Henley told me in my boyhood, a full keen blow should be struck for a good cause by all written work, and the good cause here is to attack those who fondle fallacy

Brangwyn has not been a friend to many a fallacy which etchers must either accept or reject; and his opposition has been made public, as a rule, not by word of mouth nor in writing, but by his prints Day after day, then, he has put himself into a hornets' nest, or what the Scottish call a bike of bees. To be stung every now and then is good sport. Does anyone wish to be stung year by year a great many times, always around the same places, and always by the same bees or hornets? I don't. Do you? So many return visits from the same irritations must be bad for all skins, whether thick or thin; it puts patience out of mind, and for this reason I have been asked to say a few words on some frequent stings thrust into Brangwyn by a good many lovers of fallacy.

Let us choose the most important, and then treat them with dismal fervour as if they were precious things to be studied for a competitive examination and a scholarship

43

1. *That Very Big Plates are An Offence in Etching, hence the Brangwyn Prints are generally much Too Large.*

Do connoisseurs of etching employ foot rules and inch maxims? Perhaps they say among themselves "This print is 9½ inches by 6 inches. August and a masterpiece! It is the size Vandyck loved Yes, but this other print—'Building a Ship'—is 35½ inches by . . ? Heaven above! The width really is 27¼ inches! Not to speak of the wide margins! Are we to buy new and giant portfolios? Nonsense! Are we to order new print-cases? Rubbish! Must we sell our oil-pictures to make room for etchings of this wicked size? We should be cut by the R.A. . and by other societies also. Our lives wouldn't be worth living Oh! Let us be wary How the deuce are print-sellers to handle these elephantine etchings? Two or three boys, dressed as pages, could move them from place to place in a shop, just as the trains of royal dresses are carried out of reach of feet at a court ceremony Come, come! Let us stand up for the print-sellers What they need, let us believe, are little gems, dainty and exquisite prints, just a few square inches each, you know, easy to carry . and as easy to hide out of sight when our wives want costly new gowns instead of ideal small prints, true art in essence It's the very dickens to get even a biggish print home when milliners and things are in the air But these Brangwyns! Jove! Etched wallpapers done by machine might be easier to get home discreetly, without a bother Collecting isn't easy!"

If connoisseurs of etching do speak in this way among themselves, they say nothing about real woes when they put their sighs and groans into print. If they said that Brangwyn is *too* fond of huge plates I should venture to agree with them: but their argument is that Brangwyn offends against necessary traditions which good etchers have gained from the genius of their craft This assertion has a bold air and sound Is it a fact, or is it an "*obiter dictum,* a gratuitous opinion, an individual impertinence, which, whether right or wrong, bindeth none—not even the lips that utter it"? Suppose we take a few glances into the history of etching.

The earliest etchings were small—not because artists had a dislike for magnitude, but—because a great many hitches and scrapes had to be eased one by one in the elementary technique of a new and incalculable handicraft. Copper-plate engraving may be a German invention, as the Florentine Maso Finiguerra did not get first into the field, about the middle of the fifteenth century, as Vasari believed

44

and wrote. The etched line on copper—that is, the *eaten* line, or line eaten into copper by acid—is of later date, and a rival of the furrowed line ploughed into copper by a strong, sharp burin. Its discovery has an uncertain date, but it is attributed sometimes to a great Italian, Parmigiano, who lived from 1504 to 1540.

Rolling presses for printing the copperplates are said to have been invented about five years after Parmigiano's death ; and one of the mesmeric masters of great art, Andrea Mantegna (who died in 1506, at the age of seventy-five), declined to be enslaved by small engravings. He put his mind into some pretty large prints, highly studied and full of figures ; and with oblique hatchings he added shadows to the main lines, feeling an æsthetic need similar to that which now causes an illustrator to flow a wash over his indelible penwork. Line-and-shade etching is a kincraft to Mantegna's engraving, and helps to keep us in mind of the fact that men of mark get many a rule and law from their own gifts, and refuse to be shut up in maxims and methods that irk their just freedom.

Small etchings were inevitably right when large copper plates, hammered out by hand to an even thickness all over, were not easy

to get, and when the technique of a very tricky new craft had to gather from blunders its traditions and recipes, such as Abraham Bosse in 1645 noted in his treatise Small etchings, too, as a rule, have ever been right for book illustration, and also for men who, like Ostade, Whistler, Claude, and the great uncanny Méryon,* have discovered that a big spread of copper would dethrone their genius Whistler got as much joy from being short in etching as he got from being long and sharp in the gentle art of making foes with his written wit; and since his airy, butterfly touch could no more find its way over a large copper plate (without making a mess), than his dapper little feet and legs could have run a ten-mile race (without a start of five or six miles), he wished to endow all etchers with the axiom that small fine prints were the only deeds of grace fit to offer to their handicraft * But this vanity is forgiven when we see how elusive is the winsome self-control that Whistler treasured up in his finer or finest etchings. A spirit like that of Gothic tracery seen by twilight, dwells in some of his airy lightness, but we need only one Whistler and one Méryon, just as we need only one Brangwyn The really unique in etching, as in other arts, founds no school, a manipulation fit to inspire safe emulation, as in Vandyke's portrait etching, has a certain general friendliness like that of Nature's pleasing moods and aspects, which everyone can accept as equally good for everyone else.

Rembrandt has a great many small prints among the 260 etchings in his authentic output, but no sooner does he bring his humane realism and his heavenworthiness into communion with the Scriptures, than he begins to feel at times the need of ampler plates; and he wrestles with lofty ideas on his larger fields of copper as Jacob wrestled with a Celestial One near the bank of a river flowing between him and his father's home Yes, Rembrandt seems to etch with his soul on man's heart, and in his magnitude there is material size enough in

* Let me give the measurements of the principal etchings in Méryon's Old Paris views Le Pont-au-Change, $6\frac{2}{10}$ by $13\frac{3}{10}$, Le Ministère de La Marine, $6\frac{6}{10}$ by $5\frac{8}{10}$; L'Abside de Notre-Dame de Paris, $6\frac{6}{10}$ by $11\frac{8}{10}$, La Morgue, $9\frac{2}{10}$ by $8\frac{1}{10}$, Le Pont Neuf, $7\frac{1}{10}$ by $7\frac{3}{10}$, La Pompe Notre-Dame, $6\frac{8}{10}$ by 10, Rue des Chantres, $11\frac{8}{10}$ by $5\frac{9}{10}$, La Tour de l'Horloge, $10\frac{1}{10}$ by $7\frac{3}{10}$; La Galerie de Notre-Dame, $11\frac{1}{10}$ by 7, Saint-Étienne-du Mont, $9\frac{8}{10}$ by $5\frac{2}{10}$, La Rue des Mauvais Garçons, 5 by $3\frac{3}{10}$, Le Stryge, $6\frac{8}{10}$ by $5\frac{1}{10}$, Le Petit Pont, $7\frac{6}{10}$ by $5\frac{8}{10}$, Tourelle Rue de la Tixéranderie, $9\frac{6}{10}$ by $5\frac{2}{10}$, Rue Pirouette 1860, 5 by $4\frac{5}{10}$; L'Arche du Pont Notre-Dame, 6 by $7\frac{8}{10}$

† In my book on the early Life and Work of Frank Brangwyn (page 188), I give the famous letter written by Whistler to the Hoboken Etching Club Its argument ends with the dogmatic statement that "the huge plate is an offence"

46

several of his noblest etchings, as in "Christ Healing the Sick," to encourage all true artists who know that they are ill at ease and weak when small plates cramp their touch and dull their minds *

Consider Piranesi, for example, and imagine his tussle when he began to measure his gifts against the majestic power in the antiquities of Rome How ludicrous it would have been if he had tried to shut up his wit and zeal in a trivial maxim about the beckoning ideal in small prints! Providence had endowed Piranesi with a nature akin to the old Roman genius, and with a zest which never tired, the good man put his whole nature into the vast ruins which spoke to him about ancient builders and architects, until at last he was able with his burin and etching-needle to restore a good many monuments wrecked by time and strife Years went by, but Piranesi's zeal increased, and at last he was aided by all his children and by some pupils also Though he and they used the burin for certain broad, trenchant lines, they had greater freedom with the etching-needle, and Piranesi must have been entertained by the research and alertness that the technique of his ample plates needed from year to year He employed his acids with a most varied tact and skill, and I assume that he trusted his eyesight, not a watch or clock, as did good craftsmen during the uncertain final process in the making of lustre ware I know not with what mixture he prepared his coppers, but a better etching-ground for large plates has never been concocted Piranesi died in 1778, and a longish time afterwards, between 1835–37, his son Francesco published at Paris, in twenty-nine volumes folio, about two thousand of his big-fisted prints

At a first glance it seems to many persons that Piranesi ought to be looked upon as Brangwyn's prototype, then it becomes evident that "forerunner" is the right word, there's no real likeness between them except their kindred joy in hospitable size and abundant vigour Piranesi loved historic facts even more than he loved the transmutation of such facts into art His mind was deeply reflective, even scientific, and pretty often his passion for mimic texture and detailed breadth may be too photographic for present-day eyes And let us remember that Piranesi is not the only etcher of big or biggish plates who heralded the Brangwyn style and methods Girtin's Paris Views are not little prints, either in size or style; and Girtin handled

* It is worth noting also that in Rembrandt's etched portraits there's a great variation of size Compare the exquisite and tiny portrait of Rembrandt's mother, No 1 in Campbell Dodgson's Catalogue, with the portraits of Jan Uytenbogaert (C D 100 and 126) and Jan Six (C D 185)

the etching-needle with a fluent ease and beauty when he prepared his Views in outline to be aquatinted by J B Harraden and F. C Lewis There is much closer kinship of emotion between Brangwyn and Tom Girtin than between Brangwyn and G B Piranesi Girtin was loved by Turner, who took hints from Girtin's heroic breadth, and who said one day, in a mood of self-depreciation, "Had Tom Girtin lived, I should have starved."

Then there is Seymour Haden, whose output has no rule-of-thumb notions about size True, he never faced a sheet of metal as ample as a great many that Brangwyn has tackled, but—and here is the main point—his temperament as an etcher was too versatile and too virile to make a fetish of small prints.

And another point is worth noting. The bigger the plate the greater is the risk of failure, hence no etcher is at all likely to choose huge plates unless he feels that they are often necessary to his technical inspiration For what other reason would any man of sense add to the tricksiness of a craft full of hazard? It is more difficult to spread an even ground over large plates, more difficult also to get diversified values from the acid bath, without mishaps; and thick lines, helpful in woodcuts, are hard to manage on metals, though their value under shade and texture is as important to etchings on a large scale as were strongly marked forms to the engraved design that Mantegna originated.

Brangwyn has got himself into some hitches and scrapes with the thick, insistent lines, but he has used them many times as deftly as Turner, when Turner intended to cover them with mezzotint and to print with brown ink. Thin lines would have been lost under the mezzotint, and brown ink prevented the broad and deep lines from losing their plane, or challenging overmuch attention. Brangwyn's ink varies, like his thoughtful printing. Usually, when it is dark, it has in it enough burnt sienna to mellow the black, and enough raw sienna to add a smiling translucency Some prints have a golden tint and some a greeny lustre, and either coloured or toned papers are used frequently Still, there's another side to these matters Devotees of fallacy assert—

2 *That Brangwyn's Etched Work gets too little from Etching and overmuch from Printing Methods*

As well say that books well produced owe not enough to their manuscripts and overmuch to their printers, binders, papermakers,

48

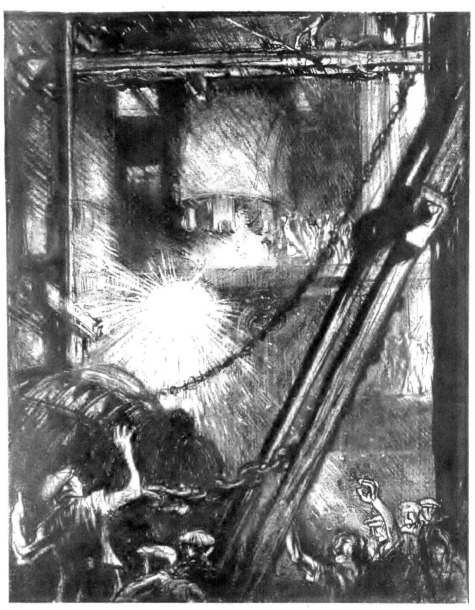

INDUSTRIAL STRESS AND STRAIN — STEEL

and publishers: for just as a manuscript book is intended to be printed, bound and published, so an etched plate is dependent also for its completed realisation on the arts of printing and publication Writer and etcher alike, if they wish to do justice to their handi-work, are bound to obtain what they need from printers and pub-lishers. Whether an etcher trains a printer, as Rubens and Turner either trained or helped to train engravers, or does the printing himself, is a matter of no consequence, if the states and impressions represent all that he desires to set before the public; and as for the means by which ink and paper are handled for definite and ordered purposes, this factor in versatile technique is governed by a true artist's purpose, and our part in it is concerned with results alone Some of Brangwyn's results I am unable to like, but a great many of their phases are unrivalled, and the management of ink and paper in all good impressions enriches what I may call the orchestra of lights, shades, values, tones and textures Print connoisseurs on the Continent know how to value the finer Brangwyn etchings. There's a complete collection of them at Paris, Rome, Munich, Vienna, as well as a great many prints in each of many other public collections At the outset of his etching adventures he bought a printing press, and toiled at it fondly, blotted with enough ink and sweat to mark him out as an apprentice, though not with enough to make him one half so remarkable as that amusing sketch of George Dawe in Charles Lamb's *Recollections of a Late Royal Academician.** The more closely you study the wonderful charm and strength that Brangwyn has obtained many times by various means as a printer or from printing supervised by himself, the more sympathetically you will feel and see why he is a master of the most difficult phase of etching—the union of line, tone, shade and texture Pure

* "My acquaintance with D was in the outset of his art, when the graving tools, rather than the pencil, administered to his humble wants These implements, as is well known, are not the most favourable to the cultivation of that virtue which is esteemed next to godliness He might 'wash his hands in innocency,' and so meta-phorically 'approach an altar', but his material puds were anything but fit to be carried to church By an ingrained economy in soap—if it was not for pictorial effect rather—he would wash (on Sundays) the inner oval, or portrait, as it may be termed, of his countenance, leaving the unwashed temples to form a natural black frame round the picture, in which a dead white was the predominant colour This, with the addition of green spectacles, made necessary by the impairment which his graving labours by day and night (for he was ordinarily at them for sixteen hours out of the twenty-four) had brought upon his visual faculties, gave him a singular appear-ance, when he took the air abroad , insomuch that I have seen a crowd of young men and boys following him along Oxford Street with admiration not without shouts '

line etching is the simplest phase to a trained hand, and line with shading comes next. Nevertheless, from time to time, without a shadow of a doubt, the linear part of etching plays second fiddle to F.B.'s printing methods. Then I believe, rightly or wrongly, that mezzotint should be the medium.

3. *That Brangwyn as an Etcher vies too much against the qualities of Oil-Painting.*

Yet it is—or it ought to be—a fact well known that most painters who have taken to etching have obtained, wittingly, or unwittingly, qualities like those in their pictures. In other words, they etched as they painted, like Tiepolo, Ostade, Ruysdael, Paul Potter, Berghem, Vandyck. In Rembrandt also, as Vosmaer points out, there is a marked parallelism between the great wizard's painted and

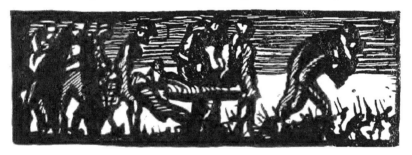

etched work, his early manner in both cases being timidly experimental, and in both he grows gradually into strength, character, passion, and intense fervour. Besides, in all his most important etchings Rembrandt is engaged with the same problems of light and shade that occupy his attention in oil-painting. The portrait of Jan Six at his window is what we may call a painted etching, so complete is the illumination obtained by studious and massed technique. Returning to a lesser genius, Whistler, let us note how the etchings gravitate towards that low tone and mystery, accompanied by an absence of organic design and decorative impact, which belong to Whistler's individuality. What is Whistler but a musician who employs brushes instead of stringed instruments, and who conceals in minor keys his elusive effects in low tone and evasive colour? But this matter can be summed up briefly. Far too many writers on art imply or hint that a versatile man should keep at his beck

and call several æsthetic temperaments, and that he should employ
perhaps a couple in his etchings and several others in his paintings;
though even Shakespeare has but one æsthetic temperament, hence
the Shakespeare style is evident in the speech of all Shakespeare's
men and women For a genius that creates, being active in all the
things that it creates, must leave the invariable signs and symbols of
its presence throughout its productions, just as sunlight in all its in-
finities of changeful effects is always sunlight.

Similarly, Brangwyn can no more delete Brangwyn from his etched
work than he could dismiss from his eyes their brown lustre; and
since the Brangwyn style in painting has the qualities that we know,
and since a passion for decorative design is among these qualities,
we are certain to find the same qualities in his etchings, and more
noticeable because their appeal from black-and-white is more definite
than their harmonisation from a rich palette

Bluntly, then, Brangwyn rarely etches for print-cases and portfolios;
he etches mainly for rooms, and those prints that represent him most
completely as a great etcher always look best when they are hung up
as pictures, or, preferably, when they are put within moulded wood
frames forming part of a panelled wall. The custom of suspending
pictures against a wall is one to be thrust aside as often as possible.
Suspended frames not only collect a great deal of dust, which is dis-
lodged by fresh air from open windows; they separate pictures from
walls, walls from pictures, though painters and architects should
have a common aim when they work for our home life. Art began
to sink into a luxury as soon as painters began to drift from mural
painting and decorative painting into easel pictures, done at random
for persons and rooms unknown. Even the lighting of most rooms
receives little attention from most painters, with the result that it is
more by good luck than wise management when oil-paintings can be
seen to advantage away from studios, exhibitions, and public galleries.
Water-colours look well in all rooms, however curtained the light
may be; and this remark applies also to etchings, and above all to
those that have a scale large enough to be in keeping with our rooms
and furniture.

Next we are told.—

4 *That too many Brangwyn Etchings are Melodramatic*

Ah! What's the meaning of melodramatic? Is the last scene of
"Hamlet' melodramatic, or is it high tragedy?

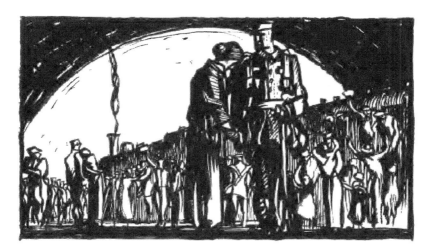

The word melodrama used to mean a variety of drama having a musical accompaniment to complete the effect of certain scenes, as in the songs written by Shakespeare for "Twelfth Night," or as in the union of Mendelssohn's music with the "Midsummer-Night's Dream." In opera, again, melodrama is a scene in which an orchestra plays a rather descriptive accompaniment while an actor speaks. But many words are depraved by unæsthetic periods. To-day, in current talk, melodramatic is a term to give offence, as it denotes false sentiment and overstrained effects.

I should be insolent if I commented on this decadent meaning in its alleged relation to my subject, since candour—sometimes accompanied by haste—is an invariable mark of Brangwyn's energetic manliness. It is a pity some act of public penance cannot be claimed from those who try to defame any big man who happens to be at odds with their temperaments or their whims and prejudices.* That they do no harm to art as art is evident, of course, but they keep in circulation a great many fallacies hurtful to that general influence which art

* When I began this book, at the end of December, 1917, I wrote to one of our leading officials in the art world, a public servant, asking for his help in certain ways. My letter has not yet been acknowledged. I guessed that his own print collecting along certain classic lines might make him reluctant to answer my questions; but if I had written the same letter to any Continental official of public art, I should have received an answer at once, as I know from long experience that the official Continental attitude towards known styles and schools is impersonal when the purpose of a book is public service, akin to that done by popular galleries, print-rooms, and libraries.

ought to have when a nation is reputed to be enlightened, and when she invests year after year about twenty-seven millions of pounds in compulsory education alone

Even sound views and opinions often ruin a mind that borrows too many, for men have no great wish to plod into thought if they get without thinking the wisdom that they wish to show off

5. *That the Brangwyn Etchings lack Ideality, being too wrapped up within the Spirit of our Age*

Ideality? This word sends us back to the Victorians, a great many of whom, in their eagerness to progress, borrowed or filched a great many, too many pregnant facts, fine ideas, big schemes, acute observations, and other collected treasures, turning their brains into classic books while helping to muddle their country's present and future They seemed to live and move between quotation marks. To-day a different peril makes much ado. Enthusiasts of the Victorian breed are uncommon, whether we seek for them in art, in letters, in science, in politics, or in economics There is not much like Ruskin's fervour, nor much like the juvenile zeal that showed itself at first in reading clubs and literary societies, there is nothing at all like the economic and cocksure politics that reverenced Bentham, Mill and Co as apostles in the cause of everlasting progress ; and who can fail to see in most current affairs that public life is relaxed, unstarched, a vagrant in the midst of detached views, opinions, fads, illusions, fallacies, with so many phases of cant that they might have a Whitaker's Almanack, entirely their own ? Even science has lowered her battle flags; no longer is she the Boadicea whom Huxley fought for with such gallant dogmatism It is now her conviction, as it has long been the belief of most artists, that Man is not a rational creature, but in the main instinctive, like other animate wonders in God's illimitable and eternal mystery The only public cocksureness comes from those whose moods are the moods of headlines, and who need newspapers by the thousand to keep their minds well stored with cant and confusion To advocate in war several principles which would break up our empire if they were applied at the Peace Conference is one example of the cocksureness that confusion begets. To separate art from the people, and to boast over this folly, is another example

Brangwyn stands apart from all this laxity, an observant critic ; and if you study with unbiassed attention—that is, with judgment, can-

dour, and fairness—his forthright handiwork at its best, as in his richer and finer etchings, you will see that its yearly sequence, without any loss of spirited and inspiriting energy, has grown stronger in those qualities which have become rare in our public life swift decision, sincerity of purpose, impassioned self-help, and a sympathy without fawning and cant for those who are handworkers I do not mean that Brangwyn makes his appeal as a political democrat Genius sees too much and knows too much ever to believe sincerely that millions of votes from minor minds can rule without doing serious harm over the few thousands who are fitted by uncommon gifts to govern wisely.

But fact and truth belong to the essence of statecraft, and Brangwyn's work has gained so much from our industrial enterprise that it is observant statesmanship as well as powerful art

<div align="center">II</div>

I do not mention by name the writers who are hostile to Brangwyn's etchings; with one exception, it is not worth while. They are journalists who pass judgment on any art that comes before them in an exhibition. But the exception is a specialist, a writer on prints, old prints and new, and a specialist ought to value discretion I refer to Sir Frederick Wedmore, who has gone out of his way, in a book on old prints mainly, and in a note added to a new edition, to make a temperamental attack on Brangwyn (*Fine Prints*, New and Enlarged Edition, 1910, Appendix, page 247).

Sir Frederick is a good judge when prints are dainty ; and his judgment is often wideawake towards those technical inspirations that merit the epithets "exquisite" and "subtle." On the other hand, he is likely to be ill at ease in the presence of energetic manliness He cannot speak of Vandyke's etched portraiture without saying that "the touch of Vandyke has nothing that is comparable with Rembrandt's subtlety, yet is it decisive and immediate, and so far excellent " Veritable connoisseur! Sir Frederick Wedmore should feel in himself why the virile structure and charm of Vandyke's etched portraits are persuasively alive with insight, and sympathy, and a style that responds to each sitter's gifts of the spirit. He admits, indeed, for thousands of great judges have said so, that Vandyke "seized firmly and nobly in his etched portraits of men the masculine character and the marked individuality of his models";

54

but complains that "practically his etchings are only portraits of men." *Only* portraits of men! And why should a connoisseur employ the futile word "practically" like a hurried journalist? Is "The Reed Offered to Christ" a Vandyke etching to be forgotten? Is it "practically" of no importance? No discreet judge would pit Vandyke against Rembrandt or Rembrandt against Vandyke. A foreign specialist, Dr. H. W. Singer, has made one of these mistakes, as Sir Frederick Wedmore has made the other. Dr. Singer says: "We have, on the one hand, Vandyke the portrait painter, an artist not without faults and certainly not outstripping Titian, Velasquez, Reynolds, and many others that have excelled in the same field. Opposed to this, we have Vandyke the etcher, really without a

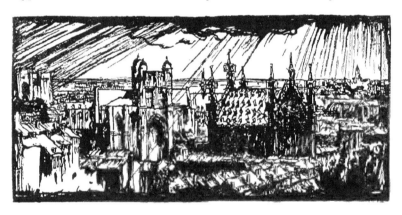

rival—I do not consider even Rembrandt a successful one in this case—the inventor of a type that has served as *the* model of all subsequent days down to our own. . . . Far from misdirecting anyone, his creations in this branch of art have served and will serve for ever as the brightest examples for all men attempting portraiture in etching." Legros had the same conviction, but never set Vandyke and Rembrandt to compete against each other. Men of genius are too inestimable to be turned by wayward criticism into rivals.

As Sir Frederick Wedmore is lukewarm to Vandyke's principal etchings, "*only* portraits of men," what has he to say about Brangwyn's modern virility? Has he tried to live with a Brangwyn etching? His attack is interesting, and original also as indiscretion, for it is found in some lines of ardent praise on Mr. E. Carlton! As well

55

attack Milton in order to praise Herrick, or Turner in order to praise Witherington. Sir Frederick desires that Mr. Carlton's etching should be popular:

"Why is it not already better known? Useless question, as far as the big public is concerned, when people go into the exhibition and fancy that some of the best work is the self-assertive work of Mr. Brangwyn, that leaps to their eyes. The German proverb says—or Mr. Robert Browning once told me that it said—'What has a cow to do with nutmegs?' And what have people who do not understand in the least the spirit of etching, got to do with the modest, thoughtful little records of harbours, quays, and all that lies upon them—of warehouse, boat and barge—by this dainty, accurate draughtsman, Mr. Carlton, who does not want to knock any living mortals down—metaphorically speaking—by the work of his needle, but to charm them rather, to put on them the spell, wrought on those who are worthy to receive it, by the rhythm of intricate line." It is easy to pity the living mortals who feel that they may be knocked down by the work of a needle; their lot in this rough world must be hard and humiliating; but Sir Frederick Wedmore forgets that critics who pride themselves on their delicacy, and who yearn always to be consoled with daintiness and the rhythm of intricate line, cannot expect to keep their balance when a masterful etcher surrounds them with the outside welter of human realities. Brangwyn makes no appeal to valetudinarians; he is to our own time what Rubens was to Old Flanders; and let us remember here what Ruskin said about the namby-pamby criticism that spoke with contempt of the swaggering, great-hearted Rubens:

"A man long trained to love the monk's vision of Fra Angelico, turns in proud and ineffable disgust from the first work of Rubens, which he encounters on his return across the Alps. But is he right in his indignation? He has forgotten that, while Angelico prayed

56

and wept in his *olive shade*, there was different work doing in the dank fields of Flanders: —wild seas to be banked out; endless canals to be dug, and boundless marshes to be drained; hard ploughing and harrowing of the frosty clay; careful breeding of the stout horses and cattle; close setting of brick walls against cold wind and snow; much hardening of hands, and gross stoutening of bodies in all this; gross jovialities of harvest homes, and Christmas feasts, which were to be the reward of it; rough affections, and sluggish imaginations; fleshy, substantial, iron-shod humanities, but humanities still — humanities which God had his eye upon, and which won, perhaps, here and there, as much favour in His sight as the wasted aspects of the whispering monks of Florence (Heaven forbid that it should not be so, since the most of us cannot be monks, but must be ploughmen and reapers still). And are we to suppose there is no nobility in Rubens' masculine and universal sympathy with all this, and with his large human rendering of it, gentleman though he was by birth, and feeling, and education, and place, and, when he chose, lordly in conception also? He had his faults—perhaps great and lamentable faults—though more those of his time and his country than his own; he has neither cloister-breeding nor boudoir-breeding, and is very unfit to paint either in missals or annuals; but he has an open sky and wide-world breeding in him that we may not be offended with, fit alike for king's court, knight's camp, or peasant's cottage." Here is imaginative sympathy, and Sir Frederick Wedmore will do well to apply its apposite principles in a frank and brave study of the Brangwyn etchings. Ruskin is not drawn towards Rubens by any kinship of temperament; he, too, likes to feel "the spell, wrought on those who are worthy to receive it, by the rhythm of intricate line"; but good sense warns him that great art is much too wide and varied to be embraced by a spell so encloistered.

I

Let this obvious fact be remembered as we pass from chapter to chapter Etchings of many sizes will be studied, and we shall learn from the spirit of Brangwyn's best art, as we learn from other invigorating men of genius, that all the world (as Montaigne says) must dance in the same brawl towards death,* and also that the great who do their best, whether they die young or old, live young for ever, and ask the world to be young with them. For Brangwyn, as the next chapter will illustrate, sees the vast human drama just as it is acted to-day in the midst of Nature's mingled cruelties and caresses His vigour cheers—his vigour at his best—just because life claims infinite courage, and perfect candour, and as much plain truthfulness as artists can reveal. A true optimist goes in search of ugly facts and makes them known as foes to be defeated, while a false optimist slinks from ugly facts into an isle of dreams where he wraps his poor weak head with rosy clouds and then prattles cant In Brangwyn's art there is no false optimism, and the true is free from gloom and morbid drooping.

* Montaigne's words "All the world in death must follow thee. Does not all the world dance the same brawl that you do? Is there anything that does not grow old as well as you? A thousand men, a thousand animals, and a thousand other creatures die at the same instant that you expire 'No night succeeds the day, no morning rises to chase away the dark mists of night, wherein the cries of the mourners are not heard'"

CHAPTER III THE PARALLELISM BETWEEN BRANGWYN AND LEGROS AS ETCHERS

I

arallelism is a thing to be sought and ransacked, being very useful when we strive to reach the best words with which to express what we feel and see in the fine arts. A parallel is never close enough as a likeness to discover among men of mark a Dromio of Ephesus, and a Dromio of Syracuse—a comedy of errors among the good gifts that Providence distributes Always there are differences enough to enrich a parallel with variation, even marked affinities and resemblances having their own lights, half-tones and shades, their own individuality. And we learn quite as much by noting where and how a parallel breaks down as by weighing and measuring its aptness and its partial fellowship elsewhere But one thing more must be kept conspicuously before the mind· that mates among artists, unless they copy from each other, have not, as a rule, a family likeness, it is in the general temper of their work, in their general attitude towards life, art, history, and the world, that they match; and thus they are nothing more definite as pairs in the spiritual world than great birds of a feather

Brangwyn has more than one second self among the big modern men, and he has ever been drawn by affinity towards Meunier, Millet, and Alphonse Legros; but I am choosing Legros for three reasons The brotherhood is most evident and various; both artists are profuse etchers (Millet's etchings are few); and I studied the Legros prints and proofs and states with Legros himself Let us choose at once the most memorable phase in their resemblance, keeping minor points and differences to be pondered afterwards The thing to be considered at once unites this chapter to the final page of Chapter II

II

What is the first problem to which boys of genius have to reconcile themselves, either wittingly or unwittingly, by instinct or by thought and meditation, when they find that they are citizens and patriots as well as artists, and that life and the world in a great many ways press

upon them incessantly from morning until afternoon, and from year's end to year's end? It is the deepest of all problems and the most perilous; the very problem that brought so much agony of spirit to John Henry Newman, that it nearly drove an exalted mind from Christianity into pantheism, the doctrine that there is no God but the combined forces and laws which are manifested in the existing universe. Whenever I think of this problem—and never can it be absent from any mind that sees truly and reflects honestly—I am sure that the title that fits it best is as follows: "*The Illusion Called Peace.*"

No illusion can ever be nearer than this one to the most private strife in human nature. Even the earliest of all tribesmen, after defeat or after famine, earthquake, or searching inundation, must have yearned to be at peace; that is, to enjoy freedom from danger with the presence of tranquillity and comfort. From the action of strife,

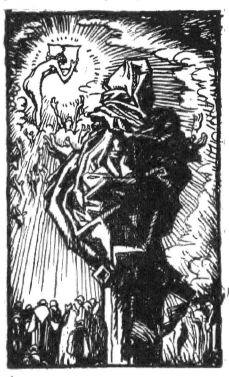

then, there came a reaction in the human mind felt as a desire to have peace—a desire felt by hunted animals and birds as well as by mankind; and the law of action and reaction being what it is, equal and opposite, a craving for peace will endure on our globe until strife and war end. Can they ever end? No. Innumerable phases of strife are as permanent as illness and hunger and thirst. Young artists have to meet this fact face to face and as bravely as they can. They observe far more closely than other folk, and feel more acutely; and those of them who pass into thought soon perceive that cant, humbug, claptrap—the cloak of lies with which the average mind wraps itself for warmth and

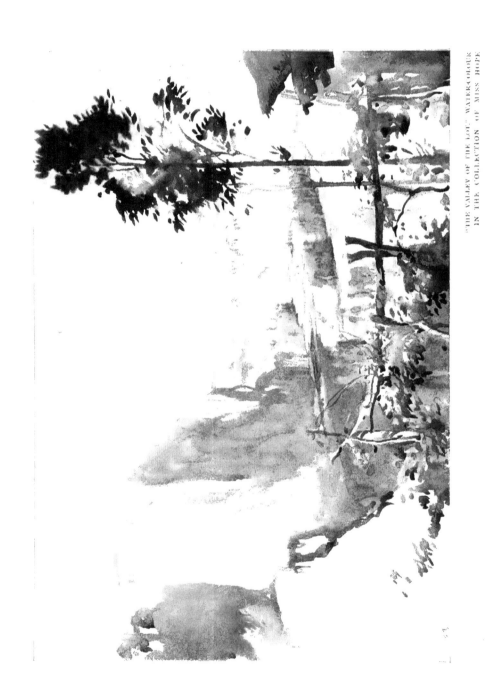

comfort—is cowardice turned into a routine by a desire not to see the awful varied phases of war that come all the year round from Nature's phenomena and from mankind as a part of Nature. How can any young artist fail to see that organic life everywhere feeds either on organic lives, like hawks on small birds, or on things that live, grow, and bring forth small copies of themselves, as corn reappears from seeds into flour and bread? Some living thing dies, then suffers a resurrection of vitality whenever appeased hunger renews the health of an organism. Nourishment, then, like gestation or like birth, belongs to the mystery of perennial strife, to the omnipresent genius of million-fold war; and what are young artists to think when this awful truth stares out upon them from their eye-witnessing? Are they to prattle about peace in a world where strife is multitudinous, ranging from love's pains in self-sacrifice to dangerous business contests, and ravaging street accidents,* and fierce brute hunger? Let us hope that they tell no lies to themselves, but continue bravely to discover true thought among facts seen, then weighed and measured

Both Legros and Brangwyn had to encounter these dread matters in the midst of raw privations. Yet they never blenched Their art is a proof that they faced life as good soldiers face battlefields. Both were loyal to their colours. Hurting facts, facts full of conflict, pain, awe, and mystery, pressed all day long on their sensitiveness, and it is worth while to mention a few because they are permanent facts, and must needs be pondered by those who have honour enough to see frankly Take the position of women in this world. If civilised women were not warriors bred and born from all the ages of courage and of pain and woe, how could they bear maternity and their lot as mothers? Babies are battles won, then lost far too often, since almost a million die in our country, year after year, before they are twenty-four months old How large a part of childhood is a campaign against heredity, often against social hindrances, often also against gnawing poverty, and always against the physical wars fermented by microbes! Scarcely an hour free from danger comes to any child. And when we turn from this fact to the casualties of ordinary bread-winning, in trades and professions, in odd jobs, in overcrowded tenements and foul slums, we arrive at a great principle

* Between 1914 and 1918 we learnt that street accidents in our country caused a great many more casualties—about five times more—that German air raids produced Yet our deceptive newspapers took the daily Juggernaut of our streets quite as a matter of course while shrieking over the air raids

—that to live is to suffer various and unceasing war Whether we sacrifice colliers to mine explosions, or sailors to the sea, or mission- ries and garrisons to bad climates, or nurses and physicians to long contests against epidemics, or artisans to perilous trades, or troops to battles, we make war, and bury the illusion called peace under the work we do as a nation Yes, and on those fortunate days when we have pluck enough, candour enough, we have good reason to rejoice over our lot For the yearning after general peace, rightly understood, is a base thing, a spiritual neuter, not a spiritual conquest over evils. Human nature knows but one peace—the inward rest and ease created by the thorough doing of brave work Briefly, then, let politicians alone prattle in a routine of cant about the illusion called peace; they are the dramatists who from a nation's affairs get farces, comedies, burlesques, and supreme tragedies *

III

Persons of common sense should note the attitudes of genius towards these tremendous matters. Brangwyn and Legros belong to that group of big fearless men who have accepted life as war, each in his own way; and this group is by far the most noteworthy in art and literature. I doubt if any fore-rank genius of any era can be found outside it, though there are wonderful rear-rank men among those geniuses who have chosen to be either monastic towards life or dwellers in unsubstantial fairy places. Shakespeare accepts life as war, like Homer; and—to choose a few examples—so do Marlowe, Dante, Milton, Fielding, Mantegna, Michelangelo, Titian, Tintoret, Rubens, Rembrandt, and—to take another poet—Corneille, of whom Napoleon said . "If he were living still I would make a prince of him." Further, we have much reason to rejoice that the modern genius, from the days of Delacroix, Hugo, Dumas, Sir Walter Scott, has endowed us with a good many big men who in various ways have seen and shown that life and strife are as inseparable as sun- light and shadow. But in Legros and Brangwyn especially we must note how varied is the candid recognition that man's life upon earth is one-third sleep and two-thirds strife, and that even sleep has its own occasional conflicts, its dreams that torture.

In Brangwyn's work I feel that this recognition, probably born

* The current notion that war is inevitably armed warfare is very unthoughtful Our ancestors were wiser. Consider these words from Psalm lv : "The words of his mouth were smoother than butter, but war was in his heart "

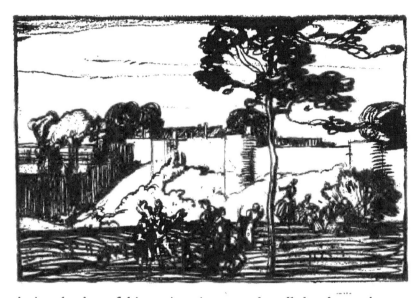

during the days of his marine pictures and cradled and reared at sea
among storms and fogs, has found its way through consciousness to
that habitual observation which unites with and enriches the in-
stinctive attributes of genius. His War Posters are exceptions. In
these, inevitably, he is at work in the cause of publicity, advertise-
ment, propaganda. Lessons are taught, pleas are made, and the
artist is conscious of his mission and towards himself and the world's
conflict. But when he is quite himself, in his usual stride of work,
he accepts human strife as he accepts the English climate and puts
it into art in his own inimitable manner. Take his memorable
etchings of "The Feast of Lazarus" (No. 139*), "A Coalmine after
an Explosion" (No. 59), the thronged "Return from Work" (No.
107), and the great etchings done at Messina after the earthquake.
Again, for waifs and strays, the shreds and patches of mankind,
human flotsam that is hustled here and there by every tide in the
affairs of men, and human jetsam that sinks,—for all this mortal
wreckage Brangwyn has a deep sympathy and pity, like that which
the poor give without fuss to the poorer. And Legros has a very

* "The Feast of Lazarus," a large print, 28″ × 19⅝″, was etched on zinc from Nature.
Who else has dared this adventure? Méryon etched from Nature on small plates,
never on large.

similar great emotion, a simple modest charity of the heart, intense, unpretending, noble, inspiring; so different from those professional almsgivers who either hurt or degrade when they go with their self-conscious goodness to dole out relief and spying words to the Miss Jetsams and the scattered tribe of Flotsams. I should like to compile a book on the differing ways in which artists have chronicled their hearts' intimacy with draggled camp-followers and depraved loiterers in life's warfare.

Although Legros in his attitude towards phases of war is always manly, strong and courageous, although there is no whimpering, no sentimentalism, in his etched tragedies and dramas, he is more conscious than Brangwyn of those perpetual neighbours—Pain, Failure, Death, and their attendants. He reminds me of a brave physician who should keep from year to year unchanged the feelings of an amateur nurse at home when someone loved is in danger The mystery of Death, and the uncountable guises in which Death visits all living things and creatures, were to Legros what the Paradise Lost was to Milton How often did he ask me to linger with him over Rethel's wonderful series of prints on Death's Triumphs! and how often did we talk together about his own noble etchings of The Triumphs of Death: "The Proclamation," "The Beginning of Civil War," "The Combat," "After the Combat," and "Outcasts from the Burning City."

These five etchings, deeply meditated and as candid as "King Lear," trouble and annoy the British public, the British public being often a singular Hercules indeed; often fed on cant and sentimentality, eager to find amusement free from thought, and so fond of illusions that it will coo over the idea of everlasting peace when a very bad war-map invites it to cry out sternly for victories. But Legros did not mind when his work was disliked The most lofty and severe of all the classic-romantic artists of his time, he never stopped or stooped to ask himself whether he was before or behind his own period To be current with mankind, the eternal human drama, is all that the greatest can achieve, or need wish to achieve, in the fugitive seasons of three-score years and ten. Among the Legros etchings, which number more than six hundred, there are many of a tender and winsome appeal; but the deeper prints, with their gravity and their sternness, will never be liked by dreamers, pacifists, and whining milksops, nor by anyone who fails to learn from the strife in his own daily lot that the perpetual toil of the living is to

64

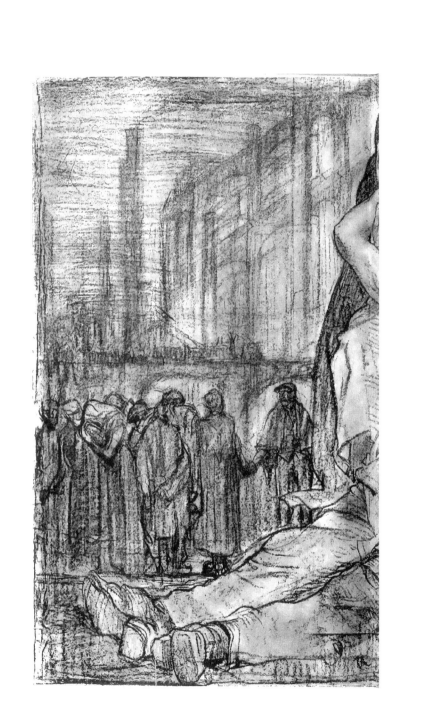

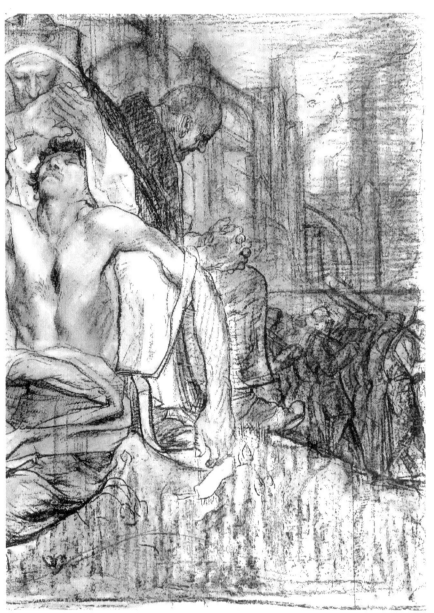

"MATER DOLOROSA

build up death; and also—since we all dance towards the hereafter in the same brawl—that the companions we need are courage and candour, not cant and make-believe

It is with these battleworthy virtues that Legros and Brangwyn explore their own ways through the millionfold war upon which the sunlight pours, often with a scorching tyranny; and both artists, obeying each his own judgment, show in their most thorough etchings a weighty repose, a tranquillity full of energy and poise Their figures, however agitated by passions, never bustle, the movement being one not of tumult but of rhythm and of ordered simplicity. Any break in the rhythm of a design, any flaw in the distribution of light and shade, any hitch in the handling of a conception, caused Legros to renew his work in a different "state", and sometimes his discontent went on until as many as nine variants of the same etching were printed off. He would toil hour after hour with his scraper to get rid of an offending part, and often he would cut down his plate or choose one of a larger size, and through all these changes, as in the austere "Procession in a Spanish Church" (No 49, in six states), his mind brooded always over the dramatic unity of his impression. Brangwyn is more direct by far, sometimes even too direct; his auto-criticism does not suffer from techiness; and it has not been his aim, as it was the aim of Legros, to be an experimental labourer, as well as an artist, in the point technique of etching.

Though Legros was unduly self-critical in many ways, sometimes he was not distressed by little awkward blunders, just as Sir Walter Scott was often undistressed by slips in grammar and by other laxities He who was a master draughtsman would be at times a fumbling pupil of his own style, and Brangwyn will admit readily that there are days when he joins Legros in this lack of command over his etching-needle *

But now one great result of Legros' untiring self-criticism must be noted: namely, the rich variation that it gave to the qualities of his etched line. To pass from his early and uncanny illustrations after Edgar Poe's tales to his portraits of Victor Hugo and G F Watts, or from one of his late dry-points backward to other early work, such as "The Communion in the Church of St. Médard" (No 54,

* Camille Corot put very prettily the difference between good and bad days in the hazards of work He said "There are days when *I* paint, on these days all is bad for me The days when it is not I who am busy, a little angel comes and works for me then it is better! It is the little angel who has done my best landscapes "

K

two states), is a very uncommon experience, so completely different is the touch of hand and the whole technical inspiration.

The younger work is much nearer to Brangwyn than the later Legros is to his own early self, though we must study his gold-point drawings, or his lithographic portraits (such as the "Cardinal Manning"), if we wish to see Legros in his most exquisite moods of classical reserve and concentration. I have no doubt that Brangwyn could do similar work if he set his mind to it, and I hope he will set his mind to it; but now he prefers to follow his masterful bent, often in moods which set me thinking of his marked kinship with that which is most grave, most austere, most virile, and most battleworthy in Legros' versatile appeal

As young men, and also in after years, these two great artists were drawn towards religious inspirations. Already we have seen what Brangwyn has achieved as etcher and painter of Bible subjects (pp. 16, 27), and now let us glance at Legros' conceptions, keeping in the background of our thoughts his biblical, evangelical, and general religious paintings: his "Amende Honorable," his "Enfant Prodigue," "Lapidation de St. Etienne," "The Dead Christ," his "Scène de l'Inquisition," the "Ex Voto," the "Bénédiction de la Mer," "L'Angélus," and "Femmes en Prière"

Among the etchings let us choose "The Death of St. Francis" (No. 56, in three states), "Some Spanish Singers" (No. 59, in two states), "The Procession in a Spanish Church" (No 49, in six states), the "St. Jerome" (No. 58), "The Communion in the Church of St Médard" (No. 54, two states), and "The Procession through the Vaults of St Médard" (No. 48) The last work, repeated in seven variants, may be described as a sort of bas-relief in etching, for all the women are grouped in a line on one plane, just as they would be in a bas-relief frieze, and it is to be noted also that this formal arrangement of the design is emphasized by its being brought into sharp contrast with a most careful display of pure realism in his women's stunted figures, and their poor empty faces, in their hideous crinolines and flounces, their grotesque make-believe of shabby-genteel fashions. All this observation from life's pathetic irony among the very poor is put in by a kind hand with rugged force, as in Brangwyn's "Old Women of Bruges," and his "Feast of Lazarus."

Apart from this, let me note, "The Procession through the Vaults of St. Médard" is the one important etching of the first series in which a faithful rendering of things seen day by day, though united

66

to religious emotion, dominates the etcher's aims and results. The other proofs and states, when equally realistic, are more imaginative, though equally bluff in technique and searchingly austere in emotion. "The Death of St. Francis," "The Procession in a Spanish Church," "Some Spanish Singers," and "A Spanish Choir"—these four etchings have intense vigour and distinction, and also a new earnestness of purpose, ascetic, persistent, dramatic, and blent with a deep and true sympathy for the early masters. Thus there is a somewhat of Giotto in "The Death of St. Francis." To be sure, one cannot localise this somewhat, just as one cannot explain how or why Brangwyn's picture of "The Baptism of Christ" has in its modernity a quaint ingenuous fervour that belongs to a bygone age There is no analysis for these finer elements of spirituality in art The point is that Legros and Brangwyn absorbed influences from the far-off past, the Giottesque giving a faint or vague ethos to the Legros etching; and it brings us into much closer fellowship with St Francis and his four kneeling disciples than any technical skill more modern in spirit could succeed in doing.

There is only one way in which an artist can teach himself to view an ancient subject from within its contemporary atmosphere, which is far and away more important than contemporary costumes He must learn to be at home in a chosen period as children live in story-books; must think in accordance with the period's thoughts, ideals, superstitions, and so become the foster-child of a vanished age But this way of studying the past is so difficult that it has only a few devotees Happily, great artists possess the gifts of divination and dramatisation, a few pictures and a few books are all that they need, unless they wish to be archæologists in the Alma Tadema manner, which is "up and down as dull as grammar on the eve of holiday." Legros, deeply moved by the character of St Francis, as Brangwyn is, wished to work as a moved spectator of the scene he recalled; and he did not go far astray from a noble success. Indeed, not his technical aptness only, but his religious fervour also, and his naive composition, come from a brave and good attempt to endow his death of St. Francis with a spirit and a style that accord with mediæval character. And Brangwyn has achieved similar feats of

67

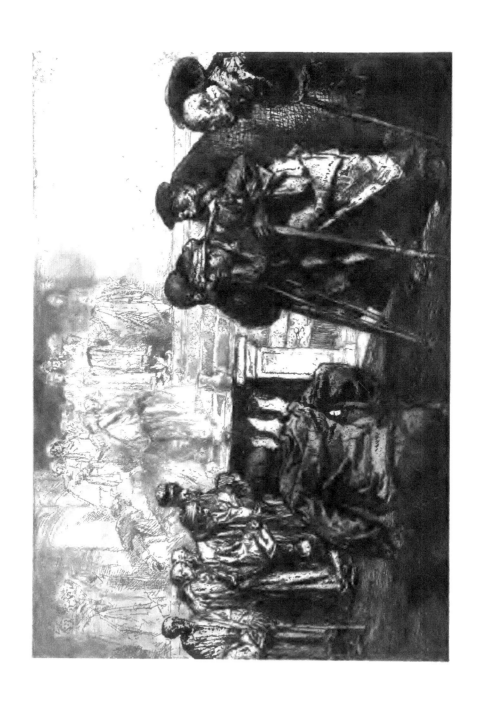

divination, though archæologists, who think far more of detail than of spirit and character, could pick—and do pick—many a hole in them; just as tailors who visit our exhibitions have much to say against the scorn that artists have for "cut" and cutters.

Again, when we think of Brangwyn and Legros in relation to their more rugged and insistent etchings, let us note what they are and what they are not. They are never puritanical, over-religious, and arrogant; but they know how to be austere, ascetic, rigorous, and fervent Sometimes they are too arbitrary, but never brutal or ruthless; and they know when to set just store by apt bluntness and sternness They keep away from qualities which are tart, sour, caustic, acrid, surly, peevish, sullen, irascible, virulent, malevolent; but, when necessary, they are curt, bluff, rugged, brusque, and pretty often uncouth They have nothing to do with boudoirs, and are never courtiers at ceremonies of State; but in their kindred passion for humble folk and the war of life, they show that chivalric emotion is a grace not of external symbols, but of the heart's good breeding. If an etcher desires to rival Legros' "The Barge—Evening," or Brangwyn's "The Tow-Rope, Bruges, 1906," his whole nature must be a perfect gentleman in the ranks—the ranks of life's warfare.

These etchings belong to similar moods, and their subjects are akin Legros returned to this motif again and again, and always with the same zest and profound sympathy A noble landscape is beyond the river, an uneven height embowered among trees and crowned with a snug French village. A great fire of sticks throws up a torchlike flame and smoke that flare into the sun's afterglow; and a poor drayhorse of a man, bent double under the jaded routine of his daily fatigue, pulls at a long tow-rope that shackles him to a long, secretive barge lying so flat and low upon the water that it seems to be a smuggling craft from that mythical river in the lower world, over which poets in their darkling hours will ever cross in thought on their way to the regions of the dead. Man and barge haunt and overcome the great landscape, just as other bad news everywhere is tyrant over all that it affects; and hence this etching belongs to what Legros named his "garden of misery," that is to say, his deep and tender sympathy for all pariahs, outcasts, tramps, beggars, and other casualties of society In Brangwyn's etching* the barge is unseen, and no fewer than five drayhorse men—they are drawn in a scale

* It is etched on zinc, like the most of Brangwyn's work, and it measures $31\frac{3}{4}$ in. by $21\frac{1}{4}$ in It was etched also from Nature, not from a drawing.

68

somewhat too big for the plate—are haltered to the rope, and make themselves known as wastrels. Each, after a slack manner of his own, chews the bitter cud of his stale fatigue while his brain—his birthright through perhaps a million years—is half asleep among surly oaths, or half awake in a poor stock yearning after faro beer. And the old great houses of Bruges, built by hands with brain in every finger, a keen wit in every busy tool, are dimly present behind these five rough blunderers of A.D. 1906.

> "Yet the will is free,
> Strong is the soul, and wise, and beautiful,
> The seeds of God-like power are in us still
> Gods are we, bards, saints, heroes, if we will "

You know Brangwyn's "Old Women of Bruges,"* in which every detail of clothing suggests a routine or custom that some poor creature has obeyed? And you know "La Mort du Vagabond" by Legros? It is an etching toned with aquatint, for the intensity of the artist's feeling needed a somewhat that etching alone would not give. On several occasions Legros mingled aquatint with etching, just as Brangwyn adds tone and body to many prints by the skill with which he applies ink to his plates.† Both artists are moved by similar emotions when they appeal to us in these details of manipulative craftsmanship "La Mort du Vagabond," the aquatint deleted, would be but a skeleton of itself; just as Brangwyn's presence at the death of those other vagabonds, veteran ships which are being broken up after all their many victories over winds and waves, would be greatly harmed if the resources of thoughtful printing were not added to their etched workmanship "Breaking-up the 'Hannibal' at Woolwich, 1905," or "Breaking-up the 'Caledonia' at Charlton in 1906," is to Brangwyn's earlier etchings what "La Mort du Vagabond" is to the black tulips in Legros' "garden of misery."

And there's another thing to be weighed and measured. Which is the more tragical in Legros' great print, the lonely outcast under a chill, wet wind, with his dying hand pressed upon a bundle in which he carries his little all of soiled comfort, or the gaunt old ravaged tree, leafless and forlorn, that grips the earth firmly, though storms

* This fine study of character was cut down and altered, and is known to-day as "The Old Women of Longpré" (No. 173)
† Brangwyn also has used aquatint with impressive effect, as in the second state of the "Bargebuilders, Brentford" (No. 20, 13¾ in. by 13⅞ in.), which could hang side by side with Legros' "Fishing with a Net—Evening" (No. 90)

ave thrown it a good many yards out of the perpendicular? Legros
delighted—and Brangwyn delights—to reveal tragedy in things in-
animate, just as that Anglo-Frenchman and sailor, Charles Méryon,
with his haunted and haunting genius, loved to put I know not
what of human passion and pathos into bricks and stones; as if old
buildings retained somehow in ancient cities low whispering minds
bequeathed to them by forgotten yesterdays and the dead who are
dust. I know not how else to express the uncanniness of Méryon,
whose etchings are at times so eery that, to my mind, they are almost
supernatural in the suggestion they give of human suffering as time's
own veteran. And now and again, perhaps unwittingly, perhaps
without conscious effort, Legros and Brangwyn rediscover for us the
common havoc in the midst of strife that imparts to all things ani-
mate and inanimate a universal fellowship in the looks and aspects
of high tragedy. Brangwyn's etched prints of the " Duncan" and
the " Britannia," for example, are tragedies that belong to our sea-
faring lot and destiny; they do not mark what is past or finished,
like the tragedies drawn from English history by Paul Delaroche.
Is there an epic emotion greater or more needful than that which,
instead of making a fetish of man's brain, his Pandora box, reveals
Mankind and Inanimate Nature as subject to the same rule and lot
in the mysterious ordering of the universe? Only a man here and
there has used his mind as ably as birds and beasts and insects have
used their apt instincts; and the result is that most men and nations
have been cursed far more often than they have been aided by their
big brains So I am always greatly moved when a fine artist gains
from things inanimate a new aspect of that commonplace which
either humbles the vainglory in men of a day (as when snow prevents
a German advance or tempests overcome artillery), or shows that there
are many greatnesses without human intellect where man is feeble
and out of place If only the sun could speak, if only his rays could
murmur criticisms from dawn to dusk, *La comédie humaine* would be
conducted by a stage manager and creative playwright with a com-
plete vision of all the futilities in mankind's history. Then progress
would be certain, and not a stock theme of human self-praise.
Later we shall see that Brangwyn has etched a good many noble
plates—and some which are not good—wherein things animate are
dwarfed into merited triviality by their inanimate surroundings, and
Legros' attitude is often similar. He admits no animate creature of
any sort into his dripping print of the " Storm" (No 288, second

state, and a dry-point); and note how he acts "In the Forest of Conteville" (No. 352), an arboreal masterpiece. Let us compare its third state with the second. Both are grim and masterful, but the second has a man in it, and Legros felt, as we all must feel, that the man should be at home, where he will have—or will believe he has—some importance. So the intruder is banished from the third state, a fine haughty tree occupies his place, and the other trees have added many years to their bulk and beauty. Justice to a forest has been done, sterner and finer justice than Ruysdael does to one in a good etching that reveals his fondness for great oaks.

And would you be glad or annoyed if Brangwyn had put a human figure in the foreground of his etching called "The Storm," with its tall dark trees and its wind-swept energy and amplitude of space? I should swear. Man's place in this dramatic landscape is in the cart beyond those gray palings where the road loses itself in shade under adult poplars. F. B.'s "Storm" is in the same mood as Legros', but receives some graver accents and sterner printing. Many landscapists would have spoilt Legros' drenched poem by foisting two or three storks into a swampy pond. How fond they are, these landscapists, of what they call "a little animal animation," or "a bit of human interest." In the eighteen-eighties they had a craze for black pigs,

begun by R B Browning, the poet's son. Negro pigs were seen even in places where black pigs were unknown Landscapists carried a piggery in their paint-boxes. And think of Claude Lorrain, or Claude Gelée Though wiser and freer as an etcher than as a painter, how seldom does he resist the spell of "animal animation!" He never asks us to remember that distrust of minor brains ought to be welcomed as the beginning of human progress Among his prints, which number thirty odd, minor brains are too busy, as in cows, goats, and their attendants. Even the best of Claude etchings, "The Drover," is a noble landscape hurt by nine dull cows and a ruminant man

Animate interest, indeed! How many men and women with faggots on their backs have limped their way into pictures? Even Legros was not proof against this faggot-bearer, but he turned the old recipe several times into Death and the Woodman. Is it not time for young landscapists to learn with other folk that men owe many stimulative acts of grace to mankind's potential virtues, and that a chief among them is the need of improving mankind by deleting a great deal of "human interest" from their own lives and labours? Legros' airy and gracious etching, "A Sunny Meadow" (No. 340), is perverted by a man who lies at full length near the foreground, giving a balancing note to the exquisite design that three or four rabbits would have given within the sweet serenity of a happy day Later we shall see how Brangwyn employs the supernumeraries that enter into the drama of his etched work, often with a varied aptness, and sometimes not *

IV

Great students of strife, like Brangwyn and Legros, are seldom much attracted in art by strife in its military aspects, except in a picture here and there, like Charlet's "Retreat from Russia," or Boissard de

* I have overstressed intentionally this attitude towards animate figures in landscape because it contains several elements of useful truth which are usually passed over in silence by critics and interpreters The introduction of human and animal life into landscape depends on two factors the character of each landscape and the degree of tact and skill and poetry revealed by an artist (a) in his choice of apt animate figures, and (b) in his handling or treatment But every landscapist believes that his figures are apt and right—a huge mistake When a landscape and its animate life are in happy, inevitable accord, every one will agree with Professor Selwyn Image, who says, "To me a landscape without, at any rate, some suggestion of human and animal life is almost as a face with its eyes gone" The word "animal" includes birds, of course, whose presence in some landscapes gives a winged, exploring hope to nature's most sinister desolateness

"REVOLT"

Boisdenier's "Episode de la Retraite de Moscou" (Musée de Rouen), a little-known great picture of epic grandeur, and within the companionship of Millet, Meunier, Butin, Cottet, Brangwyn and Legros. Among all the many etchings by our artists there is not, I believe, a military subject,* though both learnt in early youth to understand the occasional need and utility of armed strife One evening I related to Legros the argument of Ruskin's lecture in praise of armed strife, and he was moved into an assent somewhat wistful Ruskin learnt five vast things from history, modern, mediæval, and ancient.

1. That no great art ever rose on earth but among a nation of soldiers;

2. That there is no great art possible to a nation but that which is based on battle,

3. That in our times the arts have remained in partial practice only among nations who have retained the minds of soldiers;

4 That vices, not virtues, are likely to abound in social life when civilised men are freed for a longish time from the peremptory discipline of armed strife;

5. And, in brief, "that all great nations learned their truth of word, and strength of thought, in war; were nourished in war, and deceived by peace; trained by war, and betrayed by peace: in a word, were born in war and expired in peace"

It was very strange to Ruskin to discover all this—and very dreadful—but he saw it to be quite an undeniable fact But in his lecture he forgets to think without laxity. When he uses the word "peace" he means no more than the absence of armed contest, and the word "war" as he employs it means no more than the presence of armed contest. He forgets the omnipresent and universal strife, which includes all natural and human agencies that waste, ravage, kill, do harm in any way, cause pain by any means.
Moral and intellectual nerve are always impaired very much by great poverty, and also by much material prosperity, by a flood tide of high profits and a roaring trade. When Ruskin says that peace goes with sensuality and selfishness, corruption and death, we must regard the word "peace" as a synonym for disintegration and decay, dis-

* More than once Legros reveals the tragedy of revolution, as in the early etching called "L'Ambulance", but these subjects are not *military*

L

73

astrous phases of civil war; and when Ruskin adds that "war is the foundation of all the arts," and also "of all the high virtues and faculties of men," he refers to armed strife only; and even here we must note his misuse of the word "foundation," as the relation between great armed strife and great art is not one of cause and effect. Success in both arises from an awakened greatness in a people, and both are dependent on those inborn gifts for fighting which mankind has preserved through innumerable ages of combative history, social, moral, religious, commercial, intellectual, international, and internecine Delete from our national character the primal fighting virtues, and the British Empire would fall into fragments, and our social life would be invertebrate and futile. Good and evil alike depend on their motive-power; and when a noble cause—or a cause that is looked upon as noble—sends men forth into great armed battles, a whole nation may rise with the cause into greatness, like the Greeks before and after Marathon, or like that inspiration of the Crusades which became also the inspiration of Christian art and poetry.

Consider too that wonderful ferment in the soul of England which ennobled every phase of Elizabethan enterprise, or that other ferment which, extending from Marlborough's victories to its disappearance after the Crimean muddles, endowed our country with a truly magnificent sequence of big men and big achievements And the present armed war, the vastest in all history, will it be followed by a splendid new roll-call of artists, authors, and other men of genius? Let us hope so, despite the fact that incalculable agencies are hard at work. Perhaps the spiritual reaction in social life may be towards enervation and disruption. The baleful influence of noisepapers by the thousand is one perilous factor; the self-worship of democrats is another; industrialism is a third, and far too many modernists in their heart of hearts are weak and sentimental. This fact explains why most of our writers have encountered the present war in a temper often of cant and often of wistful approval, half at variance with true martial courage and fortitude and honour. The illusion called peace has tripped from their tongues and pens. Are they eager to be hackneyed politicians?

If much art as virile as Legros' and Brangwyn's should come from new men with the social aftermath of the present armed conflict, we shall be fortunate indeed. It is a great deal to expect, but those who expect little should receive no more than the widow's mite.

Turning now from the elements of strife in our parallelism, and from the reflection that these elements invite and merit, let us glance at a few other things that look out at us from the etchings. Legros and Brangwyn are equally versatile, and the world distrusts versatility. Legros in his travailing takes us not only from paintings in many branches to etchings of many sorts; not only from pen and

pencil sketches lithography, work, but also medals, like the the John Stuart some finer sculp- the monument Welbeck Abbey. chapter I speak versatility. For note, it happens gros and Brang- in the skill with chestrate their giving it a pecu- naturalness by sought and ment is vari- Compare F. B.'s Dixmude" with Abbey Farm," Burning Vill- etching of the The very first

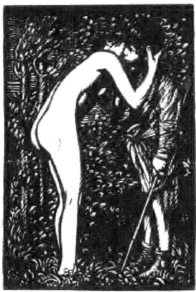

HELEN WILSON
HER BOOK 1917

to water-colour, and gold-point to some fine Tennyson and Mill, and also to ture, including fountains at In the final of Brangwyn's the rest, let us often that Le- wyn are alike which they or- composition, liar look of which the planned arrange- ously masked. "Windmill at A. L.'s "The or A. L.'s "The age" with F. B.'s colliery disaster. etchings that

Brangwyn as a boy noticed and loved were by Legros, and he remembers gratefully that he, when only about sixteen, was drawn towards "La Mort du Vagabond," and "Men Felling Trees," and some other aspects of peasant life and needy wayfaring.

Legros is charming always—delicate and meditative—in his gentler etchings, such as "After the Day's Work" (No. 559), a farm scene full of repose. He is not easy in architecture; his etching-point grows heavy and yet hesitating; and never that I remember

does he rise, as Brangwyn has risen often, into the soaring flight of Gothic cathedrals, which are always airy music in stone, and magnificent symbols of the Ascension that Christianity teaches and pleads for incessantly Classic architecture, Greek and Roman, has a might that weighs downwards with majestic power, as if eager to be earthbound like the frolic gods on Olympus. Later we shall study Brangwyn's acute judgment as an etcher of architecture. Note also his use of upright lines and diagonal lines; and his eager fondness—excessive now and then—for deep rich plots of dark tint and shadow He finds music in strong contrasts between light and shade, and believes, as Tintoret teaches, that black and white, nobly orchestrated, are among the most beautiful of colours * On the other hand, Legros' work in its later and latest moods grows towards a grayish ink as if the artist wished to get as near as he could in etching to the delicate colour of gold-point drawings, just as Turner's oil-painting passed from deep tones towards the brilliance and translucency of water-colour Legros, again, like Rembrandt, is very fond of intricate hatching and cross-hatching and the effects that he obtains with them are diversified and charming. Pretty often he seems to catch the moving air in a most delicate webbing of nervously vital lines, lines that pulsate; and sometimes, as in the tired farm-horse that enjoys a good feed "After the Day's Work," a witchery of interlaced and vibrant lines gives a very peculiar repose and tremulous atmosphere. In Legros, again, we are often drawn towards long plates, while in Brangwyn we feel very often that a square plate, or plate that approaches a squarish form, is the best of all shapes for an etcher to work within. Thus the very touching and original etching of The Nativity, with its tender rustic awe and its primitive old spiral staircase, is composed on a zinc plate measuring $28\frac{7}{8}$ in by $21\frac{1}{2}$ in. and The Crucifixion is nearly square, $30\frac{3}{4}$ in. by $29\frac{1}{2}$ in. Every contrast between artists has great interest to students of individuality.

One point more François Millet's work was an early influence for good in the lives of these fine etchers It was in 1861, the fourth year of a very bitter struggle, that Legros was cheered by Millet—but at second-hand. One day, when he called on his printer in Paris,

* As a rule—there are just a few exceptions—Brangwyn's etchings have but two states a Trial Proof and the Published and Signed Proof. and I note that the changes made between these states are *usually* towards greater depths of tone and a more sonorous orchestration of sunlight and shadow.

eager to see proofs of some new etchings, he was taken to task by the printer's wife, a good, shrewd housewife with a nipping and an eager tongue, who found neither merit nor money in the subjects and methods chosen by young Legros. "And, monsieur," she added, " I am not certain that anyone in Paris likes your etchings—except Millet, Jean François Millet." "What! Does Millet like them?" the young artist cried. "Then, Madame, I am more than satisfied, believe me." And the good woman did believe him, so tart did she look as she put on an air of reproachful resignation.

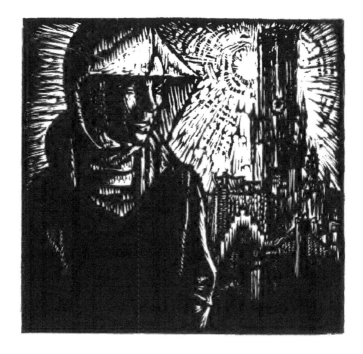

t is always useful to note how artists, and particularly painters, make their first efforts with an etching-point Ruysdael, in the earliest of his twelve etchings,* done when he was about seventeen (1646), got a touch and a vision that Corot and Chintreuil must have liked, for it is about midway between their moods. But Ruysdael passed on at once to a different style and a tussle against oak trees. Turner, governed by his inborn stinginess, fixed in a wooden handle the prong of an old fork, and then told himself that work with it must not be more troublesome than drawing on paper with pencil. But Turner with a broomstick would have drawn masterpieces on a quicksand if there had been nothing else for him to employ. Other men are abashed when they tackle for the first time the art of etching, knowing that they will hate a tiresome loss of ease and freedom during their transition from pencil and brush to etching-needle and metal plate.

Is it better for them to make a start on original work than to copy for a while from old prints? Brangwyn preferred to do original work, while another sailor of original genius, Méryon, eased his difficulties by copying His first attempt, made under advice from Eugène Bléry, was a Head of Christ after a miniature done by Élise Bruyère, from a painting by Philippe de Champaigne, and in other copies he analysed the etched line of some old craftsmen, among whom were Zeeman and Karel Dujardin. Méryon set great store by Zeeman, whose " Veues de Paris et ses Environs" were published at Amsterdam about 1650. He either copied or translated from other men too, and acquired a touch with his needle even defter and quicker than that of Jules Jacquemart, who worked at the Louvre for the French Government, etching many trinkets there, while poor Méryon fought alone through privation until his mind gave way and he entered Charenton

Brangwyn's apprenticeship in etching—his second apprenticeship, as he did some etched work during the eighteen-eighties—had nothing at all of a piece with Méryon's It began in 1900 and went on intermittently for three years Nineteen etchings belong to this

* "Le Ruisseau Traversant Le Village." Largeur, 10 pouces 3 lignes, hauteur, 6 pouces 8 lignes Vienna et Amsterdam. Duplessis 8

period in the catalogue of two hundred chosen proofs published by the Fine Art Society, London, in 1912, and they are worth careful examination. Let me note, first of all, which problems were attacked, always at pointblank range, but not always with equal tenacity:

1. The use of small plates both for landscape and for portrait heads. Examples: "The Head of a Blind Beggar" (No. 3) is done on a plate 4 inches by 4⅜ inches, and "An Old Tree at Hammersmith" (No. 14) on a plate four by five. This landscape was etched from Nature.

2. Testing different metals, copper and zinc, and choosing zinc as the more obedient to his temperamental bias. In the nineteen subjects only two are on copper. Méryon tried tin—a softer metal than zinc—at least for several etchings.* In two hundred chosen etchings by F. B. I find fifty-eight on copper; and I find, too, that in four years—1909 to 1912 inclusive—copper was used nine times, for the doing of sixty-two etchings, while in 1907 it was accepted fourteen times in the choice of twenty-nine plates, and in 1906—the most friendly year to copper—fifteen times in twenty-seven etchings.

3. During the three apprentice years (1900–1903) Brangwyn experimented with aquatint and aquatint graining, as well as with original printing methods, as if eager to know how many painterly virtues he could get from metals.

* Méryon's use of tin: Copied Portrait of Pierre Nivelle (1584–1660); and Portrait of T. Agrippa d'Aubigné, from a lithograph by Hibert. Also the portrait of Armand Guéraud, the printer, from a photograph. Burty says: "It was engraved with the burin on a soft metal, tin, which gave off only a few proofs."

79

4. In the use of large plates he made several big adventures. "The Tanyard, Brentford," for instance, an etching done from Nature, with its busy men, all typical and boldly sketched, and its timber sheds which have the uneven and forlorn look of weatherbeaten wood, comes from a zinc plate $15\frac{3}{8}''$ by $12\frac{2}{8}''$, and the second version of London Bridge, to which we shall return in a later chapter, is a copper-plate etching that measures $21\frac{1}{5}''$ by $16\frac{3}{4}''$.

As I wish to set down as clearly as I can what my research has given to me, let me ask readers to remember that an interpreter of art cannot suppress what he does not like, but that preferences are offered —and should ever be offered—not as verdicts, but only as things to be turned over by thought and talk Let us choose, then, a few small plates from the apprentice period·

(a) Head of a Jew, on zinc, $4''$ by $5''$, 1900 (No. 2 in the official Catalogue of 1912).

(b). Head of a Blind Beggar (No. 3), on zinc, $4''$ by $4\frac{2}{3}''$, 1900

(c). Head of a Suffolk Fisherman (No. 12), on zinc, $4''$ by $5''$, 1903

(d). Head of an Old Man (No. 13), on zinc, $5''$ by $4''$, 1903.

(e). An Old Tree at Hammersmith (No. 14), on zinc, $4''$ by $5''$, 1903.

The Jew is about three-quarters face, looking towards our right; he wears a tall and soft cap, and heavy shadows fall across him. Impatient handling is evident, strong lines running—in a sweep that curves from right to left—over the face and coat It seems clear to me that the etcher is cramped, like a tall good cricketer with a child's bat. Would this hindrance have been so irksome, I wonder, if our artist had taken his first lesson in a portrait etching not from Nature, from the life, but as a translator from Vandyke? Here is a useful specu- lation for young etchers to apply to their own cases A student copying from Vandyke's etched portraiture would keep the whole art before his mind, and his whole attention would be fixed on that consummating ease with which every line performs its office with- out becoming either too dark or too light, and always in scale with both head and plate. It is a joy to watch the skill with which Vandyke places a fine kitcat portrait on a small plate, the head always in the most fitting spot and never too big for the surface upon which it is drawn, as Cranach's heads are invariably, like those by Stauffer-Bern, to take only two examples And Vandyke's poses reveal his sitters' characters, wittily and charmfully To vie as a translator against this master-mind in etched portraiture, leaving

80

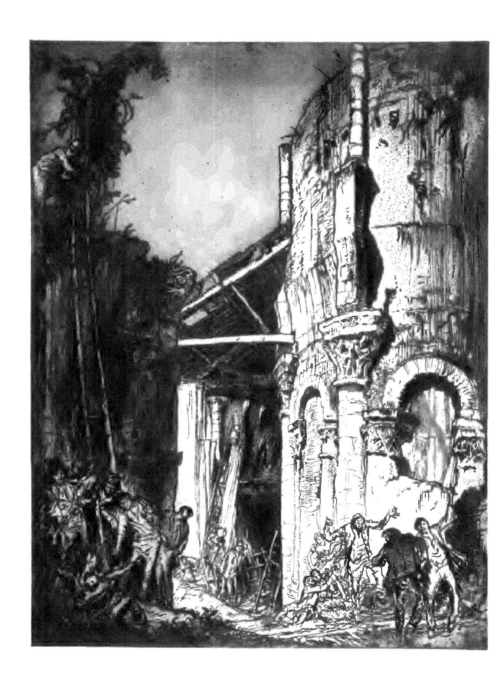

original work until the hand has gained ease with new tools and on small plates, could not be to any man a derogatory exercise, " a long farewell to all one's greatness " But original workers are naturally opposed to all copying, as a rule Why should they wish to borrow classic bats when they are either accustomed or eager to make good scores off their own ? Here and there a modernist has copied, like Degas and Van Gogh, but the usual method nowadays is to confront nature at once and in a questioning spirit free from servile and soulless imitation. Still, an amalgam of methods old and new is often invaluable during an original man's apprenticeship. As Shakespeare did not hesitate to borrow the outlines of useful plots, why should a modernist in art hesitate to copy now and then from an earlier master ?

The " Blind Beggar" may be an old salt; he looks weather-blown and tough and taut. It seems to me that his portrait is placed not at all well on the plate There's a wide gap of background on our right, behind and above his left shoulder, and it is scrambled with irritation, horizontal lines making so much ado that they draw one's eyes away from the modelling of the face, a modelling somewhat like that of a woodcut. Neither of these heads, viewed as abecedarian work, is to my mind good enough for Brangwyn. There's much improvement—the improvement, indeed, is great—when we see the humorous old "Suffolk Fisherman," and also No 13, a thoughtful well-built "Head of an Old Man"; but yet the handicraft sets me thinking somehow of woodcuts, and both heads are so big that they are out of scale with the small zinc plates I seem to be looking at each model through a square hole rather than through a window. And the "Old Tree at Hammersmith," with its bluff impression of bad weather and of material bulk, has almost the same disproportion between scale of setting and technique and the plate's twenty square inches.

It seems to me that Brangwyn has not annoyed his foes often enough by proving that he can beat at their own exercise the delicate sprinters and plodders over small plates. That Brangwyn should be a master of small work as of big, is proved by a water-

M

colour sketch, dated 1884, and treasured by Selwyn Image It is a tiny marine, apt, fresh, sincere, with a boat on the sands and a touch of sea beyond. It proves that Brangwyn at seventeen could work at ease on a very small surface; just as Rembrandt's bust portrait of his mother, a tiny thing, shows a master at home, entirely free, and as tenderly proud and happy as the dear old lady, who loves to be etched by her great son. If this wee portrait were enlarged to life-size by magic lantern, as Legros wished to enlarge Vandyke's etched portraits as a lesson for all artists, we should find that the gracious and minute fondling touch had in it a breadth and scale that magnification could not lose.

Nothing is more wonderful than the modesty with which the Old Masters turned from vast to small surfaces. Even the giant Michelangelo, who worked for eight years in the Sistine Chapel on a mural painting forty-seven feet high and forty-three wide, and who at sixty attacked marble with such fury that he made more chips fly about in fifteen minutes than three young sculptors would have made in an hour,*—even this Hercules of genius delighted to caress and cherish trifles when trifles were necessary, and here he resembled Leonardo, and Mantegna, and Rubens. When Mantegna took up engraving he was about sixty, and yet, as Delaborde says very well, though his work shows "l'inquiétude d'une main irrité par sa lutte avec le moyen," his principal mark is "un mélange singulier d'ardeur et de patience, de sentiment spontané et d'intentions systématiques" What Brangwyn's smallest etchings need now and then is this addition of patience to his ardour, and of purposeful method to his instantaneous sentiment.

But as soon as we turn to the larger F. B. etchings of this first period —the well-known "Assisi," for example, or the second version of London Bridge—we watch how a long-distance manner, with a stumble here and a mishap there, settles down into its own stride, and becomes more and more adventurous and confident. " Barkstrippers at Port Mellan, Cornwall " (No. 8, 16″ by 13″), is a good industrial group, well observed and easy, though its effect is rather weak in qualities of air and somewhat like a woodcut; and some very difficult problems are partly overcome in a bold plate etched out of

* According to Blaise de Vigenère, an eye-witness, who adds : "It would seem as if, inflamed by the idea of greatness which inspired him, this great man attacked with a species of fury the marble which concealed the statue . . . I feared almost every moment to see the block split into pieces "

82

doors, "Trees and Factories at Hammersmith " (No. 11, 16" by 13"). I like the first state, a sketch in outline, even better than the published state in very emphatic light and shade, the factories in sunlight contrasting overmuch (to my mind) with the foreground trees and land. It seems to me that the trees fail to grip the earth firmly; their charm is the branching foliage.

"A Gate at Assisi " (No. 16, 17" by 13"), with its procession in the wind and rain, its pleasant glimpse of distant country, and the trees, tall and dark, is a spirited venture; and there is alert observation with

true feeling in another Assisi plate, an aquatint on zinc, in which a beggar comes forth from under a shadowed archway through which a patch of town can be seen in sun and shade. This aquatint measures $8\frac{1}{2}$" by 10"; it is clearly seen in the right scale, and the beggar's face has a questioning sorrow that fears to-morrow much more than to-day and yesterday.

There are two etchings of old trees at Hammersmith, the one we have considered (No. 14, 4" by 5"), and No. 19, 12" by 15"; and the bigger one is by far the more impressive. Several other subjects from this novitiate period belong to later chapters, and they happen to be etchings which prevent this period from seeming as a whole perhaps a little too much occupied with the end of a perilous art before its beginning has been mastered by unflinching research and persevering labour. The early versions of London Bridge are attacked with patient industry and zest (though not, perhaps, with quite enough affection for pointwork pure and simple), and a "Road in Picardy," as we shall see anon, tackles with vigorous care and

much success the same problems that Hobbema masters with simple and serene nobleness in a spacious epitome of Holland's landscape, "The Avenue at Middelharnis," a picture as full of airy sky and cloud as it is of cosy earth that nestles into the Dutchman's heart and history. Every imagination can roam through this Hobbema with a freedom like that of a swallow over flat Dutch homelands.

CHAPTER V ETCHINGS SIMPLE LANDSCAPES AND WAYFARING SKETCHES

t is convenient to divide this chapter into halves

1 Landscape pure and simple, free sometimes, and sometimes not quite free, from the great human drama,

2. Wayside jottings, travel sketches, and matured impressions.

What are we likely *not* to find in these divisions? Every artist, wittingly or unwittingly, omits many things from his executive aims and focuses all his æsthetic zeal around certain preferences, as Corot—in his etched *croquis* as in his paintings—forgets Nature's tremendous weight and tragedy in his reverence for the soft winsomeness of her perfumed hours, or as Rowlandson turned from the sweetness of Wheatley and endows art with brawn weight, muscle, sweat, and lusty caricature For this reason, before proceeding any farther, let me try to state what I take to be the bounds within which Brangwyn has gathered his simpler motifs out of doors.

First of all, then, Brangwyn is rarely a forester in his etched work, a detailing master of trees, an inquisitive student of that elemental architecture which is plainly suggested by their branching abundance and the individuality of their columnar growth. He loves trees greatly, of course, their decorative appeal puts a spell upon his imagination; and (as a rule) he subordinates all else in their growth, texture and character to the depth of tone in ornamental plots and patterns that they enable him to use as elements of design Only once, I believe —"The Olive Trees of Avignon," a studious etching, free and great-hearted—has he studied any tree as Ruysdael studied oaks; not yet has he caught in spring the airy lightness of thickets and coppice borders, and he has not yet looked at noble holts and spinneys from within an atmospheric inspiration like that which Claude reveals in two or three etchings, and to perfection in "The Drover." But landscape art would be a dull thing if its devotees were arboreal all with one mind and purpose. To see woods and trees as Brangwyn sees them, as elements of design, is to be fascinated by wonderful varied shapes and beauties, ranging from the austere darkness of

85

venerable yews to the most exquisite diapers that silver birches make with their lady grace and overbred languor.

An artist must be moved before he can move anyone else. Brangwyn is greatly moved by the wind, and he is able to suggest as an etcher even that remnant of wind that loiters between gusts among leaves and boughs, causing there so many contrary agitations that trees appear to stand erect and still while their foliage is all astir with movements that counteract one another. He is moved also by rain, and uses it boldly and well as a subordinate agent for his decorative pur-poses. I cannot remember any etching in which he has taken for his *dominant* motif the moist discomforts, the dripping miseries of a wet day, but he has got from foul weather all that he has wished to get, as in the second state or stage of "A Road in Picardy."

Anotherimpression is equally true to me: that although Brangwyn is impassioned towards great space, he rarely tries as an etcher to deepen and extend the illusion of atmospheric distance and magic. Does a flight of birds appear in any of his etched skies? If so, I don't remember it; and let me recall to your memory how invaluable is the help that etchers have obtained from an occasional use of birds. Take Paul Potter's etching "La Mazette," in which a worn-out old farm-horse gazes half-afraid at the body of a dead mare. Two crows in the sky are placed well at the right distance. Or take Claude's " Drover" once again, and note how a few birds in the serene sky, well distributed, add limpidity and varied depth to the fresh sweet air and space around and beyond the riverside trees. Yes, but we must turn to Méryon if we wish to see a really great

86

passion for birds and their flight. Examples: "The Stryge," "Under an Arch of Notre-Dame Bridge," "Le Pont Neuf," "The Gallery of Notre-Dame," "Le Pont-au-Change," where there is also a balloon suspended among some birds, and "The Ministry of Marine," where a good sky is brisk, not with birds alone, but also with other flying wonders—even sharks, horse marines, and a few other foes of the French Admiralty, which fly as buoyantly as do cumulus clouds. A desire to enhance every illusion of atmospheric space was as peremptory to Méryon as a passion for decoration is to Brangwyn Remember always that Nature is as diverse as art, which is ever as diverse as good artists become.

Have you noticed how Brangwyn is affected by clouds? Here and there he reminds me of Peter Dewint's great water-colours, where clouds are often neglected because Dewint is in love with Mother Earth; but Brangwyn's most native temper towards clouds resembles a dramatist's feeling for a scene to be done and a climax to be built up. A gentle and pellucid sky is as touching as the soft clasp of a baby's hand ; but the sky's British routine is a variable drama, and Brangwyn prefers its most noteworthy effects Once or twice, as in the tall and noble etching of "The Monument, London" (No 200, 1912, $17\frac{7}{8}$″ by 28″),[*] there's barely room enough *perhaps* for the cloud pageant. Most etchers are as timid towards clouds as the devil is said to be towards holy water. Modern exceptions—Maxime Lalanne, for example—are all most welcome, though their appeal in skyscapes has seldom a vast range. From Brangwyn at his best we receive immense moments of the sky; and I wish he would prove in an Italian landscape by the sea, with shipping and classical architecture, that the routine praise bestowed on Claude's etched Sunrise, has been more useful to print-sellers than to etchers.

II

And now we have to study a few landscapes in our first division, landscapes pure and simple, in which nothing vile is introduced by men.

1 A Road at Longpré in Picardy, No. 10, on zinc, $14\frac{2}{3}$″ by 12″, dating from 1903.

[*] This print has two states, one with sunlight flashing out from behind clouds, and one with cumulus effects.

Here is an avenue of those aspiring trees, mop-like and very tall, that French and Dutch economy cultivates; trees that meet every wind with politely elastic bows and bends, nodding their plumes like those great ladies in wonderful headgear at whom Addison poked his mellow ridicule. It is an etching in two states or stages All Brangwynians know the first state, its clouds piled in with a few happy touches, its foreground boldly ordered with massed light and shade, and the trees delicately studied with energetic pointwork At first I could not make out why such a fine avenue, with abundant space all around it, made me feel that it grew out of a flat world and that I should come to the world's brink if I went down the road and climbed those mild hills. This hilly horizon is low enough to be too low, the land occupying even less than a fourth part of the etching's height, so there's appreciably more than three parts of sky. Paul Potter used this *ficelle* in his etched Bull, and in several other prints, naive and wisely handled, which merit much more praise than they receive No doubt it is a dodge that adds greatly to the scale of things. Potter's animals appear too big to find grass enough in their neighbourhood; and though Brangwyn's avenue soars grandly into a void full of air and hinted cloud, my own liking for very low horizons remains imperfect
A few technical details Every tree and its foliage are lightly massed and well aired, their pointwork is cross-hatched with lines that curve and disappear, except in a place or so, where no crossed lines add substance and tone On the tree-trunks, and the road's sunny part, as well as on a field, texture is suggested by a spray of dots—an effective scattered grain; and it reminds me that Vandyke in several etched portraits—the beautiful one of himself, for instance, and the Justus Sustermans, and the Josse de Momper—employs sparingly in flesh technique a fine dust of graining dots. For landscape texture in large etchings, even foul biting is often useful, and Brangwyn has employed it in several plates Heavy shadows run in a billow across the foreground, they are made with deep horizontal lines that flow curvingly; and their mass of dark tone gives body and solidity to the foreground.
Only two proofs were printed of this Picardy Avenue in its second state, which gives a deep and powerful impression of a thorough rainstorm. Under gathered clouds the whole landscape has darkened, and Brangwyn is at home in a mood that he likes better than the linear peace of his earlier version

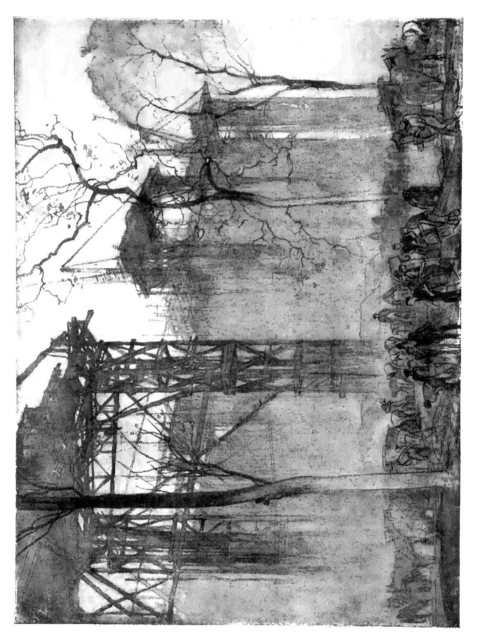

"BUILDING THE NEW KENSINGTON

2. Trees in Snow at Mortlake, on copper, No. 24, $3\frac{1}{2}''$ by $4\frac{1}{4}''$, dating from 1904. Etched out of doors.

As a fact, the trees are not in snow, for a gale has freed them from their white burden; they stand out as a dark plot against the upper sky and above a snow-laden road and bank. An effective little winter scene, done in a vein of woodcutting, decorative, and with a peculiar hush—the hush that snow enshrouds us with—even in cities among modernized traffic. Nature drapes herself with silence whenever snow falls, as we do in the presence of that completed sleep named Death.

3 A Storm near Craven Cottage, Fulham, No. 29, on zinc, $18\frac{3}{4}''$ by $18''$, 1904. Etched on the spot, then restudied at home.

We have seen this bluff and boisterous etching (p. 71), but now I note two points more: first, a telling contrast between driving rain and rising cloud, next, another low horizon, above all on our right-hand side, where, at the plate's edge, not a fifth part of the etching's height is occupied by land; and since the sombre trees at their highest nearly touch the plate's top edge, as in the Picardy Avenue, this low horizon is noticeable, though ably masked on our left by a bushy bank in strong light and shade.

4 Maple Tree, Barnard Castle, No. 55, on copper, $14\frac{1}{2}''$ by $10\frac{5}{8}''$, 1905 Etched out of doors

Beyond this maple tree, the jolly old bridge is seen in its own plane, and sky is felt here and there between the foliage. All else is land and maple tree, simple, broad, Brangwynian, though some leaves— those which sunlight picks out—are detailed almost with Ruskin's precision.

5. Cornfield at Montreuil-sur-Mer, on zinc, No 104, $14''$ by $8\frac{3}{4}''$, 1907

A true note from Nature, with a mystery that is full of the harvest season abroad. A barrier of mop-like trees, seen in vanishing perspective, screens the harvest from keen winds that winnow, and gives acreage to the cornfield.

6. The River Lot at St Cirq-la-Popie, on zinc, No 159, $10''$ by $8''$, 1910. Etched from Nature, like two other studies on the same river, Nos. 171 and 179.

This most fascinating townlet is a few miles west of Figeac; it is

built on a rock on the river's left bank. Brangwyn has done much fine work there, and this broad, delicate sketch of pure landscape, with nearish trees and water, its distant heights, and its hospitable French air and thrift, shows how refreshing etched *croquis* can be when an artist is so occupied with Mother Earth that he cannot coquet with that sweet technique over which many writers on prints talk profusely.

7. The River Lot Again, on zinc, No. 171, 9⅜″ by 8″, 1910

Serene, unclouded, airy, and a most pleasing distance with a village on the height I am not sure that ten or twelve very slim young poplars, beyond the water, have roots that grip firmly, but they have a poetry of their own, seeming to stand on tiptoe to watch, as dark and alert sentinels, over a day of thorough tranquillity Most other British etchers would have put into this happy sketch an effeminate mood, like that which finds its way also into some of Tagore's poetry on Nature and on Mother Earth. Nature is too lusty for any human mind seriously to woo her with soft little caressing ways and moods The river Lot has its floods and its valley has fitful harvests; its days of peace are but moments in the eternity of that grand tussle for existence which pits tree against tree and grasses against grasses, in weather fair and foul; and so I like the bold touch with which Brangwyn shows tenderness on a gentle day. His mood, in every one of his pure landscape etchings, has nothing like Tagore's Nature-worship: "I have seen your tender face and I love your mournful dust, Mother Earth . . . I will worship you with labour . . . I will pour my songs into your mute heart, and my love into your love." Brangwyn has felt too many storms at sea and too much dire havoc in Messina after the earthquake, ever to coo over Mother Earth His mood in landscape art is akin to the mood with which Abraham Lincoln encountered all peremptory needs of a necessary civil war: "I am not bound to win but I am bound to be true. I am not bound to succeed, but I am bound to live up to the light I have." Brangwyn has always in full force what the French call "le sentiment des masses, pas un détail superflu"; only his orchestration of this fine sentiment seems at times to be too emphatic.

From our second division
—wayside jottings, travel
sketches and matured
impressions— I choose
some typical etchings.

1. Assisi, on zinc, 15½″
by 12″, No. 17.

This print was exhibited
in 1903, at the Rowland
Club in Clifford's Inn,
with the second version
of London Bridge and
the Picardian Avenue.
It was clear at once that
a new etcher had come
with a vision hitherto
unknown, and also with
the beginnings of a
technical equipment so
much bolder than custom
idolised that it would be
to delicate writers on
prints what a route
march in rainy days has
ever been to timid and
dainty recruits.

A Frenchman expressed very well the revolution in etching foretold
by Brangwyn's work between 1903 and 1906. The difference
between this work and other British etchings, he said, is as
marked as the difference between François Millet and Léopold Robert;
the latter is full of good intentions; the other is full of thorough
rustic life and character: and most British etchers by Brangwyn's side,
however desirable in their own ways, look rather small and out of
place. These things happen when genius competes against charm-
ing talents, for genius troubles the ease of a great many excellent
persons. The "Assisi" is more than enough to trouble any etcher
who attends to his work with as much deliberation and ceremony as
a fashionable photographer. A difficult, manifold motif—historic

architecture amid brilliant sunlight, with fine trees and a landscape nobly orchestrated by intense light and shade—is treated with vehement joy as a bit of practice in experimental technique and printing. Most English etchers, when they make love to such a motif, seem to dress themselves in velvet and lace, in order to remember that "exquisiteness," sometimes called "noble daintiness," is the quality in prints that receives the largest measure of routine praise—and pelf. Well, there's nothing dainty in the Assisi. Every part of this etching is an adventure The architecture is effective, for it stands out in lusty chiaroscuro against a sky toned by printing , but yet it is only a distant forerunner of Brangwyn's later visions as a lover of great buildings There is abundant study in the tree-trunks and their boughs and foliage, only in *some* impressions—I have one, an early and rare impression—the deep tones in masses run together overmuch into one mass, losing their graduated sequence of plane and purpose, and shadowed portions of the buildings look unaired and unwarmed by reflected light and the sun's vibrating shimmer. Other impressions, including those with dry-point revision over the sky, are more aerial; and the printing in all proofs that I have seen, various always, has been alive and original.

2. A Turkish Cemetery at Scutari. $18\frac{3}{4}''$ by $17\frac{1}{5}''$, No. 31, 1904.

In its trial state—but only three impressions were printed—this fine sketch is in outline Then the plate was rehandled and rebitten, and one may expect to see few better records of an artist's travels, so ably are the figures distributed in their proper planes; and a true sentiment puts mystery among the cypress trees and around and in the cemetery. I call it a sketch because it is pictorial in a way that suits a fortunate sketch, with those happy accidents that come to æsthetic emotion, and with that lack of "finish" that has the value of a genuine impromptu Other ardent impressions in a kindred mood are two important Turks dallying with postponed business amid the hot shade under pleasant trees (No. 137, $16\frac{3}{4}''$ by $12\frac{3}{4}''$, 1908), and the Normanesque "Castello della Ziza at Palermo" (No. 30, $19''$ by $18''$, 1904), most valuable as architecture, and as a Brangwyn study, always free from those qualities that photographs give with detailed uniformity. A blend of Moorish elegance with the usual blunt massiveness of Norman building is well suggested; a few shades are overstressed in some impressions, between the shadowed foreground, with its musicians, and the castle, a Sicilian festival is busy, a few lines and plots of tone suggesting a rustic dance that whirls.

3. A Road at Montreuil-sur-Mer, No. 34, on zinc, $13\frac{9}{10}''$ by $10\frac{9}{10}''$, 1904. Etched on the spot from Nature, like "Mill Wheels, Montreuil" (No. 35).

I choose this proof at random from etched *croquis* and other good work that Brangwyn has done at Montreuil, often out of doors, as in 1904 and 1907. It is a jolly sketch, despite the low horizon, and we follow its road into the happy moods that Brangwyn has had at this most pleasant hillside townlet, now nearly ten miles from the sea. "The Mill Bridge at Montreuil" (No. 33) is one sketch to be noted, and "The Gate of a Farm" (No. 90), an outdoor study, is another, but not quite so good in tone and charm as "A Haywain" (No 97), or the deeply considered "Paper Mill" (No. 93), etched on the spot, to which we shall return in the chapter on Industry and Labour.

4. The Butcher's Shop, Wormwood Scrubbs, No 46, on zinc, $19\frac{5}{8}''$ by $18\frac{3}{4}''$, 1904.

Here is the most impressive etching in Brangwyn's greater landscapes, and only in Méryon do we find work so matter-of-fact and yet so eerie and haunting. In 1910 I tried to put into words the impression made by those two vast old trees and their uncanny lighting, by the butcher who waits for we know not what, while curious figures behind peer out from a mysterious timber cabin I wonder how Méryon would have been moved by this exceptional work; and also if he would have felt a somewhat akin to himself in two or three other Brangwyns Houses at Barnard Castle (No. 53), for example, and the deep, austere Porte de Gand at Bruges (No. 63), etched on the spot in 1906. And I am sure that Méryon would have liked to dream over that mysterious etching where men at night, aided somewhat by the local glare of a lantern, unload great barrels of wine from a ship at Venice (No. 109). Brangwyn has done nothing better than this rich study in the distribution of light and dusk, air and generous tone, unforced by any plot that is too dark or noisy.

5. A group of minor etchings at Furnes, all done on the spot in 1908, like the "Market Place" (No. 126) and "A Gateway" (No. 127). They connect the popular life in street, market and café, with the churches of St. Walburge and St. Nicholas. "The Apse of St. Walburge" (No 120, $17''$ by $15''$) like "The Church of St

Walburge" (No. 124), is among the more typical Brangwyns; it is peopled with most pleasant life, and abundantly toned and designed

6. A group of fine etchings at St Cirq-la-Popie, all done between 1910 and 1912 They were etched from Nature.

Humorous sketching frolics in "The Mountebank" and "The Bear-Leaders" (Nos 176 and 177), which are as good as two other swift *croquis*, made in France and out of doors, "A Caravan at Albi" (No 169) and "A Farmer at Laroque" (No. 164), with its charming distance of climbing heights dappled here and there with trees and houses There is so much body and vim in these wayfaring notes that they form a *genre* apart, as do Daumier's wit and the peculiar epic poem that Gavarni drew from townsfolk with his inimitable feeling for the heroic whimsies of mankind Brangwyn has not done enough yet in the manner of his Mountebank and his Bear-Leaders. Laughter in etching, witty observation and satire, with good humour, are as welcome as they are uncommon. The mountebank's antic posture is a genuine "find," and the bears are well observed, though sketched with unusual swiftness. Let us welcome also, as examples of rapid sketching from Nature, "The Village Green of St. Cirq" (No 165), "A Village Shop" (No. 183), and "A Street at St. Cirq" (No. 198), connecting them with such notes of hand as "A Café at Cahors" (No. 174), "A Beggar Musician, London" (No 187), and "The River Lot at Vers" (No 179).

As for the greater etchings from the neighbourhood of St Cirq, let me name three, beginning with some "Old Houses at St. Cirq" (No. 160, 10¾" by 14¼") What a discovery of secluded architecture ! Note the high walls, with a shuttered window here and there, as if masonry were cheaper than window-panes. Yet there's true hospitality in that light fantastic balcony suspended below shallow eaves, where wind cannot find room enough to make much noise "On the Road to Figeac" (No. 161), the companion plate, is as desirable. A quaint little hamlet finds refuge below a huge rock, whose age and weight are made real to us with freedom and a dominant ease Equally good is a larger print, "A Cliff

Village at St Cirq" (No. 162), with stalwart trees, and a picturesque raised pathway, and a majestic rock, strata after strata, towering above those frail homes ! Romantic France, sometimes her own sweet enemy, is everyone's friend in the varied magic of her country scenes. Brangwyn understands her, and pretty often he has modified his art to please her, as in his war posters.

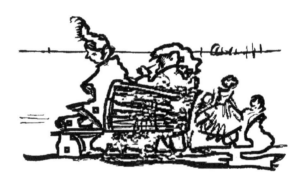

CHAPTER VI ETCHINGS · WINDMILLS AND WATERMILLS

It education were rational and national, if it were not botched by routine-mongers, children would be taught how to read history in the common useful things that they see all day long There is a delightful tale, as merry as Peter Pan, in the evolution of every piece of household furniture, from chairs and tables to beds and wardrobes ; and every room has another tale charmed with centuries of home. If children knew all the bewitching stories that could and should be told about these good old things, and about many other mute historians, they would be educated as naturally as they grow; everything around them would help to make the past present and the distant near; they would feel that the generations dead and gone ought to be always of their company. I know men who are thorough scholars in so far as books and cobwebs of the study can give and embellish learning, yet they know nothing at all about the evolution of handicrafts and architecture One of them asked me to explain the difference between Gothic and Classic architecture, and to give him an example of each in London He asked for this information as if such details, as a rule, were below the aspirations of a bookman deeply versed in Greek and Latin And we are all quite ignorant of many precious enjoyments which ought to have been opened to us between our nursery years and our early teens.

Windmills and watermills are among the many unread phases of social history that retain the past ages, here and there, in modernized towns and landscapes; retain the past ages, and at the same time enrich life and the arts in two different ways, by their own diversified charm, and by many rich associations that we gather partly from them, partly from their history, and then add to the great paintings and prints that do justice to fine old buildings. Most of us are overapt to forget how variously the memories and the hearts of mankind enrich great art from their stores of recollections and associations Just as the voices of larks and nightingales are forever beautified by the rapt praise of poets, to those who recall this praise

96

verse by verse after the birds have sung, so every great picture inspired by things seen receives from a great many minds emotions that do not belong to its art, emotions emanating from studies or from personal experiences or from both. A great landscape in art is a landscape no more when we add to its magic as art many sorrows and joys that blend our past years with its permanence, and I note also another point in the spiritual intercourse between artists and the generations. When George Eliot says that differences of taste break 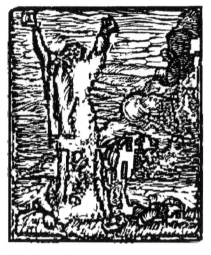 many a friendship, she forgets to add that these antagonisms come often—not from rivalries between opposed temperaments and æsthetic feelings, but—from happenings of a private and personal sort which have given a bias to a mind's higher faculties. If as a boy you had been nearly drowned in a mill race, you would not be drawn by pleasure towards pictures of watermills, for instance, because memories of your fight for life against water hurrying to the wheel would tyrannize over the artist's intention, causing you to muddle a picture's presence by thinking of an unpleasant episode in your own past.

Brangwyn must be fonder of windmills than of watermills, as he etches them with a much more attractive power and persuasion. No incident in his life comes between him and them, as an influence that alienates him from their historical shapes and romances. Perhaps he feels that most rivers are but make-believe in comparison with the sea and what he has experienced at sea under western and eastern skies and storms, and certainly he is greatly moved by the downright way in which windmills reach up to catch their motive-power, however keen a gale may be. Even his old ships, like the "Duncan" and "Britannia," are not felt with a truer and more affectionate touch than he gives to every part of a windmill, and above all to intricate vanes, which few artists have put in with the right suggestive blend of detailed fact and entertaining mystery.

Again, who can be blind to the humanity that windmills display

o

during their toil? They chatter, and they bicker, they grumble, they growl, they lose their temper; and there are days of easy wind when they seem to be entirely pleased with themselves, like trade unionists who have gratified their devout belief in limiting their output as much as they can. Indeed, the history of windmills has been stored with a trade-unionism of its own, for men of science have estimated that a windmill on duty all the year through, for 365 days, would do only 120 days of hard work, owing to the wind's holiday making and variableness. And let me give in brief a few facts more that help us to unite Brangwyn's windmills, and every windmill in art, with history.

Not one of Brangwyn's few windmills has a type that is regarded as typically mediæval, though windmills, like wheelbarrows, have changed but little during their long history. Viollet-le-Duc describes the mediæval windmill as a round tower with a conical roof and with four vanes and sails. Ruysdael's breezy picture at Amsterdam, known as "The Rhine near Wijk-By-Duurstede," has a round tower that is very high, and a coned roof that is low, and a timber gallery encircles the stone tower about half-way up. A tall doorway is entered from this gallery. Only one window is seen, but a fringe of arrow-slits for ventilation, if not once for defence as well, is placed on the topmost floor. Brangwyn's "Windmill at Dixmuden" (No. 123, on zinc, 29⅝″ by 21⅞″), has a circular ground-plan, but with a strong octagonal feeling in it, and its roofing is a peculiar sort of patched beehive into which a Gothic liking for gables has found its way somehow. Its vanes, too, seem to be more complex than those in Ruysdael's mill, and a finer architectural taste has embellished the tower with purposeful ideas Low Flemish cottages, tiled and white-washed, are close to this windmill, and a swineherd with his drove, after passing the mill on our right, enters the shaded part of a lively foreground. This etching is among the most pictorial that Brangwyn has published. Its windy sky is a painter's sky, and its manner throughout is so fat and fluent, so rich and ample, that it is almost succulent, although careful pointwork all over the windmill is expressive.

Some persons believe that round windmills were never a general vogue among Englishmen, as they seem to have been in mediæval Holland and France, because of the old English fondness for gabled timber buildings. Such a gabled windmill is represented in a very famous manuscript of the fourteenth century, the Romance

98

of Alexander, in our Bodleian Library, where we find also a magnificent watermill with a Double M roof, four decorated windows like those in church architecture, and three waterwheels following each other, all undershot I know nothing to warrant the assumption that our mediæval mills, whether driven by water or by wind, belonged usually to local styles of domestic architecture that our ancestors loved Mills and their owners were not at all popular, and very often they were hated—and hated with sufficient reason too. No mill could be established without licence from the Crown, and, whether it was owned by a manor or by a monastery, it was a symbol of despotic power, everybody in its neighbourhood had to use it as an obligation Mills, then, were very valuable property with oppressive customs and rights. In many cases they seem to have been attached to manors, and to have been transferred along with manors; and by this means, many a time, they seem to have passed from laymen to monks Often they were granted by the Crown to monasteries, and often they belonged to lords of manors and to the Crown Some English watermills occupied the same sites from Saxon days to modern times, like the castle-mill and the king's-mill at Oxford, which are mentioned in Domesday survey, at which period also a mill at Dover was driven by the sea's flux and reflux. But the main point is that mediæval mills were imperious monopolies, and connected daily bread with much popular bitterness.*

Often among the French these monopolies were upheld sternly, defaulters losing their corn and their carts and horses; so it is not surprising to learn that many French watermills were placed for security on eyots, or at the end of bridges easy to defend, and that they were often fortified, above all in Guienne, when our own forefathers ruled over this French province. A watermill here and there resisted long attacks, like the King's-mill at Carcassonne, which in 1240 held at bay a biggish force commanded by Trencavel. Some

* Thorold Rogers gives some useful facts "The most important lay tenant of a manor was the miller Every parish had its watermill—sometimes more than one, if there were a stream to turn the wheel—or a windmill, if there were no water. The mill was the lord's franchise, and the use of the manor mill was an obligation on the tenants The lord, therefore, repaired the mill, the wheels, or the sails, and found—often a most costly purchase—the mill-stones. Sometimes the homage at the court baron supervises the contract with the local carpenter for the labour needed in constructing the mill wheel, sometimes the jury of the court leet prosecutes the miller for using a false measure and for taking excessive toll The miller figures in the legends and ballads of the time as the opulent villager, who is keen after his gains, and not over honest in the collection of them."—*Six Centuries of Work and Wages*, chapter I

fortified watermills were noble buildings, as Léo Drouyn shows in his most excellent book *La Guienne Militaire*. And among Englishmen also mills provoked much social unrest, as during the fourteenth century, when useful handmills were invented as a protest against despotic watermills and windmills, and when monks and other millowners opposed the innovation with stern selfishness But the people clung to their rightful purpose, declaring their will to use handmills without trouble from persecution; and time's mockery has laughed at the monks who wished to force their mills upon a nation or archers and sportsmen. At Fountain's Abbey, Yorkshire, for example, an old abbey watermill outlived its owner hundreds of years, for it existed in 1850, and part of it was as old as the reign of Henry the Third. One of Brangwyn's watermills — etched out of doors—recalls to mind those militant days when millers liked to be quite sure that they and their mills were safe against attack. It is a Méryonlike etching called "The Mill Wheels at Montreuil-sur-Mer," where one wheel is not seen, as it is carefully boxed over. This enclosed wheel seems to be a descendant from the mediæval custom of hiding wheels away from stone-throwing weapons like mangonels and from raids by boat down-stream. At Melun, for example, a thirteenth-century waterwheel was built between two great pointed cutwaters upon which turret piers were built, then united by an arch; and I like much to think of these matters when I look at Brangwyn's etching, with its agitated water and its hidden wheel.

Montreuil watermill appears also in another etching (No. 33, 14″ by 14⅞″), but here a timber footbridge is the main motif

Many writers believe that the idea of building windmills came from the East with returning Crusaders, and it is certain that Norman windmills have been known always as *Turquois*. This popular nickname appears in a document of 1408, and is still in use, I believe Yet the windmill's origin remains obscure, a subject for useful discussion. Some time in the twelfth century windmills appeared in France and England, and as early as our third Henry's reign they were

used for various purposes. In 1251 three windmills were ordered to be built in the park at Guildford, one for hard corn, another for malt, and a third for fulling, just as the Dutch of to-day use windmills for irrigation and also for draining swamps Yet few persons regret the disappearance of windmills from our landscapes. Progress murders so many great old things that life is as new and as noisy as a growling aeroplane Let us be just a little old-fashioned, then many permanent mills in art will be surrounded by what we can learn about the romantic history through which mills of all sorts have passed in Europe.

Rembrandt's etched windmill, a beautiful synthetic drawing, is an idler, a windmill in the doldrums, hallowed with history For a long time it was regarded as Rembrandt's birthplace, as a small rustic cottage adjoins the mill; but modern research has proved, as in the work of Rammelman Elsevier, that the windmill run by Rembrandt's father was situated on a salient of the rampart in the town of Leyden itself, quite near to the White Gate (Witteport), that it was *un moulin à drèche* (or mill for malting) *sur un des bras du Rhin;* and that a drawing made by Bisschop in 1660 represents this windmill. Nearly two centuries later, in 1853, Bisschop's drawing was etched by Cornet, keeper of the museum at Leyden; and another etching of the drawing was published by Charles Blanc in the first volume of his *Œuvre complet de Rembrandt.** Yet truth can be very dull. Lucky were the good people who preceded the discovery of Bisschop's drawing, for they added to Rembrandt's etching their belief that they knew the home of their Master's childhood

A windmill in art, however fine as a line etching or as a painting, does not attract me fully unless I am made to feel around it the pressure of wind and the spacious firmament of air. Rembrandt's etching brings a charming old windmill too near to us; it needs the concordant and seductive romance with which his oil-painting of a windmill is environed and saturated Brangwyn has no idler among his few windmills, and he turns their poetry into epics Here is the Black Windmill at Winchelsea (No. 135), toned and glorified by sunset during a fine harvest season, with two groups of tired

* This etching is most interesting Imagine a round hut with a cone-shaped roof, cut off the top of this cone, then build upon it a tall wooden structure with a gabled roof add four great vanes and their sails, and you have the Rembrandt windmill on the ramparts. The tower portion, though circular, is patterned into many angles, how many I cannot see, but more than an octagon, I believe.

harvesters plodding across a pleasant foreground towards wooden rails on our right, which climb picturesquely up the mound to the great mill. On our left, beyond the semicircular mound, is a distant view of Winchelsea Flats, with a cornfield in cocks. A boy climbs the mound, his body standing up sharp against the sky. Boys will be boys, of course, but this lad is a trespasser in art, and I should like to see him displaced by a flock of homing birds, whose presence at different planes of the sky would increase the vast depth of space very finely suggested by a radiating sunset with clouds enough to keep us very near to a fanning wind. As for the windmill itself, we see it in a side view, with three of its great vanes, and the radiance of sunset is all around its bulk, causing it to look almost spectral, almost translucent.*

A much finer windmill, architecturally, with a smaller one, appears in "Windmills at Bruges" (No 70, 20⅞" by 18⅞"). It was etched on the spot in 1906, two years before the Black Windmill at Winchelsea It stands on a hillock, its whole bulk cut out against a sky thronged with thunder clouds But a gleam of sun breaks through these clouds and illumines one side of the mill, casting two bands of shadow from a massive vane across old timber, which is handled with Brangwyn's keen sympathy for weatherbeaten wood Here is a mill of uncommon height, and its upper part or storey, just a little overhung on corbels, forms a most attractive Mansard roof—a hipped curb roof having on all sides two slopes, the lower one being steeper than the upper one. As François Mansard or Mansart died in 1662, we may assume that this mill may be not much later than his time The mill rests not on the ground but on triangular supports which seem to be somewhat more than a foot in width; so a considerable space under the mill can be used for storage. High up on the first floor is an entrance, flanked on our left side by a suspended lean-to, and connected with the ground by a fixed ladder, which tapers upwards from a wide base At one spot, about half-way up, this rustic ladder must be rather difficult to mount with a sack of corn on one's back, for a curving beam passes through it from the hollow under the mill to a narrow trestle at the ladder's foot, where the beam is held up also by two posts fixed against it slantingly. There is a shuttered window above the entrance door, and another opening in a gabled

* The poet Verhaeren was very much impressed by this etching "Here is the fantastic Black Mill," he wrote, "ruling over plains and the heather; clouds seem to make signs to it afar off through space "

end has above it a rough sort of hood or canopy to act as an umbrella against beating rains. On our right, passing over the hillock's brow, a miller's wain turns its back upon us; and on our left, beyond the ladder, a smaller windmill throws up its arms and catches wind and sunlight.

A windmill similar in type, but perched up high on slanting posts, was etched by Brangwyn at Furnes in 1908 (No. 133, 15″ by 12′). Its lower part is mostly hidden by a very rustic piggery, roofed by tiles and creeping plants; and a man with a small pig in his arms has passed through the gate and crosses a lane to a rough shanty on our right.

I have to speak of only one mill more, a jolly old watermill at Brentford, a fine timber building that progress has devoured since 1904, when Brangwyn etched it out of doors on a zinc plate twelve inches square. It is a lively etching—and scarce, for only fifteen proofs have been published, and its metal plate is destroyed, like the watermill.

etween 1901 and 1904 Brangwyn put the name of London Bridge on three etchings, all different from that well-known pastel which shows two arches of Rennie's bridge, rising behind a wide and deep foreground occupied by interlocked barges and merry boys bathing I am not very fond of New London Bridge, she is too small to be in scale with our prodigious city, so I am pleased when only two of her arches are sketched in a background. But Brangwyn, I think, in his first etched version of London Bridge, is just a little too ironical towards George Rennie, who designed this bridge, and Sir John Rennie, who watched over the work and brought it to completion by 1831. Not a single arch, nor even half an arch, is distinctly visible, because a tramp steamer, anchored in the middle distance, is deemed preferable, and she *is* entertaining, with her pleasant lines and her wreathing smoke. This etching was drawn on copper, and is nearly square (11¾″ by 11½″). Its motif is that part of our riverside which, seen from below bridge, looks towards Cannon Street Station and St. Paul's Fishmongers' Hall, with its lethargic masonry, another episode of 1831, is in the middle plane of a busy composition, it has nothing concordant with the vast gray antiquity of our mysterious Thames, which needs from architects a massive grandeur* in design like that which Roman architects put into Vespasian's amphitheatre, the Coliseum, and into many a wondrous bridge, like the mighty and magnificent Puente Trajan over the Tagus, at Alcántara, erected by Caius Julius Lacer. As a rule our countrymen have no lofty feeling for

* Lord Morley has published some excellent remarks on the quality of grandeur (*On Compromise*, pp. 10–11)· "There is a certain quality attaching alike to thought and expression and action, for which we may borrow the name of grandeur It has been noticed, for instance, that Bacon strikes and impresses us, not merely by the substantial merit of what he achieved, but still more by a certain greatness of scheme and conception This quality is not a mere idle decoration It is not a theatrical artifice of mask or buskin, to impose upon us unreal impressions of height and dignity. The added greatness is real Height of aim and nobility of expression are true forces. They grow to be an obligation upon us A lofty sense of personal worth is one of the surest elements of greatness. That the lion should love to masquerade in the ass's skin is not modesty and reserve, but imbecility and degradation. And that England should wrap herself in the robe of small causes and mean reasons is the more deplorable, because here is no nation in the world the substantial elements of whose power are so majestic and imperial as our own. . . ."

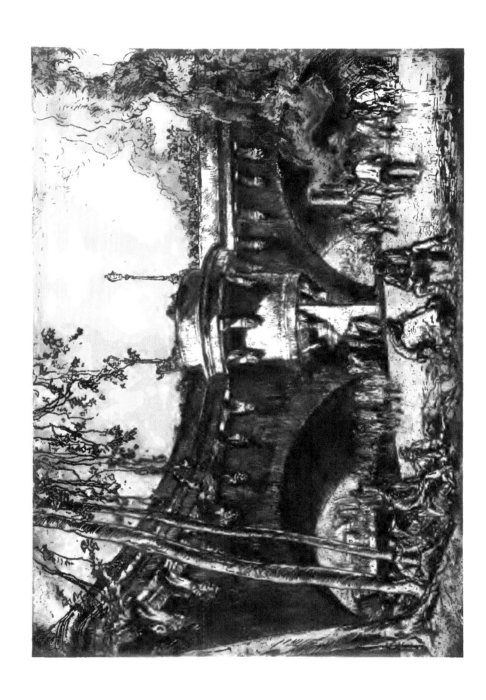

heroic scale, except in the wandering haphazard of their colonization. Must we believe that our natural fondness for cant and compromise strikes with atrophy that right and high sense of personal worth which candour nourishes and imagination fires with ardour ? Fishmongers' Hall, indeed ! and Rennie's mild bridge, which in less than fifty years was advertised in Parliament as too narrow for our city's traffic ! It's a terrible thing when a great nation prides herself not only on cant, but also on being pre-eminently practical, superlatively businesslike, or as rational as a chartered accountant. Her imagination falls asleep, she fears audacious dignity, and tries to achieve greatness by creeping into it little by little, as she creeps into a big war. Not one of our London bridges represents our city's magnitude as the Pont du Gard represents the fearless and massive enterprise of ancient Roman

Still, we have Fishmongers' Hall and New London Bridge, and the Hall is well placed in Brangwyn's etching We see not too much of it; and some tall warehouses on our left, and that huge crane stretched out from one of them to a diligent steamer, are more typical by far of riverside energy and purpose, qualities which the etching shows also in a foreground simple and effective as design and abundantly suggestive of those oddments that gather about quays and attract sympathy as emblems of hard toil.

At first this etching was an outline only, or nearly so, only a little shade was put in sparingly here and there; and its pointwork being lightly bitten, the printing was grayish and restful, and many hinted matters of fact—row after row of windows, all alike, for instance— remained mute This stage or state I like very much ; it mingles quietness with briskness ; but Brangwyn was not yet satisfied, and only six proofs were taken from his copper. Then change after change came; with much rebiting, until a lively and desirable sketch retreated under massed light and shade. This painterly effect was not a brilliant success. The steamer grew darker, her smoke more abundant and coalish ; a murky opaque sky shut up the distance beyond Fishmongers' Hall, and overmuch emphasis appeared elsewhere. Only one proof was taken of this laboured state, it belongs to Mr. A T Gledhill, so the official Catalogue tells me.

In its third state this etching lost its name and much of its copper, becoming Fishmongers' Hall (No 50, 5″ by 7⅜″). Under this name it was published as a gift in the "The Acorn," a quarterly review belonging to the Caradoc Press. To-day, says the Catalogue, "there

are in the market a fair number of unsigned and inferior prints of this subject. Later the plate was bought back, retouched, and issued in a limited edition"—fifty proofs in all, and noteworthy.

A partial failure ends one venture and begins another so Brangwyn made a second attack on his motif, not in a skirmishing mood, but with that fine temper which Wellington described as hard pounding. The first venture was a reconnaissance only, and it uncovered some very stiff problems Our Thames atmosphere, with its frequent magic of smoke and mist, makes a painter happy and an etcher ill at ease ; and when to this blurred atmosphere we add the mystery of line in riverside houses, barges, and shipping, we come face to face with an amalgam of difficulties outside the ordinary scope of etching Méryon was aided by the neater and sharper atmosphere of the Seine, which amused the delicate vigour of his persuasive and decisive touch; while Brangwyn has been troubled somewhat by the Thames, whose magic has appealed perhaps overmuch to the painter in his etched work. Though his second attack on the motif named London Bridge achieved much more than the first, it is not to me a victory all along the line, it strikes me as being a drawn battle between his intention and his tools.

Setting aside a trial proof in outline, this etching is known in three states, printed from copper measuring $21\frac{1}{6}''$ by $16\frac{3}{4}''$ We see, then, that in order to encounter his motif on terms as even as he could choose, our artist greatly increased the size of his plate, though eleven inches square could not be deemed a poor battlefield. Important changes appear, the whole motif being reviewed and recast. The steamer has put on a bolder look, and another shows her funnel plainly; we see an abutment of our bridge, with part of an arch; and in the middle distance more attention is given to riverside business and much less to riverside architecture Indeed, the warehouses have almost disappeared, and that huge crane is lifted up towards the roof, becoming a minor thing now in a design full of smoking business; and Fishmongers' Hall, more carefully studied, forms with the bridge an extended plot of sunned light, foiled by shadow over

the glimpse of warehouses and across the middle distance. A sluggish cumulus cloud trails from behind the Hall and upwards, billowing until it seems almost to blend with much varied coal smoke belched from both steamers. Massive girders run across the foreground where eight or nine workmen take their ease and talk cosily as democrats with votes.

It is said that this etching has four states, but a single trial proof is really a test, not a state, except to printsellers, whose minds bask among mysteries. To me, then, "London Bridge No. 2" has three states, each with points of its own. There is much in the first state that I like best, it retains many qualities of a good sketch, and the motif seems not grand enough for elaborated light and shade Aquatint graining and foul biting play their parts well along the foreground of later states, but yet I prefer the hinted foreground in the first stage, with its light aquatint texture

Still, by means of technical experiments, Brangwyn gained much control over his tools This fact is very noticeable in London Bridge No. 3, etched on copper like its forerunners, it measures 21″ by 16″, and has no history of states. We are in a wharf below bridge, and most of the foreground is an orderly disorder of barrels, all suggested with first-rate skill A cluster of barrels, grappled by thin chains to a suspended chain cable, has begun to rise, and beyond it is an empty barge lying close to a great warehouse, an apt and attractive building because it looks fit for its purpose. Boats are moored against a landing platform, and beyond these boats, high up on our right, we see Fishmongers' Hall again, and a glimpse of Rennie's bridge.

Here is a thorough Brangwyn, resonant, opulent, masterful; and it has certain qualities also that are controversial, qualities that come to those artists who prefer a decorative synthesis to any display in receding planes of meticulous perspective When these certain qualities appear in etching, they are apt to show themselves as plots of uniformity in an orchestration that rules over relative values and the distribution of light, shade, and half-tone But yet I must speak on this point with sufficient explanation.

Decorative work ought to displace at least seventy-five per cent. of

easel pictures; and I am equally sure that a big artist has a right to form a genre of his own in the management of light and shade, just as Gregory the Great had a right to introduce plain-song, or *canto fermo*, a noble kind of unisonous music. Brangwyn's etchings have plain-song qualities of their own, unisonous and massive, they remind us how alert he has ever been to the fact that painters are often called upon to find happy compromises between too little perspective, which is primitive and archaic, and too much perspective, which makes holes in our walls. A French artist writes on this matter as follows.—

"On veut que la peinture murale, noble et belle, mais circonspecte, complète avant tout l'architecture qu'elle décore. Sereine et détachée de nos préoccupations directes, elle a, dit-on, pour rôle de personnifier et de continuer, dans sa langue austère et muette, l'enseignement de la chaire ou l'idée de la loi. Elle poursuit, en le modifiant selon les sujets, le caractère auguste et impassible qu'elle a hérité des Égyptiens, des Assyriens et des Grecs, dont parfois, de nos jours, elle emprunte encore les formules. Ainsi comprise, elle est certes digne d'admiration et de respect: sa gloire a traversé les siècles, mais elle est dépendante d'un art jaloux de ses droits contre lequel elle s'est souvent révoltée pour prendre ses libertés d'allure, ne se contentant plus de célébrer des symboles et de balancer des lignes harmonieuses Elle s'est alors franchement détachée de l'Architecture, qu'elle a animée sans s'y mêler. Je ne crois pas que cette dernière y ait perdu. Car si pâle, si effacée que soit une fresque, si elle n'évite pas les ciels et les plans fuyants, elle troue les murailles et, comme Samson, ébranle l'édifice. . . "*

This is put with fairness, if we pass over the unphilosophic convention of describing the painter's art as a perennial person that plans, meditates, achieves, and rebels. Confusion of thought comes as soon as writers forget that art is what good and great artists do from age to age. It is rubbish to say that the art of painting rebels against the discipline of architecture. The rebels are painters, often minor men so full of self that they cannot see how foolish it is to turn their art into a reckless courtesan dependent on chance buyers who visit shops, exhibitions, and auctions Only five or six easel painters in a generation enjoy more than a fugitive vogue. The others as a rule waste their lives in producing baubles for an overstocked market, as if householders yearned to buy painted canvas fastened into gilt frames. Most painters would serve their country to much better purpose if they decorated homes with panels and friezes, and taught

* *Nos Peintres du Siècle*, par Jules Breton, pp. 225-26.

the people how to furnish their rooms with courageous economy and good taste More nonsense has been talked and written about easel painting than about any other artistical subject, so persons of common sense rejoice when an artist of real genius, like Brangwyn, keeps constantly before his mind what qualities decorative design can and should make real, without drifting into archaism, or into a bloodless routine, like that by which Puvis de Chavannes enfeebled his seductive conceptions, after achieving in 1859, his opulent and noble work called "La Paix" (Musée d'Amiens)

Nothing is more difficult to achieve than a wise compromise. Puvis de Chavannes, wishing to avoid overmuch perspective, turned his back not only on his natural self but also on Tintoret, Michelangelo, and other supreme masters of decoration, and then, with faint colours and a childlike ingenuousness, far-sought, and to some extent dear-bought, he tried to separate decorative art from human passion and the world's life and vigour.* As for Brangwyn, while wishing to avoid overmuch perspective, he lifts into decorative art our modernized industries, with much else from the outside welter of human realities, simply by giving what I called a plain-song orchestration to his management of values, perspective, and light and shadow. Often his compromise has a splendid allure, but yet it is easier to manage when paint or pastel is the medium. Then he and we can be happy in his original distinction as a brave and splendid colourist. Black and white being a convention by which the many-coloured magic of Nature is translated into lines and monochrome, all changes in those values that mark planes and receding space add another formalism to an art already opposed to our many-coloured world; and when this added formalism becomes very evident, a whole composition may lose the flow of a spontaneous rhythm, and may seem to be shut up and airless, like a tapestry in black and white Brangwyn has never shut up his etchings, but occasionally I see and feel that his tone and his light and shade are somewhat too

* He cut artists who questioned his later manner, never pardoning their just right to think and speak with becoming modesty and candour. With infinite pains he began by drawing his figures from the life; then he traced them, suppressing all detail Afterwards he arranged and modified his composition by ringing changes with his tracings, which he placed side by side in experimental groups and combinations until he was pleased with their balance and their ingenuous beauty and allure Very original and charming results were composed, but Puvis failed to see that his groups and their gestures were never animated by a sentiment which united them all together in an action common to all

succinct and uniform, somewhat too arbitrary towards relative values and planes *

Portaels said to me many a time. "Always verify your darkest shadows and your sparkling lights, because in all work they are likely to be overdone." What advice could be better? And one point more. When etchings are deeply bitten, then printed in an ink not so brown as Turner's, over-emphasis not only may appear here and there, it may appear unnoticed by an etcher, who is trying to gratify an emotion that needs for its complete expression the magic of paint or pastel. Rembrandt, who etched often as a painter paints, sometimes carried his light and shade—and particularly his shade and his depth of local tint—into monochrome painting with an etching needle, and what the greatest do with zest is not a thing for you or me to question, unless a too emphatic shadow or plot of deep tone invites criticism, not unlike a mistake in grammar made by a great writer. As a chess-player often loses a game by thinking too much of his own attack, so an artist's research along one line, when too ardent, leads to errors in other considerations.

In Brangwyn's etching of "Brentford Bridge," another early print, we may watch a combat between his mood as a decorative painter and another mood aroused in his mind by the fact that he is at work with a point on the ground covering a zinc plate His motif is a simple bridge of one arch, a cluster of houses fit to be honoured by good sketching, and a foreground with barges and a few figures, all in shade. In a study of this sort, blending the urban and urbane picturesque with commercial toil, one has no wish to feel that a sky and its technique are anything more than hinted, a distance left vague—and alluring because of its vagueness. But Brangwyn had observed a sudden effect of sunlight on an overcast day, and his sky even in his trial proofs had a tone which, I believe, invited too much attention. This tone was deepened into threatening clouds, and the foreground also was intensified, while a brilliant light shone with

* I am speaking, of course, of the impressions which I have studied, but the impressions vary much, as Henri Marcel points out, and no student can see all of them Brangwyn never fails to store his shadows with enough animating detail, but in some impressions defective printing harms the etched workmanship When a dark plot in natural chiaroscuro is side by side with a sunny and glowing plot, all detail in the brightness appears to be eaten up by the sun's radiance, while abundant veiled detail remains among the shaded parts, unless a shade marks a hole For this reason Brangwyn studies every shadow that he etches, and as a rule, whenever it seems too dark, something has gone wrong with the printing

concentrated warmth on Brentford Bridge and to less extent on the houses. As an exercise it is well worth while thus to play with dangers which few etchers would seek. Still, what appeals to me most of all is precisely that portion which is least sought after—Brentford Bridge and the experimental way in which the houses are resolved into an epitome of their own character. An alembicating touch is a rare thing among architectural etchers;* and as for research among problems of light and shade, its value depends, I suggest, not alone on an effect observed, but also on two other things—imaginative feeling in a true artist, and the charm added by an apt effect to the appeal that a chosen motif possesses at all times, let the light and shade be either prosaic or epic. For the idea put into action by so many modernists, that purpose and effect deserve more attention than artistic pride and judgment in the choice of motifs, tends to banish from art the difficulties of selection, and to lower its devotees to acquired tastes very apt to go out of vogue.

Brangwyn's light and shade are often musical with varied imagina-

* We find it in Cotman, as in Prout's pencil drawings of Gothic architecture.

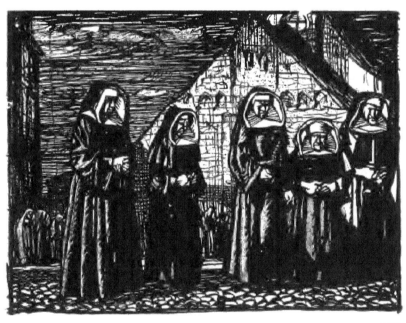

tion, and it is only here and there that he dwells too long on a motif that has not enough in it to justify more work than a sketch needs. In "Brentford Bridge," as in several other early etchings, he is occupied more with a complicated effect than with its æsthetic value, unless I misjudge his versatility here ; and I give my opinion because a big man's work is likely to attract young students as much by its occasional errors as by its usual merits

"Old Kew Bridge" (No. 51, 15¼" by 13"), belongs to the same year, 1904; it is a good example of such heavy biting as one likes to see under mezzotint It is less attractive than a coloured aquatint of the Gothic bridge at Barnard Castle (No. 56, 14" by 10⅞"), the music of a moonlight very well felt and orchestrated Three years later Barnard Castle Bridge was etched again, this time on a much larger plate (22" by 17¼"), and the work was done out of doors. The qualities here are those of a searching study from Nature that does not pass from suppleness into tightness. There is a generous feeling for historic stonework and for the angled rhythm of the parapet ; and as for the two arches, only one is seen in full, with its ribbed belly, like those ribs in the Monnow Bridge, an old fortified structure at Monmouth Barnard Castle Bridge is said to date from 1596, when its forerunner was destroyed during the insurrection led by the Earls of Westmoreland and Northumberland ; but its rebuilders kept the Gothic pointed arch and gave the bridge power enough to resist frequent floods on the Tees. Those "lost" archlets that strengthen the abutment and ease pressure on a ring of voussoirs, belong to the year 1771, when the bridge, after being seriously damaged by a huge flood, was repaired and widened A chapel used to stand on this Gothic bridge, just as a chapel stands now on Wakefield Bridge. Mediæval pilgrims and wayfarers, often with bad roads and footpads to encounter, liked their bridges to be symbols of Mother Church and to throw out light from beacons after dark. Reformers and Puritans, followed by our modern highway authorities, scorned the sacred character that bridges long possessed, tearing down the cross or crucifix that graced a parapet midway between the abutments, and either desecrating or pulling down the pontal chapels, chantries, and oratories At Droitwich a high road passed through the bridge chapel, separating the congregation from the reading-desk and the pulpit St. Thomas's Chapel on Bedford Bridge became Bunyan's gaol, and a small oratory on the bridge at Bradford-on-Avon, Wiltshire, still extant, declined also into a "lock-up," and in 1887 it was a powder magazine. Yet

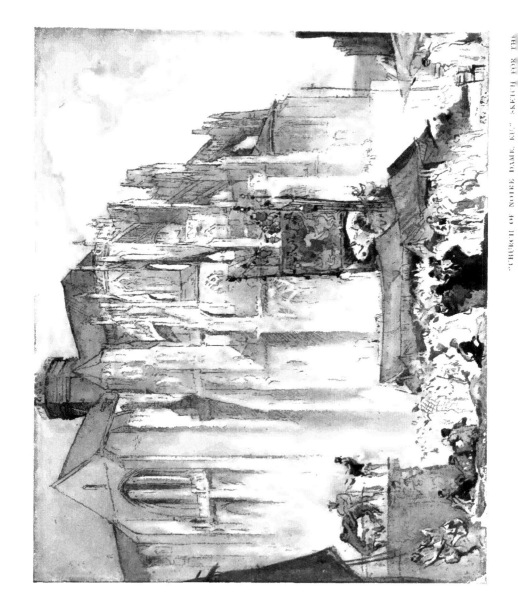

humbugs say that the Germanic elements of our mixed race have always been inactive.

A bridge appears in Brangwyn's etching of the "The Parrot Inn at Dixmuden" (No. 131, 1908, 14⅞" by 21¾"),* but it is foreshortened or hindshortened so much that its office in the print is to conduct the eye to a picturesque old inn with an adorned gable, well placed among villagers who, six years before the war, took life not too seriously Has Brangwyn noticed that all the words on this etched inn are upside down? Two years later Brangwyn painted and etched from Nature a very notable old bridge near Taormina, called Alcantara, which is Arabic for The Bridge (No. 156, 16⅞" by 13"). Its uneven parapet has a fine curving sweep, its round arches gape in the hot sun, and they are separated by such wide expanses of masonry that they seem to form a breakwater as well as a time-ravaged bridge, rising from the bed of one of those parched rivers which the rainy season in a few hours will turn into spates and torrents. Bad weather threatens in Brangwyn's etching, a grim storm cloud appearing suddenly on our left A dark foreground accents the sunlight, which clasps the bridge, and a shallow river, and part of a forlorn old tree growing near the long abutment

"A Bridge at Bruges" (No. 166), also etched out of doors, dates from 1910; it is among a few really small prints in Brangwyn's etched work that take their ease in Brangwyn's vigour. Here the metal plate measures only 6⅞ inches by 5⅜ inches, and a great deal is achieved on it in a style that does not act as a tyrant over a small surface, though it is ample enough for a bigger plate. It is a style, too, that keeps the sketching charm so attractive in wayside jottings and travel studies—above all when architecture has to be hinted briefly and aptly. The sky and its tone are suggested with right sympathy; houses and trees take their place with a naturalness free from over-emphasis; and a pleasant bridge, with its tall gateway and its three arches—a wide central span flanked by two narrow openings, all round—could not well be better sketched with a rapid needle, though a little more water along the foreground would be welcome It is a bridge with what is called an "ass's back," its roadway and parapet rising to the middle of their length, then shelving down to an abutment. This up-and-down movement is pretty steep, but much less so than in those Chinese bridges that sometimes need steps; or, again, than in many an old Spanish bridge, such as the

* This plate was etched out of doors

Puente de San Juan de las Abadesas at Gerona, and a longer and finer example over the Mĩno, at Orense in Galicia.

Brangwyn is very fond of the bridges at Albi, and I know not which, as a picture, is preferable—the high bridge, with its tall piers and round arches, or a barbarian bridge over the Tarn—one of seven pointed and uneven arches, with uncouth piers and cutwaters—whose erection, it is said, was arranged in 1035, at a great public meeting held by the Seigneur of Albi and the clergy Brangwyn has painted these bridges and their fine surroundings, and has put them together into one of his finer etchings (No. 221, 19$\frac{8}{10}$" by 24$\frac{7}{10}$"). A Gothic bridge at Espalion, as famed in controversy as Albi Bridge, is another recent etching done out of doors , and it is printed with so much art that its general effect seems almost to unite the work with mezzotint. Some brawny men along the foreground are washing skins, Espalion being famous for tanning, and I cannot say that I prefer them to the refreshing water and the historic bridge

Brangwyn's favourite mediæval bridge is the Pont Valentré at Cahors, a fortified work of the thirteenth century, and a noble masterpiece, remarkable for its massive elegance or its elegant massiveness. But I have no right to speak of this monument as "it," a mediæval knight among bridges being a genuine Sir, a great male in chivalric bridge-building He appears in two of Brangwyn's etchings—a big one on zinc (No. 178, 32" by 21$\frac{1}{8}$"), and a smaller one on copper (No. 189, 9$\frac{1}{4}$" by 6$\frac{7}{8}$"). Both date from 1911. The smaller print, rich, airy, velvety, romantic, shows the bridge almost

in a front view, but partly hidden by trees on our right It is good to note how this bridge crosses the Lot on his five vast piers and his six ogevale arches, with three proud towers, proof against all mediæval attack, looking bold in their challenging sequence As for the large print of Le Pont Valentré, it has two states, and in its second one a light sky is darkened; while the huge triangular piers, with their battlemented parapets, are freed from dark shadows and illumined with strong sunshine. We see the bridge from below and foreshortened by sharp perspective, with men at work,

and certain details enable us to see how the arches were constructed. For example, each embattled pier has a transverse bay or passage on a level with the springing of every arch. Below this bay are three holes, and another row of holes runs across the arch's under surface beneath the springing. It was with the help of these bays and holes that simple and effective scaffolds were put up by thirteenth-century builders For saplings were thrust through the holes till they jutted outside the piers; then they were covered with planks and used as platforms by workmen, and also as resting-places for barrow-loads of dressed stone, which were lifted up by movable cranes. Masons were served through the bay, and the centering or scaffold of an arch started out from those other holes that Brangwyn has noted in his etching.

Good as this etching is, it is not better than "Le Pont Neuf, Paris," an august proof; nor is it so well known as Brangwyn's vision of "The Bridge of Sighs" (No 181, $17\frac{5}{8}''$ by $27\frac{5}{8}''$), an etching already so scarce that its price has risen to seventy guineas, if not higher. As an interpretation of architecture—not surface architecture, but the inner essence and the life of that petrified music which architecture either sings or orchestrates with varied charm—this print, with its two bridges and its Renaissance palace and surroundings, is one of the finer achievements by which Brangwyn has been placed among a few unique etchers—men who stand apart from one another, each with a great style all his own, which every student ought to study, but which no student ought to copy, though study may lead to unstinted enthusiasm. According to some writers, "The Bridge of Sighs" does not represent its etcher typically, but variation from a type is as invaluable as auto-imitation is harmful

The most recent bridges in Brangwyn's etched work, apart from those at Albi and Espalion and "Le Pont Neuf," are "Le Pont Marie, Paris," a very desirable print; and the sunny, gracious Toledo, shimmering through a haze of heat that makes it look almost unsubstantial A great advance separates these achievements from the first version of London Bridge, and also from the second "Le Pont Neuf," I confess, has put me somewhat out of

friends with Méryon's etching of the same bridge. Both artists identify themselves with the architecture, pictorial architecture, not noble enough for a citizen bridge ; but Brangwyn gives much more of its weight, and his broad symphony of light and shade has orchestral notes and tones, with glimpses of popular life.

CHAPTER VIII ETCHINGS: BARGES, BOATS & HULKS

s it a pity that Brangwyn has not yet done a few typical marine etchings? He remembers what he learnt about the open sea, and tides and storms teem with those attributes of power and splendour by which his genius has always been fascinated Some of his early sea pictures, translated into etching, would put an uncommon patriotism into our national prints, while renewing an admirable period in his enterprise.

And another matter is worth consideration Now and then a very rapid artist should seek an influence strong enough to be as a master to him, and the martinet sea keeps all men under discipline. There are times when Brangwyn forgets that powerful etchers, like wise rulers, must blend their vigour with persuasive tact Of course, I am not thinking of his finer or greater etchings, wherein, as Emile Verhaeren said, an epic grandeur puts virility in its rightful place—the first. But, in a big man's life, the finer or greater etchings are never a great many. Legros told me, and allowed me to print his words, that quite two-thirds of his own etched work should be destroyed, as minor prints followed the major as persistent foes, but this self-criticism goes much too far—a great truth is overstated. Consider also the authentic prints even of Rembrandt's long record as an etcher, from 1629 to 1661; they number only 260, not by any means all of equal merit, and Brangwyn has etched in about half the time, almost the same number. No prolific etcher can keep watch with too much care over his minor prints, seeking for those that may do harm to his best achievements; and because some chosen land motifs give inadequate scope to Brangwyn's energy, an occasional return to his marines would benefit his etching—and our patriotism also

Though England has ever been our Lady of the Sea, British art has in it not much ocean, marine painters being few and far between. The sea is able to defeat most observation and technique, while landscape and portraiture are often kind towards even second-rate men. To summon the sea into etching is even more difficult than to paint some of her marvels Even Méryon, a retired naval officer, who had visited many far-off shores, sailing round the world, and

sketching day after day in his leisure hours ; even this true sailor among artists of original genius etched no devouring waves
If Brangwyn tried as an etcher to collect visions of the open sea he would succeed, perhaps with the aid of aquatint, or with that of mezzotint; and I am hoping that he will win some victories for us in blue water and among ocean tempests Meantime, in a good many proofs, he has been a sailor ashore, revealing his fondness for barges, gondolas, boats, and his austere affection for big ships which human breakers destroy on shore.
Barges, as we have seen, appear among his earliest etchings, and their long and even lines, with their flat, low-lying shapes, foil that ascension—a soaring movement and rhythm—that Brangwyn delights to make real; as in "Barge-Builders, Brentford" (No. 20, 13¾" by 13⅝", 1904), where several trees in a group occupy so much space that their massed foliage seems like a protector watching over the barge-building. To produce this effect the etcher used aquatint, and students will note two moods and two methods, aquatint portions, with their ample breadth, contradicting much neat pointwork in several houses beyond the river Such contradictions are most valuable when we study an artist's manner and his temperamental bias and power
In "Barges, Bruges" (No 60, 15" by 14", 1906), mood and manner are in easy unison, and produce some notes of that resonant dark colour which is often to Brangwyn's orchestration what the deepest notes are to bass and baritone singers. Barges are important in two other studies done at Bruges, both of delightful tone, where a picturesque brewery is sketched with a sportive touch and mystery The larger print (No 66, 18⅞" by 20⅞") could not well be bettered. All seems to have come at once, to have grown out of the zinc plate, and as inevitably as patterns and colours come into the new plumage of moulting birds. The smaller plate is an etching on copper, eight by ten inches, a barge lies across the foreground, and I know not why so much attention is invited to a blank wall across the canal, with a tone about as light as the water's
"The Boatyard, Venice," sometimes called "Boatbuilders, Venice" (No 112, 25¾" by 20¼", 1907), is among the fine Brangwyns, and some portions of it—above all some shuttered houses behind, with their weathered age and fluttering clothes drying outside inquisitive windows—belong to the finer Brangwyns A gondola is being built; litter of many sorts lies around her; and sunlight on a hot day pours
118

upon the houses and here and there into the yard, where men work as mildly as they can or dare A shady and shadowed foreground, splashed musically with sunlight, is composed with facile knowledge, right accents distributed ably, and a discreet rhythm putting order into scattered timber and other oddments It is an etching to live with as a daily chum.

There is a print called "Barges at Nieuport," an etching on copper and small in size (7¾" by 4"), that attracts me always as a cheerful sketch Its pleasant sedgy river, with a cornfield and hinted trees beyond, is a fortunate impression, and its old barges *are* old, their timber looks worn and aged, and I think of those adept pencil drawings by William Twopeny that give the age of so many historic things, from a twelfth-century house to Gothic ironwork. In the middle distance a woman stands on a small peninsula, keeping her place and plane; and I note this point because in four or five good wayside jottings there are figures that look too outlined. Examples. "Old Houses at Dixmuden" (No. 121, 7⅞" by 6", 1908), and a "A Water Carrier" (No 130, 9" by 7"), another print with a barge in its design

A few etchings have very important names, though the subjects that these names ask us to see, are almost hidden by boats or barges. This joke has been noted by many writers. Frank Newbolt says, for instance "'The Porte St Croix at Bruges,' that massive structure of town defence, is dwarfed by enormous barges"; and Henri Marcel is struck by the "Santa Maria della Salute" (No. 118), seen behind the masts and rigging of tall ships fastened to groups of piles. On our right a medley of picturesque anchors and cranes makes a complicated framing for Santa Maria, whose leaden domes stand out rather clearly against the sky I like this *genre* Not only does it blend architectural motifs with sailoring and commercial activities; it suits Brangwyn, and discovers him as much as he discovers its charm and variety.

And now we turn to those etchings where two opposed phases of industrial work are revealed with poetry and unrivalled power. One phase shows how great ships are broken up; and the other how they are built.

Here we touch the subject of my next chapter, Brangwyn's attitude towards Industry and Labour, an attitude often so true and so original at its best, so charmed with rival qualities rarely found united in graphic and pictorial art, that it is probably the most varied and most modern epic of sweat and toil in etching, and also in black

119

and white. But it is an attitude that appeals differently to its devotees

Emile Verhaeren stood outside it, fascinated, awed as a poet, and as a poet intimately familiar with Constantin Meunier, Brangwyn's great forerunner as an impassioned student of modernized labour and industry A poet is often apt not to be a faithful interpreter because his own genius, moved by the work it studies, begins to create ; and Verhaeren imagined that Brangwyn's later etchings and lithographs of industrialism, while revealing the whole essence of contemporary toil, contradict the most impressive thing of all in to-day's business—the domination of imperious matter and machinery over the striking classes In Brangwyn's earlier enterprise, we are told, mankind appeared to be of the lowest and compressed together in heaps "At the feet of disembowelled ships, of haughty ruins, of thundering factories, men formed only a grouping of pigmies at work All domination was reserved for imperious matter. But a change came as soon as modern workmen interested Frank Brangwyn A sort of reversal took place in his manner of conceiving things. Scale and proportion were transformed, and man now rose up as a giant in the face of things. His gesture, his attitude, his bearing acquired a sudden importance and reigned over the entire work. Farmers, watermen, sawyers, bottle-washers, navvies, reapers, became to the artist's vision as monuments of force, ardour, violence and beauty "

Here is Verhaeren's Brangwyn, but is it Brangwyn's Brangwyn, when we identify ourselves with his etchings and lithographs ? No, not altogether. Only an inferior artist would be so unShakespearean as to belie his chosen motifs, to rob them of their own significance, instead of revealing with comprehensive fervour their inner essence and their outward aspect, drama, and allure It is because Brangwyn, at his best, is comprehensive towards industrial toil, grime, waste, conflict, and tragedy, that he achieves inspired truthfulness, with that impersonal and penetrative observation out of which all masterpieces come when human life and character are explored by artists and authors.

Verhaeren forgot that many a statement in words, which looks and sounds very well, is found to be absurd when it is called up into pictorial presence before a studying mind. At a time when labourers and artisans are becoming menials to huge machines, mere Gullivers in a Brobdingnag of portentous mechanisms, how is it possible for any artist to show that modern workmen have risen up as giants in

120

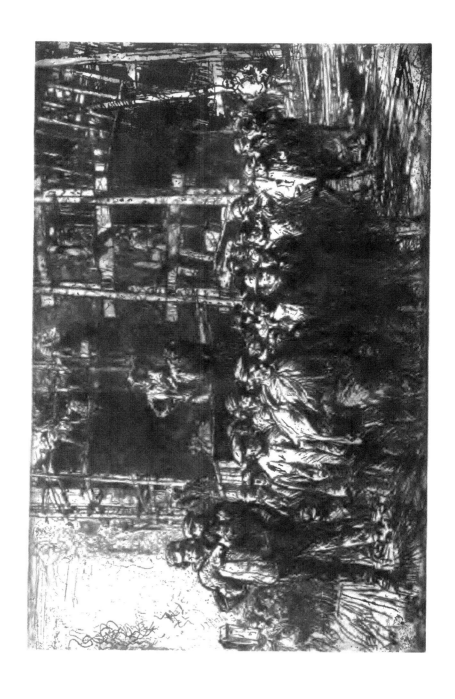

the face of things? Verhaeren imagined that because Brangwyn etched a group of tall sawyers on a large plate, in a bold scale and with passion, therefore he wished to show that sawyers triumph over their toil and lot, but handsawyers are busy on a job that machines do much better, far more swiftly, and at less cost; hence they are inferior as workers to machines. They have gone down as workers and their machines have gone up and up. So their pride of craft—that inestimable boon to mankind which acts as healing cement in society—has dwindled and continues to dwindle, not among handsawyers only, but also among nearly all manual workers, only an artisan here and there is a true handicraftsman whom machines cannot displace either partly or entirely. No wonder that the lust for strikes increases, while the old pride of craft diminishes; and no wonder that social tendencies everywhere are towards dis-integration—empires dissolving into separated states, and nations into noisy factions misled by fraudulent catchwords For pride of craft is not only as healing cement to society, it is also a self-esteem, so just and necessary that it puts imperishable soul into human toil. Even genius, that inevitable ruler over social enterprise as over all enduring work, after inventing and perfecting its vast industrial mechanisms, is often ensnared and held in bondage by its own achievements and their intricate ramifications, and thus we have all observed since 1914 that not even patriotism during a thousandfold tremendous war has been able to liberate into action any such genius among the belligerent nations as could use enormous mechanisms as a great chess player uses each of his pieces And all this very sinister and tragic history, plucked from the strife of machine-governed industrialism and from War's blood and valour, is the motive of Brangwyn's unrivalled attitude as an artist—or, in plainer words, as a man of genius who reveals but never preaches—towards mechanical Industry, Labour, and Armed Conflict

Though he never preaches, turning his best work from a revelation into a pulpit and a social sermon, there are moments—not frequent moments—when he gives to an industrial etching or a lithograph a depth of irony or satire that I find too painful. This irony or satire appears in one way only. men toiling at jobs below the needs of their dignity as men of the twentieth century A.D are shown in a scale too vast for the print surface around them, so they are brought too near to our eyes as by a magnifying-lens. In "The Tow-Rope," for example, a most poignant etching, as true as great

sorrow, the five poor wastrels harnessed to a barge unseen occupy so much of the print that a background of great old houses has to be guessed almost. It does not matter when six platelayers are epitomised in this magnifying scale, because, although many machines do far more wonderful work than platelayers do automatically, there is nothing too hurtful to human dignity in their position as labourers toiling for a railway. They cannot take rank with those village craftsmen who, without help from architects, dappled England with those fine cottages and farm buildings which architects of to-day study, and which are different in most counties ; but they are not industrialised by tyrannous machines into evident outcasts from mankind's improvement. It is by brains and character that ordinary men must be weighed in the scale of progress

Emile Verhaeren misread the significance of this ironic scale, just as Victor Hugo misread François Millet's "Semeur." Greatly stirred by this emphatic sower, Hugo said that the peasant's gesture *"voudrait s'étendre jusqu'aux étoiles"*—wished to reach as far as the stars ; but ideas fit for an ode by Hugo are not ideas inevitably fit for a picture. Millet's peasant has no wish to be astronomical : his gesture has the monotone of a tiring job, and seed falls close by his feet, where furrows gape for its coming. Still, Verhaeren wrote nobly about several aspects of Brangwyn's genius, above all when he rebuked those artists and writers who think that a hesitating and frigid examination is all that they need give to Brangwyn's etched work, as if to put out its fire with their frost and ice

And Verhaeren was right to warn his readers that Brangwyn's etching at a first glance astounds more often than it reassures, its artist being among those who capture, not among those who beguile or employ a seductive vogue To all who know not the industrial phases through which Brangwyn has developed his way, etchings of barges, boats, hulks, and shipbuilding are invaluable as an apprentice-ship Not only are they less imperious than many others, they appeal also to the waterman in our national character; and thus they help new students to understand that kindred enthusiasm alone is able to discover in an original artist his cardinal merits.

Sir Joshua Reynolds withheld much of this sympathy from even Rembrandt and Poussin, declaring that they, in their composition and management of light and shade, "run into contrary extremes, and that it is difficult to determine which is the more reprehensible, both being equally distant from the demands of Nature and the purposes

of art." And another Academician, Opie, spoke of Rembrandt as "foremost among those who in the opinion of some critics cut the knot instead of untying it, and burglariously enter the temple of Fame by the window." How silly it is thus to be a fool towards the great! In January, 1912, when about eighty Brangwyn etchings were exhibited in Paris by the French Government, Verhaeren noticed that the work prevented critics from employing their stock phrases. "Quelques uns se sont tus, d'autres ont approuvé banalement Aucun n'a haussé le ton comme il le fallait On a employé les flûtes et les clarinettes, mais les orgues n'ont point chanté Or ce sont elles qu'on eût aimé entendre. Même les artistes ne se sont point émus, ils n'ont point compris la leçon âpre et ferme qu'on leur donnait."* True, many an artist has no wish to understand the sharp and steady lesson that Brangwyn's finer etchings plainly teach

"Building a Ship" (No 195, 35½″ by 27¼″) is an etching that appeals— or should appeal—to everyone The gigantic skeleton and its upright scaffolding are made real with consummate ease, and surrounded with an atmosphere that beats and throbs with multiform labour A storm grows up from behind some distant factories, but there's sun enough to multiply the skeleton's huge ribs with some shadows thrown by upright and slanting props How minute are the men at work high up on this tremendous vessel! In the foreground some men in a line toil rhythmically, strapping fellows with characters that mark their attitudes, and they are but pigmies beside this embryo liner, which already has weight and power enough to ride out a storm on land without much peril. This etching was evoked in 1912, and I like to compare it with an earlier one, "A Shipbuilding Yard" (No. 26, 1904, 23¾″ by 17¾″), showing a stern fight between our artist and his materials. The plate was rebitten again and again, then scraped, then burnished, and so forth, until it had seen three states, apart from some trial impressions. Its published state has dour, robust qualities; it is a battle fought to a fine stalemate, while the later etching is a battle won with ease, like a quite recent plate, "Building a New Bridge at Montauban"

* "Some held their tongues, others approved lukewarmly Not one pitched his tone high enough Flutes were employed and clarinets, but no organs sang, though it was they that one wished to hear . . Even artists were not at all moved, they had no inkling of the lesson sharp and steady that was given to them "

As for the demolition of great ships, it is well for students to study these etchings chronologically:

1. Breaking-up H.M S. "Hannibal," a wooden screw-ship of the line, built in 1854, with only 450 horse-power engines. In 1905 she was torn into fragments at Charlton, Woolwich, and Brangwyn's etching shows her completely stranded in Castles' shipyard, with a heavy list, and tiny men at work around her body. The hulk is brought too close to my eyes, occupying so much of a large plate (24½″ by 19½″) that I cannot see her poetry because I see overmuch of her bulk. In 1838, when Turner painted "The Fighting 'Téméraire' towed to her Last Berth to be broken up," he was governed by that enchanted modesty which places the elements of poetry in their right places and in their proper scale "The Téméraire" and her paddle-wheel tug are surrounded by a great seascape and a visiting sunset, yet they are all the world to anyone who loves our Navy and the sea as Turner loved them. As a big study full of apt concentration, Brangwyn's "Hannibal" is very good; but yet . It seems to me that he ought to have achieved more because his emotion was all of a piece with Turner's

2. Breaking-up the "Caledonia," formerly H M S. "Impregnable," built at Chatham between 1802 and 1810. In 1816 this old battleship helped to bombard Algiers, receiving no fewer than three hundred shots, and some of these shots were found in her when she was pulled to pieces The etching was made in 1906; it measures 31¾″ by 21¼″ Here is a composition with four horizontal planes In its foreground, running from our right across more than half the plate, are some floating jetties. Beyond, in the middle distance, is a merchantman used as a jetty alongside the battleship: and towering above the greater part of this merchantman is the "Caledonia" glowing with sunlight Then on our right, past the battleship's bow, is another plane, a distant view of smoking factories with the murk that London often gathers to herself It is an etching full of light, bravely composed, with fine textures and a lofty sentiment.

3. Breaking-up "The 'Duncan,'" etched in 1912 on a zinc plate 32⅜″ by 21⅜″.

Here is another battleship, but of later date, she was commissioned for the first time on All Fools' Day of 1871, becoming flagship at

124

Sheerness. She was demolished in Castles' Yard at Woolwich, and Brangwyn represents her in flying perspective with her stern towards us, and great portholes like sorrowful eyes giving an uncanny pathos to this derelict of our sea power. The upper part of her body has gone, and upright portions of the skeleton cut out against a London sky. Huge cranes extend towards and above her, and there is distance enough to keep the "Duncan" from being tyrannously big in relation to the print's whole surface Though all is ample and abundant, the plate has mystery with infinity. A feeling for grandeur is present everywhere, except in those poor midgets who toil around and upon the ship, undoing what other poor midgets put together, in our Brobdingnag of machines.

4 "Breaking-up The 'Britannia'" is among the most recent etchings, and it cannot be studied enough No words of mine could give a fair idea of its fervent and seamanly charm A fine impression is beautiful with a velvety technique in which vigour and weight and mystery compose an amalgam of good fortune, and the mystery here extends to a warm sky. What other artist has done similar work with such grip, such penetration, such breadth of power and vision?
Pennell is equally moved by industrialism, only his touch lacks body and weight, he reveals seldom the essence of things. A little-known Frenchman of the last century, Bonhommé, painter and lithographer of forges, factories, and miners, heralded Brangwyn like Constantin Meunier; but is there even one artist whom Brangwyn resembles or who at times resembles Brangwyn? William Ritter believes, with just a bit of reason, that Mehoffer does, here and there, in a drawing, though Brangwyn *n'a rien de barbare ou de tartare comme Mehoffer*. Verhaeren believed that Brangwyn had chosen Rembrandt for his æsthetic guide and his spiritual master. "One cannot remember the one without considering the other, as one cannot remember Delacroix without thinking of Rubens or of Rubens without thinking of Veronese" Yet there is not much resemblance between Brangwyn and Rembrandt. Both feel the Gospel story as their contemporary among humble folk, and both are often drawn towards ugly faces. Rembrandt's cardinal marks are brooding concentration, wondrous patience and pathos, and a divination as gracious as that which mothers feel and show In some moods Brangwyn is near to Peter Breughel, while in others he is much nearer to Rubens than to Rembrandt, for both achieve without long concentration, with

prodigious energy and speed, and a passion for sumptuous colour. If Brangwyn tried to etch with minute breadth, as Rembrandt needled in the labyrinthine technique of his "Three Trees," he would feel like an athlete caught in a net and held fast. But he would paint with zest such a picture as "A Boar-Hunt" by Rubens.

I

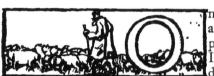nly a few F. B etchings are un-associated with industrial enter-prise or with *la vie populaire*; but I have now to speak of those that depict individual workmen at their jobs, just as an artist of the fourteenth century illustrated "'The Romance of Alexander" with cooks and cooking, smiths and forging, bakers at their work, chariots and their drivers, mills and millers also, and many popular amusements, from tumblers and jugglers to performing bears and apes. Tanners and barkstrippers, as we have seen (pp 80, 82), appeared in apprentice etchings (No. 6 and No. 8), and barge-builders also (No. 20), like shipbuilders (No 26); but here is a perspective of brickmakers hard at work near their low sheds. They handle their bricks cleverly, and stooping all day long has produced over-developed muscles across their shoulders. It is a large etching (No 38, 22¾" by 19¾"), and attacked with almost as much energy as Michelangelo poured forth when he chipped marble Weighty things rest on weighty earth , and every man's clothes hang in those stiff folds into which rough materials settle when they are often splashed with wet mud or clay, and frequently drenched with rain and sweat One man looks over his shoulder, but his face holds me less than his posture, with its physical character and vigour. Textures of many sorts add variety to swift and sure workmanship ; and here and there, as under those low roofs, deep cross-hatching nets enough air and light to keep the darks from looking shut up and solid. How different in mood and manner is an etching called "Scaffolding at South Kensington!'" It is a small print, not more than five inches by seven, and though one cannot put it among the finer Brangwyns, it has the charm of a rapid sketch, fresh and free, with a decision tempered by delicacy

Brangwyn is a master of scaffolding To me his effects are better even than those of another master, Muirhead Bone, who is equally alert and wide-awake to the elusive architecture that tall and intricate scaffolds imply, and whose style is vivacious and meditative, if some-what matter-of-fact. When Brangwyn shows how a bridge is built at Montauban, etching on a large plate direct from Nature (No. 221),

or how the Victoria and Albert Museum looked in its embryonic stage, all the matter-of-fact goes up with huge scaffolds into rough poetry, and stress and strain of building enterprise are present with their weight and energy, their toilers and their mechanisms. And now we arrive at a deeply serious and meditated work, "A Coal Mine" (No 59, 19" by 24⅛") There has been an explosion and colliers in two groups—one in shade, and one in vivid light—are bearing away a wounded comrade. Two tree-trunks, upright, tall and boldly modelled, grow between us and a fine pithead, one part of which rises like scaffolding around a tower. Smoke in soft waves resembling shredded tow, as if from huge torches, curls up to the pithead and licks around its timber Behind is a uniform sky with a technique that does not appear in any other Brangwyn. It seems to have been scratched horizontally with a fine metal comb, then bitten by mild acid, and from this process comes a monotone sky that looks well in a tragic episode. Everywhere this etching is contemplative, it has distinction, like Meunier's "Colliers waiting to go Below", and these and other qualities make it a maturer work than "Some Miners" (No. 87), a rugged study etched on zinc from the life. "Bottle-Washers at Bruges" (No. 61) is one of those Brangwyns with coloured high lights; here sunlight comes through green glass and suffuses a greeny tint over a workman, his bottle and his round tub. The effect is original and charming, it enriches with a diffused glow the chiaroscuro and gives us a good example of Brangwyn's art as a printer.* Henri Marcel says very well: "It is not alone in a line more or less soft that he finds expression, and not alone by careful observation of his acid and its biting that he graduates his linear appeal; these things are merely a fraction of a complete process in which inks and their preparation and printing and its subtleties play a highly important part I have alluded elsewhere to his method of getting atmosphere in his plates by employing a surface made with diluted ink, either spread or wiped off to make an effect that he desires. Brangwyn knows very well to what extent inequalities of pressure that his print undergoes are able to give unexpected aspects and peculiar beauties to various proofs Aided by this process, and also by diversely tinted papers, he produces differences between proof and proof, which endow each with an interest and a

* Like a good many of the large plates, these "Bottle-Washers at Bruges" were etched on the spot, direct from Nature In this case the spot was a wine-faker's place of business.

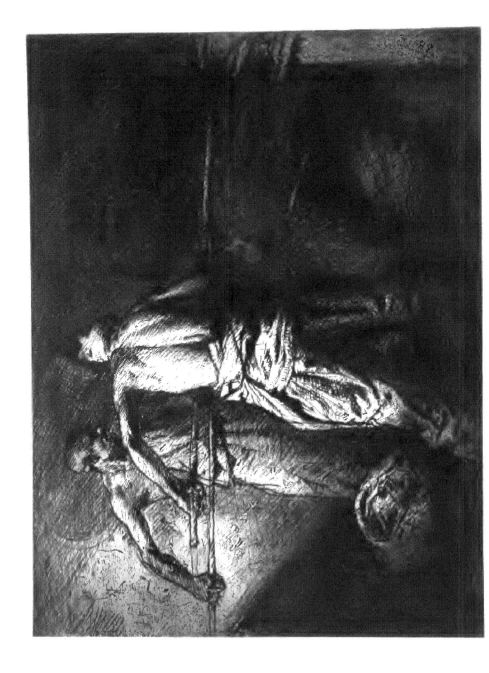

charm of deliberate artistic intention, making it almost as valuable as an original."
*True: and writers have reason to be uneasy. They cannot see all the varied proofs from each plate, and their views on one impression may be contradicted by your just views on another.**
Here is a light brown print etched out of doors, very long and narrow (No. 68, 20″ by 6⅜″), called "The End of a Day at Mortlake"; it represents, with true rusticity, some farm labourers returning homeward, with filled sacks behind them, some heavy sacks, while two are light enough to be easy on tired backs. There's a capital impression of Hodge's walking, the plod-plod of peasants, a series of different movements making a single, half-limping,

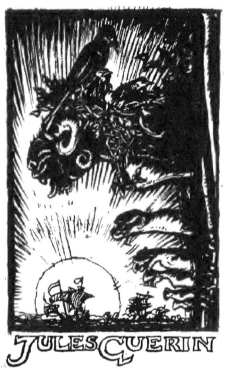

but rhythmic stride, that reveals how jaded peasants tramp over ploughed land. Every touch is free and swift, negligently wise, so this long print is a most welcome sketch. Perhaps a low horizon is too low, and I wish that two sacks did not touch the plate's top-edge. Just a bit of sky above all the sacks would enlarge a happy fortunate design, which, with but little change in its grouping, would make as good a frieze as one would wish to see, like F. B.'s lithograph of Arab fruit-carriers.

"A Tanpit, Bruges" (No. 76), also etched from Nature, is a very

* The best impressions of the earlier etchings were printed by Brangwyn himself, and everyone who has seen two prints, one by Brangwyn and one by an ordinary skilled printer, must have been struck by the great superiority of F. B.'s printing. In recent work his plates are usually etched for an ordinary skilled printer who has a right feeling for the etcher's guidance. Often a light undertone is put on the metal plate with acid and in a manner which, I believe, no other etcher used until Brangwyn thought of it and made experiments.

muscular sketch, its handling nervous, lean and keen, like a rough Spanish mule well seasoned by long journeys through dust and heat. It shows how an unpleasant job acts variously on the bodies of three tall men, rawboned fellows, with gristle as tough as whalebone, and muscles that seem to be proud of their alertness. Two of these men with long poles are probing for skins, while their companion—a long-bodied Fleming with a small waist, powerful shoulders and arms rather misshapen by too much exercise —lifts a hide from the vat. So exact and swift is the observation that we may dare to speak of it as quite medical, and we may dare also to add that its impression of generalized truth seems to include the penetrative reek that visitors *feel* in tanpits. Under Brangwyn's hands these workmen have grown, as usual, and one fellow's head nearly touches a big plate's top-edge. This growth comes as naturally to Brangwyn's genius as upward growth comes to plants and trees; but sometimes it troubles good workmanship, as in two plates of "Skinscrapers" (Nos. 79 and 80), both etched on copper, both charmed with earnest modelling, and both small, but abundant in weight and scale

Very pleasant are the soft ripe tone and earnest workmanship in two certificates etched on copper—one a certificate for the Shipping Federation, and one for the Master Shipwrights' Company These thoughtful plates are foiled by another big plate etched from Nature, "Bootmakers at Montreuil" (No 92, 21⅛" by 17½", 1907)—a vivacious *croquis*, true to rustic manners One bootmaker, a fat man, seated at his littered bench, works methodically almost from dawn to dusk, never takes any exercise out of doors, and comforts a congenital thirst as often as he can. He lets himself be shaved perhaps twice a week, for a chat with his barber enters into every week's routine. His two companions are not so well characterized; perhaps they belong more to F. B than to Dame Nature in France. A witty frieze of old boots above the men's heads comes from humorous observation. But my favourite etching in the Montreuil series of working life is "A Paper Mill" (No. 93), admirably studied at first hand, with a complex light and shade that could not well be bettered. A golden light plays in upon huge grinding stones and

some busy workers, who keep their small size near
big machinery and under great beams. Another
good print is "Men in a Bakehouse, Montreuil"
As for "The Blacksmiths" (No 94), a big, jolly,
bouncing sketch from the life, it adds nothing
new to its artist's research and progress, unlike
No 107, where a throng of men leave a London
shipyard, while another shift continues work
on great scaffolding behind. Here motif and
plate are large together, and the men's faces are
thoughtfully studied without detaching them
from their planes in the mystery of a crowd
Fine as this etching is, it lacks certain riper
qualities which are present and persuasive in
"Old Hammersmith" (No. 128)—qualities in
which keen vigour accompanies coaxing re-
search and patient and elusive tact, while
charming us with a magnificent display of light, shade and tone, free
from assertive accents Workmen lounge along a good foreground
and in open-air shade, others are busy with their horses in a sunny
middle distance, and behind them a fine old house, partly shaded by
a fan-shaped tree, is transformed into a factory, now beautifully
aglow with sunlight. All is excellent: rude where rudeness tells,
delicate where delicacy is needed, as among the horses, and note
also how happy and lofty is the feeling with which that house is
understood. And the tree is very well seen and felt, and the sky has
lightness and mystery One has an inkling that Brangwyn not only
loved but feared this intricate and sunny motif—feared it enough to
treat it with tender patience and respect, lest he should lose it in a
fiasco. Can he return too often to this technical inspiration? I
think not. It chastens two of his familiar qualities—formidable
dash and insistent push—as in "Men Rowing on a Lighter" (No. 73)
and "The Sawyers" (No 43) An artist multiplies himself by
being unlike his usual appeal
"Men in a Bakehouse at Montreuil" (No. 132) comes from a mood
rather similar to that of the seductive "Paper Mill" (p. 130); and here
is the well-known "Sandshoot" (No. 138), rivalling Whistler in
touch, and a Brangwyn through and through in weight and com-
position, like a kindred sketch, "The Ballisteria at Inchville" (No.
141), with its quaint locomotive and its puffing machinery And

131

what of "Unloading Bricks at Ghent" (No. 140)? It has humour,
atmosphere, mystery, with vivacious richness ; and it brings us in
touch again with a technical mood reminiscent of "Old Hammer-
smith." The gray, vague, wise old church behind is most difficult
and delicate for an etcher to suggest, being an epitome of distant
Gothic veiled by sunny haze. Yet Brangwyn has got pretty near
to a perfect rendering And what could be more apt than this
foreground, with workmen on different levels? I am not sure that
they look like Belgians, these men of Ghent, but is there any
conclusive reason why they should? That old toper in a tall hat,
bottle and glass lovingly clasped, gets rid of nationality; he is
cosmopolitan enough to form here a very popular thing—a League
of Nations, with Falstaff as patron saint
I know not what to say about another print, an uncommon aquatint
of "Stevedores" (No 190). Is it a practical joke? Did Brangwyn's
humour wish to be more than current with the passing moments of
post-Impressionism? However this may be, I prefer his appealing
mood in "Old Roadsweepers at Hammersmith" (No. 192), a
heartfelt impression from our streets. Here we feel the tears of
things. Some slapdash writers have said that Brangwyn has not
felt sorrow as poets feel it—as an atmosphere surrounding all animate
life, and needing as a counterpoise two divine things, sunshine and
harmony in every home. These "Old Roadsweepers" come from
the heart ; their sorrow is a genuine pathos that gives alms to their
loneliness, and I am almost startled by the contrast between them and
the rough electrical energy of "Boatmen Hauling at a Rope" (No. 77).
Let us pass on to a few etchings which have not yet been catalogued,
and among them a "Tannery at Parthenay" (No. 202, $9\frac{15}{16}''$ by $7\frac{18}{16}''$),
with its gray wealth of tone and its most fortunate sympathy of
touch and outlook An etching of this humble size, after so many
which are either big or bigger, is like a pleasant fireside chat after
much public speaking, and this good "Tannery" has several good
companion prints, all uncatalogued, and all done in France, like
"Wash-houses at Parthenay" (No. 211, $9\frac{7}{8}''$ by 11") A good
English motif, and a good Brangwyn, is the "Demolition of our
General Post Office" (No 212), a large plate, nearly 31 inches by
26 inches It is good enough to placate the ghost of poor Sir Robert
Smirke, who built the G P O , as well as the British Museum and
King's College, London Brangwyn is always at home in demoli-
tions and building enterprises

It needs rare courage thus to try with a needle on metal plates to call up into art huge impressions from modernized mechanics and labour. To think of seeking this adventure would cause most other etchers to feel uneasy, if not ineffectual, and even Brangwyn here and there has reacted against the stress and strain, not feebly, but in jaded spurts like those that good soldiers make at the fag end of a long forced march. In these moods he may outdo his usual fondness for extensive plates, and he did so when he chose as a motif his "Hop-pickers inside Cannon Street Station" (No 207). In this work his zinc measures not less than $37\frac{3}{8}''$ by $25''$ In 1911, when he etched Cannon Street Station from outside, and achieved one of his best works, his plate was a necessary tool, though it measured twenty-nine inches by twenty-eight. The later Cannon Street does not attract me, though some parts of it are largely handled within the scale of a huge improvisation

About forty years ago a professional Hercules named Gregory, famed among the strongest men that ever lived, told my father that one sorrow had been present always in his prosperous life , he was devoted to children, yet afraid to embrace them, as he knew not how powerful his love would be. "If I took my own boys and girls into my arms," he said, "I might crush them."

Now there are times when Brangwyn reminds me just a little of this Hercules , times when he does some harm to his art by pouring into it overmuch energy—overmuch for me, though I like to make my home among the most manly artists and authors. To me there's an excess of energy in another recent plate, a work of imagination suggested by Nature, yet much nearer to Darwin's "Descent of Man" than to any work that Brangwyn's variousness has produced hitherto It is called "The Swineherd" (No 215, $15\frac{1}{4}''$ by $11\frac{7}{8}''$), and its conception is as aboriginal as it is original, almost within Caliban's own province With enough meditation it would become as primitive as primitive man, a complete revelation of barbarism. Brangwyn sees the whole thing as a vision, and ravishes what he sees into a great suggestion on metal, where he leaves it to be

matured later. On the outskirts of a neglected glade is a group
of three stunted trees with their drooping foliage; and beyond them
we see the glade and a forest, then a sky as dull as dried leaves. A
fat sow with her litter has set up her quarters between the trees,
leaning with obese joy against one of their trunks; and her companion
and friend, a primeval swineherd, lounging over the beast, shoulders
himself against the same tree, while nursing a small pig. Primitivity
is adumbrated in a chaos of lines The vision is not as a living
model that an artist's imagination keeps and employs with ardent
coolness, as Shakespeare's rapid genius—that sweet foe of haste, and
gracious autocrat over form and style—retains Caliban, part beast
and part man
Gurth, the Saxon Swineherd, thrall of Cedric and Rotherwood, in
Scott's "Ivanhoe," had savage forerunners. Brangwyn has hit the
trail of one, and soon he will follow the fellow home into a complete
success

<center>II</center>

Henry James, in his lecture on Balzac, says "The fault of the
Artist which amounts most completely to a failure of dignity is the
absence of *saturation with ideas.* When saturation fails, no other real
presence avails, as when, on the other hand, it operates, no failure of
method fatally interferes" A profound truth, of course, but could
it have been put into better sentences? It seems to me that writers
should hate the definite article—"the fault of the Artist," for in-
stance—and should get rid of it by thought as often as they can;
and is "saturation" a good choice of words? Does it belong to fer-
tility among things without brain, fields, gardens and their produce?
What intellectual fertility needs, I believe, is a mother-idea that fecun-
dates, producing other ideas that increase and multiply, until an
artist is governed by their companionship A mind without ideas
of its own is barren, though its memory may be as retentive as
Macaulay's; and as soon as original ideas do impregnate a brain as
Millet's was impregnated by original observation out of doors among
peasants, or as Brangwyn's has been impregnated by his original
sympathy for hard-handed men of every sort, productive concepts
and enthusiasms, if genuine, are as revelations, and no failure of
method will be fatal. Blake is not killed by his nearly complete
ignorance of things material, for example; and though the temper of
antique Egypt is in complete antagonism with the human spirit of our
134

own modern selves, who can help feeling that antique Egypt not only lives on in her arts, but lives on also as with the might and majesty of eternal duration, and a primal grandeur not to be met with elsewhere? There is no exodus from Egyptian art.

Only we must remember that some artists meditate continually over their original observations and ideas, while others pass not often from emotion into the long concentration out of which ideas in a sequence grow. As a rule, for instance, Millet represents long meditation, and Brangwyn, as a rule, swift emotion made real by swift workmanship. I have said elsewhere.* "Millet, by nature, was a man of letters as well as a painter. Words and their music were fascinations that charmed him even in childhood, and throughout his life he passed a great deal of time in dreaming over his ideas and impressions. Also, and this point is equally important, his self-criticisms when at work were not feelings akin to those that we call instincts among animals; they were verbal directions, clear-cut and definite, and ready to be spoken to a pupil like Wheelwright, or written to his friend Sensier. Now Brangwyn differs from Millet in all these points. Impulse governs him. His emotions are very strong, often vehement, and he loses himself entirely during his creative hours. Very seldom has he thought it worth while to reply to his detractors or to waste his inventive energy on explanations of his own aims and convictions. He expresses himself in paint or in etching, and if you fail to understand him there he does not help you with a literary interpretation of his purpose. This being his nature, you will not find in a Brangwyn any parade ["presence," not "parade," is the right word here] of that old and acquired knowledge that gives a Grecian air to the peasants in the finest etched plates by Millet. Jean François was himself *plus* several others, and the others are often quite easy to recognize. The antique swayed his mind, so did those mesmeric masters, Mantegna and Michelangelo; and of these influences he was not only conscious, but conscious also in that literary fashion that takes pride in the making of sentences. Seldom did he know the joy that Brangwyn feels when a subject possesses the mind entirely and the day's work is like a pleasant dream with a happy awakening."

Afterthought persuades me that this analysis requires two amendments; it is not friendly enough either to Millet's rural and rustic distinction or to his contemplative qualities, which endow his

* *Scribner's Magazine*, May, 1911

peasants with a well-bred friendliness towards ancient soil, and it should note several dangers in unpremeditated art Let us suppose that a few of Brangwyn's peasants and some of his other labourers had been brought closer than they are to the Greek passion for nobleness of gesture and feature with inspired line and rapt modelling Would their appeal as art from Brangwyn be enriched, or would it be enfeebled ? Modernists turn with hatred from a question of this decisive kind, forgetting that their modernism, if it is to be to future generations what the antique at its finest is to us, will need from age to age qualities that have staying power and abiding persuasion For genius only visits our to-day , her permanent home is a perpetual sequence of to-morrows. And what part of human genius endures best ? Intellect behind and in æsthetic emotion

More than one of Brangwyn's loyal adherents, and notably Henri Marcel, has analysed Brangwyn's handling of important human figures in lithographs and etched work, noting that his sawyers, bricklayers, dyers, tanners, miners, sailors, and other hard-handed men, are often less interesting, because less intense and expressive, than those prints where inanimate things are governed by vast natural forces Though it is right and necessary always to reveal the truth that most workmen of to-day are more or less enslaved to machines, there's no need ever to make this truth too emphatic by failing to endow their bodies with enough form and their faces with enough thought and speech. Henri Marcel suggests that two or three occasional defects of Brangwyn's work come from our London climate, which he argues, makes general aspects of industrialism more pictorial than individual workers Even in summer, he says, our city often puts on a garb of darkness, of actual night. Very often our London sky "instead of constituting the clearest light value in the field of vision, is relegated to the second or third plane, and becomes a strongly contrasting background to any object that is directly in the path of the filtering rays. These effects, which would seem paradoxical in most climates, have greatly impressed Brangwyn with their special picturesque qualities. . . He has devoted himself to their reproduction . ."

Though our London climate has bad whims enough, it is not so bad as Henri Marcel declares, and æsthetic problems belong usually to art's spiritual factors Those occasional parts of Brangwyn's work which are not yet so mature as they will become, set me thinking of a spiritual thing, the very unusual education through which this

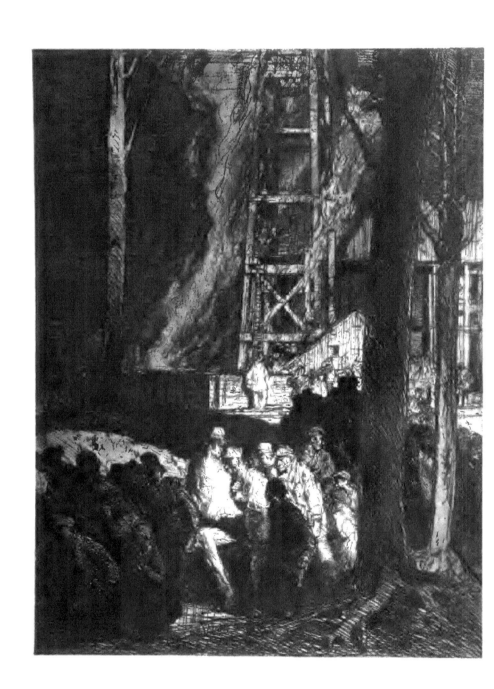

great artist has travelled, while
growing trees to make the high
ladder by which he has risen above
his contemporaries. Conflict with
life, and with life in many climes,
was his university and his art school,
and all that was innate in his passion
for art—his delight in decoration
his intrepid enterprise, his fondness for the poor, his rapid hand,
his unlimited energy, and his eagerness to collect swift impressions
—all this, let me suggest, was intensified by his wandering studies,
usually remote from teachers, and plaster casts of antique figures, life
classes, and the usual routine of a boy artist's apprenticeship.
To this uncommon education he owed invaluable qualities, together
with two or three defects; and it is precisely these defects that he
can clear away during the next period of his enterprise. For he is
not among the many artists who have ceased to grow because they
have ceased to respond to the needs of enduring work
Every bias having its own perils, a bias towards pictorial decoration
requires as much watching as any other, above all when a painter is
gifted with a wondrous facility of hand that produces at its best
unmatchably rich workmanship. If a man is a defective colourist,
like Ingres, or if he paints with slow brooding pains, like Leonardo,
he is obliged to ponder much and often, and he will value form and
intellectual expression much more than he values paint and colour.
Ingres, almost with a sneer, described colour as "la dame d'atours
de la peinture" (lady of the bedchamber to the art of painting),
though a monochrome world would be a perpetual funeral. It is
always in colours that the world's antiquity smiles into youth
renewed And let it be noted also that as a draughtsman by right
of birth is attracted by line and what line can express, so a born
painter and colourist is attracted towards brushes and what brushes
alone can express to perfection.
No one desires, then, that Brangwyn, a painter through and through,
and the most ample and varied of all British colourists, should rate
point drawing at a higher level than paint and colour. He is very
fond of drawing with a point, of course, and in his own style he
shows that his point-work is governed by his inborn passion for
colour and other painterly qualities Few painters equal his com-
mand over the simpler aspects of point-drawing, but he can—and no
T 137

doubt he will—do more than he has done as a revealer of mind and of what I may call sculptural form in his chosen models. *No doubt he will*, because no true artist can fail to see that sculptural form, varied and wonderful, is evident in all things that live and grow and suffer death. Natural angles, the antithesis of natural fertility, are produced only by agents of destruction, like earthquakes and lightning; it is always curves and rounds, charmed with rhythmic and supple modelling, that we find wherever we seek for Nature's reproduction and superabundant growth. So it is not only in Greek sculpture, and in such modern work as Ingres produced at his best, that we come upon this modelling We see it also even in blades of grass

"How can a big man grow bigger if he has no big faults to correct?" Though Brangwyn has a few defects, like every other vital and progressive worker, all industrial aspects of his finer prints are impregnated both with present-day life and with impassioned sincerity, and every new student will soon make friends with their general spirit if he will approach a unique art in a proper manner. Let him not suppose, as a good many writers do suppose, that a thing sometimes called "the democratization of art" has a lineage not at all old, perhaps not older than the brothers Le Nain, who worked in the seventeenth century An art is unique, not because it has no pedigree through human life in all past ages, but because it endows such a lineage immemorial with a new vision, coming from a genius unlike other geniuses; and thus we unite ourselves more closely to unique art when we seek out and try to understand its discoverable forerunners, just as a student of to-day's battleships likes to meditate over an evolution that goes back without a break to the first dug-outs made by prehistoric men.

Tanagra statuettes, like the athletes of antique sculpture, prove that ancient Greeks brought popular life within the gamut of their own æstheticism; but the origin of this artistic factor is prehistoric, dating from those Palæolithic artists who represented animals that they hunted, one fresco—it is at Altamira—measuring fourteen metres long Near Cogul, a village of Catalonia, there are frescoes on exposed rocks. In one a red man is shown attacking a red bison, while another has a group of ten human figures—nine women and a man—arranged in a row, the man with five women on one side and four on the other. The women's bodies are narrow-waisted, with skirts reaching to their knees and a sort of mantle over their

138

shoulders The attitudes, though somewhat chaotic, suggest a dance * Here is fresco decoration and popular life, prehistoric and post-Impressionist, and a photograph of it stirs one's imagination as keenly as that very tragical picture by the eldest Breughel, where blind peasants lead one another, and where we see in pitiful satire a quite modern attitude towards the logic of disaster that flows from follies. The more we connect Brangwyn with his predecessors, both near to our own day and marvellously far off among lost ages, the closer we shall unite him and ourselves to that miracle which is always at work—evolution. And another truth to be remembered— a truth, too, that we should give to F B as a true motto for his biography—comes to us from Robert Browning —

> " I count Life just the stuff
> To try the soul's strength on, educe the man
> Who keeps one end in view, makes all things serve "

* E A Parkyn, *Prehistoric Art*," p 110

CHAPTER X ARCHITECTURE IN THE BRANGWYN ETCHINGS

I

In the catalogue of F B 's etched work, the first motif is architectural ; it represents, in a very careful study fiom Nature, some old timber houses at Walbeiswick, near Southwold They stand on stilts out of reach of damp and rats, and their high-pitched roofs, with gables alert and sharp-angled, are lively enough to put good spirits into a rainy day. There is nothing more typical of Young England, Gothic and Tudoi England, than a gabled wooden house, whether a harlequin diessed in black and white, a magpie house, or covered modestly all over with boards.

Forrestial England bred a people so fond of timber cabins, huts, sheds and houses that neither fires nor civic rules could put the passion out of vogue where woods were common and housebote was a customary iight which tenants inherited. Fire after fire attacked London, as in 1135, 1161, 1212, 1266, and frequent decrees were issued against wooden buildings, and against roofs thatched with straw, reeds, rushes, and other litter ; but English character at its best is a true sportsman, and sportsmanship is conservative, running risks in order that old customs and pleasures may be repeated and renewed. Mere timbei cabins and sheds could be kept, more or less, under municipal control, but the playfulness of half-timbering came fiom national chaiactei, and here and there it passed thiough generations from mediæval days to the coming of our factory system, with speculative builders to jerryise our home life into perilous housing problems. We have sold cheap what is most dear— many good rustic styles of honest building, such as F.B has etched in these old places at Walbeiswick, now destroyed, and in a timber watermill at Brentford, also cleared away as old-fashioned.

As late as 1850, or thereabouts, the history of English houses, with that of English cottages, from the twelfth century, could be seen and studied out of doors, together with earlier phases of building full of Anglo-Saxon habits and customs, while our charcoal-burnei's cone-shaped hut—still extant, luckily—had and has a simplicity so primitive that its origin is probably prehistoric. Yet England saw

140

not her good fortune in having so much domestic history, with its pride of craft, out of doors and plain for all folk to see and easy for all folk to emulate. To-day, if we wish to get in touch with the same history, we learn how dependent we are becoming on ancient manuscripts, elderly pictures and engravings, books, and the topographical drawings made between 1750 and about 1850—made by Sandby, Hearne, Turner, Girtin, Blore, Nash, and a great many others, above all by William Twopeny, Boswell of our English house and its many styles Later artists also have rescued many a cottage and many a house, just as public museums collect examples of good

old furniture, and other mementoes of a younger England, a country willing to find in useful work well done a pleasure as welcome as games and sports were But, of course, young old things, when their craftsmanship is fit for its purpose and thorough, are to be loved as incentives only, as models to be outvied, for noble crafts are harmed very much when crazes for old things flood our markets with copies and with frauds Art is dying when objects of daily use are copies, mostly machine-made, when old traditions of workmanship no longer grow into fresh and fit ideas and enterprises. It is true to say that precious parts of our national character have gone with many fine old traditions of well-doing by handicraft shown in common things apt for incessant use. Cottages ought to be as enjoyable as are the Robin Hood ballads or the songs of Herrick, and they used to be so in many places, as extant specimens bear witness. That we are below our ancestors, far below them and much inferior, is a fact which most people try to hide with boastful cant, though it is proved beyond all doubt even by old barns, many of which had and have a dignity of workmanship, a true and a great design, not to be found in a great many modern chapels built by Nonconformists, sometimes with mean thrift, and sometimes with shoddy redundance. As W. R Lethaby says " We do not allow shoddy in cricket and

football, but reserve it for serious things like houses and books, furniture and funerals. . . . It is a tremendous fact that whereas a century ago or so the great mass of the people exercised arts, such as bootmaking, book-binding, chair-making, smithing, and the rest, now a great wedge has been driven in between the craftsman of every kind and his customers by the method of large production by machinery 'We cannot go back'—true; and it is as true that we cannot stay where we are."

Let me ask you, then, always to connect with our present lot, our present needs, every good model of old work that Brangwyn has found out of doors and turned into an etching or a painting. Give help, too, as much as you can, to the Design and Industries Association, since its high purpose, like that of the Art Workers' Guild, is to convince workmen and their paymasters that the joy of doing a job well for its own sake and use ought to be more natural to man than greed or than fraud, and that it makes good design, work fit for its purpose, comfortable to live with as true art

This fact the Germans have understood from its trade and social points of view, they know better than we do the history of our arts and crafts movement, borrowing from it all that they need, and constituting the arts and crafts as a fruitful branch of political economy, supported by a noble *Werkbund,* and already with a chair in one university. It was they who turned into founts of type an English study of fine lettering, begun by Morris, and continued, with beautiful skill, by Edward Johnston. What happened then? A commonplace We started at once to buy German founts and to print from them.* Many English minds have had fertile ideas, but our poor nation, misruled by ordinary minds, has been too cocky and too conventional and too enslaved by party politics for the good sense of fertile ideas to aid her to be either wise towards herself or alert in the international warfare that trade competition enforces on all countries. It is only under military and naval discipline that most Britons are thorough without much disturbance from unrest, strikes, and scamped workmanship. They need what they hate—imperative discipline. Centuries of ease in a snug little island have been very bad for their foresight and their self-denial, their workmanship and their future. To teach our country to value once more the honour of

* In March, 1915, under the auspices of the Board of Trade, an exhibition of German industrial art was held at the Goldsmiths' Hall, London; it showed that German manufacturers have taken a pride in testing brave notions and in doing excellent work.

good work always fit to be used and liked is a very pressing need, it is the only patriotism that surrounds an elderly nation with a safe life-belt. Intellect-benumbing cant must be displaced by good craftsman-ship. How can life be worth living when work is not liked with a just pride? How can a nation keep away from revolutions if her people lose the joy with which every job should be done well for its needful use and its proper place?*

Brangwyn's fondness for old and elderly relics of sound craftsmanship is a passion, as everything in art must be, and now and then it has made his touch almost hesitant, if not even timid, and therefore unlike his own The old timber houses at Walberswick are etched on a plate nearly twelve inches square, yet the technique is tighter and more thoughtful than it is in " The Old Tree at Hammersmith" (No 14), a plate only five by four inches, and the wooden water-mill at Brentford (No. 21), just twelve inches square, has qualities like these Walberswick houses, but richer in tone and freer. It seems to me that these painstaking moods, incisive and precise, watchful and studious, but not laboured, are among the most note-worthy of Brangwyn's variations. Not only are they found always —or usually—in architectural motifs, as in " Brentford Bridge " (No 23), " The Castello della Ziza at Palermo " (No 30), and " The Monument, London " (No 200), but they prove to us also that the swiftest etcher now at work, the swiftest and most virile, can summon into use when he tries a reserve fund of patience that critics either fail to see or forget to set down in their studies.

Several recent architectural etchings—French motifs as a rule, like the old houses on piles at Meaux, a penetrative and grave print—have the same contemplative sincerity, a blend of steady thought with æsthetic emotion Now and again this meditative search and research appear, with some architecture, in an industrial motif, and then we welcome such an etching as the coal mine after an explosion (No. 59) or the one called " Bridge Builders " (No 37), though it represents an iron landing-stage for coal just below Greenwich Hospital. The real " Bridge Builders " is plate No 221, a work constructed with authority and with so much power and weight that it is informed all over with the clodhopper charm that engineers put into the framework of their enterprises.

" Old Houses at Ghent " (No. 64), etched on a large copper plate,

* Wellington said " There is little or nothing in this life worth living for , but we can all of us go straightforward and do our duty "

143

24″ by 21¾″, is known everywhere as a very fine achievement, uniting to-day's industry with a lace-work of many-windowed architecture that used to be the Spanish Guild. A timber bridge, quite new, yet not discordant with old times, connects a busy foreground to the veteran houses, one of which has a stepped gable, while the other has a gable carved and adorned, such as we find in some Queen Anne buildings, so called. Windows are so numerous that the frontage has at least as many voids as solids, as much glass as wall. Yet Brangwyn, with his usual felicity, has revealed body and weight where most other etchers would have seen a sort of airy, fairy structure, unsubstantial as a dream almost. Body, weight, growth, rhythm, and the soaring flight of Gothic, that skylark rise and song of Christian architecture—these are attributes of great building that appeal most strongly to Brangwyn, as to Girtin, and he makes them real by various means in his finer plates "Old Houses at Ghent" belong to a technical inspiration very similar to that which I have noticed (pp 131, 132) in "Old Hammersmith" (No. 128), though there is a difference of poetical feeling and allure. Sunlight is all-important to "Old Hammersmith" · it composes and orchestrates a good part of the whole living design, while light and shade in the earlier work have for their mission the gentle honouring of noble old age with its charmed and charming decrepitude. Henri Marcel says no more than is quite correct when he notes that the melancholy charm of decrepitude has rarely been handled with such a fond caress as in these "Old Houses at Ghent."

Santa Sophia at Constantinople, with her arcaded crown of cupolas, and the shining amplitude of her massive façade, is another fine plate (No 71); and, as is usual in Brangwyn's attitude to mosques, cathedrals and other churches, popular life makes a busy congregation all along its foreground. This Turkish subject belongs to 1906; and let it be studied side by side with a later etching, "The Mosque of Ortakevi at the Entrance to the Bosphorus" (No. 185, 28⅞″ by 22¾″, 1911). Here is a tremendous effect, produced by contrasting the majesty of Eastern architecture with a conflagration, from which many persons are escaping. There are men carrying other men, and the movement is so lively that a first glance may take it to be the frolic movement of a festival. Then a scamper for safety and the rescuers are connected with the fire, and one thinks of Legros' etching of a burning village. Brangwyn's figures are introduced with significant pointwork, and I miss one thing only—just a little

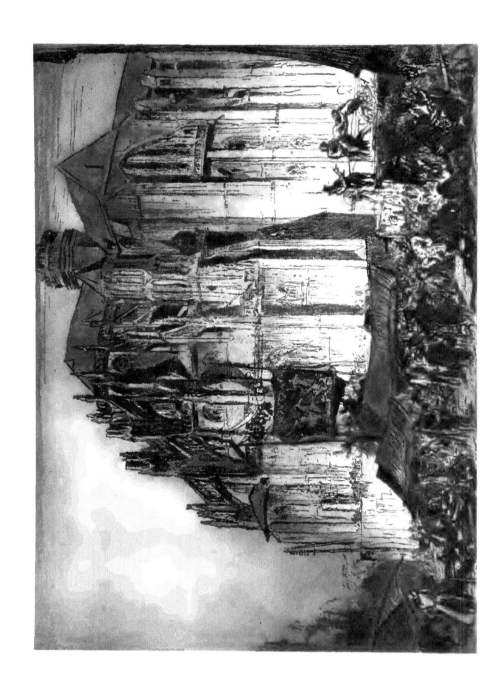

more foreground as a bottom balance to the ascending mass of living masonry.

Very different in all respects is "The Rialto, Venice" (No. 72), which is not among my preferences It attracts me little, not because very little of this bridge can be seen, but because there seems to be not much that is definite in its mood and purpose, except the doing of an alert sketch with rich and contrastive textures. To my mind, then, it does not help F. B to break his own records, and it adds no uncommon grace or distinction to the Venice that artists have seen with their imaginations.

<p style="text-align:center">II</p>

There are foreign writers who like to describe Brangwyn sometimes as *un Véronèse Londonien*, and sometimes as an old Venetian who has made his home among the fogs and horrors of a commercial time. These phrases may have been suggested by the sculptor Préault's famous *mot* · "*M. Ingres est un Chinois égaré dans Athenes, et Pradier part tous les matins pour la Grece et arrive tous les soirs au quartier Bréda.*"* Such flashes of wit are never quite true, but they amuse us into thought. F. B. is no more *un Véronèse Londonien* than Ingres was *un Chinois égaré dans Athenes.* Certain qualities in his work are nearer to Tiepolo than Veronese, and his varied style has ever been too candidly his own to be at all near to any old master's, except in kinship of virile temperament. None the less it is true that his Oriental passion for rare and splendid colour, songful, unfidgeted, is to many gray and grim phases of modernized painting what the Venetian school was to a good many Dutch and Flemish students. And it is also true that he loves Venice, her present and her past, as Ingres loved the Greek spirit in art, with its intellectual design and its alembicated form ; the Greek spirit, that human paradise of gleaming flesh and enchanted simplicity

Venice exists, but not as Venice, for genius has found in her so many Venices, all beautiful, that she lives variously as imaginative art. Brangwyn sees there—not the gossamer magic of Whistler's etched line, nor the Aphrodite of cities that Turner illumined with his own sunlight, but—a mingling of solid, energetic prose with airy romance, just as Shakespeare adds the hard-handed men of Athens to Titania and her fairies, and Theseus and his court, and the eternal

* "Monsier Ingres is a Chinaman lost in Athens, and Pradier starts every morning for Greece and arrives every evening at the Bréda quarter "

lovers at sixes and sevens Quince, Snug, Flute, Snout, Bottom, Starveling, are present in Brangwyn's Venice, with their ups and downs of fortune. Quince and Snug are busy on their gondola making, when they are not mourners at those Venetian funerals, half-joyous with merry colour, that Brangwyn has etched and painted , and we may be sure that Bottom the Weaver, who desires to act every part in a play, is not far off from that haunted night scene called " Unloading Wine at Venice," where Dame Nature herself seems to be a smuggler. Two or three etchings, and notably " The Bridge of Sighs," reveal the courtier grace and work of some Renaissance architecture which seems to rest on fidgety water, with gondolas and its own troubled reflections.

Brangwyn's " Il Traghetto " (No. 175), though rich and sonorous, is not as a good host to me. It offers too much, I fear I prefer the great pile of Santa Maria della Salute, which adds a different note to the Brangwyn Venice, a note of uprising adventure, and a pride that receives the full sunlight at last on leaden domes, and not on such lustred and gemlike tiles as old Persian craftsmen would have offered to the sky as praiseful allies.

Santa Maria is etched thrice, and the great commerce of shipping appears in two plates, adding historical suggestion to the appeals that art makes. A storm gathers around one etching (No 108, $14\frac{1}{2}$" by 11"), darkening up from the horizon, just as danger to the Venetian Republic drew nearer and nearer with the rise of England's Navy, her sea supremacy in war and commerce.

There are writers who say that I am wrong to seek in art for historical suggestions, as æsthetic emotions alone have a rightful magic in fine arts; but they are writers who employ a routine of words, they never think As we cannot delete Bible literature and its own appeal from Renaissance pictures without cancelling hundreds of masterpieces, so we cannot shut out the past of any city from etchings and pictures that represent the city's old buildings and present life and labour. It was Méryon's impassioned love for the elderly age of Paris, in part a true literary emotion, that informed his etched precision with an abiding poetry that put his own mind and soul into non-living things, and it is Brangwyn's feeling for the plurality of Venice, her permanent yesterdays and her present hours, her enduring arts and her transitory enterprises in the common work of every day, that enables him and us to blend æsthetic Venice with other elements of the great human drama. Even Turner was not

146

satisfied with paint and its inspired pictures. He wrote his "Falla-
cies of Hope"—and quoted from them in R.A. catalogues; and he
quoted also from Shakespeare, Milton, Dryden, Pope, Byron, Sir
Walter Scott, and a good many others. Yes, and Leonardo da Vinci
could write with as much ethical fervour as Ruskin: "The study of
Nature is well-pleasing to God, it is akin to prayer. By learning the
laws of Nature we magnify Him who invented, who designed this
world; and we learn also to love Him more, as great love of God
must be increased by great and right knowledge." Let us be sure,
then, that æsthetic emotion does not dwell in us apart from other
gifts of mind and heart.

Now and then Brangwyn breaks in upon our æsthetic feelings by
giving even too much space on his plates to majestic buildings. His

"Mosque of Ortakevi"
is one example, and the
stormy etching of Santa
Maria has a foreground
not quite broad and deep
enough to counterpoise
amply its architecture and
the sky. Even in "Santa
Maria from the Street"
(No. 110, $17\frac{3}{8}''$ by 22"),
where the street and its
figures are handled with
playful care and high
spirits, another $\frac{1}{2}''$ of fore-
ground would be very
welcome as a reposeful
balance, and $\frac{1}{4}''$ more of
sky would have freed the
tallest dome from the
plate's top edge. Even
a big plate may look
Procrustean when its con-
tents are not so free as
they are ample in con-
ception and fine in treat-
ment.

And another technical

W BRADLEY

147

point seems to be worth offering as a hint to be considered. Two etchings of Santa Maria (Nos. 108 and 110) are on copper, while the third is on zinc (No. 118, $31\frac{1}{2}''$ by $21\frac{1}{4}''$). Each metal gives distinctive qualities as a rule, and there appears to be more meditation, with less pictorial suppleness and texture, in most of the work on copper Which of these qualities has the happier presence in architectural motifs ? Who can say positively ? The copper etchings have an allure that many etchers like better than the aspects almost of monochrome painting that Brangwyn often obtains from zinc; but I know that most Brangwynians prefer the zinc etchings. My own view is that copper seems to be nearer to the linear genius of *most* architecture, though farther from Brangwyn's native style as a great colourist and painter; and now and then he seems to feel this himself by using copper for his architectural pieces, as for " The Church of St. Nicholas at Dix-muden" (No. 117), " Old Houses at Ghent," and a lightly-touched and excellent Messina plate called " The Headless Crucifix " (No 152).*

<center>III</center>

On the other hand, zinc qualities are adapted a good many times, with so much tact and skill to the linear genius of architecture that they have what I take to be the more disciplined charm of copper qualities. " Old Hammersmith " is one example, and we find another in "The Church of Notre Dame at Eu, in Normandy " (No. 143, $30\frac{1}{4}''$ by $23\frac{3}{8}''$). This plate has in it the spirit of French Gothic, which is generally set apart from English phases of Gothic by more display. Our English tradition—and tradition as an æsthetic factor comes always from national character and intellectual outlook—was a tradition in design of sobriety and dignity, with steadfast purpose and delicate moulding and restful craftsmanship. It was this fine temper that saved our country from a Flamboyant period of Gothic, and that gave and gives to the best English furniture

* It is probably easier to print from the white metal zinc than from the coloured metal copper, and art students who are often " hard up " must be grateful to zinc, as it is usually cheaper than copper Some etchers believe that the same qualities can be got, with equal ease or equal difficulty, from both metals, and that the choice of either is more a matter of accident than a preference coming from a temperamental bias. Legros, always a great authority, did not hold these views He knew that men of genius do many things without becoming conscious of the reasons , and he was certain that metals different in hardness, like canvases different in texture, must have, as a rule, a differing influence on a work s technique and presence

unrivalled quietness with grace and strength. French Gothic is more profuse, more fanciful, more feminine and enriched, often restless; and its Flamboyant period is concordant with those effervescent moods which Frenchmen have united often to more wit than humour, and to more revolution than beneficent, wise compromise. But Brangwyn shows also, in his finer interpretations of French architecture, that the inner merits of French building, like the inner merits of French courage and enterprise, are staunch and weighty. To-day, in fact, the French character grows into self-denial and towards reserve; while our British civilian character is becoming so much like our noisepapers and our picture palaces that little public work can be done without much aid from scenical emotion and theatrical display.

"Notre Dame at Eu" reveals a French phase of Gothic in an extract of Brangwyn's own style. The church occupies nearly the whole of a large plate, and Brangwyn feels with so much ardour all ascending lines, the upward flight of Gothic, that, like Girtin, his hand lingers with greatest persuasion on the building's upper parts. A little more foreground would be welcome, though *la vie populaire* is put in with wit and humour and frolic, clustering around the church in a festival, with booths and wrestlers and holiday-makers noisily and jocosely at their ease.

Other etchers never capture from Gothic architecture and its position in social life any visions equal and similar to Brangwyn's best. They collect much else that we need, of course, like Cameron and Bone, or like Lepère and Bauer, whose West Fronts of Amiens are finely seen, felt, cut, and made into different gems, entirely free from busy paste. But I like better still an etching-needle that is never at all pretty, because it rebuilds, like Cotman's, or like Piranesi's; and how fortunate we are when we feel, in Brangwyn's rebuildings, how solid and heavy is the petrified music which goes up and up as noble Gothic, as if eager to return the sun's daily visits.

To put into stone, maybe for a thousand years, and many more, a true and generous art that is musical with good work full of thoughtful aspirations and just pride, is this the most hospitable well-doing that binds century after century to that which is for ever best in thorough and worthy craftsmen? I believe it must be. No gap parts it from common lives and mean streets; it offers to all comers a noble welcome; and though men ill-treat it sometimes and often neglect it, because they have not been taught how to make friends with it, they

cannot befoul it often with the gambling knock-outs that auctions thrust upon any noble work that is easy to move from place to place To my mind, then, etchers and outdoor painters are always most useful and necessary to the art of living as chums among their fellow-men when they try to translate into their work the friendliness that fine architecture offers to everybody. Even etchers who give their days to trade work, far too neat and pretty for the well-doing that counts in the to-morrows, are to architecture what posters are to business They attract notice, stir up interest, and remind us that Life and Art get separated, like Art and Industry, unless many and various connecting-links hold them together as allies. As a rule, too, etchings and pictures of public architecture should be united to the people's customs and manners.

In Brangwyn's rapid impression of "Notre Dame at Paris," a recent plate done out of doors, perennial architecture is foiled, with satire, by a democratic orator who, with banners raised between the showers of a fitful day, promises a new earth to a throng of ideal statesmen dawdling with their votes among sudden shades and flashes of sun-light. The masons who built Notre Dame de Paris were kings in comparison with these triflers who rise and fall on talk like balloons on gas. Across the top of one plate—"La Rue des Mauvais Garçons"—Méryon etched with a very fine needle some pathetic verses, so eager was he to put into words, as well as into lines and tones, his thoughts on life's contrasts and ironies It is for the same purpose that Brangwyn employs popular life as annotations to his etchings of great architecture Wit, humour, irony, satire, burlesque, pathos, tragedy, terror, with other condiments from the frequent hash that nations make of their opportunities, are present among the foreground figures whenever Brangwyn desires to place in quite normal opposition the littleness of ordinary men and the varied genius that venerable buildings represent from age to age.

In "St. Leonard's Abbey, near Tours" (No 206), an etching to be studied again and again, some tagrag and bobtail—caddish moments of humanity—enjoy fuddled high jinks at the foot of a noble but neglected piece of architecture whose style seems to date from the twelfth century This satirical humour is justified by much ill-treatment which so many ancient abbeys have received from bigots, tourists, reformers, farmers, and other ideal persons, all too self-imprisoned to notice the proud thoroughness that the Middle Ages treasured up in beautiful masonry, though everyone's life was threat-
150

ened by many a disease uncommon nowadays. Is there anything more touching than the contrast between the brevity of mediæval lives and the astounding endurance of mediæval craftsmanship even when great ruins are neglected?

"St. Leonard's Abbey"—it is a large print, 23⅞" by 29⅞"—should be put side by side with Brangwyn's study of Romanesque cloisters in a noble church at Airvault, Deux-Sêvres, a town remarkable also for a Romanesque bridge of the twelfth century, *le pont de Vernay*. Few etchings, old or new, blend together so much architectural might with so much original mystery, and there's little trace of those emphatic dark plots which Brangwyn is apt to use when he is greatly moved by decorative aspects of his light and shade. A religious ceremony has attracted to these cloisters broken mendicants of many sorts, with cloaked and hooded women who carry tapers.

All this human desolation is made real with passion, receiving more time and thought than Brangwyn has given to any other plate. Yet I am not drawn into the drama that this poverty and misery represent, and I must say why if the right words come. It seems to me

that these human figures, which express deep sincerity and grave meditation, come more from Brangwyn himself, his inner consciousness, than from that alembicating observation, that intellectual grip on observed character and other truth, which, when quintessenced and raised to the highest power, enable artists to reveal the heart's tragedies as well as great outward aspects of high drama. I believe, too, like W R. Lethaby, that " a characteristic of a work of art is that the design interpenetrates workmanship, so that one may hardly know where one ends and the other begins." In "Airvault Church," unless I misjudge it, workmanship and design, the whole motif and purpose, do not yet achieve complete oneness, as their human element is not yet quite whole with the architectural parts, whose inspiration has intense magic

I am touching now on a debatable subject, and for several reasons it is a subject that keeps me on delicate ground. But the interpretation of art cannot have any value unless it is quite frank towards delicate matters, offering with modest care for consideration those hitches and imperfect sympathies which arise now and again between devotees and their chosen artists. I remember the many months of thought that Legros gave to the figures in his noble plates on the Triumph of Death. He brooded over each plate, not with that cold after-thought which generally spoils inspiration, but with that developing fervour that most epic toil needs from the highest faculties of the highest minds. Legros was braced up and heartened by his conviction that he could not go far enough into the most wondrous varied mystery enveloping the brief seasons of his and our perishable years. One day he said to me : " There are two very easy things that I am tempted all the time to do. I can put in too much with my needle-point, and I can leave out too much. A crowd is a crowd, so I must work within the spirit of my crowds, trying always not to express either overmuch or too little with lines I etch "

Again and again Brangwyn is face to face with these problems, and he seeks help of many sorts—from coloured papers, tinted high lights, rich translucent inks admirably blended, and other printing methods, full of thought and often most satisfying as producers of original and memorable beauties. And I am not perplexed when his chiaroscuro seems not to belong to our sun and our firmament of air, when it seems to come from his own mind, as Dante's awful other world came from Dante's; but, of course, art demands most

152

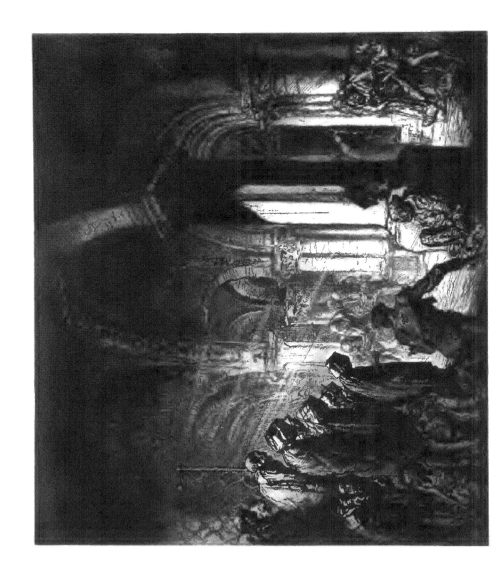

earnest realism in some of its parts when non-natural elements inform its appeal in other parts Shakespeare sketches with the utmost care his hard-handed men of Athens and his lovers and courtiers when he imagines his dream peopled with Titania and her fairies, because he knows that the human mind is apt towards the supernatural only within the companionship of real things and familiar persons. Other-worldliness needs our own worldliness as a balance and protector; and it is just here that Brangwyn, to my mind, loses some grip of his purpose in the Cloisters of Airvault Church

I know not how these cloisters are illumined, as I have never been fortunate enough to see in nature the mysterious light which he has imagined and then set free, as ambient as air, to transfigure all that it touches It touches all the proud, bold architecture, arched and columned shapes ; but the mendicants—halt, lame, blind, deformed, or depraved by suffering, with some other hostages whom fortune has kept and broken—these, I believe, are just a little outside the light and clash with it somewhat And I note also that this lighting, which appeals with so much charm and mystery to the imagination, was suggested by Nature and etched out of doors Yes, but Shelley's Skylark came from Nature, so did the Nightingale of Keats, and all poets of the world before their time had heard other skylarks and other nightingales Nature is what Nature becomes to imaginative genius. One day a lady spoke to Turner about the magician's colour "I find, Mr Turner, in copying one of your pictures, that touches of blue, red and yellow appear all through the work." "Well, madam, don't you see that yourself in Nature ? Because, if you don't, Heaven help you " Turner forgot that the good lady had but her own eyes, while he had his unique genius.*

<center>IV</center>

When Brangwyn, in 1906, discovered his own etched style by producing his " Old Houses at Ghent " (No 64), and when, two years later, by achieving " Old Hammersmith " (No 128), he improved this happy style—a duet between his own manner in pointwork and in printing—we all got from him a standard by

* " Airvault Church " is reproduced in this book, on a scale greatly reduced The photogravure gives a good many of the qualities, but not the original charm of F B 's lighting.

which to judge his later etched work; and a standard all the more valuable to us, and to himself also, because it was not hard and fast, not mannered and procrustean, but supple and plastic, and rich with possibilities His adherents knew that it was not a standard which he could repeat without a break. two lines of descent would come from it, one direct and graceful and one somewhat reactionary. Printing methods would be certain to have their own line of descent from those experiments with aquatint and foul biting to be found in several prints of the apprentice years (1900–3), and sometimes their development might turn pointwork into a maker of skeletons for the manipulation of inks to clothe with body and expressive light, shade, texture and vivid life.

Sometimes this development has occurred, educing very dramatic work, varied and original, with a long reach and a firm grip. The general aspect of "Le Pont Neuf, Paris," belongs to it partly, so does the general aspect of "Airvault Church," and that also of "St Peter's of the Exchange, Genoa" (No 209), a large and decorative plate etched out of doors. A religious procession is introduced with apt observation and allusive skill; it comes down the steps and across the foreground on our left, while many people either kneel in prayer or look on with reverence. Here and there deep shadows full of detail clasp the architecture, and a slight and effective undertone is put on the plate with acid in a manner discovered by Brangwyn This etching is a very acute, perceptive study, coming from a technical inspiration of a piece with those that appeal to us from a Brangwyn impression in rapid and flowing water-colour. It may be bracketed with "St. Nicolas du Chardonnet, Paris" (No. 208), an original old church, built in a style that somehow recalls F.B.'s own power. But generally I prefer those prints that come by the more lineal descent from "Old Hammersmith" and the "Old Houses at Ghent"; and since this chapter ends my present endeavour to interpret as loyally as I can what a rare genius has done with etching tools and inks, I wish to sum up what I see and feel in both groups of prints, in so far as they concern this chapter. And let me say that I do not look upon printing as the mere manipulation of inks— a technical matter that concerns a good printer. It is on inspirations and general aspects expressed with the service of inks and printing that an interpreter of etching has to fix his attention.

We start out from 1910 with the Messina earthquake prints—a set of etchings unique in several ways, but mainly because it reveals

154

what a tragedian artist feels when he stands among awful ruins thronged with death by one of Nature's convulsions There are seven Messina plates, and only one is what I take to be something of a truant in general aspect from the "Old Hammersmith" standard. It is a Martin-like vision of the wrecked Duomo, seen from outside, with a vague crowd on its knees in prayer around the apse, a bluff and haughty structure, while a sky burdened with smoke eddies and gleams, and the sun sets gloriously, as if no unusual event had brought horror to our world This Duomo is reputed to date from the Norman period and the year 1098 More than a century ago, in 1793, her campanile and transept were overthrown by earthquake, and in 1908, when Brangwyn made his many sketches and water-colours, much else had just perished, leaving only portions of the façade and the apse, which stood above an earthquake's terrific ruins as mediæval fortresses used to hold out in provinces overrun by a foe who spared little that could be destroyed. Though the plate is full of pointwork, close and potent, its whole conception is a mono-chrome painting, and it is printed with greater force than F. C. Lewis put with aquatint into Girtin's noble "Rue St Denis." In general allure this print is Martinesque, and I ask myself whether the shade of Charles Lamb likes it better than Lamb in the flesh liked the stupendous architectural designs that John Martin erected somehow in a world of his own creation

The other Messina prints also are remarkable for thoughtful print-ing, as in the surging waves of smoke that pile themselves up against the sky beyond the white Via del Trombe, a skeleton street littered with beams and rafters, a rescue party bearing away a dead body recovered from the havoc, and on our left, white against the sky, a ruined monastery, one of Santa Teresa's More memorable still are the "Old Houses at Messina" (No 150), a vast pyramid of ravaged walls flanked by a forlorn arch, and crowned at tiptop by two almost snug little rooms that look like dovecots a trifle startled. Looters and rescuers are at work, and looters are the more numerous, for they run off with violoncellos and other things that virtue would forget after an earthquake Dean Swift would have liked such mordant satire. He had no love for tiny and trivial human beings; and here an earthquake seems to invite satire, being more picturesque than terrible in the aspect of gaunt ruins Here, too, we owe much more to the etching-needle than to clever manipulation of able printing methods.

One Messina plate is called "The Church of The Holy Ghost" (No. 151, 28¾″ by 22¾″) The church is in the mid-distance on our right and overawed by a formidable sky, and by a huge, yawning house that rules over the etching with Dantean power. Very gladly would I delete some human figures from *this* wreckage, this grand tragedy of the ruined inanimate. Man has no rightful place here. He has been routed, and an earthquake reigns posthumously among her sepulchres of desolation Any animate life would be more impressive than that of feeble ordinary men, with their long ladders and their straggling much-ado. A pack of dogs baying to the hot sun, or rats in marching order emigrating from the ruins to a home unknown, would be more concordant with our artist's grand realization of human futility when Nature sets to work with her high explosives. Viewed as a whole, however, this great work is true incantation It employs no jugglery.

Only a few monuments were uninjured by the Messian earthquake. No harm was done to a Monument of the Virgin, the Immacolata di Marmor, a tall shrine of the seventeenth century, and Brangwyn represents it surrounded by adoring outcasts, modern houses behind, bleak, dark, and shattered, with empty windows through which a sunrise glows Human figures are welcome here, the inspiration being one of prayer and self-fear, with hope at a nearing distance In this plate greeny-gray ink is employed, and the shrine receives a golden light from the dawn—that perpetual spring in time's rough journey from the eternal old into fresh variations of life's hackneyed logic.

Then there is "The Headless Crucifix" in a ruined church at Messina (No. 152). As a rapid sketch it is finely seen, it is deeply felt, it is most expressive and apt; perhaps too expressive in two foreground figures, newsmongers, one of whom has a bald head and a back that smirks in a courtier's bow. And this irony is foiled by the undamaged pilasters carrying a round arch above the crucifix

As for the "Church of the Sta. Chiara del Carmine, at Taormina" (No 153), it has a somewhat splashy handicraft which looks slightly boastful to me, though not a braggart like the sketchiness to be found in a ragged and corrupt old bystreet at St. Cirq (No. 198), where three men are whispering such plots and plans as Eugène Sue would have liked to concoct for reprobate alleys and lanes past praying for. Similar qualities mark a few recent plates. There is the "Porte St Jacques, Parthenay" (No. 203), and "Notre Dame at Poitiers"

156

(No. 201), both effective, but I prefer the controlled technique of "The Headless Crucifix," or the study that enriches some old houses at Meaux, a tannery at Parthenay (No. 202), or a handsome and elderly café at Tours (No. 205) And there's "A Street in Puy"— a genuine "find" What fancifulness the old French builders often massed together as into a mosaic of quaint architecture!

Everyone knows how apt Brangwyn is when he sketches at what I may call high sprinting speed, covering a mile at a pace that other men might find too hot in a quarter-mile A retentive memory for shapes, colours, general impressions, aids his selective eyesight that detaches observed things and their effects *at once* into a sort of magnified focus, and these two natural gifts, stimulated by practice and experience, nourish his Iberian sensitiveness with excitants, and set in motion a hand that unites unusual grip and vigour to a swiftness unrivalled among artists of our time For years we have seen these productions of his genius, there's nothing unfamiliar to us in their nimble-footed qualities, so muscular and well-nerved, and hence he does well from time to time to explore quieter moods and more meditative inspirations.

Thrifty dry-points would be natural off-shoots from "Old Hammersmith," so would bitten work in pure, ripe outline, and his followers everywhere would value them more than they value even "The Gateway of Avila," a masterful sketch in a familiar mood and method. Such vehemence as that which informs the nefarious alley at St Cirq. (No. 198) is less attractive than "A Back Street in Naples" (No. 191), because it has no self-denial; and even this "Back Street in Naples" seems to come—not from the most meditated parts of "Old Hammersmith" and "Old Houses, Ghent," but —from looser portions of their handicraft. Though a very good *croquis*, it does not extend our knowledge of what Brangwyn can do

157

when he multiplies himself, or what he has done and should do with his etching-point

Let us look upon the best work of genius as the voice of an original artist, a dual voice, physical and spiritual, and let us believe it is a truism that genius should never be set either to overdo its natural notes and harmonies or to neglect any weak note that can be strengthened and improved. Every genius has weak notes, with imperfect chords and timbres, and always they are very noticeable in prolific geniuses, like Rubens among painters and Sir Walter Scott and Dumas among imaginative penmen. They are noticeable also in Brangwyn; and since 1910, side by side with many varied productions that the world will not let die, he has done much that I describe as his daily journalism, because it is to his racing hand what newspaper articles are to H. G. Wells and to Arnold Bennett

Are we to believe that prolific painters and etchers are as fortunately placed as prolific writers? It is right to remember that they give hostages in gilt frames to fortune Their journalism is kept, it is sold at auctions; so it does not come and go with a day, like volatile party politics that flow into newspapers from some of our novelists. Portaels said to me one day, speaking of a prolific painter, "I've told him not to forget that frequent sketches when sold continuously are to a reputation what barnacles are to ships. They collect upon it, they clog and hamper it, and may send it all at once into port— perhaps to be neglected, perhaps even to be regarded as out of date." When I think over these excellent words, I cannot help believing that it is from patient moods, apt self-denial, that Brangwyn now adds new good villages and towns to his own kingdom.

His cyclopean "Gate at Naples," with the graceful and lofty church behind (No. 172), is a descendant from that which is best in " Old Hammersmith," and the contrast between it and the suavely rich and sumptuous " Bridge of Sighs," or the nobly-handled framework of " Building a Ship " (No. 195), comes from a dramatizing aptness of judgment which a master hand cannot employ too variously. It is this gift that makes Brangwyn a master of crowd aspects. He understands human moods when the crowd temper sways them, and now he has to prove that big figures also can be put well into large etchings charmed with great architecture

Those men who live with mankind after they are dead, and whose shades might often revisit our world if our adulation did not shock

158

their humility, are the men of genius who teach us to see in men of a day what is human for ever, and also how artists can and should make wise concessions to common men and harassed lives When Brangwyn is not at his best it is never because he has any scorn for those to whom he appeals. No artist can be freer from æsthetic snobbery, with prattle about sweetness and light, and Philistines and vulgar tradesmen, and sordid city men, and so forth. His whole life is given, and has been given, to the reunion of art and ordinary people; and hence he agrees with W. R. Lethaby, who is always thoughtful.—

"It is a pity to make a mystery of what should be most easily understood There is nothing occult about the thought that all things may be made well or made ill A work of art is a well-made thing, that is all It may be a well-made statue or a well-made chair or a well-made book Art is not a special sauce applied to ordinary cooking; it is the cooking itself if it is good Most simply and generally art may be thought of as The Well-Doing of What Needs Doing If the thing is not worth doing it can hardly be a work of art, however well it may be made. A thing worth doing which is ill done is hardly a thing at all. Fortunately people are artists who know it not—bootmakers (the few left), gardeners and basketmakers, and all players of games. . Our art critics might occupy quite a useful place if they would be good enough to realise that behind the picture shows of the moment is the vast and important art of the country—the arts of the builder, furniture-maker, printer, and the rest, which are matters of national well-being."

More than any man of art in our time Brangwyn merits our gratitude, and invites return visits from us all, since his work in so many versatile ways roots itself among needs of everyday strife and the restoration of British workmanship We leave his etchings now for other productions, all springing from his passion for life as it is, that noisy welter of human toil and effort which is foiled often into such sinister and tragic aspects by a sweet serene grace nestling with the ages around old village spires and towers, and around minsters and other churches, soot-begrimed, in our commercial towns and cities
It has been suggested that I have used the word "art" too many times. It is a word staled by misuse, no doubt Theatrical companies are noted for their art, like music-halls and orchestras Is it not true that chorus girls could not believe more firmly in their art if they were spoiled sopranos? Even a hurried barber, who shaves

you' till blood comes, a notable experience, consoles himself by assuming that his art may rise through blunders into skill. Perhaps the word "artist" may become popular as a synonym for "man" and "woman," though not, I fear, for "mother" and "father," as mothers and fathers are never mentioned among to-day's artists I wonder why. Is it because they *do* create? Is it because their babies have wee hands beautiful enough to defeat Phidias and Praxiteles?

Yet this word art, misused as it is, has the virtue of being crisp and short; and if we accept it as meaning all good work done well for a nation's honour and service, we cannot do harm, nor can we invite ridicule. Mr. A. Clutton Brock, an inspiriting writer always, believes that the word "design" has a more precise meaning than the word art. No doubt he is right, right in the main; but good design as good workmanship can and should come from quite ordinary talents that take loving pains, while art in the higher sense comes only from true genius. Let the word art be design and genius also. Then small men and great men will be united by a common respect for thoroughness

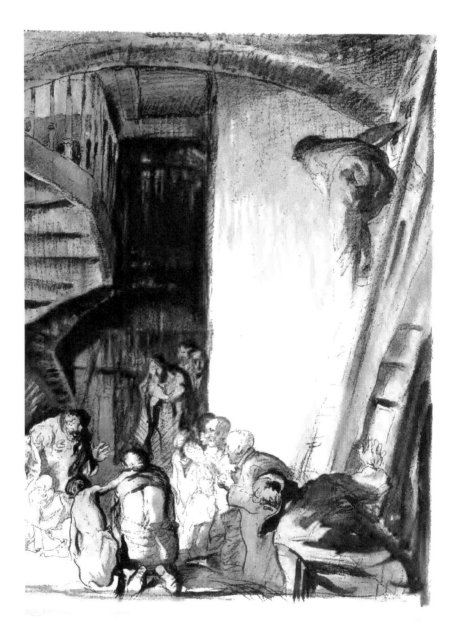

"THE NATIVITY"; STUDY

After Waterloo, in all matters of self-defence, her civilians fell half-asleep; after the Crimea, with its muddles and its frostbitten bravery, they repeated the same folly; and again also after the Boer War, despite Germany's braggart policy, with warnings from British vigilants led by Lord Roberts. Is there to be yet another repetition after the present cataclysm? Yes—if men of genius do not act together and prevent its coming. There have been so many harmful strikes during this war, and the public has bemused itself with so much canting make-believe, and has thronged with such eagerness to rubbishy plays and amusements, that we have no right to suppose that ordinary civilians have been transfigured since 1914. Englishmen returning home from Ruhleben have been greatly shocked by many of London's aspects; and at the beginning of 1918 a noble protest was written and printed by a veteran genius, Mr. Frederic Harrison, who, after five years in Bath, returned to London —

"How odious is the rush, the scramble, the roar of the many streets,—far worse than in 1912 . . It shocks, wounds, disgusts me, as if, with the poet, I were in one of the circles of the Inferno. Modern mechanism has brutalized life And in this rattle and clash and whirl, wild luxury, games, shows, gluttony and vice work their Vanity Fair with greater recklessness than ever. As I walked about streets blazing with gems and gold, and every form of extravagance, I asked myself—and is this the war for very life of a great race? If the Kaiser could come and see it all, he would say, 'I shall conquer yet, for all they threaten me!'" *

Even a little imagination would make such silly vice impossible. It would bring before all reputable minds the exalted sacrifice shown by young men from day to day and month to month, while we at home benefit It would humble us into reverence; and it is equally true that if ordinary men and women are to possess the right forethought and the right magnanimous sentiment, those who are not ordinary, but extraordinary by inborn qualities, must set and keep lofty examples As Lord Morley has written: "It is a commonplace that the manner of doing things is often as important as the things done. And it has been pointed out more than once that England's most creditable national action constantly shows itself so poor and mean in expression that the rest of Europe can discern nothing in it but craft and sinister interest Our public opinion is often rich in wisdom,.

* *Fortnightly Review* for January, 1918

but we lack the courage of our wisdom. We execute noble achievements, and then are best pleased to find shabby reasons for them."*
So it is imperative to cry out always for a quality known as grandeur, and also for candour and prevision, qualities that slay cant and herald grandeur alike in thought and expression and action. Nearly all problems to be solved after this war's ending— enormous housing

problems, for example, and habits of inferior workmanship—take their rise from a talkative self-deception eager to be gulled by phrases and unwilling to be worried by untoward facts. Year after year plain duties have been put aside as of no account, while games and other amusements, such as fads and illusions, have fired our national enthusiasm. Work has not been viewed as fair or unfair play to the nation's present and future. It has been looked on as a thing of wages and incomes, accompanied by strikes, much slacking, and a vast production of mere rubbish.

In book after book on British homes I have put these facts in italics, and to-day Mr. Clutton Brock makes the same appeal for national honour shown in reputable workmanship. Mr. Brock says with blunt candour: "You cannot have civilization where the lives of millions are sacrificed to produce rubbish for thousands who do not enjoy it when it is produced. That means a perpetual conflict growing always more bitter until it leads back to barbarism. This is not a political matter, and it cannot be settled by a political struggle.

* *On Compromise*, pp. 9–10.

163

So long as a workman has to produce rubbish he will not be satisfied with his work or with his life, no matter how large his wages may be or how short his hours . . Therefore the public, when they buy rubbish, are not merely wasting their own money, they are wasting also the lives of men and fomenting a profound and dangerous anger against themselves "

For thirty years I have worked for the same creed, advocating many practical things. For example, every town should have a showroom where the best work done by the town's craftsmen could be seen and studied, and townsfolk everywhere should be organized against a dual tyranny, a tyranny of excessive rents and jerried houses, foisted upon our public by unfair speculators, who are often aided by house agents * Men of genius alone can lead with success both in these and in other needs; they should begin at once to form a league for the common good and to make fitting plans The Design and Industries Society seems to be a vigorous young body around which they should rally, and each should add to the common stock his own experiences of public neglect and official blundering.

Brangwyn's experiences would be invaluable. Let me give in brief just two examples chosen from many. He offered to do as a gift a large decorative painting for the Victoria and Albert Museum, yet his good public spirit, which in France would have been welcomed with joy and gratitude, was put aside by bureaucratic sleepiness And then an American city commissioned him to paint for Cleveland Court House, Ohio, a great series of historical pictures! Only old-fogeyism among sleek officials, or a nation that has passed her prime, would send our Brangwyns to Panama Exhibitions, Cleveland Court Houses, and other foreign places, when they ought to be collected for Labour Halls, and Seamen's Clubs, and other popular institutions at home Good heavens! Are we so rich in brave mural paintings that we can afford to send a rare genius to colonize among other nations? Is national welfare never to have a fair chance?

Again, for a long time Brangwyn has given much thought to many aspects of our streets, because he sees clearly that the decisive test of the common good is to be found—not in Acts of Parliament, and not in words written and spoken, however just and impassioned, but—among outdoor citizen facts, in new architecture that great cities accept, and

* It is a wrong principle that grants higher pay to a house agent who helps to raise high rents or to keep excessive rents from falling. House agents ought to serve householders, and their pay should be regulated like the fees of family doctors

in other signs and tokens of street-bred customs and manners, such as the degree of liking shown toward venerable buildings. Phrases are apt either to rise into illusions or to sink into popular fudge, while outdoor facts are so evident as witnesses of current social character, or want of character, that even blind men can feel their presence

More than once, as at the Coronation of King George, Brangwyn has wished to show his solicitude for London streets by fitting some of them for a national festival; but his zeal in this direction has encountered official politeness, delay, evasion, and what Milton describes with scorn as "a queasy temper of lukewarmness." There is a great deal to be shaken from lethargy, and there are many to be broomed out of office, if men with genius are to be free to act as doers and inspirers of public work well done.

CHAPTER XII BRANGWYN, LONDON, & NATIONAL WELFARE

I

arly in 1917, while pressmen raised their eyes from bad war-maps and prattled rosily about spring and summer campaigns, I took a holiday for about five weeks among London's minor highways and meanest byways. Have you tried this holiday? It is good enough to be an obligation upon us all, and especially upon Cabinet Ministers and other politicians, who should pass through its many lessons before they ask us to regard them as rulers and statesmen It was my aim to see what men of Brangwyn's metal might do for the capital of our Empire if they held a Congress year by year and told frigid truths about that leprosy of meanness, that sinister populace of wretched ill-bred streets, by which our city is hugely blotched.

Bleak and bad weather threw its chill upon me, sometimes damp like a half-frozen sponge, at other times a splashing puddle of sticky mud; and now and then it was foul with a repulsive mist or tentative fog, a noisome twilight dishonouring even to the down-at-heel shabbiness through which I made my way as an explorer of London's bad workmanship.

Here and there was a fully modernized public-house, a flashing strumpet in Thirst's own realm, plying her trade with a gaudy leer of invitation. Many a kinema show gathered an audience too poor to be clean, yet well enough off to be swift after pleasure; and many a minor highway, broad, noisy, tumultuous, and reeking with shabby business, was multi-coloured with motor-'buses, with traffic of many sorts, and pleading shop windows, all overthronged with ill-arranged things and vainglorious advertisements.

There seemed to be no intellect anywhere, but just an automatic rush and roar, with a peculiar barbarity all its own. Had true Citizenship really lost even that personal dignity which many savages keep in Nature's wild presence? Had it become a mechanism for earning money anyhow by means of rival competitive routines? Very often pavements were blocked with competitors, and roadways were congested with their twin tides of routine movement, causing me to think of human bodies when phlebitis clogs their veins. But yet a

pilgrim through meaner London learns very soon that busier highways are least educative, having so much in common that they are commonplace, at least more often than not. Downgoing districts and byways have more character, as a rule, more personality; and among these slums I found many examples of that wastrelism in brick and stone and poverty that our overgrown city has accumulated. Though I walked at random wherever I could see dirt and gloom and what looked like the depraved picturesque, not an adventure came to me. Perhaps a shabby overcoat and cap gave me right to go anywhere as a native; but certain it is that I received no insult, nor did I see much drunkenness. I passed through so many housing problems, new and old, that I gambled in guineas by the hundred million when I tried to estimate how much it would cost to lift up the seemingly bathless portions of meaner London, and to give them for disciplined use rational decencies of a true home life. Our London County Council would do useful work if it could make known as a public penance how many baths London houses possess, and how many times they are used weekly My pilgrimage took me through several neighbourhoods where stench from a crowd remained as acid in my throat, and I remembered those medical men who, when examining unclean recruits for our Army, had suffered too much through their noses to be fit for their diagnoses. Dithyrambs about freedom and progress are all very well, but a prelude of cold truth about soap and water is better sense and patriotism

One pretty episode full of pathos I did see—in a foul corner of a grimy suburb. Just before dark I came upon five dirty little girls, not more than six or seven years old, who, while dancing slowly in a circle, shrilled the first verse of "Onward, Christian Soldiers." The wee things moved like clockwork figures, and sang like gramophones, no feeling lit up their worn faces; and their circular dance went on and on, with a quiet sedate rhythm, until some pennies put buns and toffee into their minds How had it come to pass that, in the year A.D. 1917, and in the wealthiest city of the wealthiest Empire, I should find these half-starved children and their drotchel suburb, while a thousand noisepapers and more boasted over mysterious things called civilization and freedom? And thought being as free as wind, I wanted to know why a nation that looked on at strikes while a war was raging to preserve her life, had never known a down-at-heel district which put aside its tools for the orderly purpose of advertising its vile lot as an outcast from proper citizenship.

167

II

For a long time I feared to summon before my mind, in sharp focus, a great many horrid impressions, and this fear of seeing hateful truth clearly had its rise among several harrowing things. I had seen far too much that was tainted and unsound, and pregnant with ill-omened prospects. Day after day a most untoward word came into my mind, a descriptive word that patriotism rebels against fiercely, because it is to living affairs and a body social what the word putrescent is to dead bodies. If eye-evidence compels us to believe that big parts of a capital city are decadent, how can we help feeling that decadence is in complete antagonism with our country's future? But when I knew that homecomers from Ruhleben were startled by many of London's aspects, and that Mr. Frederic Harrison had put into plain words his disenchantment, I drew together into a ground-plan my facts and impressions. Things that foretell nothing at all good cannot be examined too soon, since an autopsy is apt to come if a correct diagnosis be put off too long.

As I went from a gloomy neighbourhood to a sluttish district, and watched the cringing zeal with which edition after edition of our incessant noisepapers trafficked for pennies with scraps of war news headlined and magnified, it seemed to me that business was baseborn cynicism. Since then, from a large poster, Sir William Robertson has asked the people not to put overmuch trust in material chariots and horses, and Sir David Beatty, following Lord Roberts, has pleaded for reverence and a spirit that prays Not a trace of such thoughtfulness did I meet with anywhere in my wayfaring

Poster after poster, in words of journalese either too smugly clever, or flamboyant and odious,* missed the heart and soul of a vast war for life. Let us hope that only few of our war posters will be delivered down to historians. Apart from some pictorial appeals, among which Brangwyn's come easily first, our national efforts by poster and placard have been generally wasteful and confusing, at times frenzied and degrading, and too often mawkish and self-righteous. Democracy was to be wooed and won by coaxing, soothing, pleading, shrieking, and cringing

Each of us must judge from his own experience what effects were produced by pouring tropical journalism into placards and posters

* An example must be given. Here are four poster questions addressed by self-righteous cant to the Women of England, when "our liveliest publicity men" and "our most astute party managers" were trying not only to show the world "what free-

168

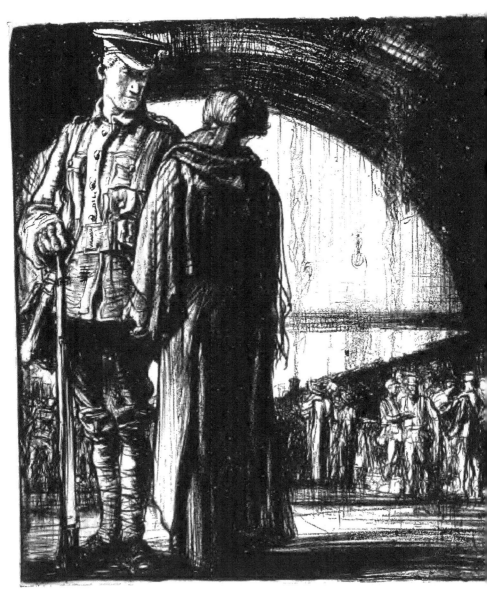

WAR CARTOON: "OFF TO THE FRO[...]

for our streets. Often the well-to-do tried to believe that perhaps, after all, democracy might need such appeals; but they were wrong as a rule. It is the half-illiterate, not the genuine poor, on whom good work with its quiet candour and honesty makes but little impression. Artists of every sort would much sooner try to influence a public of genuine poor than try to sway with their best work either the half-illiterate or society dilettante split up into groups and sects. Poor folk were not often attracted by screaming and caddishness from bad posters. As Mr. F. S. Oliver has said. "The simplest and least sophisticated minds are often the severest critics in matters of taste as well as morals. And this [poster propaganda] was a matter of both. Among townspeople as well as countryfolk there were many who—whether they believed or disbelieved in the urgent need, whether they responded to the appeal or did not respond to it—regarded the whole of this 'publicity campaign' with distrust and dislike, as a thing which demoralised the country, which was revolting to its honour and conscience, and in which the King's name ought never to have been used"

From this antithesis of true art, this diffused weak judgment, have come many mistakes in propaganda, statecraft, and social discipline. Consider three:

1 It was believed that journalism, either flaming or hysterical, would be much nearer to democracy than art in cool and quiet management—that is, than sound work done with judgment and pride for given purposes and known places. So art and artists were generally snubbed and flouted.

born Englishmen would stand," but also what freeborn Englishwomen must do if they wished to save Government from the perils of governing boldly and wisely —

"1 You have read what the Germans have done in Belgium Have you thought what they would do if they invaded England?

"2. Do you realise that the safety of your Home and Children depends on our getting more men *now*?

"3. Do you realise that the one word 'Go' from *you* may send another man to fight for our King and our Country?

"4. When the War is over and your husband or your son is asked 'What did you do in the great War?'—is he to hang his head because *you* would not let him go?

"Women of England! Do your duty! Send your men *to-day* to join our glorious Army"

Was there ever before in this world such caddish appeals during a war for a great nation's life? To coerce women by posters rather than use an equable compulsion ordered by Parliament for the purpose of enlisting men fairly! What will historians think and say? Will they like our wondrous national virtue as volunteers in a noble and peremptory cause?

2. It was believed that words, inevitably, were more democratic than form and colour and fit design, as if our nation's memory for words were boundless.

3. And it was believed, too, that our streets were—not open-air exhibitions of concrete workmanship, in which worthy pictorial appeals had an increasing value, but—mere offshoots of our noise-paper press.

Artists of every sort were most eager to help as orderly and reasonable patriots, but the tyranny of words, words, words, held office. For instance, a Committee of Architects, who represented their profession entirely, prepared a scheme for building military huts, with able men of known name attached to it for all districts in Great Britain; but this work had one drawback. It was not an apotheosis of amateur much ado and haste; it was only a work of true art, thorough, entirely fit for its purpose, and therefore as frugal in its costs as it could be made without ceasing to be the sound and appropriate work called art. When delivered at the right quarters this fine scheme was praised; and yet officials made no use of its excellence, though military huts were built by hundreds. Let soldiers declare how, and officials at what cost. To be employed by those who rule, or misrule, you must be of their company. How often in modernized affairs do bounce and brag displace brain and honest workmanship?

Again, Brangwyn was eager to fix his mind upon doing fit recruiting posters as a gift in national service, so he tried to bring his desire to Lord Kitchener's notice. With what result? He was told to apply to the advertisement department of our War Office. Advertisement departments are right enough for pills, soaps, jerried furniture, dead editions

170

of encyclopædias, and other selling virtues in need of electrical overpraise; but a great nation's grapple for life needs untiring thought with candour, truth, dignity, true inspiration, and some other qualities also that "the livest publicity men" don't welcome often as marketable blandishments. To send a great artist to a publicity department is like asking a Tennyson to write puffs on Green Gloves for Girls of Garrulous and Gracious Forty, or Scarlet Soaps for Sinners, Sane and Insane.

Even our War Correspondents have caught the publicity craze, collecting oddments of news likely to glut a morbid appetite, while harrowing anxious and thoughtful persons They have written columns each during a day's fight, and have told us daily what we all know—that our troops are as brave as their forerunners, and thus as brave as the brave can be; while they have put out of mind the need of war perspective and the imperative duty of teaching us to weigh and measure our foe's generalship and his fighting power All along the line, in fact, publicity has implied that a war for life must be connected somehow with kinema shows and the sale of patent medicines, though the greatest peril of war is that it sets in action cerebral disturbances harmful to cool thought and right balance

If the publicity campaign had been put under the control of true artists—painters, sculptors, architects, men of letters, and some women of genius also—no flamboyant and crapulous methods would have been tolerated, and our native land would not be ashamed to hand on to posterity how and what her people advertised while fighting for her life as a free old nation.

How can it ever be wise to banish our national dignity into a Barnum show? Even Whistler's portrait of his Mother—a great act of filial piety, which seems too private to be well placed even among masterpieces in a public museum—was turned into a war poster, so eager were "the livest publicity men" to flaunt their peacebred vulgarity. Yet Mr Lovat Fraser, a devotee of candour, has deplored *with a certain surprise* the wonderful capacity for self-deception which our country has exercized since August, 1914. Nearly all self-deception has come, and come inevitably, from journalism and its offshoot influences

A wit has said that things exquisitely English are almost sure to be entirely irrational, whether we see them in fights against huge odds or in national delay, indecision, and what not besides. As we make in war a game fight for life while keeping our old strikes between labour and capital, so among municipal affairs we are overapt to halt waveringly, yet complacently, in a zone parting "never mind" from civic pride and probity. It is a matter of bad custom, and often it makes fools of us all.

Beaconsfield mocked at the intermittent zest with which London had muddled her opportunities when she had tried to ennoble herself by means of building enterprise by Act of Parliament. Let us hope that his banter and ridicule will be used as guides, when, the war ended and renovation begun, town after town will try to keep labour strife as far off as possible by attacking many benighted housing perils, though abnormal prices for building materials will rule. Since we scorned with dismay the need of putting into Lord Roberts's plans a national life insurance of only five or ten millions *a year,** there may be a grave official wish after this war to get health and safety from some attitude of charming folly in wrong thrift towards our national housing affairs. To advocate, with plausible business pleas, the scamping of vast jobs for the people is easier than to bring into dominant favour the art of earning all the good that can be won out of civic and national reforms, because ordinary minds are at ease with hole-and-corner ideas, reasons, arguments, plans; and after this war, of course, money will be "tight," as some hundreds of millions a year, for who knows how many generations, will be spent merely as interest upon debts incurred since 1914.

There may be a tough effort by civil engineers to settle themselves among housing problems between architects and our people's welfare They are able men of their own affairs, these engineers; alert, confident, patient, bluntly persuasive, crisply suave; and if they wish to show that they can do overmuch with too little and for not enough, they have a case around which they can spin webs of seductive figures; but their successful diplomacy would be a bad thing indeed for work that counts as cottage and street architecture What we need, no doubt, is a Board of True Artists, with first-rate architects to have most sway within their own provinces; and we need also a

* At present (September, 1918) *daily* costs of the war come to about £7,000,000 ! Was the act of defeating Lord Roberts's foresight costly enough ?

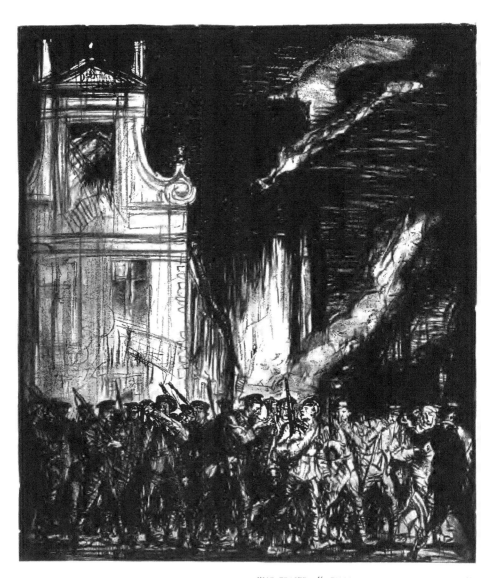

WAR POSTER: " BRITISH TROOPS OCCUPY DIXMUDE."

small Committee of True Artists not only to pass judgment once a year on London's aspects, but also to read its verdict, with its proposals, at a Congress open to citizens chosen to represent all districts. And other cities and towns need Watch Committees of this good sort. Not a town among those that live and toil amid our industrialized stress and strain has a general citizenship at all wide-awake toward streets as art museums for the people, where there should ever be a scrupulous regard for good work put in places where its fitness will be a public joy and a benefit. A public joy; for we need not be chilled by the
common belief that most eyes and most minds care not at all how much civic patchwork and muddle be kept in vogue. Though most people grow into bad surroundings, and custom reconciles most of us to bad habits, yet a change from bad to good among outward things and prospects makes its coming instantly felt by that inward life which is best worth living. Even caged birds love their improved lot if you take them from a dull, chill room into a sunny one. And as long as human creatures feel sunlight with joy, they have, and will keep, a capacity to improve, however sapped by un-toward influences their high interests may be.

Londoners have one great foe in their climate and another in their citizen character, which is diffused among many big townships and village communities by which our scattered nation-city is made up loosely. A climate bleak and wet, and often misty (when it is not soot-laden into fog), is in need of every ordered gaiety that wise management can get from colour—colour in architecture, in well-dressed shop-windows, and well-chosen posters, in letter-boxes also, and metal standards for electric light, in 'buses, motor-cars and trams, and in everything else where good taste can be active as a public need and boon under proper guidance from true artists like Brangwyn and Lutyens With a general improvement in colour aspects and

173

architectural aspects of London's streets there will come, and come
inevitably, a general improvement in citizen feeling for London *as a*
whole At present she is an enormous overgrown disunity of shreds
and patches, and also a place where a small income is often tragical,
as it cannot well afford to pay an average rent, with season tickets,
'bus fares, and so forth.
Yet these and other urgent matters are generally skipped over by
those who write and talk with fluent ease about improving London
Most reformers are apt to think that castles in the air are more ador-
able than rude spadework among workaday facts and evident needs
grown decrepit after long neglect. Reformers improve, or try to
improve, the better parts of London; are eager even to prattle about
beautifying our parks and public gardens, which bestow on London
all the sweet air freshness with which she smiles fitfully upon us,
but how often do they shock their gentle æstheticism by visiting
slums and faked suburbs and those sere, gloomy districts where in-
dustrialism has set up her quarters? Let improvement begin where
it is wanted most of all, namely, in those places where little incomes
and the poor make shift

<center>IV</center>

So a Watch Committee of True Artists would have a great many
things to weigh and measure during annual motor journeys through
London, accompanied by several photographers to collect camera
facts to be shown at a yearly Congress. Let us suppose that this
committee included Brangwyn, Lutyens, Derwent Wood, and four
or five other men of genius who link art with our common lot. Of
course I don't say that this Watch Committee is at all possible. Too
well do I know, after thirty-eight years in the strife of art, how
the reunion of art with the people and the people with art is hindered
by twin evils
First, most authority over London's art has been annexed by narrow
little sects, whose placemen find their way into all posts of honour in
public galleries and museums, and whose pride is envious when
earnest men outside their aims win and wield some influence There
are even officials in public galleries who write for noisepapers about
matters that affect the art markets. They call themselves art critics,
in fact, forgetting that no public servant has a moral right to influence
the rise and fall of prices by reviewing the work produced by
living men, men with families to rear and debts to be paid weekly
174

and quarterly. No official in our Treasury would be allowed to write for the Press on stocks and shares and companies; no official in our Foreign Office would dare to give tips in the Press to financial gamblers; and physicians have to give up private practice as soon as they become Medical Officers of Health. So it is utterly wrong that any man in a public museum should write on current art for the Press. There's no law to compel him to be a servant of the State, and he should be far too busy in his official duties to have time and physical energy for another profession also. His writings should be published by his department and should be sold at cost prices, or nearly so, for the people's benefit. More than once I have protested in print against this evil. When are the societies of art going to act for our common good?

Then there are certain groups of old fogeys—not all old fogeys are elderly, remember, nor aged—who get themselves upon art committees, and as naturally as oil circulates through grime on rusty locks. They have had long practice among devious tactics of talk, talk, talk. An international exhibition sets them agog with suave fuss and flurry (perhaps a Knighthood may be won); and if they wish to entangle a committee in a labyrinth of heated argument they know how to be as troublesome as they are smooth and polite and adept. In brief, they are stock committeemen by nature and training. Still, we can do no harm if we suppose that a good Watch Committee, with Brangwyn and Lutyens as essential to it, can be formed. Let us sum up, very briefly, some of its work.

Take the question of colour in architecture. William De Morgan gave much thought to this matter, and Halsey Ricardo, among others, has made valuable experiments along right lines; but, of course, good ideas must be ordered into a growing system if they are to have any progressive influence upon our streets. Lustred tiles for roofs merit wide consideration, for rain would keep them clean, and architects would be inspired to build higher roofs, and to put concordant notes of colour in walls and windows and woodwork.

Several sculptors have done in colour some very able ornamental slabs, with strong incised lines and a decorative charm full of breadth; and this and similar work would enrich many street buildings, and it would call attention also to the sort of business that a big firm carries on. A shipping office, for instance, should be known at once as a shipping office; a Board of Trade should bear on its façade decorative signs and tokens of its duties, and this right suggestion applies also to a War Office and the Admiralty of a great naval Power.

To be inapposite is to be weak and small, it slackens moral fibre and weakens a public feeling for public duty and high interests. We possess naval traditions the substantial elements of whose power are as majestic as they are far-flung over troubled centuries. Yet Londoners are not astounded that they have no heroic building that belongs evidently and with imperial art to their Navy and her traditions. Are they ashamed to be apposite and therefore great and free? And note how Westminster Abbey has been rejected as the cardinal keynote for all buildings in her neighbourhood. Where the Aquarium stood as an eyesore, an edifice has been built with pride by Nonconformists, but for what purpose none could guess from anything apposite in its architecture. Yes, a Watch Committee of true artists would have much to say about the patching of patchwork London Take the lighting of our streets as another example What a chance we have missed here for a great revival of English metal-work, both cast and wrought! We have a glorious light that could shine in peacetime through other substances besides glass, thus Alexander Fisher could apply one phase of his beautiful enamel to the globes of electric-light standards, and what is there to stop well-to-do households from lighting their streets in the aptest manner possible? They could ask a Brangwyn to design metal standards, and a Fisher to make enamelled globes; could have the standards cast or wrought by first-rate men; and their district would gladly accept the finished work as a gift to good citizenship. Then householders in some other streets would follow a good example, taking care to suit their needs in a manner concordant with the height of their houses and the dominant note of style in their streets' architecture. At present we get a dead routine in the place of workmanship that lives; mere metal instead of true art. Dull metal standards of the same sort and size, as a rule, stand in streets with low houses and in streets with tall houses, no fitness appears in their colour, or in the design that they show before great styles of architecture And why? Is it not

176

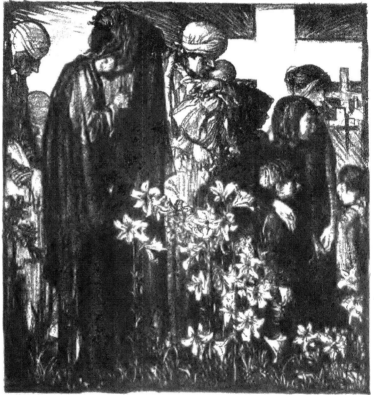

because they come from an official system, a municipal routine with little more aspiration in it than would clog the foot of a flea? Cardinal Newman made gentle game of that very "safe" man who adores mistiness as the mother of wisdom; who cannot set down half a dozen general propositions which escape from destroying one another unless he dilutes them into truisms; who holds the balance between opposites so adeptly as to do without fulcrum or beam; who never enunciates a truth without hinting that, as a person full of discretion, he cannot exclude the contradictory; and who feels he is marked out by Providence to guide a naughty world through narrow channels of no meaning, between the Scylla and Charybdis of Aye and No This dear man, wonderfully sober, most astutely temperate, ploddingly dull and insincere, is the man that feels at home among official routines , and his multiplicity accounts for our civic woes. He is the widespread foe that a Watch Committee of true artists would bump up against, only to find that he yielded like rubber and recovered as alertly

He would recover with a certain recoil of fierceness if candid remarks were made to him about slatternly displays all over London of scream- ing and pleading self-advertisers; for this very "safe" man is certain that a great capital city exists—not as a well-ordered legacy to be handed on, with fine improvements, to every new generation, but— as a mere hurly-burly for all who wish to flaunt their self-praise in streets, and fields, and against our unoffending sun, moon, and stars No wonder Brangwyn is amazed by the zeal with which London is defamed by business as usual, by the riotously precipitate self-praise of salesmen, who harm our streets and the sky without paying even a tiny tax to a city for which they have no true liking.

Not even a motor-'bus nor a railway station should be free to do just what its owners think profitable with a display of jumbled placards, posters, and other advertising It is part and parcel of our city, and dependent on our city for every penny that it earns , therefore it should be wisely controlled by good taste, and this good taste ought to be a municipal affair under the guidance af true artists As for public advertising of shoddy wares it ought to be forbidden, of course, and for three sufficient reasons To make shoddy is to debase work- men; to debase workmen is to injure our people, present and future; and to sell shoddy by advertising is as bad as to sell shares in a bogus mine by public appeal sanctioned by our city and by Parliament. Daily papers are very culpable in this matter, like our municipalities.

2 A

They have city editors on the look-out always for company sharks and isolated pike Have they city editors also to keep guard over the probity of advertising? No They advertise for large fees almost any shoddy that is not bestial and lewd Indeed, as often as not it is the shoddy-makers who advertise most profusely, because rates of payment for advertising are too high to be paid by those who invest money enough in good work quite fit for its purpose. And another point to be stressed is the fact, usually forgotten, that advertisers pay for the cost of their headlong self-praise only when their advertising fails. When it succeeds buyers "foot the bill," as advertising belongs to costs of production Consider, then, how anti-social it is to permit free trade in advertising King Jerry and his ebullient zeal

As soon as all ethical aspects of this grave national matter are well grasped by townsfolk, advertising of every sort will be put under fair discipline and will pay to towns or to our State a proper tax for the use it makes of our streets, fields, skies, stations, and what not besides Our newspaper press should pay a tax on every column of advertising matter that it circulates, and should be responsible to the Board of Trade if it accepts payment in order to help those who sell trash with lures of words and pictures

Yet these matters are only the beginning of order in a good fight for our streets and other public places A knighthood granted for modest veracity from an advertiser would be a great boon to our common good. Here and there a modest and a truthful advertiser is to be found, by rare good fortune. Recently Brangwyn has done several posters for a firm that has no more wish to work miracles than to pretend to be Shakespeare. It is content just to put its goods quietly before the people in decorative drawings to which very few words are attached; and these few words give simple facts modestly, not pleading lures noisily.

But there should be special places for posters of this good sort—and, indeed, of every sort, and these places should be designed by our best architects, built by our municipalities, and hired at reasonable fees to men of business after posters and placards have been accepted for publication by proper official judges. Let there be an end of go-as-you-please , of wild licence, with negligence from public opinion, and hubbub and lies from a great many advertisers. How can a city respect herself when her people don't take care of her? Is she a trumpery bazaar for any and every person who increases the

cost price of his wares by bawling self-praise from megaphone hoardings and scrap-album motor-'buses? Is industrial strife, called business as usual, to harden into a fixed routine, with never a protest from citizen high thought and right feeling? Let us have as soon as we can a great Board of True Artists, and a Watch Committee with a will to be thorough

One aim in thoroughness, as Brangwyn argues, would be the emigration of poster design from Trade to History, from lures put before buyers to appeals made to patriots. For children and our striking classes, youngsters of an older growth in wild oats, cannot see in our streets and public places too many fine posters and pictures wherein noble and inspiriting deeds from our history—naval, military, social, industrial, and philanthropic—are made real with a passion as easy for all folk to feel and grasp as a play well acted. Dr. Augustus Jessopp proved years ago, by his beautiful serene talks in most able addresses, that the English people are not dull toward great history when they find a chatty, charming teacher—a voice from bygone times in a big soul of to-day. And what words can do, this and more can be done by historical posters in our streets if they are drawn and coloured by artists of Brangwyn's metal. Every naval battle from our country's drama should be present in all minds as a series of pictures gathered from national appeals by posters, for example, since we are what we are because our seamen in their brave deeds have always been magnificently loyal to Our Lady of the Sea, to whom Henley sang with the right militancy.—

"England, my England.—
Take and break us we are yours,
England, my own!
Life is good, and joy runs high
Between English earth and sky;
Death is death, but we shall die
To the song on your bugles blown,
England, my own!—
To the stars on your bugles blown!"

Oh! If only we civilian English were worthy of historic England! If only we had that vim in self-denial that our seamen and soldiers take with their duty into hopes forlorn—and into hopes made real! Who can see, without an emotion quite near to tears, the sere districts that London has collected, or those Victorian and sinister "hives of industry" which have devoured many a thousand acres

179

from England's green lusty fields, where joy long ran high between English earth and sky?

If the glad temper of our old ballads is to be renewed by English people, and if Shakespeare is to displace trash plays as he displaced Elizabethan bearpits, true artists of all sorts must put passion into their varied work for reforms far too long neglected. Startling facts have been disclosed by the medical examination of recruits for our Navy and Army A percentage of physical decadence far too high is one price we are paying to slumlands and industrialism. To scorn the good work called art, then, is to sow seeds of national degeneration and decline.

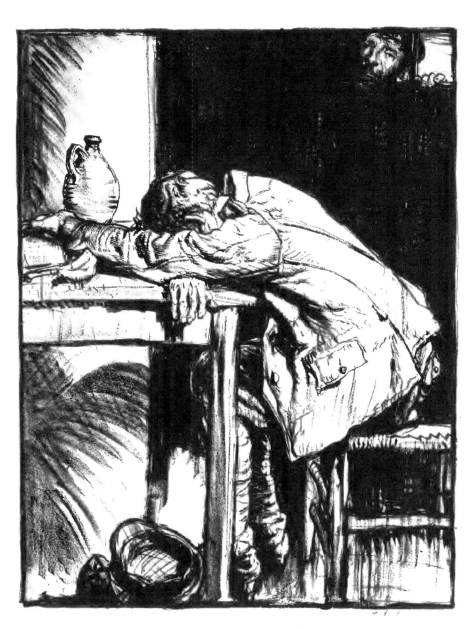

WAR CARTOON: "A SOLITARY PRISONER."

CHAPTER XIII PEACE AND WAR IN BRANGWYN'S POSTERS

I

e pass on to Brangwyn's posters, and let us note well the necessary principles by which the most genuinely social of all art pictorial ought always to be governed, however varied their application may be. For two reasons poster-work is the most genuinely social of pictorial art it appeals with definite aims to everybody, and it asks for no money from anyone who looks at it as good or bad work, and not as mere advertisement At its best it is to modern towns, with their industrial haphazard and their frequent apathy toward religion, a real restorative, though not what pictures in churches were during those generative periods called the Renaissance Brangwyn has done much to put high thought and a big style into recent poster-work; and he is most eager to do a great deal more if it be worth while; that is, if this most social art be ordered in a proper citizen manner. Then artists of standing, keen towards national welfare, can give enough time to it, and not merely odd hours or days for the purpose of aiding a good charity. Years ago Brangwyn made a coloured poster for the Orient Pacific Line, and summed up in it most of the simple principles by which all work for the poor man's art-gallery in our streets ought to be governed Its motif was a huge steamer, with some little craft not only manned by Orientals, but containing also some gay fruit symbols of Eastern lands to which the steamer went on needful affairs. Here is a subject that has a general interest; it stirs the drops of Viking blood in our veins, and it gives full scope to Brangwyn's ample and opulent fine colour, which at its best seems to be compounded of fruit, flesh, flowers, and feather hues, with good solid earth and the sky's visiting moods

Colour is all-important to poster-work, yet its popularity is not fully appreciated by many an artist who works for our hoardings and street galleries Puritans with their sour and fierce gloom, their pent-up and annealed virtue, sharp and slashing like steel, tried to cut out of our English character that old fondness for colour which softened a rude uncertain life during periods when smallpox and plague were most rampant, and when costumes were picturesque, and pageants

lively, and all good folk at May Day Festivals carried posies Romance and colour are elements of Gothic art and of England's younger life, and but for them, with the vivid and lusty national spirit that they helped to make real and to keep wide-awake, our Shakespeare could never have been what he was, for he and the drama were opposed by many a Puritan hothead like Gosson, who would have talked through his nose at a perpetual funeral if his will could have worked such a miracle Self-righteous talk remains with us, but its crape or contempt for colour, its Puritan dreariness has gone where the old moons go, seemingly Colour is greatly loved to-day, and in poor homes even more than elsewhere, perhaps During four years of this war, moreover, through many tragic months of bad battle-maps and gnawing doubts, all classes drew closer to the refreshment given by gay shop-windows and other public displays of colour A fine sculptor told me that he had noticed this fact in his own greatly enhanced relish for notes of good colour in many things which hitherto he had accepted more or less as a matter of custom, and I can give an example from quite ordinary hard-handed men.
One afternoon, outside a second-hand printseller's, I was turning over some portfolios in which were many oddment prints offered at prices from a penny to a shilling. A workman came up and began to search through the biggest portfolio Presently he chose four coloured pictures, which looked suspiciously like German chromos about thirty or so years old Though soiled they smacked me in the eye like a boxing glove flicked forward with a jab "You like bold colours that hit out," I said to him "Course. Don't you?" he asked "Need 'em in these days Pals dead, and two boys at the war. My missis won't be up against these pictels. Not she Do 'er proud they will—and me too." He thought for a moment, and then, with a touch of London's humour, "I dessay these colours *do* brag a bit and put 'emselves on strike, but where's the 'arm? They're a bit of all right these picters." So he paid fivepence each for them and went away with some chromo sunshine rolled up into a bundle
Colour, then, ought not to be omitted from any poster which makes its appeal to "the general," as Shakespeare calls public opinion, and to-day it is the General, our Commanding Officer, every Premier's Prime Minister How to use colour for posters is another question, and it receives a great many answers from Europeans and Americans.

Climate and national character have varied influence, of course In countries where torrid heat goes together with flashing light and gay colour, needs of contrast ought to produce sombre posters with sonorous black notes and chords, while the ebony frames of London's aspects can hold with cheering effects colour schemes as virgin and as rare as Persian illuminations, with their brilliantly seductive concords

Brangwyn is often something of a Persian in the magic with which he unites plots of monotint discord into beautiful original colour * None knows better than he, nor so well as he, how to use virgin pigment as Nature dapples ripening oats and wheat with flames from poppies and sweet serene chills from cornflowers. Tender gradations and most delicate transitions need not all the ado made by Whistler's evasive technique over lowered tone and far-sought mystery, they can be revealed also among most daring contrasts and by sharpening many an edge between light and shade and between well-placed patches of virgin pigment balanced into glowing colour by the right intuitive aptness, as in Brangwyn's "Trade on the Beach," 1894, and "Dolce Far Niente," 1893, where Southern women, half-clad in orange draperies, lie around a blue-tiled fountain, with a background of rich magnolia trees to give a muting concordance. With this Oriental zest for colour, but in simplified flattened tints, Brangwyn designed his first shipping poster; and there can be no doubt at all that his method and his colour effect were as lessons to most of the men who do work for our street galleries

His poster, too, got rid of that wordiness with which advertisers spoil the trade value of their self-praise. It did not promise you a visit to heaven in the Orient Pacific Line, nor did it extol the cheapness of fares (as if shipping companies were ideal philanthropies) ; nor did it praise cooks and food (as if travellers were to be angled for like trout, salmon, and pike) To get advertisers to accept a few humble words on a poster is a trouble to be overcome either by suave patience or by a blunt refusal to do a wrong thing. No true artist should be as a gramophone to any advertiser's vainglory—unless he wants to lose all self-respect Let him say outright what he will not do There's more peace in bluntness over matters of right and wrong

* In stained glass the leaden "canes" will harmonize discordant colours, and both gold and black outlines have the same effect in illuminations, and in posters also So these boundaries between unfriendly colours are peacemakers, unlike boundaries between rival nations

than in all the pacifists our epoch has known, and it is usually towards wrong that advertisers drift. "'Straight' advertising has become very rare," a Scottish advertising agent said to me, deploring a great decline during the present generation.

And some other essential hints can be got from the same poster; as, for example, that all must be seen at a glance without questions arising in the people's minds. A poster miscarries as soon as ordinary people say, "What is it all about?" "Is that a little girl or a small boy in petticoats?" "Where are the guns on this warship?" All questions of this variety show that a poster and its public are at loggerheads; and as Edmund Kean was hipped unless "the pit rose at him," or as comedians are unhappy when their "points arn't taken," so a poster artist should take his verdicts—not from his own criticisms, nor from those of other artists, but—from the streets to whose populace he has chosen to make appeal for the widest approval he can win. Let him stand near his own posters; if he looks at them attentively, then makes a remark to a passer-by, a small group of critics will soon collect and their candour is informing. I've tried this dodge many a time, and doubt if any poster artist—not even Brangwyn—has hit the people at all equally in a set of posters. And this observation leads on to a suggestion: that in this art, which fails if it doesn't attract and hold millions of passers-by, artists, like great actors, have more to gain from self-suppression than from self-revelation. A poster should be, not a print for a portfolio, but an abundant decoration for large and busy streets and other thronged public places; and hence an artist should adapt his usual style to evident needs and as attractively as he can. In his best posters Brangwyn illustrates these matters with an ample hand.

Then there's the importance of uncrowded workmanship, simple direct design, with plain spaces that suggest quietness. Example: if you hire the front page of a daily paper and cover it all over with a drawing deeply framed by words, you cannot expect to be anything more than a faked Autolycus, a bore, not an amusing salesman of trade's wares. Your drawing cancels the commercial value of your self-praise in words, and your words are so many that they cancel your drawing and worry the public's defective memory. On the other hand, place midway on your page a small square of ably-worded text, leaving all else blank, and your advertisement will magnetize readers. Everyone will wish to know what you have to say. Useless to shout when other advertisers bawl or shriek, and from this

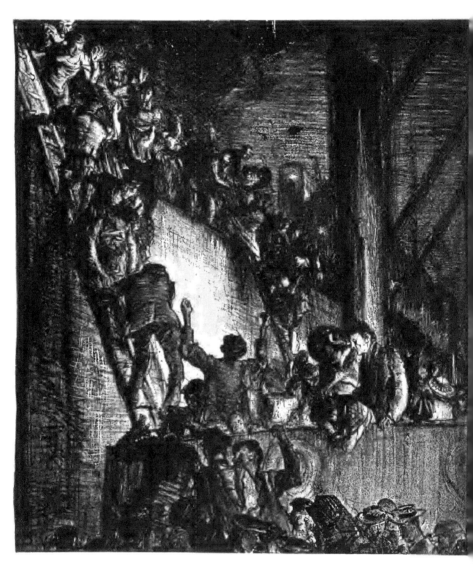

WAR POSTER: "ANTWERP: THE LAST BOAT."

fact and its varied application good effects by the million will be got when able artists comply happily with the needs of all advertising, whether by headline on "splash pages" or by poster on hoardings But let them keep before their minds yet another thing : that British people demand prettiness in women and children; they don't forgive a poster that offends against this need , and the very high prices paid for Birket Foster prove that prettiness belongs to our national home life as well as to our poster public. He who paints pretty children well enough to make his name in the hearts of English mothers runs the risk of becoming very rich while breaking his health with far too much work It is only in fun and farce that the poster public likes personal ugliness, but not in girls. Thus the Ally Sloper-like print of "Sunny Jim" was as popular as are Punch and Judy at the seaside.

Athletes are liked, so are soldiers in action, but not so much as Jack Tars, I think Sea battles and other marine adventures merit from poster artists a great deal more attention than they have won as yet; above all in episodes which have not been shrivelled by journalistic dissipation Next, as for notes of tender feeling, Miss Marie Lloyd has told us all, after reigning long over the music-hall public, that we are very sentimental as a people, not a hopeful fact among civilians who have to keep watch over an exceedingly scattered Empire. There is grit in the tenderness that younger Britain liked , it is real sentiment, not sentimentality, and touched quite often with quaintness and humour, as in the ballad about Sally in Our Alley But poster men have to take the public as it is, keeping a sharp look-out over those papers, magazines, books, plays, songs, revues, and so forth, which reveal most plainly what the people insist upon having as hobbies and toys and amusements Then let them try to do much better along the same lines of fun, frolic, wit, humour, ridicule, banter, love, courtship, courage, sensation, and what you please from life's enigma

I am keeping Brangwyn's best work constantly before my mind, with that of several other masters, French and British; and now a summing up of these qualities must be given, or offered for consideration. Whatever a posterist—can this word be used ?—may try to do, never must he be neutral, evasive, stricken by half-and-half measures And it is not enough to be positive and direct and colourful ; for a good poster, like a good short story (take *The Luck of Roaring Camp* or *Only a Subaltern*) should be art in a superlative

2 B 185

mood—not pathetic, but *very* pathetic; not funny, but *very* funny; not tragical, but *very* tragical, and so forth.

A final point. It is widely believed that ordinary persons, and above all hard-handed folk, wish to see in pictures and posters things far off from their lot and labour; and yet "shop" rules over most human interests. Sportsmen love sporting prints and pictures, for example, and sailors brood over painted ships, as women do over paintings of children. It is artists who open eyes blinded by custom, showing ironworkers (to take an example) what furnaces and casting are like, and miners what collieries are when half-naked men "get" their coal along dim, breezy roads fanned by a circulating draught. Note what Robert Browning says in *Fra Lippo Lippi* :—

> " For, don't you mark? we're made so that we love
> First when we see them painted, things we have passed
> Perhaps a hundred times, nor cared to see
> And so they are better, painted—better to us,
> Which is the same thing Art was given for that,
> God uses us to help each other so,
> Lending our minds out Have you noticed, now,
> Your cullion's hanging face? A bit of chalk,
> And, trust me, but you should though ! How much more
> If I drew higher things with the same truth !
> That were to take the Prior's pulpit-place—
> Interpret God to all of you ! Oh, oh !
> It makes me mad to see what men shall do,
> And we in our graves ! This world's no blot for us,
> Nor blank it means intensely, and means good ·
> To find its meaning is my meat and drink "

It follows, surely, that Brangwyn's research into this world, his epitome of industrialism, and his varied aspects of sea life, offer excellent material for useful and popular posters in a great many phases

II

Posters, then, when considered apart from trade advertising, have as distinctly a function in the common weal as any other phase of thought and action by which good things fit for their uses are made essential to the national welfare These duties need incessant help from first-rate advertising, too, which is to the distribution of made wares and raw materials what steam and electricity are to movement from machines, such as railway engines ; but advertising, as we have seen, is rarely first-rate, often it is very bad, a mere letting off of steam by inept self-praise. Unless artists run counter to this evil and

186

its national effects, posters are but menials to conceited salesmen, and we are face to face with dereliction of public duty on the part of those who design posters and of those who commission work for our hoardings

And we must go farther than this point. Let us not, because we deem a thing to be useful for our own brief day, a few current hours, act as if we believed that it could never be useful for ever All things in their spirit and purpose are useful for ever if they are evoked by that deep sincerity, that passion for thorough effort, which all good and fit work makes real in concrete things A young poster man said to me, " Of course, I don't give much time to this work—throw it off as quickly as I can, you know. It's for a day or two in the rain, and hooligans may scribble dirty words and jokes upon it Trash to sell pills, but it helps to keep fire under my stockpot " These excuses for dishonest work belong to an old cynical inertia named "After us the Deluge " If the time has not come for posters as good as the most able artists at their best can design, it never can come, and most of our streets and stations, with a vast number of our fields and sky scenes, will be disgraced merely for the purpose of selling work of any sort, however scamped and shoddy

Again, take the case of war posters, a case that Brangwyn has weighed and measured more justly than any other British artist. Grant, if you will, that a war poster has an evident function suggested by the word War, and that this function is performed well if it helps any institution or other agency that is needful to a nation whose life is endangered by armed strife. Let this be granted, but are we to rest here and see no more than the fringe of fact? Are we to forget that War for Life or Death is to a nation's whole being, her body social in its routine and her mind and heart and soul, what earthquakes are to inanimate Nature? Are we to forget that the highest necessary aim of such a war is not alone to win victory, since victory has been won millions of times in Man's world by greed over poverty, aggression over honour, wrong over right? Indeed, what savage could ever have risen above his tigerish lust of blood, and what civilized race or nation could ever have been displaced by pitiless barbarian hordes (as Britons tamed by Roman discipline were massacred by ferocious Angles and Saxons), if crimes from human ferocity had been deemed unpardonable by the Divinity that shapes our ends? Thoughtful sufferers from crime in war do not waste time and energy

187

on screaming indictments ; they invest them in just and effectual counter-strokes, and deliver their verdicts when they are in a position to mete out fitting punishment.

It follows, then, that posters are base and culpable if they add fever to minds already too much disturbed by abnormal events and anxieties. It is monstrous that they should be made to deprave high thought and right feeling, by restricting and narrowing a nation's intelligence, or inflaming her judgment, or misdirecting her imagination. A great nation should never lose touch with dignity, candour, and self-respect.* And since the highest aim of armed war can never be no more than to achieve victory, as lions and tigers do over deer, or as the Vandals did over city after city in North Africa, what aim are we to regard as highest in the stage of social feeling and progress which England and her daughters have reached? It is a dual aim: to prove that our civilization is wiser and better than that scientific barbarity which modernized Germans have imposed with a difficult and ravaging hand on so many parts of Europe ; better in defence and attack, in coolness and forethought, in patience under gnawing privations, and in all other qualities by which patriotism and courage are tested in the furnace of war—a furnace which either anneals or melts and wastes what it acts upon. This one aim is essential; but it includes a higher—to improve by our acts what we love best and value most—to endow what we love with as much immortality as Providence permits on earth among nations that do not let decline and decay take hold of their vitals. These are the aims that public appeals should try to make real with cool impassioned fervour, faith and grip ; and Admiral Beatty, from

* In the present war, owing to the hysteria of our Noisepaper Press, these first-rate qualities have been outraged by a routine of cant, hubbub, and misleading statement.

WAR POSTER FOR "L'ORPHELINAT DES ARMÉES."

a large poster, running counter to current moods and methods, has put them before us all in a few words.*

"England still remains to be taken out of the stupor of self-satisfaction and complacency into which her great and flourishing condition had steeped her; and until she can be stirred out of this condition, and until religious revival shall take place at home, just so long will the war continue When she can look out on the future with humbler eyes and a prayer upon her lips, then we can begin to count the days towards the end. '

It is in other phrases the appeal made by Shakespeare·

" O England!—model of thy inward greatness,
Like little body with a mighty heart .
What mightst thou do, that honour would thee do,
Were all thy children kind and natural ` "

No man can know whether his neighbours are ready for change and truth or not, but always he can be sure, as Bacon says, that Truth has ever been the Daughter of Time Never does she rise up super-naturally, she has a direct relation to antecedent conditions and to present-day needs as well, and for all these reasons, I assume, Brang-wyn in his war posters has kept far away from Press Gangs and their orgies of flamboyant emotion and display. It has been his pride to seek—now and then in a race against time not to be avoided—after such appeals as would grasp public attention while enticing it from excited unreason into cool and sincere thought

His war posters are done in genuine lithography, are drawn direct on slabs of stone and not on transfer paper. In these days genuine lithography is a rare thing, and above all on such large stones as Brangwyn has employed for several of his best prints. Most of them have tints, and they have been admirably published by Mr Praill, of The Avenue Press, whose zeal and success in printing these lithographs, both small and the very large, merit public recog-nition There's much variety also in the methods invented by Brangwyn, as well as much dramatization in the art with which he has felt and realized special needs and varying motifs Posters drawn for France differ from those which are addressed to our own country or to the U S A, for example Perhaps he does not insist quite enough upon racial types and national character

Again, as in coloured woodcuts,† so in lithograph war posters, Brang-

* This was written in April, 1918
† In 1915 the Fine Art Society, London, published in a portfolio six tinted woodcuts designed and signed by Brangwyn They represent episodes of war at the Front and

189

wyn has composed for himself a Tommy Atkins, just as Bruce
Bairnsfather has imagined another; and if we generally prefer the
British soldier that we see everywhere, let us be glad to accept from
Brangwyn and Bairnsfather what their patriotism has gathered into
types. Atkins in a mass of troops Brangwyn understands fully, as in
his darkling, dramatic poster of British troops occupying Dixmude,
a print designed to aid a fund for sending tobacco to our protectors
on all fronts. A good aim, this; for during the last weeks of the
siege of Metz, forty-seven years ago, tobacco and salt were boons
that soldiers and civilians pined for most of all
More difficult than other problems are those that U-boats have
enforced upon all nations with such terrific waterquakes of devilry
Brangwyn has faced them with a level mind, such as sailors need
when a cyclone in peals of thunder-wind ravages their ship Even
before this war his seafaring intuition compelled him to fear that
submarines, during the next grapple in armed strife, would become
more formidable than other sea perils; and they were also weapons
very fit and easy to be misemployed.
I know not by what argument or reasoning he kept his mind well
balanced. An interpreter of art has to deal as fully as he can with
results of work done, relating how he feels and sees them; it is not
his affair to spy upon an artist's private reflection; but Brangwyn's
posters on the U-boat peril, commandingly apt, are what they
should be—antagonistic to that noisy moral anger by which nations
at death-grip with stress and strain may be made unfit for cool unceas-
ing action and effectual resource; in fact, cool, good sense in action
unceasing is the only safeguard against crimes in war. And what
motive-power is behind it ? Hysteria from headlines and splash
pages ? Either horrified or flaming words ? No. Open pans of

behind at the Base Their effects of decorative colour are orchestrated with black,
white, and a buff tint approaching worn khaki The black lines are thick and fat, and
often angular, as angular drawing has greater vigour and character than rounded lines,
which are apt to look caressed and lax Black appears also in deep and wide plots, as
if washed in with a swift brush, and the buff tint also has about it a painterly wash,
direct and expressive. Here and there the faces are not comely enough to attract
British eyes, but few artists of to-day could reveal with equal weight and fervour, by
means of tinted woodcuts, an epitome of war as notable as this one In two prints we
are present with our wounded in the trenches; and here the style is monumental and
the emotion epical Nurses at a Dressing Station enable us to feel how taut and stern
are the duties which they do with proud tenderness, and which mark their own kind
faces with suffering. I speak of this work in a footnote because I wish to connect it
with the war posters

boiling water have never driven a steam-engine to a chosen place. It is patient and vigilant invention, aided by a whole nation cool enough to be thoughtful in united and continuous right action.

And here is the mood that Brangwyn's posters invite Only one—and this one a rapid sketch, not a meditated war cartoon—is like journalistic appeals. It represents German soldiers in the act of shooting Belgian civilians, while their officer looks on with callous pleasure and smokes a cigarette If such a crime as this cannot be understood in words, as Crippen's crime was understood from words, how can we set just store by Board Schools and current citizenship ? So there is no need why posters should vie against the Bryce Report and other official and proved facts about our foes' abominations. But, this one excepted, Brangwyn's war posters rise to the more urgent spiritual needs of our great Empire, who has small enslaved allies to rescue and big allies to aid, and her own errors and blunders to retrieve, turning her adversity into a victorious finish *

The U-boat posters, for example, say in their moods to all country-folk and townsfolk, " You don't know what prodigious open sea is like, so you don't see in your minds what U-boat crimes are We show you in full their murders on the high seas How do you intend to act ? Any fool can see at a glance that a crime *is* a crime, and any fool can wring his hands over a crime or scream at it with horror, like headlines on a ' splash page ' But is it right for *you* to let off steam in this futile way ? Or can you as a people win this war by shrieking to the clouds about ' corpse fat,' or by finding any other such vent for national energy? Is it true that too many of you strike now and then, while others try to make overmuch profit out of this war, and others grouse and growl because food cannot be cheap enough to waste, as it was in peace ? What, then, do you intend to do as a nation, millions of you acting all day long with the same cool and stern will ? Don't you see that you take part in U-boat crimes if you either cause delay or sanction delay in the building of ships to replace those that U-boats have murdered ? Come ! *How do you intend to ACT ?*"

* One error—very shameful and tragical—was our country's behaviour to Denmark in 1864, and another was the scrapping of Beacousfield's Convention with Turkey. J A Froude said of this Treaty with Turkey " It is an obligation which we shall fulfil as much and as little as we fulfilled a similar obligation to Denmark " So Turkey has been our foe in the present War.

From our hoardings Sir William Robertson has made an appeal in which he asks us to value a true perspective of the War, as it would aid the Nation to give valuable help to our seamen and soldiers. Brangwyn's marine posters have a true war perspective. They epitomize and reveal with intense passion The earliest was designed after the "Falaba's" fate caused seamen to think fiercely and steadily, while most civilians repeated headlines. It was published in the days of the "Lusitania" No one but a seaman could have drawn it, and only a colourist-painter could have put such a stormful rush and sweep of line and mass into the realization of its episode, particularly on stone with the greasy chalk used in lithographic work. Rain falls, and a German submarine looks on while men drown and some British sailors in a boat rescue others who are half-drowned A wave curls up lappingly to the periscope's base, and nothing could be more traitorous, not even the submarine's crew, onlooking, than this salt water, with its licking rhythm and broken fretfulness. Hun and sea appear to be leagued together against helpless men And cold—sea cold that numbs courage and twists bodies all at once with spasms of cramp—is made real, except among those rescuers, one of whom is as tender as a nurse, while another pauses in his work and, with a fine gesture, and muscles taut with passion under control, defies the submarine. Not all have perished. Right has claimed and saved a part of what it needs. Is there too much real terror in that drowning man who, before he sinks, hits up his arm as if to grasp an unseen support, while his jaw falls as if this last effort has brought death to him? Was it not Ruskin who said that there are times when men and nations must be shocked into thought and swift effectual action? Much better a too painful truth than those far too sanguine officials who said, more than once, that the submarine danger was "well in hand" The over-confident are always in haste to pluck laurels from henbane

Two of Brangwyn's U-boat cartoons were designed for the U.S.A. Navy and for American streets. Are these, do you think, the most effectual posters with which our Allied cause has been explained and aided? I know none that equals them. They have but one blemish, and it is noticed by public opinion, whose verdicts in our street galleries cannot be questioned after it is given. Before the bigger one of these posters—it measures 60" by 80"—a lady said "What scaring truth! I don't think I shall sleep to-night. How I wish I could build ships! Why was I born a girl, and not a boy? It
192

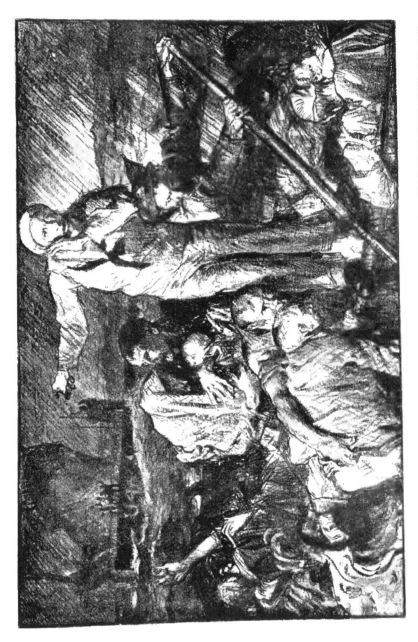

seems futile to be a woman during this war. And men should feel almost Divine, since they alone can defeat and punish these U-boat abominations." A moment's thought, and then she added: "But still, after all, a woman can do a little bit here that is useful. She can implore Mr. Brangwyn never again to blemish his right and very great appeals with a face like that one. It is early prehistoric, almost simian And it is not meant for a German face. It belongs to an Allied seaman Let us have noble faces in the men to whom we owe our all What are we but as pensioners to Allied seamen and soldiers ? Who but they give us our food?"

I am equally disturbed by the same face and by one other Battle passions have no effect on a cranium, and it is in the shapes of skulls that we study Man's ascent from his apelike progenitors Strong frontal ridges, with a shallow, fugitive forehead, are marks that come from a treetop ancestry. But when a man of imagination is over-wrought by his response to the dramatic needs of his tragic battle-piece, his peremptory eagerness to make character and passion real is apt to carry him a step too far here and there. Other artists do not mind; to apprehend is to forgive; but artists are not judges in our street galleries, they are the judged

All the rest in Brangwyn's posters for the U.S.A. Navy is incantation. It weighs upon all minds a very deep and fateful warning Even Géricault's noble and heroic shipwreck, "Le Radeau de la Méduse," its modelling being overdone and its shadows too black and bituminous, looks a sea tragedy from a studio, compared with these lithographs, with their bluff salt air drenched with rain, and their swirling waters peopled with human tragedies. The smaller one (58" by 38"), masterly as a composition, has a colour scheme of blue, gray, buff and white, while the larger is printed in black and relieved by buff, white, and gray Brangwyn has done nothing better in his many marines than the seaman who stands half erect and, with a masterful gesture full of anger under discipline, points to the sinking vessel, and cries to the Allied will, "Stop this ! Help your country ! Enlist your hearts in the Navy !" There is also a baby asleep, and the sleep is full of sea cold and its numbness. Who is not deeply touched by this little face ? There are two posters where the children are not felt as this baby's face is drawn; they neither charm by their good looks nor strike awe by their suffering, and public opinion likes children in art to rule as enchanted princes and princesses, how-ever humbly they may be dressed.

2 C

For the rest, Brangwyn's marine and submarine posters, which include "The Last Boat from Antwerp"—a fine, free, wise impression—and "Landing Men from a Naval Fight," are ample paintings done with lithographic chalk and two or three tint blocks. They have an energy as youthful as that which keeps fire and fierce persuasion in "The Buccaneers," but their varied inspiration is very different, and sometimes it is as apt for its object as is the Marseillaise, which, as an incantation that gives men heart to fight on and on for their native land, is an ideal model. What the Marseillaise has been to militant music among the French, this our national posters may become to British patriotism, if our best designers act as true dramatists in their study of national tradition and character and opinion

"At Neuve Chapelle," with its flaming contrasts of black against orange light, gives the ultra-natural in scientific war with a power altogether fit and right for our street galleries. Its cool officer, and its Tommy who cries out for more ammunition, while behind a great gun looms darkly through the glare of bursting shells, have a proper feeling for drama and patriot zeal. Very fortunate, too, are some touches of home and humour, "In the Belgian Trenches," printed sometimes in black and buff on white paper, and sometimes in purple and dark blue These five pals are jolly good fellows, grouped with effective naturalness, and one playing an accordion reminds me that Brangwyn is always good in his lithographs of amateur musicians, as in a capital one named "Music."

Two posters represent refugees leaving Antwerp; the better one is a long print (30″ by 15″), and very impressive as a moving throng urged by panic The white Scheldt behind and Antwerp far off, cloud-haunted and under battle smoke, are decorative and true as a tragic background. I am left cold by "A Field Hospital in France," though I like its colour scheme (buff, red, black, and white), and think that its adaptation of Brangwyn's brush drawing and woodcut methods adds a new zest to lithography and a new style to poster appeals Everyone is familiar with "Britain's Call to Arms," the original stone of which was presented by Sir Charles Wakefield, when Lord Mayor of London, to the Victoria and Albert Museum. Though inferior to the marine posters, it put art into the degrading much ado of our pleading for voluntary recruits—pleadings which our foes have collected and ridiculed at exhibitions in support of their war charities, taking care to omit the Brangwyn cartoons. So I am glad to hear that several sets of Brangwyn's best posters have

194

been sent officially to neutral countries as a counter-attack against German jests and mockery.

"British Troops and Ypres Tower," in general aspect, is brimful of vast war, and many of its troops march to a song. Yet public opinion finds it not quite fit for its big job "Our boys are finer than these—much"; and this verdict means that a grand manner, a truly heroic style, belongs to war posters as well as to Homer and to epic patriotism in verse. If a Dryasdust found proof that the Black Prince or Henry V had a harelip and a squint, should we not feel outraged? It is in human nature to glorify those who are ready to die for an idea or a cause or a ruling passion, because great self-denial is transfiguration; it blends mortal men with eternal grace, and frees us all by its magic from a reality that is only of to-day. Several classic battle-painters—Charlet, Régamey, sometimes Detaille, for example—have got very near to this heroic real, with which art should clothe those who are willing to die in battle that we may live here at home, and this heroic real is their perennial uniform, as magical in khaki as in red, and let it charm away all personal ugliness. If not, our great-grandchildren will say, "They were very brave, these men of the Great War, but they were ugly, father." In other words, as an artist can portray in his work only a handful of the seven million who have gone forth from the British Isles into this war, let him choose none but the finest in face and figure and bearing. It was thus that Philippe de Comines (1445–1509) described at first-hand our mediæval archers: "Milice redoutable! la fleur des archiers du monde" What more do we need as a continuation of Agincourt and Crécy?

"Rebuilding Belgium," a prophetic poster, is a general favourite, and there are six very original episodes expressly lithographed for Sir Arthur Pearson to aid our National Institute for the Blind One was set aside because it reveals how recruiting was carried on among slackers; but social truth is history, so history needs every truth that can be winnowed from rumours, lies, exaggerations, and self-deceptions, by which great moods in war are alloyed from day to day. Slackers could be reckoned up by thousands in all big towns, and in some country districts also, and Brangwyn has satirized the pavement breed with a wit which Daumier and Gavarni would have praised as right and wise. Other prints of this good series— saying good-bye at a railway station, going on board a transport, how a brave lad is blinded by an exploding shell, how he is nursed

195

in a hospital, and how he and others have become expert as basket-makers, each with that mild self-approval that deftness of hand begets when it becomes an easy routine freed from constant hazard —cannot be studied with too much care. Perhaps they are some-what above the heads of many ordinary folk; perhaps they belong more to portfolios than to a good many of our streets, but, in any case, they honour three inestimable boons to any people that would rule well over themselves and over others: three boons that much of our propaganda has not often tried to respect—truth in war perspective, cool and puissant self-control, and national dignity. Viewed only as technical aptness, or as original and useful research, they are among the most entertaining work that Brangwyn has done, most sympathetic and tender in the hospital ward, where daylight enters as a physician with soothing peace, and most varied and robust and colourful in "The Transport," and below the great arching roof of a crowded railway station. There is tenderness also and good colour in two posters designed for a French charity, "L'Orphelinat des Armées," though one would prefer to see orphans not as buds nipped and deflowered by war, but as shy and rosy heralds of a better time bequeathed by their dead parents to our great common Cause. One of these prints—in it open lilies of France are united to mourn-ing widows who watch over children not their own, pledging them-selves to be loyal in the presence of a battlefield made perennial with crosses—has a generous emotion, and a light in it that cannot fail unless we fail. The other, with its hungry child aided by two happier children, while her mother is overcome with pain and woe, is somewhat in the vein of Degroux That child is bitten so keenly by hunger that her face and hands plead for help from Him who, in the beautiful words of a Psalm, feeds the young ravens that call upon Him

Let us note also that Brangwyn, in addition to these posters, and some minor ones, like "Dawn," "A Vow of Vengeance," and "Mars Appeals to Vulcan," has done for big trading firms a few Rolls of Honour, in which typical handworkers appear; and although I shall never see why Rolls of Honour should be put up during a vast essential war for our country's honour and life, when those who cannot fight in the field are the only persons who merit pity, still, custom being custom, it is admirable that men of business should ask a great artist to make fitting designs

And two points more not only invite thought, they set thought astir

196

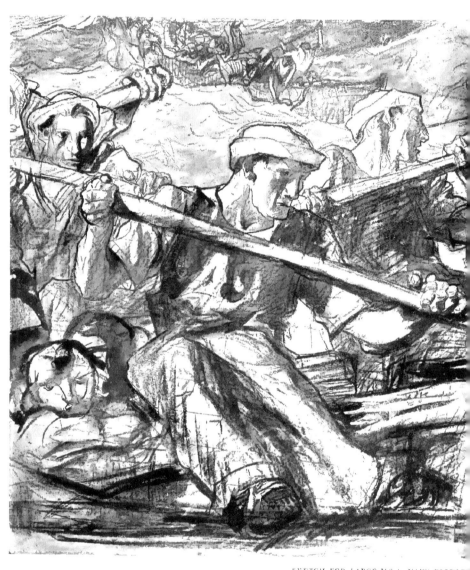

SKETCH FOR LARGE U.S.A. NAVY POSTER

over matters of general value to our future. Three good portfolios of these war posters have been issued in half-tone reproductions by the Avenue Press, and I wish to suggest now that portfolios of this sort, with designs from history of abiding worth to patriotism, made by Brangwyn and other big artists, should be issued as a routine by our Board of Education and circulated all the year round from school to school. Further, the same designs, but in large lithographs and colour prints mounted on thin canvas, should be circulated in rolls, to be hung up for a week on schoolroom walls; only, of course, no school in the same week should receive a portfolio containing the same pictures as those given in the large prints. If this system were brought into vogue as a general stimulus to education, many a good thing would come into our national life from a constant pleasure granted by the State to children. Consider, for instance, how a true affection for Shakespeare would have been passed on from school to school if E. A. Abbey's most excellent drawings from our Master's plays had been turned by this means into a national pleasure for the young; and Lamb's *Tales from Shakespeare* might well have accompanied these Abbey drawings.*

There's no end of invaluable work that draughtsmen and painters can do for children, who represent our future as a people For instance, have you seen photographs of work done in Brussels before this war by the great Professor Rutot, with help from sculptors? He has restored for us in memorable aspects that vague thing named Prehistoric Man, enabling us to carry in our minds apt probable portraits of the Combe Capelle Man, and the Man of Heidelberg, also the Neanderthal Man, and our Galley Hill Man, and the Negro of Grimaldi, and the Man of Furfooz, and the Old Man of Cromagnon, and others What good luck I Don't you love to dream over your infancy in prehistoric epochs? With coloured lithographs Brangwyn could rival Rutot and the Belgian sculptors; and some man of science, in a style fit to be read with ease and joy, could write notes for our school-children to accept gladly, and in competition for half-yearly prizes.

As for the other point, among many lithographs that F B. has done for portfolios and rooms, there are few that would not be very attrac-

* In pre-war times Brangwyn began a set of lithographs for educational purposes Several were published, and one aim was to put upon British markets a home-grown art better than those good German colour-prints that circulated all over the world But a commonplace old thing happened "Nothing doing I" Progress creeps, as we all know, but in our country before this war progress crept into retrogression

tive as large posters for our streets By way of example, take a fine
series from those who from time to time straighten their loins and
wipe their foreheads with the backs of their hands A series full of
sweat and truth, it includes men who carry fruit, stalwart harvesters
who sharpen their scythes, and men who roll barrels as if a barrel
were a world; skin-scrapers and brickmakers, labourers carrying a
plank, platelayers with their crowbars and in a shimmer of light,
which seems to put tremulous vibration into their movements and
clothes, musicians as happy as bees on a fine day, tapping a furnace,
steel-making, a Spanish wineshop, and the act of unloading oranges
from boxes Here is humanity at grip with stern old facts, and
every fact an element of primal poetry. "In the sweat of thy brow
shalt thou eat bread" In one form or other we all suffer bodily
punishment; and who does not prefer a lean harvester to the paunch
carried before him by a sleek alderman? The velvet of lithography
is a friend in Brangwyn's hard-handed men to some qualities, elusive
and most attractive, that etching cannot give so well, and for this
reason Brangwyn's outcast or beggar comes before us in lithographs
with a new appeal, illustrating differently the famous lines from La
Fontaine ·—

> "Quel plaisir a-t-il eu depuis qu'il est au monde ?
> En est-il un plus pauvre en la machine ronde ?"

It is often a surprise to me that our philanthropic societies fail to
put upon our hoardings everywhere great posters like Brangwyn's
lithographs of beggars in order to advertise many horrors that pro-
pagating poverty and vice collect into national legacies. Let us as a
people shame and scourge ourselves into reform.
Now and then Brangwyn has gone to old history for his litho-
graphs, as in "Columbus Sighting the New World" and "Hadrian
Building His Wall", and these good subjects also are fit for our
street galleries if we wish graphic and pictorial art to become con-
stant elements after this war in discreet education.

CHAPTER XIV AFTER THE WAR REFORMATION AND RE-FORMATION : BRANGWYN IN RELATION TO LABOUR CLUBS AND HALLS

I

s national welfare depends on bravery, truth and honour, loyalty and hard work, each man at his post and fit for his job, let us apply once more to citizen needs, current and future, the national right feeling of Brangwyn's outlook and work

Shakespeare says, " There is no English soul more stronger to direct you than yourself " A fact inspiring to self-help, but yet it lights up only some parts of a sovereign truth as good for us all, as are fine dreams made real by finer deeds From Shakespeare himself we learn that our inherited guide and guard as a people, now and for ever, is the soul of England that reigns among her best doings. And it is also a fact that few, except genuine artists, before this war and since 1914, have tried to grasp in full what the soul of England should be to each generation Brangwyn, Kipling, Henry Newbolt, for example, have seen deeper into this cardinal matter than our politicians, who chatter on and on as nympholepts of democracy, though there is no democracy in naval and military discipline, and although democratic disunity took us unprepared into this long-threatened war

There are four beliefs of immediate necessity to the soul of England, and they are beliefs which no political party can oppose without evident unreason and wrongdoing —

1. That England's wealth is not merely material wealth—the number of acres she has tilled and cultivated, her havens filled with shipping, her vast factories and her mines, imports and exports. Not these alone, nor her Colonies and great daughter States, form England's principal wealth and power, for she has, what Disraeli loved as " a more precious treasure "—*the character of her people;* and this character has been injured by the ungluing ferments of modernity Freedom has passed from a river into a flood As a people we have become far too emotional, for example To free England from gush and shoddy, in order to renew in all workman-

ship her proud old temper of breadth, vigour, reserve, candour, and endurance, is a beautiful duty resting upon us all as an imperious obligation.

2 That British home life must pass through a long series of improvements, fitted to ease expenses and to displace cares by contentment

3. That British workmen everywhere need and should have an industrial position as fortunate as that which Mr Millbank, in *Coningsby*, the prototype of Lord Leverhulme, gives with affectionate justice and pride to his wage- and wealth-earners.

4. That we must learn to distinguish between political ferment and social improvement.

Politics may try to muddle all these things; they deserve the cutting verdict which Disraeli passed upon them. But artists have no rightful place in party misadventures: their creed always should be their country's welfare; and if they concentrate their energies on three peremptory needs—the restoration of British workmanship, a general improvement in British homes, and alert justice not to Labour only, but also to every class whose incomes are uncertain and small—they cannot fail as national doers and incentives. For these reasons Brangwyn's mind and heart are set on ideas and projects which, if carried boldly into thorough action, not by artists one by one, of course, but by artists as a body, with full support from their societies, Royal and other, would aid all workers who *are ready to aid themselves*, which is the sovereign temper in social recovery and advancement Not by philanthropic effort, with its amateurish fuss and fume, can anything be done that is national and inspired by public dignity and self-respect. What philanthropy would be needful if nations were in sound, robust health ? Charities are nurses only, while duties to the State are true physicians.

Brangwyn is eager to do what his experience fits him to undertake. He knows at first-hand the outside welter of human realities, and, looking for reformation in re-formation, desires to see contentment as a citizen among those who feel most keenly the increasing pressure of industrialism upon physical stamina and home life.

Though his work never preaches, never drifts into such commonweal sermons as Victorian artists often composed, like Dickens, Charles Reade, Ruskin, and others, yet its best achievements are like all

200

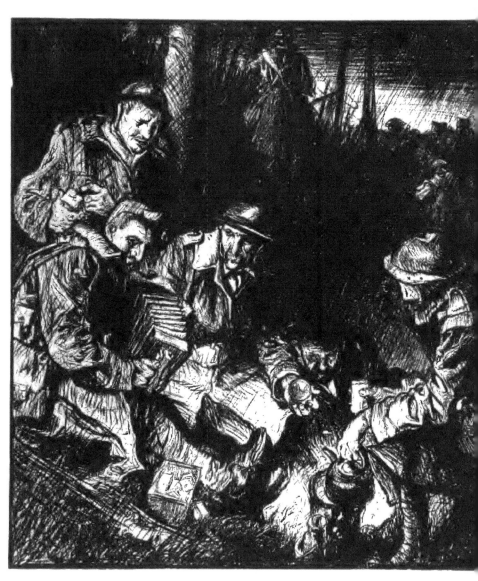

WAR POSTER : " IN THE BELGIAN TRENCH

observed facts and truths alembicated from special stress and strain and great drama; they contain material from which historians of the future will gather correct views of to-day's conditions and warnings. Towards four or five phases of our life—as to seafaring, for instance, and industrialism—Brangwyn has been a good historian, and no part of his wide outlook is fatalistic as Millet was fatalistic. He believes in general improvement and Millet did not. Millet asks us to have faith in technical progress only and to delete society from advancement. "What everyone ought to do," he said in 1854, "is to seek progress in his own profession. Everything else is dream or calculation." Feeling no desire to improve the lot of peasants, Millet relates how he wants "the beings whom he represents to have an appearance of being bound to their position so that it should be impossible to imagine them having an idea of being anything else" And Millet enjoyed melancholy, a deep genuine sadness "It might almost be said that if sadness did not exist, Millet would have made it afresh, so singular is the charm which it had for him," says Romain Rolland. Bitter poverty often gnawed into his home, and he accepted it without surprise and without rebellion It belonged to his lot as the peasant of peasants, always melancholy, never depressed. "The joyful side never appears to me," he writes. "*I have never seen it* The most cheerful things I know are calm and silence. . . Even art is not a diversion: it is a conflict, a complication of wheels in which one is crushed. . . . *Pain is perhaps the thing that gives artists the strongest power of expression*" And his own life was certainly inhabited by pain

Great art Millet got from his melancholy, his inspired gloom and pain, but from such a temperament no social advance could come to society; and better that men in the bulk should cease to be than that they should be unable in the bulk to improve There is no abiding place between "Let us improve" and "Let us backslide"

What we need, then, are able workers who are also men of action, high-spirited and enterprising, and if Brangwyn is not an artist of action, what is he? Into many social needs both he and other artists can put ever more and more of their ameliorating zeal if they are aided by those who scorn intellectual timidity.

Let us take the use and abuse of liquor, in order to see what artists can do as craftsmen to improve bad industrial conditions friendly to intemperance. About eighty years ago many hosts were aggrieved if their male guests at dinner did not get inside their cups; and there were thirty-two slang expressions to describe a merry fall from elevated joy through potvaliance to the table legs. Even Charles Dickens in *Pickwick Papers* grows a great deal of his fun and humour from vines and hops. His pages are steeped in good wine and in other drinks. Since then a quite wonderful improvement has taken place; yet we hear to-day from many quarters a more fanatical outcry against an abuse of liquor than was ever heard before in free England, whose people always have been nearer to Falstaff than to any wish to have total abstinence enforced by Act of Parliament. Is it forgotten that by far the noblest boon in life is the fact that we have to choose all day long between the use and abuse of good things? Providence allows no man to live free from an unceasing choice between enough and too much

So it is an act of good sense to be at odds with dragooning teetotalism, which is good only for persons and nations unable to choose between enough and too much. As Lord Morley says, " You pass a law (if you can) putting down drunkenness; there is a neatness in such a method very attractive to fervid and impatient natures. Would you not have done better to leave that law unpassed, and apply yourselves sedulously instead to the improvement of the dwellings of the more drunken class, to the provision of amusements that might compete with the alehouse, to the extension and elevation of instruction, and so on? You may say that this should be done, and yet the other should not be left undone; but, as a matter of fact and history, the doing of the one has always gone with the neglect of the other, and ascetic lawmaking in the interests of virtue has never been accompanied either by lawmaking or any other kinds of activity for making virtue easier or more attractive It is the recognition how little punishment can do that leaves men free to see how much social prevention can do."

The main problem is to improve wrong conditions without raising public opposition, and without forming habits or customs that abase citizen ideals by lowering civil and personal self-respect; and only a social problem here and there is difficult in morals, however costly

it may be in money put out at delayed interest, when it is looked at as a matter of business, to be done well and as a duty to England and the future
There is nothing difficult in the moral idea or giving seamen good clubs and halls in every pest-haunted harbour around our coasts, for example Philanthropy has done a great deal since Nelson's time to benefit our seamen's lot ashore, but philanthropy carries with it evils of abasement Instead of inviting sailors to be masters of self-help, it asks them to run from vice to a pleading shelter, as ducklings waddle from rats to a hen's wings. Let us give them clubs and halls entirely freed from philanthropic much ado, taking care to advertise them on all ships, to endow them with rules approved by officers and men, and to put into them as much varied comfort and attraction as art—that is, good and apt work—can produce for men who are essential to our sea power and seafaring wealth.
Think of a seamen's club or hall decorated with marine pictures by Brangwyn, some from naval adventures and others from exploits of fishing fleets and our great merchant service The hall could be an epitome of our seagoing history, past and present, and can anyone suppose that it would not "draw," that it would not be loved by every sailor that could take his ease in an inn of such good luck, or that it would not decrease from year to year those foul temptations that are leered and ogled upon sailors in every seaport ? Years ago the late G T. Robinson designed for a ship of the White Star Line a series of modelled slabs, on which the evolution of ships was represented, and he told me that this work, carried out by a good sculptor, was visited by sailors whenever they got a chance of seeing its many varied interests. This being the effect of sculpture in flat relief, consider the impression that marine and naval pictures would make from Brangwyn's great-hearted and sumptuous colour and vigour !
Here, for example, are two great series of sea actions, reproduced in colour by *Scribner's Magazine* in August, 1903, and November, 1907. The earlier set in four noble subjects illustrates Hilaire Belloc's "The Sea Fight off Ushant" One picture shows grandly how

203

"Lord Howe sails from Spithead," under a towering spread of sail, and with battleships and cruisers, while supply-boats dally along a heaving foreground, and behind it all is a pageant of English sky, islanded in blue among windblown clouds, gray and exquisite in tone and protean mass. Spirited and inspiriting colour sings from every nook and corner, free and fresh and breezy, yet pent-up with motive power, like those bellying sails. To look at this naval episode is to become a mariner Imagine this picture framed by Brangwyn in a panelled wall for a billiard-room in a seamen's club. Would it perform no great office in the most rational phases of urgent national service?

"The 'Brunswick' caught Anchors with her Enemy" is another subject, and equally fit for such a sailors' billiard-room Battle-smoke adds a gray mystery to rich colour, and our great English ship—beautifully drawn, with a fluent brush full of affection, her sails here and there showing how shots have rumpled and pierced their setting and their rhythm—rises on a swell of tide above her much-damaged foe, while along her side there runs a thrill that denotes the eager gathering of boarders. Is there no tingling of naval war in your blood? "How the 'Vengeur' went down " comes next—a grim requiem at sea during a battle. All buoyancy has gone from this vessel; she appears to sink as a fact, inevitably, and with a grandeur that a good fight has wrapped around her like a torn shroud In the foreground two rescue boats hail a remnant of crew on the *Vengeur's* deck, while the tragedian sea is engaged in her old, old work of swallowing up wrecks and the defeated. And now we turn to actual fighting at close quarters on an English battleship, to watch "The Best Gunners in Europe [or anywhere else, let us be thankful] for Sea-fighting" Here is a revel of colour and of action; a superlative Brangwyn, a chaos that resolves itself into a drama brimming with life and animated and varied form. Would that these four pictures were in a seamen's hall, with two or three from our present war! If this idea is not good, if it is not worth advocating, let me be "a peppercorn and a brewer's horse," as old Falstaff says.

The other series, illustrating John C Fitzpatrick's "The Spanish Galleon," has also four plates in colour—the immortal fight of the little "Revenge," more remarkable than a fight between a voracious thrasher shark and a huge tempestuous whale; "The Great Galleon Fair," "Galleons sailing from Cadiz," and "Loading a Galleon."

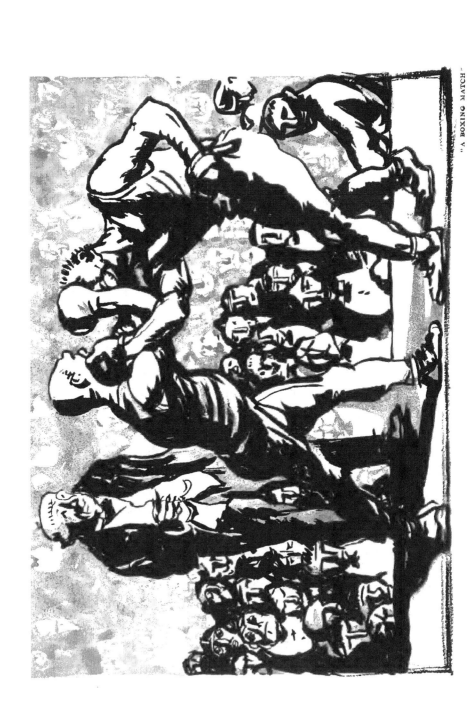

Here are splashing harmonies, profuse, glad-hearted, and as typical of Brangwyn in passions of colour as they are of departed seafaring, which for ever will hold the affection of those who delight in naval history. Is there a waterman that he doesn't understand ? All sorts and conditions of tars delight him, from Vikings and over-salted sea-wolves, veteran buccaneers, to jollies, bluejackets, skippers, fishermen, A.B.'s, bargees, coastguards, gondoliers, and pierhead wiseacres and loafers. Have they not all taken berths in Brangwyn's varying moods and methods ? And there they will live on and on, let us hope, as long as his paintings and his graphic arts find answering states of mind and gifts in human nature.

Surely it is far more than time that our Government should consider with a will the best means by which this great master of true marine adventure can be employed for the benefit of present and future seamen, more especially as three or four questions of long-neglected vital interest, such as the spread of certain virulent diseases, have come to the forefront since 1914, there to remain with peremptory self-assertion. For it may be said, without a shadow of a doubt, that the sea and its perils will be to future generations of our country even much more important as influences nearly felt by all citizens than they were in past ages, because submarines and

205

aircraft have invaded history with durable menaces against every island not self-dependent, and also against all nations united to their destinies by sea-coming and sea-going trade and traffic Ever more and more England's education will have to dwell on ships of all sorts and air fleets and submarines for their guards against sudden armed war; and thus we cannot begin too soon, as a people, not only to meditate over this forecasting matter, but also to take wise action to renew among civilians a skipper feeling and a true admiral alertness. Schools of every sort, and Board Schools even more than others, should be brought close to such marine work as Brangwyn's and Napier Hemy's; and if two or three Board Schools in all big towns, and in other districts also, were devoted always to the education of sailor boys, nothing but great good would arise from a training so useful and essential to England's welfare. Add to this the patriotism of seamen's clubs and halls, with other kindred associations and institutions for other workmen, and national art and rational free life would soon be as closely at one as they ought always to be in progressive citizenship.

III

England was a merrier country, and greater also in all essentials of good honest workmanship, when every class took its ease in its inns, as the French take their ease in cafés, and in other rallying places for their sociable temper. Our modernized public-house, as a rule, makes men into thirst's prisoners at the bar, it is as remote from true citizenship as it is close to bad manners, and this fact has received some official attention since 1914, with help from several architects. Let us try to evolve bars into homelike inns where cheery talk will be of more account than thirst, and where overworked wives may find with their men a chattering leisure apart from their dull, drab cares Surely here is one thing to be desired, for it is a thing as English as the English language. Do you remember how Dr Johnson, an epitome of England, used to thank his lucky stars that his native land triumphed over the French in her inns and taverns? "There is no private house," said he, "in which people can enjoy themselves so well as at a capital tavern. . . . The master of the house is anxious to entertain his guests—the guests are anxious to be agreeable to him; and no man, but a very impudent dog indeed, can as freely command what is in another man's house, as if it

were his own. Whereas, at a tavern, there is a general freedom from anxiety. You are sure you are welcome, and the more noise you make, the more trouble you give, the more good things you call for, the welcomer you are . . No, sir, there is nothing which has been contrived by man, by which so much happiness is produced as by a good tavern or inn. . . As soon as I enter the door of a tavern, I experience an oblivion of care, and a freedom from solicitude " So he spoke of a tavern chair as "the throne of human felicity." Let this minor English throne, with an ordered good fellowship, belong once more to the English people. Rules are easy to make, and not hard to protect

And artists of all sorts can aid in many ways to bring about this revival. Some can work for it, while others can contribute books, pictures, etchings, and so forth, which they cannot sell or do not need, sending such gifts to a municipal warehouse to be shared among inns of their neighbourhood. Thousands of good things, year after year, litter studios and studies. Why not give them to homes of friendly talk called inns? And I believe, too, that Labour should have ceremonial clubs and halls free to all comers, where class could meet class apart from ballot-box rivalries, with those narrowing and impoverishing habits of mind that men hackney when they read always the same political views and jeer at all others. To listen to views unlike your own is the beginning of social fairplay, of honour in politics, for what just value can you set by your own views if you have never studied rival opinions? And how can you be sure that your vote is not a national peril, as were those that sanctioned in pre-war days a most culpable unreadiness for defence, unless you review with the utmost frankness all political beliefs, convictions, fads, and illusions?

So I think of a ceremonial Labour club as a great and vast hall where opinions of a thousand sorts would meet on given days in candid and friendly debate, a hall noble as architecture, noble also as an exhibition of British furniture and mural painting, with a central stage or platform and a speaker's chair, and around this platform a fine café. There should be two galleries from which men and women would enter reading-rooms, billiard-rooms, and a good library, all fine as architecture and in mural decoration If every big town had a hall with this true citizen appeal, Labour could not fail to lose a great deal of its breeding discontent, inherited from such wrongs as Disraeli portrays in *Sybil*. It would be delighted, encouraged and uplifted; and

207

during many years there would be abundant scope for right patronage of excellent craftsmanship. Art and Labour could be made into associates and chums.

In this dream I think always of Brangwyn, not only because no decorative painter of to-day has risen to his level as a splendid colourist and what the French call a "visionnaire prodigieux," but also because he alone is an ample and a robust poet among industrial and commercial affairs, both at home and abroad, and also in many old historic aspects It is a regret to me that the mural paintings which he has done for the Skinners' Hall, and Lloyd's Registry, and Louis Mullgardt's Court of the Ages at the Panama-Pacific Exhibition, are not to be found in British Labour Clubs. Neither Lloyd's Registry nor the Skinners' Hall is free enough to all the world to be a public home for great mural painting, which needs for the exercise of its public influence what good books and plays need always—the widest publicity that can be granted. The noble work done for St. Aidan's Church at Leeds is different , it belongs to the whole nation; everyone can see it who has a wish to see it; and as for the Brangwyns at Christ's Hospital—The Stoning of Stephen, for instance, The Arrival of St Paul at Rome, St. Paul reaches shore after Shipwreck, St. Wilfrid teaching the Southern Saxons how to fish, St Ambrose training his choir at Milan, The Conversion of St Augustine at Milan, St Augustine at Ebbsfleet, and The Scourging of St Alban—are they not finely placed in a school that ranks high among the best that Europe knows?

A book on all these mural paintings is to be published at a fitting time by another interpreter of Brangwyn's genius—and published with great success, I hope. But when they are studied in sketches and cartoons, some in black chalk, others in glowing pastels or in swift, blobby, most expressive oil studies, they have also a rare charm like Charles Dickens's confidential letters to friends about his next book or the book upon which he is engaged Or we may affirm, without any great extravagance, that Brangwyn's preparatory sketches and cartoons are the scaffolding of his vast mural pictures Some decorative painters put so much energy into their cartoons that they have not enough reserved to carry them, with a generous, life-giving zest and rhythm, through their second and major campaign, the transformation of cartoons into paintings that breathe and generate growth until they are as complete as they need be. In Brangwyn's case, without exception, a cartoon is a scaffolding only, and thus

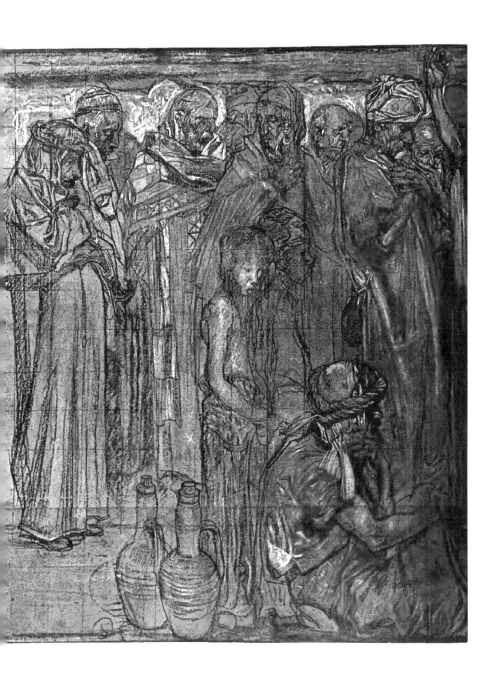

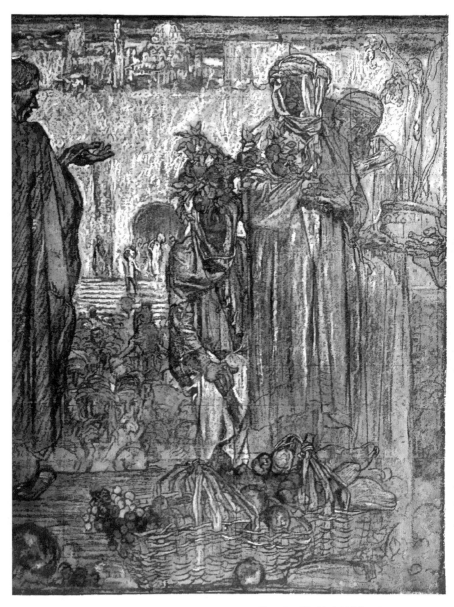

inferior by far to its transmutation into
its destined place upon a wall as a
symphony of mingled life and action
and colour in a large decorative scheme
allied with an architectural setting.
For a painter-colourist, as soon as he is
at ease on ample spreads of surface and
with big brushes, finds his most desirable
and fitting tools among those that bring
his work to completion ; just as a great
composer, who writes for orchestras and
opera singing and staging, wins more
freedom and more inspiration from his
accustomed work than from solos for
single instruments and private rooms or
small concert halls. Colourist-painters
of the first rank are at least as uncommon as great masters of the
opera ; and if I venture to call Brangwyn our Wagner in the realms
of sumptuous colour and dramatic decoration, I believe that this
new analogy will be found useful. They are many who fail to pass
through his natural mannerisms into his frequent grandeur as a
master of decoration.

It is the connection of one part with another, and the bearing of
external matters, such as colour, not only upon each and upon all, but
also upon an artist's mood, inspiration and purpose, that most on-
lookers fail to see in a cartoon or a mural painting. From mere
simplicity and want of appreciation, they do not look at things as
parts of a whole, nor at outward aspects as visible signs and tokens of
inward motion and passion, and often they will sacrifice the most
vital and precious portions of an artist's own magic merely to note
what everyone else can see at a casual glance. Thus, for example,
the sovereign quality of Brangwyn's cartoons and mural paintings,
its most welcome grace from a public and national standpoint, has not
been studied by any writer whom I have read, nor even so much as
recorded bluntly as a fact. Yet this grace gives an atmosphere to
every mural study and painting that Brangwyn has produced. It is
partly an aloofness from gloom, a good health that scorns melancholy,
morbid thought and drooping, though it rarely draws near to Milton's
conception of Euphrosyne, goddess of Mirth, who, with jest and
youthful jollity, quips and cranks, and wanton wiles, nods and becks,

and wreathed smiles, gets rid of wrinkled care and sets Laughter to hold both his sides. Mere aloofness from gloom would not be rare enough to endow virile work with an original atmosphere, this quality being evident among decorative painters of the Italian decadence, as in those Rossos and Primatices at Fontainebleau, which appealed so potently as opposites to sorrowful Millet, who enjoyed not merely their pulse of life, their glad and rough good humour, but also their inbred and natural affectation. "One could stay for hours before these kind giants," said Millet, "noting recollections in their art of the Lancelots and the Amadises, all as childish as a fairy-tale, yet as real as the simplicity of bygone days."

If Brangwyn went no farther than these Italians his deleting of gloom from decorative painting would be in many respects a revival, but he does go farther, like those of us who wish to disenshroud old inevitable death from craped pomp and threatening music, in order to array him in colours and hopes humbly promiseful of another and better life beyond the few years of this one. Even in such a tragedy as the stoning of Stephen we are present—not at a marvellous event which seems for ever contemporary with mankind, as in Brangwyn's "The Crucifixion," but—at an episode from religious persecution away off from ourselves, inevitable since it happened, and never likely to be repeated, hence we should renew the crime of it if we brought it near to ourselves in a mural painting inflamed with realistic frenzy and terror. It is as a dream, not as a nightmare, that Brangwyn calls up into pictorial presence the death of Stephen, and a dream that has a sort of aureola, a questioning contentment which is to it as a nimbus or halo. The spirit of the whole conception and its realisation seems to say "If no such events as this one had happened, are we sure that the Gospels would have passed from land to land and from age to age as permanent lights to be hidden often by human follies? Are we sure that martyrdom with its crown of thorns is not the only enthroned glory that enables mortals to feel the immortality of the loftiest faiths? In any case, though life is a mystery inextricable, yet a great deal of its hidden meaning grows into the minds of those who, understanding the eternal contrast between Christmas and the Crucifixion, are glad to have big things to do in the midst of grave difficulties"

The same temper comes to us also from Brangwyn's decoration of "The Scourging of St. Alban," history at a distance from us and veiled not by the ages only, but also by that just hope without which all capacity to improve withers. St. Wilfrid in the act of

210

teaching the Southern Saxons how to catch fish with a net, is a glad-hearted episode; and when we turn to St. Augustine, an austere and ascetic white figure, seated amid an arbour of figs, we see how he wrestles with mute brave woe against his inner self, while children sing to him, and across the foreground, where some other children stand as onlookers, open and tall white lilies are as full of joy as they are of beauty.

As for the ten tempera paintings done for Lloyd's Registry, and shown first of all in a special room at the Ghent Exhibition, they were designed and carried out for a purpose so charged with difficulties that preparatory work needed unusual will-power. Imagine a very large room panelled with oak It has a barrel roof and a top window. The roof, like a phase of decoration loved by our Henry III, true patron of the English Home, is bright with stars dappled on a lozenge moulding that is painted a deep and rich blue At a height of some eight feet from the floor there are places for nine decorative paintings, all of the same size, about nine feet by five feet, and they draw our eyes towards a culminating point— a vast lunette, more than eighteen feet by ten feet Brangwyn decided that he would fill his nine panels with workmen of various sorts, all in the midst of rich and happy colours, as when men gather grapes and pumpkins, or display rich carpets from the East; and that he would place behind them as much majestic plenty as he could suggest as a part of our commerce. His studies for all these things are most varied and apt, though we cannot say of them they are the most perfect expression of his emotion, his real artistic media. As regards the huge lunette, Brangwyn used it as a space upon which he could sum up with power the genius of mechanical industry, choosing for his motif the final stage in the making of a big ship's boiler. A blast furnace near at hand, a foreman explaining a plan to his assistants, other men in strong light hammering on iron bars, and a blue sky as a background also to the tall chimneys that mark what Victorians called a hive of industry Some men on the boiler add height to the great central mass of the composition, and prevent it from being too horizontal in the arrangement of its planes

For Louis Mullgardt's Court of Abundance, or Court of the Ages, at the Chicago Exhibition, with its most varied displays of colour in architecture, Brangwyn painted eight decorations, measuring not less than twenty-five by twelve feet each. His motifs are the four

elements—Earth, Air, Fire, and Water, each of which is symbolized by two paintings, and symbolized with a freshness and simplicity that have their welcome source in Nature herself and not in emblematic figures from a routine of official decoration "Primitive Fire" is rather disenchanted by the fact that it has in it several models who have appeared in several other Brangwyns, while "Industrial Fire" is just what it should be—a revelation. But my favourite is "Air ii: The Windmill," with nude children at its base and windblown figures, some nude, chivied by a strong breeze along the foreground

These Brangwyn decorations are within the enjoyment of all persons who are natural enough to feel attractions that good colour radiates. To place and keep these attractions before an ever increasing number of men and women, busy persons who toil in our drab towns and bleak climate, is a patriotic need, so let us hope that no more Brangwyn decorations will go abroad or be shut up here at home from the common crowd

I write as an Englishman, believing that England's inevitable cause, now and ever, must be her honour and her proud self-respect; and that her pole-star, beaconing and beckoning, must ever be her own cresset soul For even if England were to fall through the delays and follies of momentary politicians, her soul, with its thousand years of inspiring prestige, would take her victor captive. Let us think of England as we think of Shakespeare Whole editions of her works may come and go, just as her American colonists left her; yet *she* will remain profuse and imperishable

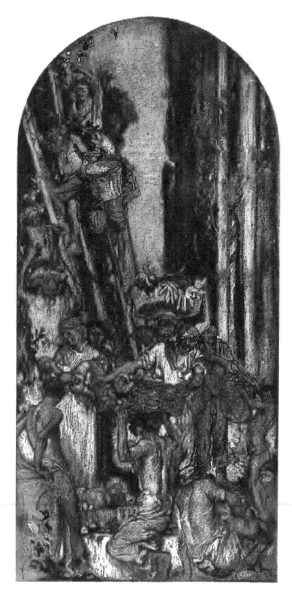

"FRUIT PICKERS": SKETCH FOR A PANEL IN MULL-
GARDT'S COURT OF THE AGES, PANAMA EXHIBITION
(The Blocks lent by "The Studio" Magazine)

CHAPTER XV BOOK ILLUSTRATION AND DECORATION

I

n 1910 I published a chaptei on these valuable off-shoots from Brangwyn's versatility, choosing here and there some examples from his early bread-and-butter work, with some specimens of earnest and genuine "parerga," as the Greeks named the byplay efforts of their hobby hours To-day I wish to recall some other early work, and to speak also of those books into which, since 1910, Brangwyn has put much time, thought and invention

During these eight years our publishers have been pretty keen and wide-awake They have issued with the utmost care a good many beautiful books, some of them illustrated by men of original mark, like Rackham, who is a whole court of fairies, and much else besides, in the realms of precious whimsies, and these fine books, often too good for nurseries and schoolrooms, though inspired usually for Christmas, have kept our country in the first rank of the world's publishing seasons. We have an aristociacy in book illustration and decoration But have we also a commonwealth? Brangwyn complains, not without reason, that the average level of workmanship is not only too low for a great nation, but also that it is often pinched, starved, poor and mean, and thus inferior to that which ruled in England between the time of Hearne, Girtin, Turner, Stothard, Nash, Wilkie, Rowlandson, Bunbury, Gillray, and those other brave days which connect Cotman and Cox and Gilbert (who in several ways was a forerunner of Brangwyn) with Leech, Doyle, Tenniel, Caldecott, Charles Keene, David Roberts, Prout, Small, Harding, Pinwell, Houghton, Fred Walker, Millais, Rossetti, Burne-Jones, Sandys, Hughes, Ford Madox Brown, and many others.

In the days when steel engravings and woodcuts and lithographs were as varied as they were often valuable, book production, as a rule, had about it a less flurried and industrial air; the evil now known as intensive culture appeared only from time to time, mercifully free from mechanical half-tone blocks, and also from that pestilential nuisance the camera fiend, who seems often to be neither brute nor human, but a ghoul. Fine books and periodicals have a fight uphill.

213

During five-and-twenty years, indeed, and always more and more, bookstalls and bookshops have been littered with fleeting productions, in which good things have often been overwhelmed by trash ; and it has become increasingly a risk to pay what is called a living wage for good illustrations by men rising into fame. American publishers have been more fortunate. Much more often than our own, they have been able to pay well and at once for capital work, thanks partly to an eager public more than twice as large as our own, but partly also to the much higher revenue that American publishers gather from advertisers.

On three occasions—April 1904, October 1905, and October 1906— Brangwyn has designed a cover for *Scribner's Magazine*, and as far back as 1893 he did a windy series of marine drawings for the same excellent periodical. It appeared in July of that year to illustrate a good article by W. Clark Russell on "The Life of the Merchant Sailor." There are twelve drawings, and only two are reproduced in half-tone One of these, from a swift pencil sketch, shows in perspective a forecastle, with two sailors in their rough bunks, another taking off his sea-boots before he turns in, while a tall negro, standing erect, lights his pipe and makes the too human air friendly with twist tobacco. The other half-tone is a pencil sketch touched here and there with a wash. It represents a burial at sea, and is full of weight, character, and observation. The remaining illustrations are excellent woodcuts.

"Two Men at the Wheel," one a negro, is a capital piece of work, unforced in its keen realism, and with just the right bluff vigour for a dirty day "Dinner in the forecastle," with light pouring down through a small vent-hole on six merchant sailors, whose uniform has a serviceable negligence as the only sign of discipline in dress, is equally sincere and apt. Its diffused light is well managed, and a story could be written about each sailor, so clearly are these six men made known by their faces and postures Other woodcuts reveal how a deck is washed at dawn, how a topsail is stowed by five salts, how the lookout is kept in thick weather, how rescuers get into the quarter boat after a man has fallen overboard, how jibs are stowed when a ship puts her nose into a swelling sea, and also how the lead is heaved These drawings are signed 1893, the year in which Brangwyn exhibited "Blake at Santa Cruz" (Glasgow Institute), "Shade" (Society of Scottish Artists), the "Adoration of the Magi" (New Gallery), "Dolce Far Niente" (Institute of Oil Painters), "The
214

Buccaneers"(Grafton Gallery),and two pictures at the Royal Academy, "Turkish Fishermen's Huts" and "A Slave Market," now at Southport in the public gallery

Nine years later, in September, 1902, Brangwyn returned again to the sea for *Scribner's Magazine*, and made five first-rate drawings to illustrate a stirring yarn by James B Connolly, *A Fisherman of Costla*. These are wash-drawings full of realness and power, and the half-tone blocks are closer and firmer and weightier than those that appear in an English magazine whose circulation is equally large. No drawing has its texture or its body at all unloosened by the meshed grain; every touch tells as in an original design; and even spray, flicked cleverly with a brush, keeps its own right place and value in one reproduction, where two very typical fishermen and a boy pole their boat off to the end of a quay

Let us compare these American illustrations, some process blocks and some real woodcuts, with the good seafaring work that Brangwyn has done for English books In 1891, for example, he illustrated W Clark Russell's *Admiral Collingwood*—a theme sufficiently national and permanent to forbid all trite and tame compromise among those who had to do it justice. Our London publisher chose the right artist, but he did not choose the right means of reproduction, preferring weak process blocks to full-bodied woodcuts or rich photogravures As Collingwood is the most lovable true hero in our naval history, a marine Sir Galahad always on duty at sea, who is to explain this prosy, commonplace thrift and fear? We cannot suppose that the British people, twenty-seven years ago, were land-lubbers who had no wish to pass from seaside trips to companionship with Collingwood, whose biography had received hitherto not enough research and colour.

Clark Russell and Brangwyn did their work well, producing a book for old boys of seventy and more, and old men of seventeen and younger. In one drawing, well composed, Brangwyn shows how Collingwood in the "Excellent," helped Nelson off St. Vincent. Sails are blurred by battle smoke, and in the foreground some men find refuge on a broken mast

215

afloat Collingwood and his first lieutenant, Clavell, asleep on
a gun-breech, worn out after blockading, is the subject of
another good impression, which contains also a capital group
of five tars around the next gun Not even a penny-wise block
can spoil this revival of the younger days at sea, when cannon
were but popguns compared with our battleships' most recent
weapons It is also refreshing to see how the "Royal Sovereign"
went into action at Trafalgar, "glorious old Collingwood a quarter of
a mile ahead of his second astern," and opening the battle with his
undying attack on the magnificent black "Santa Anna" As soon as
he reached this great ship, he cut the tacks and sheets and halliards of
his own studding-sails, letting them fall into the water; and when
his mainyard caught his opponent by the missen-vangs, he let off into
her stern a double-shotted broadside, and soon got rid of one foe
among the thirty-three that our fleet attacked Perhaps Brangwyn's
drawing has too much sea in the foreground and not enough space
above the ships' decks, but in other matters, at any rate, it is a top-
sawyer, though weakly reproduced
Collingwood had but little chance of enjoying home life with his
dear family at Morpeth, but once during a holiday there a brother
Admiral caught him in the act of digging a garden trench, with old
Scott, his gardener. Here is the subject of another drawing, which
shows Brangwyn aside from his usual moods. The episode is made
real with sympathy and high spirits Old Scott is an excellent
veteran, quite clever enough to feel wisely superannuated while his
master does most of the work, in order to be sure that he is at last
on land and at home. We get a back view of Collingwood, and
note how his broad shoulders have been rounded by a habit of stoop-
ing on board ship in low cabins and between decks.
More interesting still, as work apart from Brangwyn's usual appeals,
is a piece of real fireside genre, illustrating a passage from a letter
written by Collingwood in 1801 to Mrs Mowbray· "How surprised
you would have been to have popped in at the Fountain Inn
[Plymouth] and seen Lord Nelson, my wife and myself sitting by
the fireside cosing, and little Sarah teaching Phillis, her dog, to
dance." Just a few days before—on June 13, 1801—Nelson had
parted from his wife for ever, so his presence at Collingwood's happi-
ness must have been a painful experience to him The drawing is
clearly seen, well composed, and sympathetic. Nelson is seated with
his back to us, while Collingwood talks quietly, his face wearing
216

that half-anxious look that settled upon sailors during the long and stern blockade.

And now we pass on to *The Wreck of the Golden Fleece*, written by the adept Robert Leighton and published in 1894 It is the story of a North Sea fisher-boy, and Brangwyn made for it eight sketches, which were not so well reproduced as they ought to have been. Here is another entertaining bit of genre, showing how Peter Durrant spelt out a handbill in a printer's pleasant old shop; and there's a good fight on board a plague-ship. It sets me thinking of Alan Breck's fight in the Round House, on board the brig "Covenant," in Stevenson's *Kidnapped*, which did not reach lads as easily as Robert Leighton's tales.

Two years later, in 1896, *Tales of Our Coast* appeared, with a dozen illustrations by Brangwyn. They were written by Q , W. Clark Russell, Harold Frederic, S. R. Crockett, and Gilbert Parker. Once more the blocks are not good enough to be fair to a big artist, whose fame on the Continent was increasing fast, and who was then at work on his young masterful picture "The Scoffers." What hope can there be for genius in book decoration when second-rate blocks are offered as a sop to penurious enterprise? Brangwyn did well to turn from such thankless toil to the freer scope that he found in design applied to household things, like carpets and furniture and stained glass

Of his drawings for *Tales of Our Coast*, four or five should be mentioned. In Russell's yarn, "That There Mason," there are two "*You* killed him !" and "Old Jim Mason's the worst-tempered Man on our Coast." He looks it too, a human cauldron always ready to boil over, and Brangwyn shows in Mason that spinal weakness of character which goes frequently with ungoverned temper, as with other uncontrolled emotion. Q 's thrilling story, "The Roll Call of the Reef," has a tragedy on a seashore, and I should like to come upon the original drawing. Crockett writes about "Smugglers of the Clone," and I find in a Brangwyn sketch—"Black Taggart was in with his Lugger"—an episode from shipping affairs that foretells a very good thing in Brangwyn's etched work, unloading wine at Venice by night But the main point of all is the varied observation. Several drawings do not seem to come from Brangwyn, so closely do they belong to the tales. "Saw his head spiked over South Gate," in Harold Frederic's "The Path of Murtogh," is one example. Thackeray says that no one can have any guess what

ideas are in his mind until he begins to write; and certainly Brang-
wyn does not know how much he has gathered from his travels and
his reading until he sits down to illustrate a book. What is it that
Shakespeare tells us about Art and Nature?—

> "—Nature is made better by no mean,
> But nature makes that mean so, over that art
> Which you say adds to nature, is an art
> That nature makes You see, sweet maid, we marry
> A gentler scion to the wildest stock,
> And make conceive a bark of baser kind
> By bud of nobler race this is an art
> Which does mend nature,—change it rather, but
> The art itself is nature. . "*

So it is always, though fashions in all things come and go
In 1899, Brangwyn went again to the sea and illustrated *A Spliced
Yarn* for George Cupples, doing five drawings and a title-page
Across the head of this title-page he put in decorative outline some
warships of Edward the Third's reign, or thereabouts, and his
drawings are brisk and welcome, though three add nothing fresh to
his graphic variety. They repeat a familiar good seamanship in art,
like captains who meet on their voyages with no event which is un-
expected. We see how H M S. "Brutus" fought Le Caton, and
also how an old frigate tumbles home in the fangs of bad weather;
while the third sketch carries the canvas of a fine merchantman who
gathers knots from a stiff wind, while clouds pile themselves into
threats "In the Hooghly," boarded by native traders, is a new vein
in Brangwyn illustrations, and a busy impression called "The Panama
steamer came in," is a new tributary also into Brangwyn's main
stream. But the reproductions are only better than nothing. From
what they do with a fudging thrift, by which a few pence are saved
on each block, one has to guess what a true artist did with appre-
hension of two sorts, conceiving and expressing right things, while
he anticipated ill-treatment from block-makers and printers What a
pity it is that his earlier book work was never reproduced in England
with such royal care as the brothers Dalziel in their woodcuts gave
to Millais, Leighton, Pinwell, Ford Madox Brown, and many others!

II

We pass on to four or five series of later and riper designs. In 1910
I spoke of Sir Walter Raleigh's "The Last Fight of the 'Revenge,'"

* *Winter's Tale*, Act IV. Sc. 3, Polixenes to Perdita.

218

which Brangwyn illustrated in 1908, choosing six subjects for colour-prints and making many headpieces and tailpieces. The finest colour-print is taken from an overmantel at Lloyd's, and represents, with majesty and splendid pomp, how Queen Elizabeth went aboard the towering Golden Hind Brangwyn has done nothing more stately in historical seamanship, and I am glad to know that lads of the U S.A see this noble decoration in Scribner's *The Boy's Hakluyt* * In 1911 he enriched and completed a very charming edition of Southey's *Life of Nelson*, for which John Masefield wrote an excellent preface. Several colour-plates, all from good blocks and well-printed, we have seen already, in *Scribner's Magazine*, August, 1903 (p 204); but the others are less familiar to students of Brangwyn's versatility. "Building a Frigate," for example, is most romantically conceived, and as mellow in colour and tone as one of those rich baritone singers who rise all at once into a climax of pure tenor. An officer and his friends, women and men gaily dressed, visit the frigate, and their presence as plots of colour is put in with just the right allusive touches from a full brush "An Italian Water Festival" is amusing as an extemporised pageant, and also because of its contrast with "After Trafalgar," where imaginative fervour gathers with coming dusk and storm around crippled battleships, one of which has a fatefulness accordant with Nelson's death in victory.

Brangwyn's headpieces and tailpieces, now so many and so various, cannot be interpreted one by one Their method has a frequent interest of its own, and strength of its own, with a charm not felt by everybody If you do not like it, you must leave it alone, but not, I hope, before you have tried to put yourself into friendliness with its decorative breadth, its robust and subtle variety These qualities go hand in hand with humour, and wit, and romance, enlisting as aids a great many motifs that other designers are overapt to pass by. Note how varied and ornamental is the use he makes of ships and of bridges, for example, and as for the designs composed for endpapers, they are always original and apposite On one, drawn with a brush almost as fresh and swift as an incoming tide, a fleet of old timber battleships goes sailing into action, and so full of promise that it hurries us into the pages that it recommends As for Brangwyn's initial letters, are they not often rapid sketches rather than designs within that formal art which good printing has delivered down to us from Caxton's day ?

* See also *Frank Brangwyn and His Work*. Kegan Paul and Co

In 1913 Messrs Sampson Low and Co prepared with thought and pride a capital edition of Kinglake's *Eothen*, with a prefatory note by S. L. Bensusan and designs by Frank Brangwyn. This book, with its traces of travel brought home from the East, has a chatty, refreshing naturalness that keeps young and true, despite the gradual alloy of Western manners and methods that the East receives, as a copyist sometimes, and sometimes under compulsion. Brangwyn, like Kinglake, was born with gifts swift to apprehend with sympathy all that is venerable and highbred and glowing among Eastern customs, manners, and peoples, and thus the wise temper of his Oriental work should be of use to our British patriotism, which, as a rule, has dangers all its own. If we compare our patriotism with that of the French, for example, we see at once that French patriotism has in it the stuff of a burnt sacrifice, a passion so intimately filial that France lives in French minds as mothers live in the hearts of little children, while our own patriotism, as a rule, is a multiple and a vagrant achievement wherein pride of race, inherited from age to age with a far-scattered Empire, is the main factor So we are apt to forget as a nation that Empires invariably have to hold at bay two encroaching foes; either Imperial pride may become excessive enough, as in ancient Rome, to disintegrate most national feelings, or national feelings may become too subdivided and too zealot-ridden for Imperial unity to be possible, as in present-day Russia. India also has imported epidemical ideas from Western socialism and democracy, and unless British minds undergo a thorough orientation, grave perils will come upon us unawares and find us unprepared To publish temperate and sympathetic books on the East, with illustrations by men who understand the East, is thus very useful and necessary.

Macaulay complained that books on India attracted little notice, and Disraeli's thorough understanding of the East was never appreciated at its worth by our insular aloofness and over-confidence One reason is apposite here, and it happens to be a reason that statesmen have passed over in silence. Most minds learn more from drawings and pictures than from printed words, and our pictorial arts, unlike the French, have been scrappy and patchy, and also infrequent as explorers of Easternism Off and on we have had a true and a fine Orientalist, like J. F. Lewis (1805–76), Holman Hunt, and Brangwyn; but across the Channel, for about a century, there has been a flourishing school of Orientalists, whose abundant work has done a great deal to unite the French people to the daily presence of Eastern affairs.

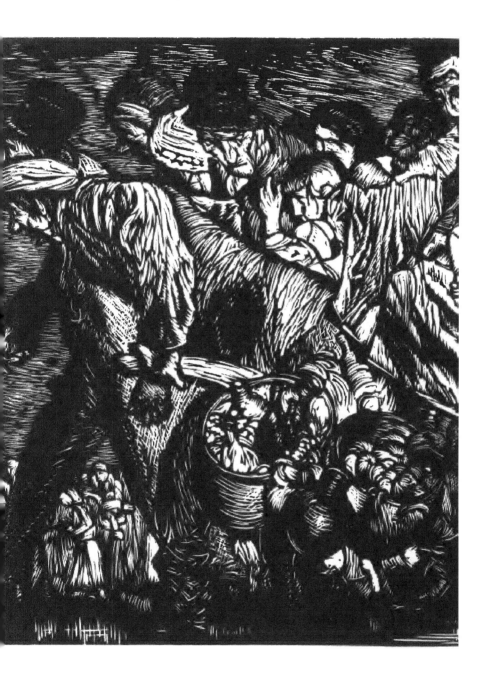

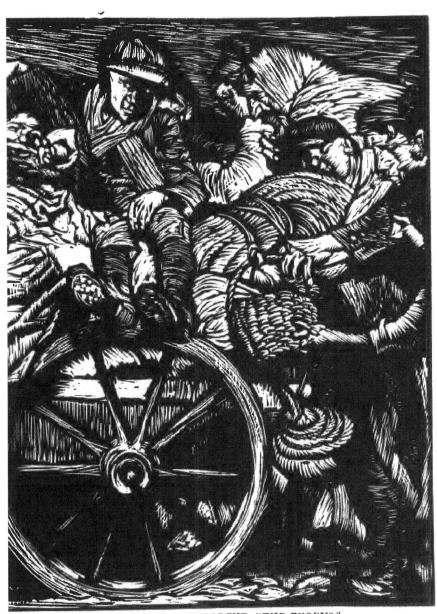

WOODCUT "THE EXODUS."

It was this education in the aspects of Eastern life and character that enabled Frenchmen to like at once the splendid and intrepid orientation through which Brangwyn's art passed after visits to the Near East, while at home his departure from gray sea-pieces and his arrival at real Eastern colour and life were treated, far more often than not, as outrages on insular domesticity and gentleness—on what may be called the Darby and Joan of æsthetic orthodoxy. His Easternism was regarded as a dissenter, a new courage and candour, to be feared and disliked, though the British Empire in Asia had a population of three hundred millions, all Orientalists, and therefore persons to be understood in the British Isles.

Kinglake and Brangwyn, then, go happily together, and usefully also They take us far off from our gray and self-absorbed insularity and then bring us home with a sunrise in our minds—an East full of light and magic There is nothing stale, flat, and unprofitable The orange cover, upon which we see through an Eastern arch a city of promise, has nothing to do with the beaten track of bindings; and the half-title page has on it a white mosque and a quiet crowd, which takes its ease in an avenue of cypresses, dark trees and very tall. The plates are in colour, some little known and some familiar, like the Turkish fishermen with their trellised huts from the Prague Gallery, or the Orange Market at Jaffa, which I was lucky enough to reproduce in *The Spirit of our Age* "Arabs on the Shore," from F J Fry's collection, and painted in 1897, is among the wittiest and happiest of Brangwyn's penetrations into character and manners It reveals much that Western pride—or is it short-sighted careless-ness ?—cannot, or does not, perceive. These tall Arabs are stately figures and content with their lot Though commoners, men of the people and poor, they have a well-bred look and carry themselves with an easy distinction. Some are seated, while others stand erect, and friendly badinage passes between them, with a reserve which has a long ancestry, and they have from nature a peculiar grace some-what akin to that of lions and tigers

Here is a higher type of physical man and manner than that which is bred and stereotyped by Western industrialism, and it recalls to mind the fact, now forgotten perhaps, that many of the Indian troops at Queen Victoria's Diamond Jubilee were mistaken by most Londoners for Indian princes, so regal was their bearing on horse-back, and so high-bred their direct, proud faces Is it not time that Europe should breed among her common folk both better looks and

221

thoroughbred manners ? Rough Shetland ponies are all very well, but racehorses and shire horses are far and away preferable Every sort of good caste Eastern is understood by Brangwyn, and I wish he could be busy for a year and more in India. A school-book on India, illustrated by him and written by Sir J D Rees, would be a liberal education in the conservative progress that our Empire can never do without
Meanwhile let us read or re-read this good edition of *Eothen*, and let us hope that more pictures will appear soon in a reprint Those which are published—"Eastern Music," for example, and " Moon-light in a Turkish Cemetery," "A Damascus Garden," " At the City Gates," and " Merchants and their Camels," with a gleaming distance of white architecture and a foreground aglow with amber and other mellow rich notes of colour—are entertainingly character-istic, but overmuch of Brangwyn's most impressive Eastern sympathy has been omitted
More than once he has proved his sympathy for "Omar Khaiyâm," and we should note above all the plates that he added in 1913 to FitzGerald's version This edition was published by Foulis in the Rose Garden Series, and Foulis has a liking for good workmanship whether old or new. He makes few mistakes, but I believe he went too far, when he put this edition of "Omar" into a lilac cover and between lilac forepaper and endpaper, lilac being one of those colours which, like mauve and vermilion, should be used with chary thrift as rare notes in decorative harmonies Dame Nature tones lilac with her gray brilliance and relieves it with tender green leaves, while in machine-made paper and cloth, lilac is as cold as death and almost as dissonant as emerald green When put cheek by jowl with enough gold or enough black, as in illuminated work, lilac, like emerald green, sings pleasantly in chorus.
There are eight illuminated pages in this edition of "Omar Khai-yâm," beautifully printed, delicate and charming, and eight illustra-tions in colour by Brangwyn, reproduced very small, yet keeping his abundant scale and the magic of his colour, complete a book that needs for its guardian a strong and a bold binding. It is with ex-quisite little books as with jewels, which set us thinking of safes and locks and keys. Yet there's a belief in England that delicate books ought to have delicate bindings, though a delicate binding is dirtied in a few months by our dusty and sooty towns This false belief takes its rise from another—that harmonies of affinity are better than
222

harmonies of contrast. They are more feminine, of course, but in men's work they are so effeminate that no great colourist has ever failed to employ rich neutral tones as a keyboard for triumphing harmonies of contrast. How to reconcile discords is among the essential victories that Brangwyn gains, like every other original colourist.

Belgium, a book published in 1916, and *The Poems of Verhaeren*, with cuts by Brangwyn, belong to woodcuts and brush drawings, and will be considered in the next chapter.

CHAPTER XVI BRANGWYN WOODCUTS AND BRUSH DRAWINGS

I

In good prints they are alike, and some woodcuts may be mistaken for good process reproductions from brush drawings, but many a one is cut straight upon wood, without a drawing to give help, only a few guiding lines being used to space out and to point a premeditated design.

Brush drawings make their appeal in this book from a good many prints, headpieces and tailpieces, bookplates also, and a civic revolt, swift and thrilling, like Delacroix's "La Barricade," but not so terrible as Meissonier's "La Barricade," dated 1848, with its desolated street littered with dead bodies not yet cold and rigid. Note also Brangwyn's black and white impression of a boxing match, a negro among sporting prints, which, though it comes not from an artist who, like Maurice Maeterlinck, is elusive and bruising with gloved fists, shows decoratively what movement and muscle and character are brusquely shadowed by one method of Brangwyn brush drawings. It is a method apart from that which you will find in many pen and brush drawings contributed to *A Book of Bridges*,* where line and wash are equally graphic and original Examples: Bridge of Boats at Cologne, a vast Gable Bridge at Gerona in Spain, Bridge at Waltham Abbey attributed to Harold; Smyrna: Roman Bridge and Aqueduct, Ruins of a Roman Bridge at Brives-Charensac, France, Bridge at Zaragoza, partly Roman, Ponte Rotto, Rome, anciently Pons Palatinus or Senatorius; Ponte Maggiore over a Ravine of the Tronto at Ascoli-Piceno, Primitive Timber Bridge in Bhutan, India, and—passing over other brisk and expressive sketches—a noble bridge across the Main at Wurzburg in Bavaria, built in 1474, and adorned with statues of saints in 1607 By contrasting these illustrations with Brangwyn's methods in his two boxing matches, one in two colours, and one mainly in black, we get rapidly to close quarters with his versatile and often figurative handling of monotint wash, and pen lines and brush contours.

Bookplates have added other notes to his graphic work with both line and brush. Some are etched Ex Libris: like the men carrying

* By Frank Brangwyn and Walter Shaw Sparrow. John Lane, 1915.

224

"AN OLD STREET IN ANTWERP." DRAWING FOR "A BOOK OF BELGIUM, BY FRANK BRANGWYN & HUGH STOKES. (*Kegan Paul & Co.*)

books (Nos. 81 and 82), or the boy crowned with a garland, who plays on cymbals above an Italian garden (No 84), or, again, the plate inscribed "Ex Libris, Frank Newbolt" (No. 86) Here a full-rigged Tudor ship makes against a dark sky a bold and brave ornament A bit of heraldry, a shield, is put in the right-hand corner of this bookplate; while at the top a scroll bears the inscription Then there are some bookplates in colour, and as for those in brush drawing, Brangwyn has proved here, several times, though seldom elsewhere, and never as an etcher, that he loves birds and their value in ornament, decoration, and symbolism. Never does he forget, moreover, that changes of a ruling sort among social customs and manners ought always to leave marks of their activities on book-plates. At a time when cobwebs of the study no longer cling around most ripe scholarship, and when a duke, knowing that our times are non-aristocratic, is ready to practise the chivalry of strap-hanging on a tube railway, neither heraldic pride nor Latin motto-seeking belongs as a typical right and grace to many current hobbies and routines. Yet many a commonplace democrat, with not a word of Latin to trip into speech, picks up from a dictionary of classic maxims a Latin tag with which to part his bookplate from his family and friends. Armorial achievements among professed socialists and true democrats need no pedantry of this old sort, unless it be put into dummy books on the top shelves of lofty bookcases, where affecta-tions may well be kept with printed languages that we cannot read. Brangwyn wants to do bookplates for those men alone who are not ashamed to show in a design what they are as workers and readers and citizens. Good English, from Chaucer's day to our own, should have been deemed classical enough to be worn as a motto on any coat-of-arms or below any family crest Though Montaigne delighted to hobnob with ancient master minds, concealing his quota-tions and his authors, so that his critics might give a stab to Plutarch or a fillip on the nose to Seneca, yet, as soon as he wished to find a maxim for his own workaday motto, he thought as a witty French-man, choosing the simple and ironic words · " *Que Sais-Je ? What do I know ?* " This alert modesty is a lesson to our fussy, flurried generation; and there can be no doubt at all that bookplates, as Brangwyn says, should be right as emblems as well as English, and modest in their mottoes

Their symbolism can be national sometimes and sometimes private and personal, to denote what a man likes as a hobby, or what he is

2 G

during the day's work, or what his family likes best to remember. Sailors have abundant motifs from which to make a choice, for example, so have soldiers, lawyers, barristers, judges, architects, men of letters, athletes and sportsmen, and all other sorts and conditions of men ; so that bookplates could and should express, with fitting emblematic designs and with original mottoes in English, what each generation of our countryfolk does and will do as a reader, and a worker, and a pleasure-seeker Social history in brief, then, not heraldic honour or glory, whether real or feigned, is the main thing that we should wish to see among the bookplates designed by artists. Brangwyn has been far too busy to make this art anything more than a half-holiday on various occasions, as Newman, I believe, described to a friend his heart-abiding " Verses on Various Occasions ", but a few designs he adds year by year to his bookplates, while some other artists add—shall I call them " duds " ?—to theirs.

And now let us turn to the essence of his work in brush drawing and wood engraving It is found among four things

1 The tinted woodcuts published by the Fine Art Society, London, under the title " At the Front and at the Base " These I have reviewed in a footnote on pages 189–90, in order to unite them to Brangwyn's War Posters

2 In significant and impressive work like "A Fair Wind," or like " The Exodus, Belgium, 1914," a subject which has inspired Brangwyn in several War Posters printed from stones

3 In a book on the Poems of Verhaeren, to be published in Paris by R Helleu, for which Brangwyn has made about forty woodcuts, all so alive with imagination and so rich and varied in motif and expression that Verhaeren examined proofs from the wood *avec une grande émotion* I have entered some of these woodcuts in my index, and students of Brangwyn cannot give too much attention to their persuasive power and originality They will note, for instance, eight full-page woodcuts "La Mort," "The Church," with the religious ceremony in a street, "The Port," "A Colliery," "A Monk Preaching to a Throng of Workmen," "The Monument," "A Revolt," with a Gothic church in flames, and "Building a Ship " As for the smaller cuts, each has its own charm, and the headpieces and tailpieces come hot-foot from a great artist through the poems that he illumines as well as illustrates In fact, Verhaeren and Brangwyn

226

are at one, and the poet's enthusiasm over the proofs is the best re-
compense that his interpreter can receive.

4. In another memorable book on Belgium, accompanied by careful
and sympathetic notes by Hugh Stokes, who knows his Belgium
well It was published in 1916 by Kegan Paul, Trench, and Co., to
be what is known as a Charity Book In this time of war Brang-
wyn did this work as an act of homage to a great little nation
stricken by disaster.*

II

In this book on the little towns of Flanders it is evident at once that
Brangwyn's woodcuts have a manner all their own ; they are as apart
from routine as is the volcanic and scientific warfare by which they
were inspired to aid a "charity"—a word too often employed to-day
as a synonym for duty They come from a genuine innovation, de-
pending for its effects on the varied art with which white lines and
white shapes are flashed, as it were, upon a black surface, to fashion
what I ask leave to call a meteoric picture, a picture so very ardent,
and vivid, and expressive, that its lighting has a power not to be met
with among other woodcuts, whose graphic method is a synthesis of
black lines and shades on a white surface
Not only is this Brangwyn manner a realm apart, it is also auto-
cratic, altogether arbitrary, though pregnant with magic Its best
æsthetic results are wonderful, inviting us to think of illuminations
akin to those which come after dark from lightning and searchlight,
or from luminous meteoric phenomena, or from active volcanoes, or
else from star shells. If we speak of it, then, as searchlight wood
engraving, thrown upon midnight darkness, we get as near as we
can, in a figure of speech, to the very original poetry, incanescent
here and incandescent there, that these new phases of Brangwyn de-
coration often conquer from the little towns of Flanders.
Vividness of harmonious effect from block printing between con-
trasts of white and black owes much to differing papers · common

* As a boy, let us remember, F B did much woodcutting and engraving, so that his
present delight in the qualities to be got from wood renews, as well as extends, a phase
of his versatility He never attached himself to the Bewick school of wood-engraving
that derived its delicate fine lines from copper plates, preferring the broad, fat line
which began to come into vogue just before the eighteen-sixties, when three periodi-
cals—*Cornhill, Good Words*, and *Once a Week*—started to lead the way in a series
of sterling woodcuts after Houghton, Pinwell, Fred Walker, Whistler, Millais, and
others also

227

wood-pulp rubbish dulling the blacks, while Japanese paper gives in full measure to Brangwyn s woodcuts their eruptive brilliance and their eery power and charm

But we must carry this analysis a good step farther. Let us remember that action gives rise to slow reaction only when it is mild, gradual, and close to ruling customs and routines. As soon as it grows intense, like this white-hot crescendo of innovating light and mystery, swift and intense reaction is invited, and many a mind, I fear, accepts the invitation with a will, though a little reflection would or should convince it that Brangwyn has called up into graphic art woodcuts and brush drawings not less valuable than they are off the beaten track, somewhat like Edgar Poe's tales, which Brangwyn should translate into his uncanny wood engraving Yet this newness, so ardent, superlative, unique, would be easier to enjoy if it were put before the world with as much thrift, as much royal avarice, as a musician of genius employs when he goes at full strength and speed into an orchestration that seems to make symphonies out of thunder peals and exploding shells

A woodcut here and there suggests another analogy. Here, for example, is tempered moonlight around and upon the cathedral and belfry of Tournay, which seem to be lit up by—may I suggest a flight of angels flushing into sorrowful anger as they pass through a nation ravaged by foul war ? You may dream into it what you please, so very suggestive is the ghostly or spectral design enchanted from black by white, leaving the black pure in many places and making it incanescent elsewhere This art, which evokes a dark city at midnight into a dim etiolation, is not for all the world, and let it be shown in a book with a thrift like that which should rule over the use of rare gems amid a drilled and dressed assembly at Court. As Crown jewels are kept in the Tower of London, so there are manifestations of unique art which should be kept by their producer under lock and key, as it were, to be revealed now and then, by books and exhibitions, in a few chosen examples only. Koh-i-noors would be prized no more than herrings if they were as numerous and as easy to get

If unique splendour is to put its own complete spell on everyone who has imagination, and a willingness to feel intensely, its qualities should never be seen all at once in a large enough number of kindred things to stale their uniqueness After reaction, as a rule, staleness comes. A fire burns down into ashes, which glow and

228

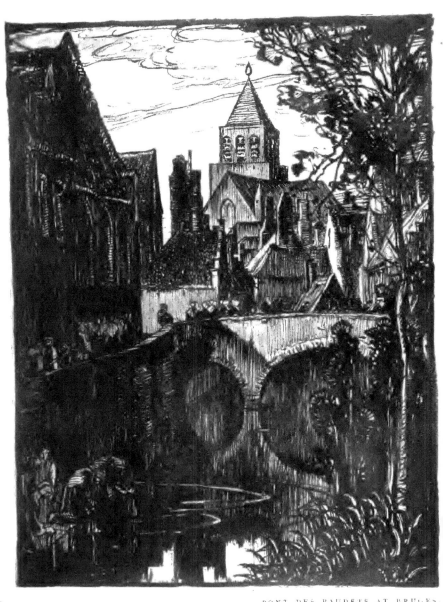

smoulder until they die out one by one. Such fires are lighted by most innovation, and they burn fiercely for months or years, then flicker into cold commonplaces

Already I have listened to some fierce raids on Brangwyn's woodcuts in his Belgian Book, listened, for a man who replies by word of mouth to flood-tide dislike or reaction, is as foolish as he would be if he hurled barrels of gunpowder into a burning house. Listen quietly, then, remembering that noisy fault-finding is no more criticism than the crash of a falling tree is arboriculture Besides, it is the lot of genius to strike flame from hard minds, and Brangwyn has passed from one stake to another in that sort of censure which is intended to burn or scorch

But when I ask myself why his great Belgian Book has enabled me to hear once more such hot and foolish talk as that which assailed "The Buccaneers," and "Trade on the Beach," and "St Simeon Stylites," and "The Scoffers," and even "The Cider Press", when I ask myself this question, one answer comes from day to day, and it seems to be correct that too many jewels were put into the same casket when the book on Belgium was gemmed with fifteen initial letters, twenty-three headpieces and tailpieces, and nine and twenty full-page plates * We see, then, that Brangwyn's original search-light, with its unique brilliance, its eruptions of glorious patterning white on midnight darkness, appears in no fewer than fifty-two designs, excluding the initial letters

For all that, it is a book enchanted, and surely permanent ; a classic in English book production Is it really above the heads of that vast public to whom the Charity Books published since 1914, to the injury of many authors and their families, have made a frequent appeal ? As well offer Dante and Milton to a music-hall audience. For the rest, though too many jewels triumph less than just enough, the excess of innovating beauty in this book may be countered by those who wish to enjoy it properly

Indeed, there are two ways by which this excess of beauty may be neutralized. So let me say a few words on each. The main thing to be considered is the influence of those plates where this new art is most superlatively itself, a quite wondrous glory of insurgent white design flashing out from a blackness that answers formidably; as in The Cloth Hall at Ypres, where architecture and graphic art are transfigured as by an aurora borealis Other examples are the Palais

* H G Webb engraved fifteen blocks, and C W Moore ten

229

des Archives at Malines, quite magical, and The Calvary of St Paul at Antwerp; The Church of St Walburge at Furnes, which seems to be illumined by a bursting star shell, and The Broll Toren at Courtray, with its darkling poplars; also The Belfry and Town Hall at Ghent, where enchanted flags and banners wave from black phantom buildings above an uncertain procession that might well be a midnight visit under the moon from dead rivals who are not yet friends In all these kindred invocations the frisky Ulenspiegel would be at home, with his friend Lamme Goedzak, and Nele also, "sweet as a saint and beautiful as a fairy," though daughter of an old witch named Katheline *

But if you look at them all in the same hour, or on the same day, you will set them to cancel one another by staling their brilliance and their eeriness Don't, then ! On the same day never look at more than two or three, and for the same reason which caused Edgar Poe to say that a long poem must be read as a series of short poems, if good sense wants to answer the appeals in a proper mood and with full enjoyment.

Further, the Church of St Walburge at Furnes ought to be compared with Brangwyn's etchings of the same architecture Then you will see that his woodcut, though it seems to be a flashlight in arbitrary decoration, has achieved more than the etched work, just as moonlight and sunlight achieve more than gray weather And it is equally useful to compare Brangwyn's woodcut of Windmills at Bruges with the noble etching in which they are transfigured. I know not which is preferable as a work of original vision and uncommon emotion Different qualities are present, but equally satisfying Note, too, that although Brangwyn in many etchings has proved himself a master of crowd impressions, he is a better master often in the crowds that people the foregrounds of a good many woodcuts; though I wish he had not put a democrat orator into his woodcut of the Cathedral of St Peter at Louvain, as he has used this mordant good idea in his etching of Notre Dame, Paris

In St Peter's at Louvain the engraving follows vertically the grain of the wood block, which runs up the cathedral and the sky, white and gray lines etiolating a black surface until spectral architecture with its many pointed windows looms out from a streaked sky, across

* Have you read the story in which De Coster has renewed the adventurous follies of Thyl Ulenspiegel ? Thirty years ago I read it with delight. That it has not been done into English, and illustrated by Brangwyn and Rackham, is a thousand pities.

which, high up, from another building, a gargoyle juts forth its head.
The sky here is a quivering duotone, while in some other woodcuts
it has either sinister or unearthly effects, with rolling cumulus clouds
piled into what I feel tempted to call a rhapsody of flashing move-
ment, as behind the Palais des Archives at Malines
And there's another thing to be sought by those who wish not to be
startled into inept criticism by a new method as powerful as it is at
odds with custom. Several full-page plates, like the charming old
timber house at Ypres, now destroyed by shell fire, or like the heroic
old street at Antwerp, at once exquisite and venerable, would put life
and charm into any book on architecture, so much do they give of
form and mass and inward spirit Consider, too, the neglected
Abbey of Ter Doest at Lisseweghe. What a genuine discovery ! It
is a godsend to students of primitive architecture, for its great façade
comes sweeping down to earth as a triangle, a vast and rich gable of
the thirteenth century at rest upon the ground. Five pointed
windows remain, each with two lights and a round eye in its head.
A lean-to of some sort has been added by spoiling hands to hide the
lower part of this rare façade Bruised, battered, in ruins, this abbey
is treated as little more than a grange, seemingly an offshoot from a
farm, so Brangwyn has added a timber-wagon and its horses—a
pleasant mask across that lean-to.
Sidney O. Addy will be charmed by this woodcut In his excel-
lent book on the Evolution of Our English House he treats of
triangular buildings, gables on land, and shows two in photographs.
One of them is an Irish example at Dingle, known as the "oratory"
of Gallerus; a primeval structure made of dry rubble masonry and
with only one room, 15 ft 3 in long by 10 ft wide The other
example is a thatched house at Scrivelsby, near Horncastle, popu-
larly known as Teapot Hall, and built of two pairs of straight
crucks These crucks or gavels extend from the four corners of
Teapot Hall to the ridge-tree, which they support, and the frame-
work is firmly strengthened by wind-braces In length, breadth,
and width this triangular home is nineteen feet. Bede tells us that
Bishop Eadberht removed the wattles from a church built in this
way and covered it all over with lead, from its roof to the walls
themselves, and we learn also, on Malmsbury's evidence, quoted
by Addy, that an old church at Glastonbury was covered with
lead from its summit to mother earth Here, then, we find
triangle churches of the eighth and twelfth centuries, so the

231

Abbey of Ter Doest, or All Saints, at Lisseweghe, had sacred forerunners

And now we pass on to the second means by which anyone who does not yet know Brangwyn's book on Belgium can prevent its uncanny woodcuts from seeming too many and too startling. Since 1914 two books of woodcuts on the little towns of Flanders have been published, and it is useful to both when they are studied together, because they come from kindred spirits, though their methods differ. The second one contains twelve woodcuts by Albert Delstanche, with good notes by the engraver and a charming prefatory letter from the later Emile Verhaeren * If you compare Delstanche's treatment of the Quai Vert at Bruges with Brangwyn's Pont des Baudets at Bruges, or Brangwyn's Cathedral of St Rombaut at Malines with Delstanche's decorative vision of the Belfry at Bruges, you will see at once that these artists are cater-cousins in their woodcuts, though their orchestration of black and white differs Yes, and Delstanche's old houses on Le Quai aux Herbes, Ghent, is a parallel to Brangwyn's etching of old houses in the same proud city , and what Verhaeren wrote to Delstanche brings us very close indeed to Brangwyn's enchanted Belgium —

" You are working here in London from notes and rough sketches made in happier days, and you are ignorant as to whether the beauty you are revealing is already dead or still alive. But the very strain of this uncertainty will inspire you, surely, with a deeper fervour, and you will approach your work with a sort of ardent piety and a sense of almost sacred devotion. For it is certainly true that anything we love, when danger threatens it more and more, grows more and more dear to us. The very stones of our towns are like memories, mustered and brought together from age to age ; so they have become blended with our inmost thoughts and feelings—a pile of little souls, as it were, massed and cemented in a bond of perfect sympathy. . . .
" These little towns, then, began by arousing your interest. Later you grew to love them , and now you lavish on them all your art. For you know . . . their quiet streets—where at footfall of a passer-by, little curtains at small windows flutter apart that those within may look out and see who it is that can be troubling the silence. You are familiar, too, with places made glorious by fights of long ago, where blood was spilt in those famous combats between Fullers and Weavers, Butchers and Brewers , you have listened to the tragic bourdon of big bells, and airy music from the carillon, with grave and punctual chimes that sound from many a clock tower. You have loitered at inns, at the *Trois Rois* or the *Cheval Blanc*, to

* *The Little Towns of Flanders*. Chatto and Windus Price 12/6 net.

232

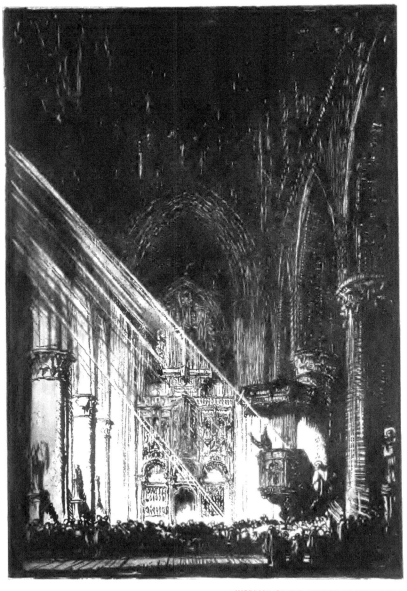

"INTERIOR OF THE CHURCH AT DIXMUDEN."
DRAWING FOR "A BOOK OF BELGIUM" BY
BRANGWYN & HUGH STOKES. (Kegan Paul & Co.)

sketch from its doorway a brewer's cart whose pile of barrels oozes at the
bung with frothy ale, and you have loved to stand a-gaze at the same
old bridge with its three arches, reflected so clearly in the water that you
almost hope to descry there the arrow that an invisible archer is stringing
to his bow, to shoot the mirrored stars * And even now you can recall to
mind the pitch of that roof at the far end of a market-place, or the angle of
that gable on the front of a burgomaster's house, or the column under an
oriel window at the left of a market-place, or that carved capital, in the
right aisle of the Cathedral, which beautifies St Peter's Chapel with its
Norman monsters intertwined in a struggle of tooth and claw . . . So
you are able to translate more than the crude reality of these things You
surprise out of them their spiritual significance. For you do not try to
separate the image from its aureole ; on the contrary, you are content that
the aureole shall give its value to the image. You succeed, then, not
merely in entertaining us, but also, and much more, you make us feel
And your book, it will be a book of faith For it is understood, is it not,
that everything of ours that is down shall soon rise again; that Ypres,
Dixmude, Alost, Termonde, Louvain, Dinant, Visé, will lie in ruins only
for so long as their invader soils our soil; that already stones that are
fallen, but not broken, begin to be impatient to regain their true position,
here on a pediment, there on the base of a column ; and that from the
death of so many things shall spring the life of many things more Thanks
to your woodcuts, handled so tenderly and confidently, this resurrection of
the little towns of Flanders will come to pass, perhaps all the more quickly
You are giving us good counsel It is the best I can wish you And it
will be, I trust, your reward "

Nobly said, and in bulk even more apposite as a tribute to Brangwyn's
vision than to that of Delstanche ; for the frequent coming of a
supernatural spell and glory into the Brangwyn woodcuts may be
taken sometimes as a prophecy full of hope, a transfiguration of to-
day and a suggester of that new birth through which the torn and
trampled little towns of Flanders must be made to pass. above all by
those who, in the years before this war, often made their homes in
a gabled quietness as eloquent as an aged chronicle Once more, as
in Brangwyn's woodcut, happy poor shall taste the anodyne of a
sweet serene charity below the great beams of a Cloth Hall at Ypres,
and once more, as in Brangwyn's woodcut, at a midnight service, a
wonderful mystery of darkness and glowing light shall dwell within
a Gothic church at Dixmude. To Brangwyn then, who was born
at Bruges, and to myself also, who lived in Belgium for the greater
part of ten student years abroad, there can be nothing now that is

* See Brangwyn's "Pont des Baudets at Bruges '

prosaic within the little towns of Flanders, where a whole race of men, age after age, put itself into monuments before each of its generations made way for another. Whether Brangwyn gives a manifold realness to the lofty Castle of Walzin, Province of Namur, or records the ruins of Villers Abbey with a procession of monks who revisit the midnight air, a genuine poetry as epical as history informs his technical expression; and so we get to close quarters with the inward secrets of this book on stricken Belgium, who has yet to feel even the presence of purgatory after four years of a Prussian hell. How completely tragical her lot has been; and yet, note with grief, how seldom her lot is mentioned in daily talk!* Even her most native poet, true expression of her deeper and better self, Emile Verhaeren, died tragically, as if sorrows must end their frieze of tragedies as sculptors do a frieze of figures, in a line but little broken and on the same plane But yet the frieze of tragedies will end: so I turn once more to Brangwyn's vision of the sometime Cloth Hall at Ypres, glorious in a northern daybreak, a wondrous dawn ascending in streams of light toward the zenith from behind a black bank of cloud below the old tower and its pinnacled high roof.

Still, I know that this interpretation of imaginative art comes within the verdict that Russell Lowell delivered on human speech:

> "Words pass as wind, but where great deeds were done
> A power abides transferred from sire to son."

* This was written in the tragical spring of 1918.

234

CHAPTER XVII BRANGWYN & ENGLISH WATER-COLOUR

I

His frequent work in this melodious medium dates from his first marine period and the Royal Academy of 1887, when, at the age of twenty, he began to take his place among our aquarellists, exhibiting a sober and reticent study named "Sunday" It was a sailor's day of rest, with men at ease in the stern of a boat, leaning over the side and puffing idly at their pipes.

Eight years ago I wrote a chapter on the general trend of Brangwyn's water-colours—a brief chapter about four pages long—in order that they might be seen more or less in focus among the more important work done during five and twenty years of professional industry Too much was said about Melville, who owed as much to Brangwyn as Brangwyn owed to him. They had a kindred courage, an Orientalist daring that a great many persons either feared or flouted, and each aided the other to go ahead cheerily, using their own colours without awe of authority, and shaping their lives without obedience to routine They had made up their minds that their outlook on life and art should not fall asleep in any old lap of custom Controversy raged around them, and the heat of those days—or one somewhat like it—may be recalled to memory by quoting a passage from H M. Cundall's *A History of Water-Colour Painting* In the last page of this book, after a few remarks on Brabazon, who is dubbed "an amateur painter of considerable means," H M. Cundall says —

"Although there has been much clever work executed with rapid effects produced solely by the brush, it is doubtful whether a teaching which dispenses with accurate drawing of details with a pencil, and relies solely on broad washes, now pervading even schools for the instruction of children, will ultimately become a permanent one. 'That there is,' says Sir William Richmond, R.A , 'a great mass of amateur work exhibited as consummate shorthand, much praised and prized by persons of strangely distorted taste, is evident and growing, so that being trained to accept as great that which is small, and what is puerile is advanced as naïve, this work can easily be tested upon principles laid down by modern dicta : "as little labour as possible, as much indifferent drawing as possible, as little selection as possi-

235

ble, as ugly as possible, and as badly painted as possible". nor is it needful to test the work of a great artist by any theories '"

The answer to all this criticism is not far to seek First of all, action of every sort produces a reaction, which has its beginning among those who hate innovation ; and from action and reaction alike art and life gather good and evil, blessings and banes; classics, inveterate customs, and some catastrophes. Then, as regards the need of testing the work of a genius by theories, as well try to test by theories the rival beauties of sunrises and sunsets, or the infinite varied moods through which the sea passes from year to year Are Mantegna and Luini to be tested by the same principles, or Raphael and Michelangelo, or Herrick and Shakespeare, for example ? What Emile Verhaeren wrote on Brangwyn is true of all original artists who are inspired by unusual power :

"One does not speak of this Master with ordinary calmness Customary measures of praise and blame are out of place Unwittingly, one's tone is pitched higher Violent attack can be understood. A hesitating and cold examination is not permissible Frank Brangwyn impassions like all complete and mighty artists. He is accused of being romantic, but how can this accusation touch him ? It employs a term so obscure that none has ever been able to define it clearly. Classic, realist, symbolist, romantic ! What is there more vague and more irresolute ? As well might we make a public prosecution in the name of a cloud that is blown across the sky !"

Results alone count, "by their fruit ye shall know them"; and results can be tested fairly by those alone who have trained eyes, and unbiassed minds, with a willing sympathy, and who remember that great men are but superior men, not demigods, and have their defects. In water-colour Brangwyn has been himself, bold always, and often apt as an explorer, a collector of adventures, some little and others big. To the Royal Academy of 1890 he sent a large gray aquarelle, with loiterers on a pierhead who watched a foreign boat come in, and a larger one was exhibited the same year at the Grosvenor Gallery. Its motif was a group of fishermen reading *The Weekly Dispatch* in the yard of a seaside inn They had come upon a good story, and each enjoyed it in his own way The colour was gray and quiet; but in 1890, also, at the British Artists, an oil sketch of men "Loading Grain on the Danube" marked a coming change in Brangwyn's outlook, gamut, and technique. Two years later this fact was evident in a vivid, splashing water-colour, "Puerta de Passage, Spain."

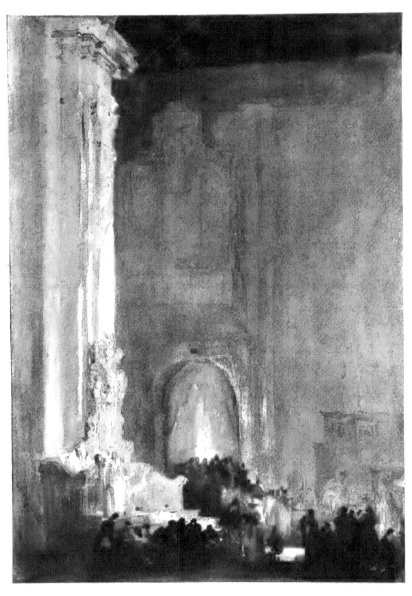

"THE DUOMO, TAORMINA" FROM A
WATERCOLOUR SKETCH IN THE
COLLECTION OF R. A. WORKMAN, ESQ

Between 1895 and 1904 his water-colour was represented at various exhibitions by "The Market Place of Algeciras," "The Beach at Funchal, Madeira," and "A Moorish Well," which was bought for the Luxembourg Gallery, and which to this day represents worthily his Easternism A Morocco boy in a golden yellow gown carries a water-gourd, and behind is a group of figures, who make plots of sunned form against sober green bushes. Every touch has verve and life in it and hue after hue joins in a vigorous cry of good original colour Boldness and breadth, with illusion, belong to Eastern effects of heat, light and repose, and they are present in this water-colour

Two years later, in 1907, as an immediate forerunner of an etching now famous, Brangwyn painted on blue paper a design called "Boatbuilders, Venice," employing body-colour with resonant effect Frequently I distrust coloured paper—except in such a drawing as Brangwyn's "Ironworkers," where a tinted paper accords quite well with the local tone and the impact which a fine subject in its own setting expresses. Often I am sure that coloured paper does no more than enforce a rather despotic convention on drawing. Now drawing is conventional itself partly because there are no lines in Nature, and partly because all things in Nature are veiled by atmosphere, even dark holes never being so black as ink, or black chalk, or soft pencil. In drawing, then, we have to admit, as an essential art factor, that, while painting and its surface technique reveal by various methods a selection of natural coloured forms, which pattern one upon another in unified contrasts and concords of light and dark tones and hues, a master of linear drawing has to employ a stringed instrument alone and not an orchestra He is a Paganini, not a Wagner, and he must display the strings upon which and with which he charms us into his convention White paper helps him because it throws into relief his convention, it intensifies his black lines, while representing by its colour the sky, with the sky's reflections and the sun's luminous magic. It is thus a symbol that retains enough nature to keep us face to face with Nature's clearest light value in our field of vision out of doors, but as soon as a tinted paper is chosen and employed as a background for a drawing, whether a line drawing or a coloured design or composition, we fear that Nature's luminous field—her sky and the sky's agencies of light—may vanish altogether, we may cease to find any normal order of relationship between the various elements of a picture. Then, as I have said, a despotic

237

convention is imposed upon an art already conventional, and many
a danger is added voluntarily to the difficulties and risks which
traditional tools and materials keep in an art as natives

Blue paper denotes the Venetian sky and its reflections, but it does
not suit Venetian houses and a yard in which gondolas are built, and
it makes the use of body-colour necessary, though the most beautiful
and varied qualities of aquarelle come from luminous paper under
washes of pigment which, in glow, impact and transparence, are
various, melodious, and free from the glossiness of dried oil paints.
For these reasons I prefer white paper under water-colour, though I
know that Brangwyn, like other men of genius, has a right to break
rules and principles As a disciple who tries to interpret his ver-
satility, I do not question this right, but as this book will be read, I
hope, by some young art students, among other students of art, let me
say that an Achilles named a man of genius has his own bow and his
own archery, both too strong for lesser men to practise with

It is true that Cotman, a rare spirit indeed, used tinted papers pretty
often, and gave substance to a good many of his water-colours, em-
ploying a sort of paste—I know not how he made it—and not flake
white Another giant, David Cox, used coarse tinted paper under
some grand broad impressions which used to be deemed too rugged;
and Turner also, for sketches, went away sometimes from that
passion for translucency which, during the dark period of his early
oils, when Loutherbourg and William Daniell were among his glean-
ing fields, caused him to sprinkle a prepared canvas with sand, in
order that grains of sand might sparkle dimly like wee globes of
light under his pigment Great art being Nature passed through the
alembic of genius, we accept with a level mind what a genius does,
off and on, outside his usual practice, though we have a right to
choose what we like best from his deeds done

When I look back at Brangwyn's early work in water-colour and try
to see it in company with the later, I feel how varied and honour-
able his course has been, and mainly in original sketching To
speak figuratively, he has produced many a sketched ode, many a
lyric, like the exquisite "Valley of the Lot," many a beautiful
tinted elegy of the wayside and the countryside, with a few stern
tragedies, a comedy here and there, and a few epics, like the
"Exodus from Stricken Messina" There's truth in what Whistler
wrote —"Nature contains the elements, in colour and form, of all
pictures, as the keyboard contains the notes of all music But the

238

artist is born to pick and choose, and group with science, these elements, that the result may be beautiful—as the musician gathers his notes, and forms his chords, until he brings forth from chaos glorious harmony. To say to the painter that Nature is to be taken as she is, is to say to the player, that he may sit on the piano " It is in Brangwyn's water-colour that we see most intimately—almost in the nude, so to speak—how he picks and chooses elements from Nature, and then groups them with science swiftly and spontaneously. Long practice as an artist has taught him *to do* ; instinct guides his choice of motif and his use of fine colour ; but science, which teaches a man *to know*, rules over his versatile spacing and design.

<div align="center">II</div>

Since 1910 water-colour has been a necessary companion on his holidays. It is convenient to carry, it dries quickly , its brushes are easy to wash, and it is not much affected by windblown dust. If you travel with oil colours and canvases they rule over you, and you become a menial to your tools and materials As for the aquarelles that unite 1910 to the present day, they do in sketches precisely what Brangwyn is bound to do, unless he runs counter to his own genius ; and thus my interpretation must sum up from his water-colour work as a whole and in its most notable aspects and allusive qualities.
He has done one set of water-colour impressions, numbering about fifty, that may be described, without extravagance, as tragic and epical. In 1908, after the earthquake, Brangwyn went to Messina, as we have learnt from a few of his etchings, and these fifty water-colours are the history of his experiences Two Messina sketches were seen as colour-plates in my earlier book , and the whole series proved, with mingled glow and gloom, pathos and satire, grandeur and meanness, that men of a day among the ruins were often about as foolish as moths are at night when they see naked flames Now and then gamblers and thieves were busy, and some other fools made themselves into beasts with drink and revel. Contrasts between prayer and levity jostled one another, as if comic songs at a death-bed would enforce attention, like deep harmony Below the Duomo, itself partly a ruin, and awed as by Dante, little busy men would pray sometimes, and at other times would care not a jot, seemingly, that Nature had ruled again over human pride, destroying

with terrible speed what men had put up with slow pains. Human vice remained, and gregarious custom, with half-hours of emotional prayer, and some other ordinary good behaviour.

Thus, in Brangwyn's historic water-colours, sketched at a white heat among sinister ruins, Messina in one aspect seems to be what Chaucer writes about drunkenness—a horrible sepulture of man's reason, more fate-haunted, of course, since earthquake has made an epic of desolation where many a year of good material work done by man is injured, or broken, or smashed Yet we cannot say that human folly seems to have a longer tenure of life than human thought and handicraft, for almost all we know about many a people and many a tongue is learnt from what seems to be the first and most fragile of man's inventions, pottery, fictile art, like those clay vases wherein primitive tribes buried their enshrined dead But yet it is imperative that painters, like other historians, should gather from disaster all that Brangwyn learnt both of nature and of human nature amid the wreckage, grand and mean, at Messina.

For art is a great deal more than it is summed up to be by Rodin's four aphorisms It is more than taste, and more than a reflection of an artist's heart upon all things that he creates, more also than the smile of a human soul upon the home and its furnishing; and more than thought and sentiment—each with its charm—embodied in all that is of use to mankind Art retains past ages, and reveals our own times, and along many lines foretells what is to come, else it could have no chance of being accepted by future generations; and it owes quite as much to tragedy as to those sacred qualities which make some lives and some works nearer to a selfless candour and peace than most men are in their prayers. Messina in art, after an earthquake, is thus as valuable to us as a Fra Angelico, or a Cardinal Newman, whose very controversies prove him to be as a saint among lovely and gracious poets

A collector offered to buy for the Tate Gallery one of Brangwyn's Messina sketches, if the men in office would receive it properly ; but some policy of the backstairs became too active, and the water-colour went elsewhere Yet Turner's water-colour sketches, and his grand feeling for tragedy among the Swiss mountains and in wrecks and naval battles, should have taught even momentary men in office that Messina and Brangwyn should be accepted together, being as durable in water-colour as paper and pigment would be. I have no doubt that Turner would uphold the best of Brangwyn's Messina

240

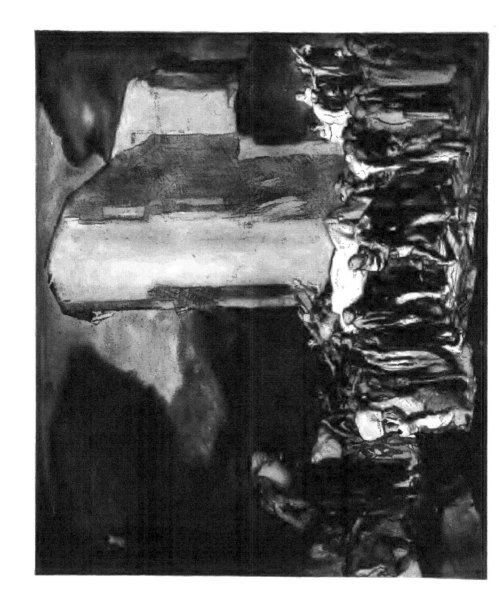

sketches were he living to-day. He was drawn toward painters who, like Girtin, Cotman, J. J. Chalon, George Jones, and William Daniell, had grit enough to adventure

As I have hinted, many of Brangwyn's impressions in water-colour, easy, swift, and slight, are to him no more than shorthand notes are to travelling men of letters, quite necessary as aids to future work, but likely to irritate those who help to form the cocksure dunciad of mediocrity. Dunces like to fizz over when they see things outside their ken, it would tire them to seek in their brain for a little thought Brangwyn's coloured shorthand was frequent in the Messina jottings and hence, perhaps, the Tate Gallery episode. But every sketch heralded the principal Messina etchings, preparing their artist for work more testing than any other—sublimation, the act of putting a tragedy into aphoristic brevity and power. Three plates were etched at Messina, and of these one is memorable, "The Headless Crucifix", but for incantation we return to large plates etched from water-colours and other sketches, like the Immacolata di Marmor and the Church of the Holy Ghost

Does Brangwyn himself set a high enough value on his water-colour notes, wayside jottings, and studies? Does he keep enough of them always at hand hoarding these confidential memoranda as Charles Lamb cherished books, thumbed old folios and "ragged veterans"? It seems to me that he gets rid of far too many, revealing his methods through all their ways, and his most secret emotions in their gestation As a rule, even when sketches are given to the world as posthumous works, like diaries and private letters, their cream alone should be circulated, unless they come from inferior artists, mere moments in art Dewint's wayside jottings were dispersed unthoughtfully, and now that collectors decline to sell his best sketches, his oddment industry has begun to rise up against his fame English water-colour has been harmed often by a want of reverence for sketches, Turner alone setting a just store by them and treasuring vast numbers But Turner, like Tennyson, watched over his spiritual products as jewellers do over gems He was far too astutely cautious to display with abandon to all the world his methods and their undress of gradual development. So he declined to teach drawing—except, it is said, to Fawkes of Farnley, his host of hosts, and once when Mrs. Paris, Fawkes of Farnley's daughter, appealed to him about a technical matter, he touched with a forefinger his outstretched palm, hinting that his words of water-colour were to be

bought at a price perhaps, but not by a pretty and sweet manner in asking questions Good Turner! His loneliness was peopled with sketches, sunny parts of himself

That Brangwyn and others do not prize their sketching enough, though a thing to be noted, is not a thing at all hard to explain Its results, as a rule, are as intimately personal as the counterfoils of their cheque-books, where the autobiography of their finance in spending is as evident as the autobiography of their moods and methods will ever be in their unrehearsed efforts, outlines, rapid impressions, and hinted improvisations But sketching to a Brangwyn is a great deal easier, because far and away more pleasant, than signing cheques, and we value most what we do with most difficulty Turner was aided by the fact that the art of water-colour—an art, too, of English development and English practice, like mezzotint— was often snubbed as a Cinderella, so that even Cotman, that prince of style, had to teach drawing, like Dewint, a colourist unique: and like Cox, our English Corot, full of English breeze, beauty, and waywardness

Brangwyn has points of affinity with these masters ; loving colour, romance, and the sea as deeply as Turner loved them; feeling as near to mother earth as Dewint was and is all through his profuse work ; and being as fond as was David Cox of that peculiar, merry music that seems to have no other homes than those that it plays from among British landscapes, English, Welsh, and Scotch, with their backgrounds of wondrous clouds.

To-day, fuller by far than in 1910, I see Brangwyn as a legatee of English water-colour. Some have put a wrong name on his apt allusive glow, sparkle, breadth, rush, and unity, calling his water-colour a rebel against our national medium and its traditions; though the newness he has added, easily, spontaneously, is not more of a rebel than was the varied newness that came from Girtin, Turner, Cotman, James Holland and David McKewan. Note, too, how emphatic is the contrast between John Cozens and David Cox, Rowlandson and J F Lewis, Hearne and Tom Collier, John Gilbert and our Metsu, J D Linton, or Albert Moore and Charles Green, our Jan Steen. F. B and Rowlandson have several fine points of union, notably their weight of style and their frank outlook on common lives; and to Rowlandson we may add, with some reserve, the impetuous John Gillray, whose political and satirical drawings, in number more than twelve hundred, and in force and fun and mood often akin to Rabelais, are

242

fat with life and jocund, frequently, with beer and broad farce. Off and on Gillray used water-colour, and as boldly as he employed chalk and pen. Brangwyn could never be coarse, as Gillray is often, but he has shown more than once, as in "The Mountebank," that frolic and satire can go cheek by jowl with his other gifts. And then there's Gilbert, Sir John Gilbert, whose best water-colours, robust and alive, versatile, vehement and fanciful, give Brangwyn another team companion among his forerunners Though Gilbert worked far too much "out of his head," as children say, he was a big man by right of birth , and such work as his "Crusaders on the March," with the weight of steel and the pride of chivalry—or again "The Arrival of Cardinal Wolsey at Leicester Abbey"—reveals his cousinship with Brangwyn. The Crusaders *do* march, as F B.'s warships do sail and fight , and as for the Wolsey, on a sheet of paper $14\frac{1}{2}''$ by $21\frac{1}{4}''$, we find an abundant decoration lit up by cardinal scarlet outside old Leicester Abbey. Dramatic verve is evinced through a throng to a sky troubled by wind and storm, yet, somehow, as in Brangwyn, without fuss and noise, with a certain quietude inside the decisive power, impetus, and improvised romance Gilbert ought to have been our Delacroix of water-colour, but he was far and away too busy, scattering often with rich depth of colour, and often with surprising vigour, stocks of ideas that seem to have no end.

As a rule we have to look abroad among foreigners, mainly French, when we wish to aid our interpretation by placing Brangwyn side by side with his affinities, cater-cousins, and other free birds of a feather. But no sooner do we come to his varied records in water-colour than his kinsmen, both near and weak of blood, are found to be English, one and all He would have been at his ease with Ibbetson, and Cristall at his best , with Luke Clennell, too, who illustrated Fielding and Smollett, and painted in water-colour "Newcastle Ferry"; and then there's the good Frederick Tayler, of whom Ruskin says in *Modern Painters* · "There are few drawings of the present day that involve greater sensation of power than those of Frederick Tayler Every stroke tells, and the quantity of effect obtained is enormous in proportion to the apparent means." Consider this praise, and note how truly it may be applied to those water-colours into which Brangwyn has instilled his happiest hours out of doors—in Spain, Italy, France, the Near East, and elsewhere Tayler is a colourist, and, as a rule, it is in his rapid improvisations, his cheery sketches at their best, and not in

243

finished pictures, that he, like Peter Dewint, is a classic, perhaps for many centuries With some men, effort is failure, while work in a flash wins with ease a fame that abides, or a charm that lives on and on When Tayler with an alive touch summoned into a hawking scene his cavaliers and chatty, coaxing ladies, all aglow with high elegance and freedom, his joyous art came presto as a creature of impulse, as by magic , and so do Brangwyn's bolder and deeper transcripts of the life he loves best when he travels. In 1912 about a dozen typical water-colours were made at Toledo, and in France he has made find after find—at Larogue, Figeac, Puy, Parthenay, Poitiers, Albi, Auvault, and many other places.

One Brangwyn water-colour—"Cannon Street Railway Station and Bridge," very similar to the etching, and a sober, reticent, and sterling work—has a fawn and brown hue that recalls at once to memory a very versatile Englishman who, like Brangwyn, was discovered first by the French, and, like Brangwyn, passed from landscape to architecture and from coast scenes to history, failing not often. Though R. P Bonington died at the age of twenty-seven, in 1828, he left his mark on Delacroix, and his name in durable oils and water-colours In such swift easy work as " L'Institut, Paris," he heralds Brangwyn's Cannon Street, though he never gets in water-colour a rich depth akin to that which drew French artists to his oil-paint. It was Bonington, more than Turner, whom James Holland loved in boyhood, and an exhibition of Venetian work by Holland, Bonington, and Brangwyn would be of great value to those who like to see how birds of a feather fly when they are seen in company, with the aura and spell of different methods and times all around the quarter-cousinship of their good gifts As a painter of sunned light and colour under hot skies, James Holland, like J. F. Lewis, helped to prepare a public for Brangwyn. No disciple of Turner, not Alfred Hunt, for example, nor Brabazon's "late Turners," had a vogue even a sixth part as wide as Lewis's and Holland's ; and let us note also that Ford Madox Brown's water-colour, as in "Elijah Restoring the Widow's Son," breaking away from English reserve and sunlight, was another pathfinder into that ardent and intrepid Easternism from which Brangwyn has won many large-hearted gains and some big victories

There are writers who think that originality is to some extent harmed when it is looked at side by side with its rambling pedigree, yet interpretation is impossible without help from parallels, analogies,

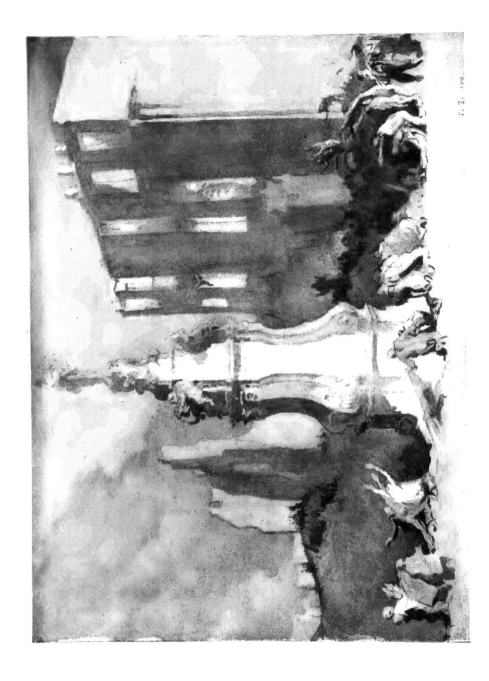

and other aids that give useful hints If, for example, you take
Turner from gray boyhood to his versatile second youth, you must
needs feel and see that his art, at one point or another, has affinity
with men so far apart as Loutherbourg and Titian, Gainsborough
and William Daniell, Claude and Cotman, Van der Capella and
Wilson, Girtin, George Barret, and several others
So let me gather from Brangwyn's moods just a few more hints that
recall his predecessors, while bringing us closer to his holidays in
water-colour, which, like other sketches and jottings, cannot well be
approached by detailing analysis In past days water-colour had a
varied influence, translucent and enriching, upon English oil-pictures,
suggesting to Gainsborough his use of thin, fluid, melodious paint,
causing Turner, in his late and lyrical oils, to aim at effects which
he achieved completely in water-colour lyrics, and causing Holland
and Dewint to transpose some of its qualities into their finest oils
So, too, in Brangwyn's case, if you study his Pont St. Bénézet over
the Rhône at Avignon, a masterpiece, an epic, you will see that
beautiful glowing oil-paint, full of depth, and with a vigour that
seems to radiate, has a luminosity akin to the gleam of Whatman
paper under a great colourist's water-paint Gautier said "Drawing?
It is melody, and painting? It is harmony" There's harmony as
well as melody in fine water-colour
Again, among Brangwyn's aquarelles there are some drawings in
that monochrome wash which several big men of the past employed
frequently, like Turner, David Cox and, less often, Dewint Here,
for example, is the old bridge at Kreuznach in Prussia, on the river
Nahe, with quaint and tall timber houses built out on corbels from
low and wide piers. Here the monochrome is grayish, while it is
amber-brown in a most virile and expressive drawing of the huge
defensive bridge at Córdova, originally a Roman bridge, but re-
modelled by Moors of the ninth century At one end this bridge is
guarded by the multi-towered Calahorra; and the city entrance has
a worn classic gateway and an elevated statue of Saint Raphael,
patron saint of Córdova Another good monochrome is a prepara-
tion for Brangwyn's etching of the Pont Neuf at Paris. One point
more it appears to me that, with an exception here and there, his
use of water-colour has much in common with Constable's, in that
its function is rapid, vibrant statement, and not such built up effects
of sunlight and shadow as Clausen has gathered into mosaics
composed with deft elaboration. In many oils Constable grows

245

heavy ; he remains free and brisk and light in his rare water-colours.

Brangwyn's wash gets easier, swifter, freer, adding song after song to its accented sweep; three or four hours enable it to flow over a large sketch, leaving there a decoration as well as a travel study.

It is most entertaining to study such contrasts as "The Valley of the Lot" and the "Exodus from Messina" and "The Interior of Notre Dame at Eu," setting them side by side with an earlier method, also expressive, where chalk drawings, meditated as carefully as his cartoons are, receive from water-colour the gleam and glow of a sunny climate. Sir T. L. Devitt has a typical work in this line; it is named "The Orange Market," and belongs to the year 1901. Its quietude is at once so rich, so ample and so ornamental that, when a reproduction of it is viewed side by side with water-colours by many other living men, reproduced in facsimile, "it puts them to sleep," as old boxers used to say.

I

astels have never taken their proper high rank in Society. At first, and for a long time, they were kept down by the jealousy of oil-painters; and then they became pets in boudoirs, drawing-rooms, and a few dusty, enjoyable studies where collectors defied their womenfolk and spring cleaning. Never did they rise into the company of oil-pictures, either in homes or at public shows. Because they were liked as very nice, pretty, clean things—"not messy, you know, like oil-paints"—pastels achieved fame as a boon to any girl who wanted to be a Rosalba Carriera without spoiling her frocks, or staining her hands, or shocking papa and mamma with the drying smell of oil pigments.

Among the Academicians of Reynolds's brave days, there were two pastellists, both good, and neither took his place as an equal in art among those oil-painters who failed to prove themselves better men. Good Francis Cotes graduated into oils from pastels, taking with him his pastel colour, some of his portraits in oils have been given to more marketable men, while others have passed from obscurity into rising prices. Cotes was not so plucky as John Russell, who, living between 1744 and 1806, worked on and on in pastels, and became in this medium our English Raeburn, English through and through, as candid as Fielding, humorous, and either rubicund with good wine or rosy with health well aired by our English woods and fields and gardens.

How many persons of to-day care a peppercorn for Russell and his free, fresh, and glad pastels? He loved colour as Etty loved it, and put hot blood under the skin, while forgetting at times to give enough body to flesh. And another thing of interest is the fact that George III and the Prince of Wales honoured Russell as their "painter in crayons" *Painter in crayons !* Here is a phrase that I like. It includes coloured chalk as well as pastel, and supplies us with a generic term. Pastels are nothing more than crayons made of a paste composed of powder pigment ground with gum water and then dried into sticks; and whether we use crayons in dumpy and powdery sticks or bound up between wood into firmer pencils, we work in pastel crayons, and a generic term is always welcome, above

247

all when, like a wise religion, it unites the separated charities of many rival sects and doctrines.

To my mind, for example, Brangwyn's crayon study for The Crucifixion is among the great deeds which should convince us that pastel belongs essentially—not to the art of drawing, but to the arts of colour and painting Reticent as it is in hue and tone, it has qualities—original freedom and power, with amplitude and rapt imagination—which we expect to find in a virile master's inspired sketch with paint , and any oil-painter who tried to copy its appeal would find that he had undertaken a hard task indeed.

Or let me choose another example from Brangwyn's versatile pastels. Here are two British workmen whose job in life is to feed masons with bricks, and who lean on their hods to take breath after some up-and-down exercise upon a high ladder. They are frank and typical, and also old enough to be bricklayers, not hodmen; but there's not much brain to help them, and ambition is frozen up in a habit. To what do we owe this excellent study of character? To the dumpy sticks of powdery pastel, or harder crayon en-circled by wood, or pieces of coloured chalk as naked and about as hard as conté crayons are ? It matters not in the least, for the effect is one of a dry pigment without sheen or glossiness applied as decorative colour to a grained paper. Such pigments are members of the same family, whether a red crayon named sanguine or a fragile stick called pastel , so why should they be treated as members of different and rival families ? To my mind, anyhow, the title given to John Russell by George III, founder of our Royal Academy, has a catholicity that frees art from unneeded subdivisions

But the trouble is that customs have as many lives as cats enjoy in a stock proverb Crayons, pastels, tinted chalks, are not allowed to live together in one art as paintings in crayons ; they are looked upon as drawings, and so are water-colours. To hang either among the oils at a public gallery might startle conventionalists into fits almost Life being a sort of gnome story in a perpetual fix, its Cinderellas don't turn the tables entirely on jealous and splendid sisters, who are usually so astute that free trade in their markets finds a defence of tariffs. Who knows why oil-paintings should fetch higher prices than pastels and water-colours of equal merit ? None knows · but they do, though oil-paintings are often more difficult to live with as they need often a clear studio light.

But, after all, pastels have gone up in the world, though they have

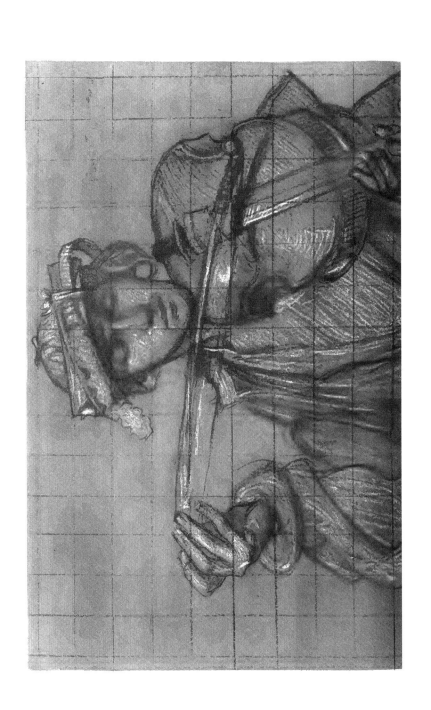

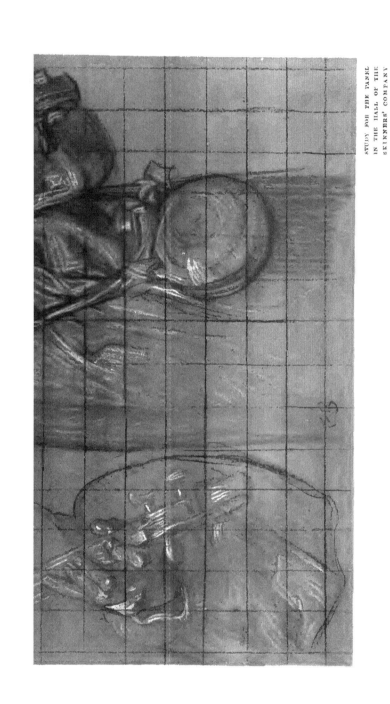

not reached what used to be called
" the upper crust " of élite custom
and fashion In 1898 they begot
their own society, and in London
too, which often acts as a bold
rearguard to delay art's new colon-
ists. During the early eighties
pastels were honoured by Belgians
at " L'Essor " and " Le Cercle
des Vingt " Meunier used them
masterfully on occasions ; and in
1900, at our Pastel Society,
Brangwyn made a hit with a

Meunieresque bit called " The Meal," a record of Black Country
life, and contrasting strongly with a pastel named " The Needle,"
shown the same year at the New Gallery

Three years later F. B did in pastel a set of Thames impressions for
the *Studio Magazine*, and it was hoped that the series would run on
and on, but so much work of more urgency pressed upon Brang-
wyn that he was obliged to break off. One day he said in a fine
image : " So many things goad at me, claiming my time, that, upon
my word, I feel as a baited bull must feel in a Spanish arena, when
he doesn't know which tormentor he should attack first."

If Brangwyn be ever able to show in pastel all his fondness for the
fatigued old Thames between London and the Sea, he will produce
an epitome of his Western art, with boats, barges, great ships, ware-
houses, workmen of many sorts, and striking architecture, with
patches of venerableness, which is all we have of a real old quarter
in our city, whose multitudinous haphazard lost so much charm and
age not only in the Great Fire of Wren's time, but also among those
building adventures by Act of Parliament which Beaconsfield ridi-
culed in *Tancred*.*

* "It is Parliament to whom we are indebted for our Gloucester Places, and Harley
Streets, and Wimpole Streets, and all those flat, dull, spiritless streets, resembling each
other like a large family of plain children, with Portland Place and Portman Square for
their respectable parents The influence of our Parliamentary Government upon the
fine arts is a subject worth pursuing The power that produced Baker Street as a
model for street architecture in its celebrated Building Act, is the power that prevented
Whitehall from being completed, and which sold to foreigners all the pictures which
the King of England had collected to civilize his people In our own days we have
witnessed the rapid creation of a new metropolitan quarter, built solely for the
aristocracy by an aristocrat. The Belgrave district is as monotonous as Mary-le-bone ,

Though industrialism at a great speed eats up what is venerable, a good many nooks and corners neighbouring our beloved river are to this day the best parts of London; and hence they are the parts which Brangwyn loves best. A daily walk to the Thames at Hammersmith refreshed him during many a year; and he may yet do in pastel for the industrialized Thames what Turner did in water-colour for the romantic rivers of France, and what William Daniell did in aquatint during his "Voyage Round Great Britain." His pastel of London Bridge, with boys bathing and many barges dove-tailed into a picturesque platform below two of Rennie's round arches, is among the happiest of Brangwyn's many gleanings from the Thames.

About Brangwyn's frequent use of pastels in his prefatory studies for mural paintings, and for cartoons, I have spoken elsewhere This phase of his work represents all his familiar qualities, together with the special charm that dry colours give on papers which are chosen with care—that is, on papers having a good enough " bite" to hold a powdery material firmly.

He has written briefly on some of the early pastellists—La Tour, and Perronneau, and above all the great Chardin, whose pastel portrait of himself, like that of his wife, heralded that method of visualization which is usually attributed to Monet. Chardin broke up his light and shade with touches of pure colour put side by side with such aptness that they helped one another to suggest more sun and fresh air than painters had yet made real in their studies of atmosphere.

II

Diderot says " Masters of art alone are good judges of drawing. A half-connoisseur will pass without stopping before a masterpiece of drawing " For this reason, probably, those writers on art who have never passed through the schools where practical effort often fails, and where stern teachers give daily advice, have been cold towards the many and various forms of good drawing which have come from differing endowments. Many a time very simple matters have been

and is so contrived as to be at the same time insipid and tawdry. Where London becomes more interesting is Charing Cross . . its river ways are a peculiar feature and rich with associations. . . The Inns of Court, and the quarters in the vicinity of the port, Thames Street, Tower Hill, Billingsgate, Wapping, Rotherhithe, are the best parts of London; they are full of character, the buildings bear a nearer relation to what the people are doing than in the polished quarters "

forgotten. For example, a man of genius, when he tries to overrule his inborn bent, sets affectation to defeat him; every phase of his changing work should arise from inward and unforced impulse and necessity, like Legros' gradual transition from rugged vehemence to the bewitching tenderness of many gold-point drawings, and thus genuine differences between men of genius, which are revealed always most nakedly in sketches and jottings and studies, whether coloured or monochrome, are things to be received as we accept from Nature the distinctive marks of species, genera and breeds

"Le dessin c'est La Probité de L'Art," said Ingres, and so it is when it represents as fully as possible what every true artist has natural power to express through the periods of his unaffected work; but how mad it would be to go to Ingres for the qualities of Rubens, or to ask Brangwyn for drawing like that with which Ingres informed his Monsieur Bertin and his Madame de Senones, or his Vénus Anadyomène, or those incomparable pencil portraits, as manly as they are delicate and exquisite, where for all time the society of an age lies within a magic of wonderful pencil strokes! Brangwyn takes delight in Ingres as Ingres, like Degas, who treasured for years the great pencil portraits of Monsieur and Madame Leblanc, saying to a trustee of our National Gallery, in the presence of Arsène Alexandre· "Et sachez bien, Monsieur, que ces deux portraits ne passeront jamais le détroit."*

Brangwyn loves all good drawings, no matter how much at odds they may be with his own imperious bent, and since this large catholicity comes from within his versatility, none can guess what work it may do on its own accord, for its own gratification, during the next decade or so Thus far two inborn joys have ruled over his best drawing, his original design One of them is action, action accompanied by adventure and unusual power, while the other is the gift that makes him an ample colourist-painter who is fascinated by decorative weight, mass, synthesis, and expressiveness. No matter what his medium may be, whether etching or wood engraving, pastel or water-colour, oil-paint or ink lines, stained glass or designs for household furniture, he is always a man of action, and a genuine painter who is among the colourists of art.†

* "And mark well, Sir, these two portraits shall never cross the Channel"
† In the earlier catalogue of his etched work, compiled by Mr Newbolt, you will find good large reproductions of the drawings from which many etchings were made, and you will note in the drawings the painterly qualities, above all in " The Butcher's

One of his near affinities, Eugène Delacroix, forgot pretty often that genius, like every other thing that lives and grows, gains what is best from within itself, spontaneously, whatever favouring influences aid it from outside. Again and again Delacroix spoke in the voice of Ingres,* failing to see that drawing is the scripthand of forms, and that every true artist has such a scripthand of his own, by means of which he gives expression both to himself as a man apart from ordinary men, and to those aspects of Nature which awaken his most frequent and most seductive emotions. With infinite patience, after choosing a motif as naturally as a bird chooses its own food, Delacroix toiled at preparatory drawings and studies, often dry and tight, only to learn from his genius, as soon as he began to paint, that brushes and pigments were his birthright instruments, and that abundant improvisation was his native strong point He said that his imagination, without which he could not live, would wear him to nothing; and yet, by running counter to his imagination, he increased his inward fever, to which he must have owed his "*tête bilieuse de lion malade.*"

And these considerations conduct us into the most useful and necessary of all maxims in art · always to wait with patient eagerness while a man of genius unfolds in his native way all that he has to grow out of his own good gifts. The variations in Brangwyn's graphic art are unexampled, in so far as living men are concerned. There are three or four rich fields which he has not explored ; as, for example, the field of portraiture,† and the field of elusive and

Shop," "Building the Victoria and Albert Museum," "Brickmakers," "Bridge-builders," "The 'Caledonia,'" "Haymaking," "The Sandshoot," "A Coal Mine after an Explosion," and "Breaking up The 'Hannibal'" All invite careful study, and those in pure line, like the "Old Houses at Ghent" and "Old Women of Bruges," a very earnest study, come from a painter and colourist It is almost impossible ever to say of Brangwyn that his drawing lacks colour and a painterly sweep. *Almost* impossible, as a crayon drawing for his great etching "The Bridge of Sighs"—a drawing reproduced in *The Studio*, Feb , 1911—is neat and tight, a mere skeleton of the deep, rich and ample etching.

* Léonce Bénédite says, for instance "A-t-on assez plaisanté, dans le camp des coloristes, cette école du 'fil de fer' qui cernait les corps d'un trait inexorable. Et, pourtant, nous voyons le grand chef romantique s'écrier à diverses reprises dans son journal et aux dates de la lutte la plus violente '*la premiere et la plus importante chose en peinture, ce sont les contours*' Après Géricault, il ne pense qu'aux '*contours, fermes et bien osés*, et il ajoute quelque part (1824) . · '*y songer continuellement et commencer toujours par la.*'"—*L'Art au XIXᵉ siècle*, page 65

† There's a sympathetic etched portrait in profile, half-length, of Mr Frank Newbolt, in barrister's gown and wig, but Brangwyn tired of it, so he spoilt the plate, making it into a dyspeptic and jaded legal crank in the act of trying to look too judicial

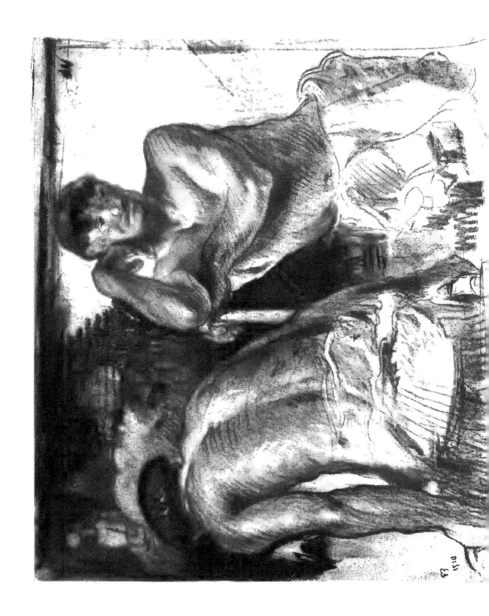

classical balance and delicacy, and that field of enchanted sylvan loveliness which Cotman, in many a monochrome drawing, unites to manly design. But even these fields cannot be closed to Brangwyn, since the masters of each put a spell upon his catholicity. Of Cotman he said to me " I could weep when I think of what this big sublime man suffered from cruel poverty Turner rescued him, we know, and his last eight years of life as drawing master to King's College School were free from a good many bitter humiliations, thanks to Turner. Still, England went wrong over Cotman—even vilely wrong."

But, whatever Brangwyn may do during the next decade or so, perhaps evolving into methods which he has not yet entered, the best work already done, and done with full zest and zeal, is enough for a long life beyond the present one. What could be more versatile than the difference between his "Ironworkers" and "The Crucifixion," or between his "Mater Dolorosa Belgica" and "The Butcher's Shop"? He descends with ease from tremendous tragedy into comedy, as in "The Mountebank," and also in a lithograph that appeals greatly to Henri Marcel, who says of it "The print where Brangwyn has aligned ten types of Buccaneers, with their ridiculous accoutrements and their whimsical awkwardness, is most graphically comic." And then we pass on to a drawing so noble, so charmed with divination, imaginative fervour, as the serene study for The Nativity, where, without effort, the rusticity that environed the birth of Jesus assumes a new fascination I wish Legros had seen this drawing. How enraptured he would have been with those adoring old men, and with the whole setting and its mysterious charm and atmosphere! I think of Rembrandt's "Adoration of the Shepherds," and of Jacopo Bassano's "The Angel of Our Lord announcing to the Shepherds the Birth of Jesus", think of both as apposite, and yet feel and know that Brangwyn is himself. Note, too, the symbolism in that quaint, uneasy old staircase—a presage of the difficult rise of Christianity from an obscure lot among humble poor folk to the world of competitive races and nations.

CHAPTER XIX BRANGWYN'S VERSATILITY AND THE WORLD'S DISTRUST OF THE VERSATILE

t is true to say of Frank Brangwyn that no other artist of our time has done more in so many ways and with so many differing motifs, methods, and materials. Yet his profuse handiwork, his total output as a versatile master, is not miscellaneous Here and there its abounding life and growth are unpruned, but its multiform appeal hangs together; the same decorative purpose runs through it, and the invariable tokens of our artist's presence—"Frank Brangwyn, his marks"—are evident everywhere. And let us remember also that branching is a natural element of harmony when growth and development are natural, unforced, and therefore spontaneous

To find a modern parallel to this versatility we must recall to mind the works of Alphonse Legros, as we have seen in an early chapter, and to find another we must go to the most affluent writer of manly romance, the greater Dumas, whose colonizing genius won from history a vast Empire, and united it to the realms of enchanted books Our modern Alexander went in search of many risks, of course he might have become a miscellany but his unrivalled high spirits never forsook him, and in a thousand volumes he achieved his conquests, without defeating his unity and his staying power, though he employed little Maquet and others *

Sometimes Dumas is variously good, at other times he is variously better, and every now and then he is variously at his best, and this verdict in brief applies also to abounding Brangwyn. These big, bold men have turgid hours and days, of course, when reaction settles into lees and dregs; but is there anything bad in these sediments ? I believe not, as thought declines to use the word "bad" when it notes the waste thrown off by agencies of abundance Rubbish in good and great production, as in Sir Walter Scott's teeming friendship, is like mildew in neglected parts of a fine old house quite natural, but misplaced, and easy to be cleared away by time and spring cleaning

* One day some mistake or other was pointed out to him "Oh ! This fault is little Maquet's," he answered, "and next time we meet I'll punch his head for it." When Maquet attempted to score off his own bat, he made a duck

254

In 1910 I was conventional towards versatility, fearing that it might decline into volatile haphazard, or that it might make far too many calls on Brangwyn's mind and health, like tyrannous interruptions from an importunate telephone. I forgot that change of work, not overdone, is refreshing, it prevents too much brooding over one thing, and how can artists do better than choose hobbies within the united states of art? After the overstrain of huge, opulent mural paintings, it has relieved Brangwyn to explore lithography or etching, or another hobby in which art and life can be viewed as ideal business partners, life providing the capital from age to age, while art has created many profits which have outlived Rome, Greece, Egypt, Assyria, and other perishable glories.

But the world never looks at versatility from this rational standpoint. She wants a man to do the same thing over and over again. Our own age is reputed to be pre-eminent as an age of specialists, and all human effort, we are often told, should get nearer and nearer to the unmellow accuracy that perfected machines multiply. Yes, but the stepmotherly old world is a humbug How often does she speak the truth accurately like that modernized bank clerk named the calculating machine? There's no reason to believe that specialism is more valued to-day by ordinary persons than it was in past ages Men of one job apiece have ever been among the world's favourite conventions except in politics, which have been fields of misadventure for a great many Jacks of all ambitions who have earned by versatile bungling both titles and tragedies.

What the world fears, and ever has feared—yes, in the arts as in political strife—is versatile greatness, which has never seemed in keeping with the mediocrity of mankind, as versatile blundering has been. Shall we take two examples? First, then, the spirited and wise novelist in Benjamin Disraeli caused the world to be suspicious about the abler statesman in the same genius; next, Leonardo da Vinci has not yet been pardoned by the mundane "Why was Leonardo too versatile? Why didn't he stick to one thing?" The mundane are troubled by these questions, as if Leonardo had not answered them in his labours. What else could he do with the busy populace of ideas that kept his wondrous brain incessantly inventive and prophetic?

To be versatile, then, is to give hostages to the stepmotherly old world. Many a time it has been said that Brangwyn grows too many different crops in a year on the same field, or that he has

255

too many strings to his bow. Yet the answer to this cant ought to be plain for all folk to see In fields of art, as in other fertile fields, rotation of crops has been a useful thing, most of the old Masters were versatile ; and as for the archery figure of speech, every string has its own bow, and several bows and strings have a necessary rest when one bow and its string are active and enterprising Enough to say that off and on too many arrows have been shot

But this fact is opposed by another. Our British distrust of useful versatility is the main cause of the imperfect sympathy which Brangwyn has received from his countrymen A general liking for versatile good work cannot come from a nation that declined to face her sinister housing problems until she had spent many thousand millions of pounds in a long-threatened war, for which she made no pre-war preparations.

It is easy to prove that Brangwyn, among his own countrymen, is not yet appreciated as he ought to be Though he has a fine follow-ing, his name is not a household word, as were the names of several Victorians, and notably those of Frith, Millais, and Edwin Landseer. As a famous dramatist said to a friend of mine· "Brangwyn is scarcely known to the vast multitude that a playwright must keep around his writing-table. A thousand pities ! It would stir the people up if they knew his manliness and loved his colour " And what an irony it is that the one artist we have who is as fond of our industrial handworkers as Cottet and Simon are of French fishermen and peasants, should be outside the people's education !

A contributory cause of this limited fame is worth noting. The British people like their heroes to be tyrannously evident, either advertised all the year round by newspapers, or decorated with honours and abundant ribbons A man is certain to be "discovered" when he is made a lord, however obscure he may have been as a civilian. The more we prattle as a nation about the ideal democrat named Equality, the more we value those external symbols of success which draw attention to Nature's real autocrat, Inequality. But title-hunting is a sport unattractive to shy men, and Brangwyn made no effort even to enter the Royal Academy as an Associate. Four-teen years have gone by since he became A R A., and yet he is still detained in the same rank by wayward voters at elections. True, he has sent only a few pictures to Academy Exhibitions; but let us remember that his decorative paintings, which have occupied most of his time, have had their proper places of exhibition in public

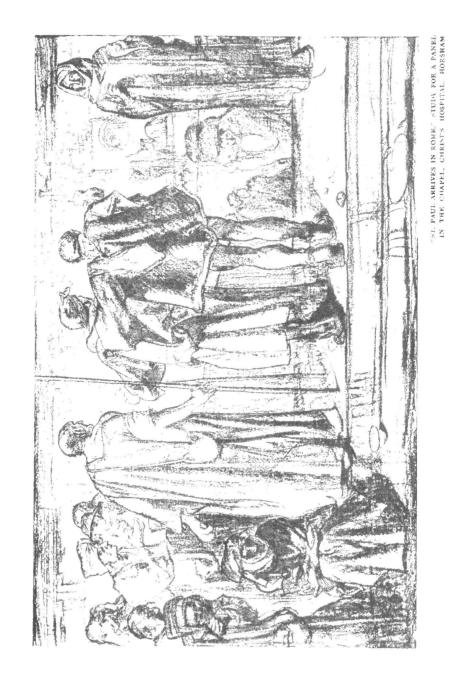

"ST. PAUL ARRIVES IN ROME." STUDY FOR A PANEL
IN THE CHAPEL, CHRIST'S HOSPITAL, HORSHAM

buildings where they are allies of architecture Easel painters alone can take always for their guide that devotion to the R A shows which Turner wished to see in all Associates and Academicians

In 1916 a Frenchman said to me " Though the title ' Sir ' is very common, I find that your original artist, Frank Brangwyn, is just a simple Mister like myself, though he would confer honour on a higher title than ' Sir.' I take this matter to heart You wish to know why ? Well, I've loved Brangwyn's work from the days of ' The Funeral at Sea ' and ' The Buccaneers,' and I'm one of the Frenchmen who believe it was Brangwyn, with a few other English artists, who began the Entente Cordiale, many a year in advance of King Edward and his statesmen They were at home in our exhibitions, they loved French art and the French people, and often they received in France a fervent encouragement denied by their own country Has Brangwyn lost touch with this fact ? No Believe me, the set of etchings that he gave to the French people was valued very much as a most gracious offering of sympathy in this time of war. The French do not wish to be praised because they fight well for their native land, but true sympathy is sweet to them, particularly when it comes, not in words, but in art from a great artist How glad I should be if Brangwyn were French, not British ! And as these are my feelings towards him, how can I help being—shall I say surprised ? or is it pained ?—by the imperfect fame that he has won here in London ? I call it a fame in half-tone, with a spot of sunlight here and there Yes, and the half-tone is surrounded by black shadow, Why ? Some Englishmen tell me ! What do they tell me ? Bah ! They say that Brangwyn is too versatile, because those who do much in many ways cannot do enough in one way to beat down dislike from settled foes and to attract neutral support from artists in other lines. If so, then art is war, modern war, and versatility in art is to be feared as the Boche of artistic enterprise and achievement. A comic idea ! Was the

versatile Michelangelo a Prussian of his versatile period? And if Brangwyn is too versatile for the versatility that won your British Empire, how much permanent support can the versatile movements in art and letters receive in your country?"

An important question, indeed! To let versatility run wild in political follies, while we remain frost-bound towards the generous adventures that the fine arts gain from versatile genius, cannot be a custom fit to keep society and art at all safe and progressive. Yet there is no need to be astonished. Democracy at present is a boiling pot of party strife attended by millions of apprentice cooks, and who can divine what the cooks and their pot are going to concoct for our nation's future?

The fine arts have nothing wrong to do with political strife, thank goodness, their function is one of amelioration; whereas the apprentice cooks are so eager to be cocksure before they know that they look upon their boiling pot as far and away more important than the fit and thorough work named Art. Not yet have they studied even recent history Already Turner and Cotman are more important by far than the party strife of their period; and already Dickens, Thackeray, Tennyson, Darwin are more important by far than Gladstone, Liverpool, Canning, Melbourne, and Salisbury. However humble a true artist may seem to his generation, he may outlive a type of society many thousands of years, like prehistoric craftsmen. Though we cannot see, yet we can feel, the Hundred Portals of the Pharaohs Always I think of the world's past drama as an illimitable mortuary built by changeful politics, through which the arts run as beautiful shining corridors open and free to the solacement of millionfold ordinary man

Yet the stepmotherly old world never wearies of saying to each new generation. "Why do you play the fool with my customs and conventions? I live in them, and what right has your inexperience to insult *me* by wishing to alter *them?* You get yourself into scrapes by hunting the horizon, and poison life with your vanity. Take care! Any fool can enslave himself to the present day; the wise alone are *free*, for they alone know that there never has been a great movement which has not drawn its inspiration from bygone times. Don't talk to me, then, about using your minds without too much awe of authority. Cant! Cant and conceit!"

Of course, new crops grow for ever on old fields, and repetition is an eternal law in all natural production and reproduction, yet it is

258

equally true that the main function of the human brain is—not automatic action as in other vital organs, but—creative enterprise, which carries a just desire to advance into a greater natural law than repetition—the infinite variation out of which new species emerged and newness comes continuously What is evolution but a vast series of variated resurrections, by which base forms of life have been changed into better forms ?

Yet ordinary human nature has ever been a foe to its own welfare Only a person here and there has trusted his mind, refusing to repeat stale old acts requiring no more thought than he has given to a sneeze Most men have shut themselves up in customs and conventions—to live there as hermits. And note how dreadful, how unimaginably horrible the results have often been When Pasteur and Lister broke loose from arid medical conventions and began to make experiments with antiseptics mankind may have been a million years old. Who can imagine how many persons, reckoned in millions of millions, were slain by the toxins of microbes between the Lister-Pasteur awakening and man s advent from apelike ancestry ? And other recent boons to the common human lot have mocked all the dead generations—that poor dust, which in the ages past was mankind interned by customs and conventions. Yet the world distrusts versatility in a Brangwyn or in some other genius! And the Modernists who love it in their own creeds or sects, however much they may hate it in outsiders, brag about progression as if the creeping visitor named Progress needed trumpets and banners! From age to age Progress has been a charity of tears so long has she been kept away from her duties.

For in every one of us there are two selves at least . the outer self, or husk-self, of convention, and the inner self that becomes active when we pass from routine into a passion. Sometimes these agencies act together as friends and allies, uniting and exalting men and nations during a time of peril , and then we learn that the inferior self needs but enough ardour from the better self to be nobly enterprising. As for the better self alone, unaided by some custom and some convention, it is apt to get itself into scrapes, its character being childlike, wayward, inconsequent. Discipline and roughened experience do it good and so the useful and necessary thing is to discover the means by which it can be ordered and not subdued. The inner self is versatile in most children, whose original questions, fancies, criticisms, often do justice to the big size of their brains

259

Always in children there is infinite variation until too much custom and too much convention enslave them ; then they dwindle from originality towards the dead-level on which their elders deliver lessons and punishments If only we elders used with pious care the great treasure of versatility with which Providence has endowed childhood ! If only we remembered that it is ruined by too much routine and spoilt by too little ! I have seen truly wonderful brush-work done by children in our board schools, often very small children, but this infantile genius rarely outlives the early teens. In a few years gifted youngsters are boy-men and girl-women, eager to be "free" and to forget what they have been taught, eager also to prove that they are British by being half-hearted towards work and whole-hearted towards wages.

Unless we wish to augment the tyranny of custom and convention, in order to make the chances of truth and right more unfavourable, we must learn as a nation to pass from versatile muddles into versatile merits Why should any sane mind think that a new baby art crying outside the fortress of convention is an abortion to be mocked ? Bacon says on this point "As the births of living creatures at first are ill shapen, so are all innovations, which are the births of time " So a civilized people should be as a nurse to the versatile, and this no people can be unless they divide customs and conventions into two divisions into those which are permanent, like the height and breadth of tables and chairs, and those which are routines to baulk thought and experiment.

Would it be useful, then, to have popular exercises in the art of innovating ? Sports, games, courts, trades, professions, without help from Parliament, could set a good example by changing periodically their rules or their customs, for the purpose of showing that the large human brain is alive—not in amusements only, but also in dead-earnest pomps and etiquettes. I wish, too, that versatility in truth-telling could be enticed into politics by granting titles to those parties that dared to break away from cant and make-believe, as innovations of all useful sorts would have a much better chance if our political life could be lifted into candour Have the Sir Con-servatives told more truths than the Lord Radicals, or have the Lord Radicals risen in honour above the Sir Conservatives ? The highest title for political truth-speaking might well be Prince , but any political campaign managed by craft, and not by candour, would reduce to the ranks an unprincipled strategist.

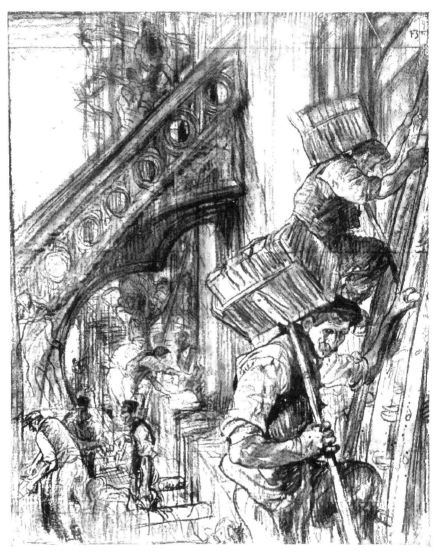

SKETCH FOR A POSTER: "REBUILDING BELGIUM"

Anyone who thinks thus of the arts—thinks of them socially—finds always that they lead him—not into isles of dreams, not into unsubstantial fairy places, nor into sects where mutual admirations dwell like echoes in a cave, but—into the vast human drama. All the social influences which have played around Brangwyn, harming him sometimes, and often aiding him, have stored up in his genius so much of our own age that his life and work, as I have said before, are allied with both East and West in our Empire. We go to them, not for the scholar's attitude towards our lot, but for the virility and the versatility that achieve great and enduring things in the midst of rugged hindrances and many perils. And Brangwyn has not stopped growing, or, rather, his genius goes on adapting itself to life in the protean give and take that make art and life changefully interdependent.

As a rule development in middle age is from exploring colonization either towards or into concentration. Ideas come as single guests, they do not arrive in parties, and the rarer they are in their un-invited friendliness, the more eager their welcomer is to grow all that he can get from their appeals to his productivity. So he puts into a single idea as much maturing purpose, as much penetration and breadth of vision, as he used to divide among several when he enjoyed the springtime of his traffic with ideas. If Brangwyn is not an exception to this usual change in middle age, his development during the next few years will be very remarkable. His self-criticism, instead of being like an overseer on horseback ranging here and there on an enormous ranch, will become more like an English farmer who has only a good hundred acres to cultivate in the most thorough manner possible. It will question and cross-question many a thing which in the years gone by appeared to be as inevitably right as the gray brilliance with which Nature chastens her most sumptuous displays of colour. Constable was happy when he could stand before a six foot canvas without being harassed by the forth-coming cost of its frame. Brangwyn used to be quite happy when at work upon huge spreads of canvas, which were often almost a tyranny in length and breadth of surface; and he is still somewhat resentful towards any motif which invites him to run a hundred yards, instead of a Marathon race. Does this mood belong to early manhood, or will it be continued through the next ten years?

Lucky is the artist who can review his past work when he is well and strong. Many a one has died too soon, like Girtin and Bastien

261

Lepage, and many a one has not seen until too late that work done in early manhood is but a preparation, the making of an abundant manner, for hale middle age to chasten into maturity The good Gainsborough is a case in point Like Brangwyn, he indulged his emotional alertness and his wondrous facility, and achieved effects which could not be analysed well in terms of technique, so much more varied and commanding were they than the simple and often sketchy handling of his paint explained at near range. Then, suddenly, a cancer formed behind his neck, and Gainsborough began at once to review all his affairs. He pondered much over his art, seeing a defect here and there, and wishing that in future works he could do greater things than those by which he would be remembered Too late ¹ He died at sixty-one, a greater Gainsborough dying with him, for he had gratified his facility with so much fervour that he had rarely plumbed the deeps in his brave serene genius.

Brangwyn is only fifty-one, so we expect much more from him, not in quantity, but in that essence of his deeper self which the concentration of middle age is fitted to alembicate from the ample and ardent qualities exercised and ripened by his past labours. In posters, for instance, he could illustrate a period chosen from heroic English History, could illustrate it with so much vim and truth that the whole Empire for a long time would be grateful to him. In portraiture, again, there is always a wonderful field for concentration, and Brangwyn as a portrait painter could not fail to make rich discoveries Most of our portraitists are so very self-conscious, or so enthralled by their methods, that they often paint almost as much indiscreet autobiography as discreet biography. Only once in a way, by rare good fortune, do they solve the most difficult problem in their dramatizing art: how to reveal character as a subtle and complex agency that directs its painter, and not as a thing that painters can either flatter or caricature at their ease and for the indulgence of their idiosyncratic technique

Brangwyn understands the sovereign first principle of portrait painting, by which portraiture is turned into a most perilous art in and of honour. The whole truth, when unpleasant, ought never to be put into a portrait unless the sitter is a professional model, because no sane person commissions a portrait in order to be made odious in a painted dossier of the worst in his character So an artist who accepts money from his sitters accepts also the first principle governing his work Instead of being a private detective to find out evils

262

in his paying models, he must be governed as a gentleman by moods and aspects of the true which are not unpleasant and libellous Writers on art cannot speak too frankly on this point of honour when a portraitist forgets his position as a paid craftsman, and betrays his models with relentless zeal Now and then present-day portraiture is so much like an inquisition that onlookers ought to be angry, as they would be if a painter stole his sitters' private diaries and then boasted about a shameless misdeed Portraiture is not raided enough by men of Brangwyn's mark We get from it over-much fawning, sometimes overmuch spying, and generally too much technical self-assurance. Often it brings paying models very near to that peculiar intimacy which unites novelists to their invented characters

Last of all, to interpret faithfully is to prophesy, since there is in all growth an order that tells what it is going to do; and for some time Brangwyn has given hints of a desire to enjoy work less fatiguing than have been his many great adventures over very large mural decorations With this desire as a motive-power, how can he keep away from its gratification? It is likely to guide him, just as his growing distaste for the noise of London has caused him to buy in Sussex, at Ditchling, a retreat as pleasant as it is quiet

So in this book, as in 1910, a confident note of expectation ends the last page Yesterday's best work is but a herald of a better best, as no genius has reached its full meridian until it has begun to decline

INDEX

2 N

Lightning Source UK Ltd.
Milton Keynes UK
UKHW020633151122
412232UK00009B/442